Jewish Women and the Defense of Palestine

Jewish Women and the Defense of Palestine

THE MODEST REVOLUTION, 1907–1945

Meir Chazan

Front cover photograph: Women training in Kibbutz Ein Hashofet (named after Judge Louis D. Brandeis), published with permission of Central Zionist Archives, Jerusalem

Published by State University of New York Press, Albany

For information, contact State University of New York Press, Albany, NY
www.sunypress.edu

Library of Congress Cataloging-in-Publication Data

Name: Chazan, Meir, author.
Title: Jewish women and the defense of Palestine : the modest revolution, 1907–1945 / Meir Chazan.
Description: Albany : State University of New York Press, [2022] | Includes bibliographical references and index.
Identifiers: ISBN 9781438490137 (hardcover : alk. paper) | ISBN 9781438490151 (ebook) | ISBN 9781438490144 (pbk. : alk. paper)
Further information is available at the Library of Congress.

10 9 8 7 6 5 4 3 2 1

To My Beloved Sisters
Dvora Mintz and Hannah Reingold

Contents

Acknowledgments

I would like to thank Prof. Hannah Naveh (chief editor), Prof. Hanna Herzog, and Dr. Orly Lubin from Tel Aviv University, who are between the main Gender research leaders within the Israeli Academy, for their support in publishing the Hebrew version of this book as part of the "Migdarim" Series by Hakibbutz Hameuchad—Sifriat Poalim Publishing House (2015). The book was written within the framework of a research project (no. 134/08) headed by my beloved mentor and teacher, Prof. Anita Shapira, supported by the Legacy Heritage Fund of the Israel Science Foundation. Tel Aviv University supported my research project generously. I am grateful to Dr. Nurit Cohen Levinovsky and Dr. Avner Molcho for their help in collecting documents. Special thanks to the book's translator to English, Kaeren Fish. My thanks also to David Ben-Nahum who translated several parts from the fourth and fifth chapters. I would like to give my heartfelt thanks to Philippa Shimrat, who advised me during various stages of this research. My dedicated thanks to Haddasah Brandeis Institute for their respectable award. Previous versions of some of the materials in this book were published in the *Journal of Israeli History*, *Iyunim Bitkumat Israel*, and *Kathedra*—thanks them all.

Introduction

The women's revolution was one of the quietest and most angst-stricken of the revolutionary processes experienced by Zionism and the Yishuv (Jewish community in pre-1948 Palestine) during the first half of the twentieth century, but at the same time one of the most profound and lasting among them. Rachel Katznelson-Rubashov (Shazar), one of the most prominent women activists in the Workers Council and in the Labor Movement, declared in 1937: "The movement's special love for [the poet] Rachel rests, to a considerable degree, on the expression she gave to the woman's soul."[1] She was referring to the poet Rachel Bluwstein, who had written quite innocently, in 1926, "I have not sung to you, my land, / And haven't glorified your name / With heroic deeds, / With variety of battles." The valor of triumphant militarism was not among the ideals upheld by the women of the Labor Movement.[2]

At the same time, as noted by historian Muki Tzur, "Among Rachel's readers were those who viewed her as a sort of Marianne, the symbol of the French Revolution. It was specifically her modest poems that symbolized for many the revolution that they believed in, which could speak only humbly, for it was a revolution of doers."[3] The poem "For My Land" is perhaps the most influential of Rachel's poems of this genre. It is revolutionary and militant in its human, poetic, unique, and quiet way. The path of these women doers, who sought to add the realm of security to the range of their activity in Zionist fulfillment, is the subject of this book.

A debate that received only minor attention in Israeli society, on the eve of the 62nd anniversary of the establishment of the State, was which event should stand at the center of the celebrations. The ministerial committee for ceremonies and symbols decided against highlighting the

1

100th anniversary of the Kibbutz movement; rather, the decision was made to mark 150 years since the birth of Theodor Herzl.[4] At the first Zionist Congress in 1897, one of the representatives raised a question concerning the seventeen women participants (in contrast to 192 men): "Are the ladies entitled to vote, or not?" Herzl replied, "The ladies are, of course, most honored guests, but they do not participate in the vote."[5] In a speech he delivered in May 1899, Herzl asserted that "In Zionism, the women's question has effectively been solved."[6] The fact that, starting from the Second Zionist Congress in Basel, women also participated as representatives with equal rights—a matter that "in other countries will remain just a dream for a long time," as Herzl announced at the end of his last speech at the Zionist Congresses in 1903—was viewed by him as the solution to "the women's question." For him, this was one aspect of his aspiration to establish a modern, progressive Jewish society, and at the same time one way of building and nurturing support for Zionism among diverse Jewish circles.[7] Although one might doubt the view that equal rights for women was merely the "external appearance of a liberal regime," their integration into Zionist political life was gradual indeed, as testified by writer Sholem Aleichem, who attended the Eighth Zionist Congress in 1907: "They [the women] endow the Congress with special grace. It is a pity that none of them wishes to, or none is capable of, appearing on the stage."[8] The prosaic account of the goings-on in the corridors and hallways of the early Zionist Congresses revealed that "the first Congresses were attended by important householders, and thus the Congress became a fair for 'matchmakers'; good girls seeking to marry doctors were invited here to 'be seen.'"[9]

The year 2010 marked not only the 150th anniversary of the birth of Herzl, but also the 110th anniversary of the birth of someone less important by all accounts: Lilia Bassewitz. Her public career was based on an absolute denial of Herzl's assertion that by the end of the nineteenth century, the "women's question" had already been solved by Zionism. Bassewitz, along with several other women pioneers, devoted a considerable part of her public activity over the course of the first half of the twentieth century to dealing with the "women's question" within the embryonic Jewish society in Palestine. These women proceeded from the same theoretical and political point of departure that had prompted Herzl's unfounded declaration, as asserted quite forcefully by Hayuta Bussel, one of the founders of Degania Alef: "The problem of humanity cannot

be solved without addressing the problem of the Jews. The problem of the Jews cannot be solved without solving the issue of women."[10]

According to historian Billie Melman, the issue of women and their place in the history of Jewish settlement in Palestine "arouses discomfort." The reasons for this discomfort arise, inter alia, from their marginality in the historical past of that period and their relegation to the outer periphery of its historiography.[11] Today, two decades after academic research in this area began to develop and diversify, it is still sometimes difficult to work out whether their marginality has been illuminated, in retrospect, with excessive emphasis, or the opposite—whether their centrality has been obscured because of emphases and academic preferences that are legitimate in and of themselves, but have led to a tendency that requires updating and correction. In light of this obscurity, it is necessary to establish, at the outset, that the direct contribution of women in the realm of defense and security, during the Yishuv period, was a minor one. At the same time, we might adopt the assertion by Yossi Ben-Artzi, meant more generally but applicable also to the discussion at hand, that although the women's "participation" in security matters was minor, their contribution in the realm of "motivating, explanatory force" is vital to an understanding of defense activity in pre-State society.[12] Because of the centrality of the defense realm in the Jewish national life as consolidated in Palestine over the course of the first half of the twentieth century, this realm represents a fertile and multilayered source for the description, characterization, and analysis of the situation and status of women in Yishuv society. Moreover, the story that unfolds here presents and highlights, in various ways related directly or indirectly to security aspects, the processes of maturation and development undergone by Yishuv society, and especially by the Kibbutz movements, in the period between the Second Aliya (1904–1914) and the end of the Second World War.

The public debate that erupts in Israel from time to time concerning military service for women is, inter alia, a product of the flourishing field of gender studies. The debate encompasses a wide range of issues, from limitations on the positions open to women in the army, through women's avoidance of army service, to the vulnerability of women within the framework of their military service.[13] There are periodic outbursts surrounding ancillary issues. For example, in 2011, there were two heated public debates: one concerned the circumstances of the

promotion—for the first time—of a woman, Orna Barbivai, to the rank of major general in the Israel Defense Forces (IDF) and her appointment on June 23 of that year as head of the army's Manpower Division. The other was related to the offense caused to religious soldiers by women soldiers singing at military ceremonies and events. The matter of women singing in the army in Israel, as noted by Hanna Naveh, is one of the conspicuous areas in which the battle for equality, citizenship, human rights, and other civil rights has been abandoned.[14] The situation itself arises from two fundamental processes that occurred over the course of the twentieth century: the growth of manpower needs in large-scale wars, on the one hand, and the intensifying battle for equal rights and obligations for women in all aspects of public life, on the other.[15] The main argument raised in discussions about women and the army in Israel is that the army amplifies gender differences that perpetuate the woman's status of "helpmate." In studies by such scholars as Dafna Izraeli, Nitza Berkowitz, and Orna Sasson-Levi, there is a marked tendency to focus on the Israeli military and social reality from the 1980s onward.[16] The kibbutz, beyond its importance as a central focus of identification and as a significant emblem in the eyes of the pioneering generation, was chosen for the present study also because of the availability and accessibility of the primary materials from that period, allowing us to sketch the development of the struggle to integrate women into guard duties on the kibbutz, in contrast to their participation in guarding and defending other forms of settlement—the moshavim, colonies (moshavot), and towns. The scope of our discussion necessarily precludes attention to other relevant bodies, such as the Moshav Movement and the Religious Kibbutz Movement.[17]

While the contemporary reality of women in the Israeli military receives increasing academic attention, there is a great lacuna when it comes to systematic historical discussion of the events and processes that laid the foundations for the present situation.[18] A review of women's attempts to integrate into the security realm during the period of Mandatory Palestine allows us to examine whether, and to what degree, there was a transformation of their self-image over the first half of the twentieth century, and how their aspirations were received and realized on the level of public life—of which security represents one element. The study of different issues arising from this historical question is conducted here without adopting the academic position maintaining that a sort of glass ceiling, based on traditional "laws of nature" that needed to be

shattered, blocked the way of women in kibbutz society and obstructed their activity within it. Our view is that this approach blurs a proper understanding of the circumstances of that period, with the backing of a gender-oriented discussion framework that obscures the historical perspective and sometimes leads to a deflection of the real dilemmas faced by that generation to the periphery.[19] Although the fundamental thematic core of the present study is located in the sphere of security, the particular aspect that we examine is closely and comprehensively bound up with the social life of women on the kibbutz in the realms of work and public involvement. These three dimensions are almost inextricably interwoven, and this becomes immediately apparent in the various frameworks that we examine here. While the women's activity was conducted in areas perceived by male colleagues in the kibbutz (as well as in the broader Yishuv society) as marginal, it would be wrong to present it as a chronicle of ongoing failure. The focus and presentation here is true and faithful, because the debates over the place of women in the kibbutz led to processes that brought gradual progress, along with regressions, and produced achievements that were sometimes partial or wavering. At the same time, the general direction of our discussion is that analysis of the Jewish Women activity leads to the conclusion that these were gradual, hesitant processes of development, growth, and success.[20]

As in other areas of Yishuv life, in the realm of security, the pioneers of collective settlement were creative, groundbreaking leaders. During the period of the Second Aliya, productive labor in general—and agriculture in particular—had been viewed as the most manifest and tangible realization of the idea of Jewish revival and the creation of the "new Jew." During the second half of the 1930s, however, much of the emphasis in realizing this dream and its objectives was shifted to the realm of guard duty, defense, and the army.[21] The manner in which women perceived the nature and aim of their ongoing struggle to participate in guard duty was, inter alia, an angry reaction to masculine perceptions of the relations between the sexes and objectives that were "proper" and "permitted" for women to set for themselves in their social and professional activity.

As support for this general statement, we examine the struggle of the women of Ein Harod—including Eva Tabenkin, Shulamit Zhernovskaya, and Lilia Bassewitz—for the right to participate in guard duty, with an amplification (through various public forums) of their involvement in molding communal life on their kibbutz and within Hakibbutz Hameuhad (the United Kibbutz Movement).[22] While their success was temporary, it

did entail a breakthrough—mainly symbolic—in the development of the overt and self-aware aspiration on the part of Jewish women during the Yishuv period for active participation in defense and guard duty. These women perceived this aim as a central component of a more comprehensive view of the woman as an equal when it came to obligations, but also in the rewards of building the Jewish national home. From the perspective of kibbutz women, their struggle in the security arena was an integral part of their more general struggle, starting from the early days of Degania, for the right to be considered equals in practice, and not just in theory.[23] From the impression that arises from developments in the security sphere (as well as in research on, for example, the Women Workers Council), it seems that we need to review the idea that the pinnacle of the feminist struggle during the Yishuv period came with the struggle for the right of women to vote for the Assembly of Representatives (asefat ha-nivharim),[24] despite its symbolic importance. Ultimately, this was an institution with fairly limited concrete influence in pre-State society. The struggle of the women of Ein Harod was a link in the chain of efforts by Jewish women during the nation-building period to integrate themselves in the molding of the national character of the new Jewish society, including the "new Jewish woman,"[25] that was being created in Palestine. Previous chapters in this struggle, in the realm of security, had included the demand to include women within Hashomer, and in the demand by women led by Rachel Yanait (Ben-Zvi) for inclusion among those enlisting for the Jewish Legion during the First World War. Later chapters during the pre-State period included women volunteering to serve in the British army during the Second World War and in the Palmach.[26] The credit for the first systematic historiographic descriptions of some of the security-related issues reviewed here goes to Shlomit Blum, Shulamit Reinharz, Uri Brenner, and Yaakov Goldstein, and, of course, the various genres of documentary literature, including memoirs of the veterans of the Hashomer organization.[27]

The story presented here sketches a historical process at the center of which stands the kibbutz. The Socialist-Zionist Kibbutz camp was the leader, the backbone, the metaphorical standard-bearer and—more importantly—the real political factor in the full realization of the constructivist vision and path that had been created and nurtured in the school of the Labor movement in Palestine. Indeed, in some important respects, the kibbutz was the very foundation for the establishment of the State of Israel. Although both the historical narrative and academic interest

in recent years have shown great indulgence—sometimes as a deliberate provocation, usually well deserved—toward other feminine elements within Yishuv society,[28] it seems that the possibility of illuminating significant aspects of the period in question through a study of the history of the kibbutz represents a most valuable creative and analytic source.

The description of the battle waged by the women to take on roles in the realm of security proceeds hand in hand with the intermittent manner in which it was conducted. Elisheva (Eltka) Spektrovsky (Haimowitz), a member of Kibbutz Dafna and active in security matters, who later served in the 6th Company of the Palmach, has ably depicted the ebb and flow of this motif, which is interwoven throughout the years relevant to our discussion: "My conscience troubles me slightly when we come to make our demands. For us [women] there are periods of ups and downs. We suddenly wake up with demands, and then afterwards there's silence."[29] Our discussion also includes, in varying degrees, other aspects pertaining to the situation and status of women in Yishuv society in general, and in kibbutz society in particular, with an emphasis on their struggle for representation in the public arena. To define and illustrate the boundaries of this arena, we are guided by the words of Hayuta Bussel at the Fourth Conference of Women Workers, in January, 1932:

> By the word "public life" we mean not only high politics; in a collective (*kevutzah*) everything must be clarified amongst a circle that is broader than that of the family. Lately there have been many meetings in Degania, and almost all of them have pertained to matters which, in one's private life, are sorted out around the table, at mealtimes, or during work, between worker and co-worker: questions concerning the alfalfa, the bananas, the budget, and so on. In a collective that's impossible. And if a female member isn't sufficiently active in these questions, it's clear that community life is defective. Because if a female member doesn't take part in the deliberations, the decision will be made at her expense—to plant or not to plant, or how to live during the next budgetary year. If the female members don't take an active part, in life, they harm themselves as well as the *kevutzah* as a whole.[30]

Academic discussion of the issues related to military service for women in Israel is continuously expanding, and this is reflected, inter alia, in the

historical and sociological dimensions that come to be included within it. For instance, in her study of the process by which the woman's image in the Palmach was molded, Yonit Efron highlighted the revolutionary and traditional forces whose contradictory influence limited the ability of women members to break the boundaries of gender separation.[31] In other historical contexts of military service at the start of the twenty-first century, Orna Sasson-Levi has examined how the encounter between masculinity and gender that takes place in the army creates norms and identities that preserve and entrench traditional processes of stratification, while at the same time contributing to the remolding of the seemingly fixed images of women and men in society. She argues, in *Zehuyot be-Madim* (Identities in Uniform), that the exclusion of women from combat positions creates structural and cultural differences that help to replicate the inequality between the sexes that prevails in civilian society.[32] In contrast to these scholars and the discussion of the diverse issues related to the enlistment of women for service in various armies in the twentieth century, in all their varying emancipatory, feminist, and patriotic dimensions—especially during the World Wars[33]—the discussion here focuses on the women's demand to defend their homes, in the narrowest sense of the word. Not their private homes, but rather the collective, socialist, pioneering home, which was perceived as a central element in an all-encompassing theoretical, social, and political ideology.

A common trend in gender research analyzes, from different perspectives, the reasons why women who fulfill military roles do not share status and recognition equal to those awarded to men, despite the fact that they serve militaristic needs that aid in the structuring of a masculine, belligerent society. The emphasis in our discussion is on the repeated demands by women to participate actively in security tasks. The women we discuss were not pushed into service as available and cheap manpower whose abiding passivity facilitated their control and exploitation in conformance with patriarchal codes. The idea of gender equality in the area of guard duty was not a goal that the women of the kibbutz movements yearned for. They did not perceive the equality that they sought as a station on the way to establishing an ethos of "a nation in uniform." Their overt and covert hopes to enjoy the prestigious dividends to be gained from the establishment of this ethos were, for them, merely an adornment for their original aim—to feel a partnership in advancing the national goals of the Yishuv as a whole in Palestine.[34] The sort of equality that they sought was an inclusive one, ready to

place its faith in women as potential partners in bearing the security burden, just as they were partners in other aspects of collective life. The tension between rights and obligations played a central role in the discourse surrounding guard duty in Ein Harod in 1936, but the dilemma presented by the realization of these rights and obligations did not push them to gender obstinacy for its own sake. Even when it seemed that their personal, aggressive battles might overstep the mark, they adhered to their main objective—which, in the circumstances of Ein Harod at that time, meant recognition in principle of the right to participate in guard duty, with a slow, gradual, and hesitating implementation of that right, which they regarded also as an obligation, in reality.

Interestingly, the first casualty of fighting in the new Jewish community in Palestine—and, as such, in the history of the realization of Zionism—was a woman. Her name, Rachel Hadad Halevy, is the first to appear on the list of casualties maintained by the Ministry of Defense. She died on April 2, 1886, following a clash that had taken place on March 29 between residents of the Bedouin village of Yahudia, belonging to the Abu Kishak tribe, and the residents of the Petah Tikva colony following a dispute over grazing land and territory. Rachel was struck by the Arabs and died a few days later.[35] No less surprising, the first bloody incident heralding the outbreak of the War of Independence occurred on November 30, 1947, in the form of a shooting attack carried out by the same Bedouin tribe. In an attack on the bus in which she was traveling from Hadera to Jerusalem, Nechama (Netka) Zeltovsky-Hacohen was killed, becoming the first Jewish casualty of the War of Independence. Nechama was the daughter-in-law of Mordechai Ben-Hillel Hacohen, whose niece was the most senior woman fighter in the Haganah—Rosa Cohen (mother of Yitzhak Rabin). She worked as a lab assistant at the Hadassah hospital and had been active in the Haganah since 1927.[36] It was in between the story of Rachel and that of Nechama that our story took place.

Chapter 1

Power, Heroism, Socialism, and Women during the Second Aliya Period

Around 250 to 300. That is the estimated number of young women among the agricultural pioneers in Palestine, representing less than a fifth of its constituency on the eve of WWI, in August 1914.[1] They arrived a few at a time, starting in December 1903. Some of them—four or five at first, a little over twenty a few years later—were affiliated with the Order of Bar Giora, founded in September 1907, and later on with the Hashomer organization, founded in April 1909, which numbered approximately 100 members just prior to its dismantling in 1920.[2] In general, the women members of Hashomer did not perform guard duty. There were a few exceptions—transient, incidental, anecdotal episodes engraved in the consciousness of the members of the organization, and amplified at times in the historical literature—but they do not change the essential facts.[3] At the same time, with the distance of time, the objective reality in and of itself does not adequately speak to the long-term nature and significance of the sporadic efforts of a few women and their overt and covert aspirations to take some part in defending their honor, property, lives, and—most importantly—the national and defense destiny that the members of Hashomer envisioned their endeavor as coming to fulfill. Later on, Israel's first prime minister and minister of defense, David Ben-Gurion, would award Hashomer the title "the Grandfather of the IDF," and this was echoed on the 60th anniversary of the founding of the organization by former Palmach commander and the most successful IDF officer during the War of Independence, Yigal Allon.[4] Beyond the flowery rhetoric, this appellation does contain a kernel of historical

11

truth, and the women of Hashomer are an integral part of this kernel of historical truth, even if it was only on rare occasions that they held handguns and rifles and actually performed guard duty.

During the existence of Hashomer, Manya Shochat was justified in regarding the issue of women's status as secondary to the nurturing of socialist revolutionary values and selfless devotion to developing Jewish self-defense capabilities. At the same time, she emphasized with hindsight in 1930 that the ability to address both of these major missions success-fully was the result of Yisrael Shochat's talent in providing a practical, organizational vessel for the daring imagination that guided the members of Hashomer away from addiction to realizing its ideas at the expense of individual affairs and interests, and of "the power of the women—the women of Hashomer—who, despite being 'behind the frontlines,' were able to bear the burden of wandering, suffering, and illness that were bound up with the life of Hashomer, constantly on the move, and to do so without weakening the spirit of the men."[5]

Is there any truth to the definition of women's activity in Hashomer as a sort of conservative, traditional, passive, and maternal activity, the fruit of a failed pretention to turn women into "copies of men?" I believe that we need to flesh out the approach viewing women in Hashomer as a factor that, through the "womanly" behavior and activity that were forced on them, reflected and reinforced mainly the "phenomenon of the new Hebrew guard" who was engaged in realizing his destiny.[6]

A long-term perspective based on study of the process of creation and consolidation of the relevant historical trends shows first and fore-most that the path that women had to travel in the defense realm was a longer and more winding and complicated one. Nevertheless, had it not been for the shaky and sporadic foundation laid during the period of Hashomer—which, as noted at the beginning of this chapter, might have been written off as a transient curiosity—there would not have developed, over the course of the years to come, the phenomenon of hundreds of women seeking to enlist in the Jewish Legion in 1918; the foundation of consciousness that led to the multifaceted revolution of the women of the kibbutz movements to participate in guard duty during the Arab rebellion would not have existed; and it is doubtful that the enlistment of Jewish women in the thousands for service in the British army during the Second World War would have been perceived as a natural and self-evident development in the process of national con-solidation of the Yishuv. In this sense, there is great significance to an

apparently incidental aside noted by Atara Sturman during the 1940s: "Although the view of Hashomer maintained that women should not participate in guard duty, the women members learned to use weapons with greater ease than in our era."[7] At the same time, and in contrast to the contemporary trend in historiography, which highlights a range of aspects of the lives of Hashomer women, Sturman said that in speaking of this subject she testifies to "this modest corner in the lives of the guards."[8] Their modesty was not put-on or manipulative; it was an honest reflection of Hashomer's view of the reality in Palestine during the Second Aliya period—for women and men alike.

Hashomer guard duty was carried out in solitary conditions (usually one sole guard, sometimes one or two more). The ongoing human contact vital for the maintenance of the organizational system over weeks and months was actually maintained—up until the outbreak of the First World War—by those who were on the periphery of the day-to-day guarding tasks: the members of the Hashomer committee (Yisrael Shochat, Yisrael Giladi, and Mendel Portugali), as well as Manya Shochat, who was ranked together with them because of her exceptional talents and qualities, which made her the association's revolutionary, moral, and maternal anchor.[9] Along with them were the Hashomer women, who lacked any formal status or leadership aura, and whose influence flowed from the practical realities of life. These women were connected with the association by dint of their conjugal relationships with specific members or because of the service roles they performed alongside them to earn a living. Either way, their belief in the importance of Jewish guard duty for the realization of the national idea, and their identification with the association's aims and the importance of devotion to its needs, were preconditions for being part of the association and dealing with the trials and tribulations that were a permanent feature of life.

The young pioneering women of the Second Aliya sought to combine the idea of self-sacrifice for the sake of the Jewish people, for the socialist-Zionist ideal, and for the survival of the group of solitary revolutionaries to which they belonged, with a fuller role in social life than was customarily played by the women of the Eastern European families they had come from. They, like their male colleagues, perceived physical labor as a means of self-liberation and national revival, which were integral to the creation of a new man and a new society. The revolutionary aspect of their approach to traditional Jewish society and toward their conduct as women in a male society was expressed in Bussel's declaration that the

woman "demands her right to fulfill obligations." This theoretical and moral point of departure gave rise not to an abstract, universal theory, but rather to drab, stubborn, continuous activity aimed at a revolutionary change in the daily reality of the woman in the embryonic Yishuv society. The wearing effect of life's difficulties, writes historian Deborah Bernstein, was an inseparable part of their existence.[10] While there exist no small number of similarities between the conduct, hopes, and disappointments experienced by the pioneering women of the Second Aliya and those of the women who had preceded them in the First Aliya, the determined decision to create a new status for women, as Gilat Gofer argues, and their long-held faith in the validity of the revolutionary culture that they had brought with them assured their long-term uniqueness in Yishuv society.[11] The romantic notions of revolution were inextricably bound up with suffering and sorrow, but within Hashomer, as Manya Shochat explained, there were "two kinds of fates: that of the women members of Hashomer, and that of the wives of Hashomer members. [. . .] The wives of the guards had only obligations; they had no rights. That was their tragedy."[12] In a similar vein, Keila Giladi added: "The essence of the woman—the need to be a person who is involved in everything that is going on—stood out in Hashomer as in all other liberation movements. This flowed from the very fact of our living the Hashomer life. At first we didn't need to fight for it. It was taken for granted. Only afterwards, when the movement grew and different elements joined, did the need arise to fight for rights and obligations."[13]

In this regard it is worth pointing out that, in contrast to a commonly held conception, the harmonious integration of "rights" and "obligations" as a central element in the value of equality as a guiding principle in communal life was not universal even in Degania until the 1920s, and fell mainly into the category of a "demand," as Bussel defines it.[14] Equality between the sexes was not even an agreed-on ideal among the men and women pioneers of the Second Aliya. On this basis it would be fair to assert that Hashomer was the most prominent arena where women bore the full burden of sacrifice for the sake of realizing the Zionist ideal and where, with the help of their contribution—and, we may assume, thanks to their memories of those difficult times, which were processed into publications in a wide range of forums over the following decades—they were unhesitatingly included, with the passage of the years, in the pantheon of Zionist heroes. A prosaic example is the meticulous inclusion of photographs of "women members of Hasho-

mer" in all the commemorative books initiated by the veterans of the organizations, with their number growing from one publication to the next—from four in the book published in 1930 to twenty-three in the book that appeared in 1957.[15] Two everyday images, selected from among dozens, expose their difficult path to that pantheon. One is Keila Giladi's story of the period when her husband Yisrael was guarding in Zikhron Yaakov; the couple was allotted a room in which they lived together with another couple and a bachelor, "and we all slept on the only 'sofa' that there was—the floor."[16] The other is conveyed by Yehezkelia, daughter of Yehezkel Nisanov, concerning the days of Tel-Adash: the sound of gunshots was frequently heard, and every mother had a defense position in the rooms where the Hashomer families lived. One night, the guard gave the warning (three shots in the air) that an attack was imminent, and everyone rushed to their posts—including a woman paramedic who had recently joined them, and who had just finished frying potatoes for herself (instead of the meal of lentils and sour cream that was eaten by everyone else, and to which she had not yet accustomed herself). While everyone was tensely awaiting the attack, the guard suddenly appeared and announced, "Everything is fine; I just ate up that spoiled paramedic's meal. You can go to sleep!"[17] The poverty, uncertainty, lack of privacy, life under the patronage of power, and constant fear of lurking danger that are reflected in these two images were constant elements in the lives of the women and wives of Hashomer.

These women spent most of their time cooking, laundering, and cleaning. They carried out these tasks along with their routine maintenance of the family unit and home and the nurturing of the Hashomer social framework. Seemingly, their occupations were a replica of exactly the same tasks that were being carried out at that time by their contemporaries in Jewish communities throughout Eastern Europe, and in this context there was also little real difference between these women and other young Jewish women in Palestine who had no connection with Hashomer. At the same time, the ongoing tension of a nomadic life, whose most constant element was prolonged stationing at the frontier and concern for the men, who were in locations and positions that placed them in constant physical danger, was unique to the Hashomer women during the Second Aliya. The mosaic of memories of Keila Giladi (wife of Yisrael), Tova Portugali (wife of Mendel), Esther Beker (wife of Tzvi), Tzippora Zaid (wife of Alexander), Atara Sturman (wife of Haim), Haya Yigal (wife of Mordekhai), and the other Hashomer women always

included one or more anecdotes about these women holding a handgun, cleaning weapons, helping to smuggle or hide weapons, and treating Hashomer guards who had been brought in, wounded, from a violent confrontation with Arab thieves. This overall description conveys the significant contribution of these women to the consolidation and routine activity of the first Jewish defense body in Palestine during the twentieth century. Their descriptions are regularly accompanied by complaints over their exclusion from guard duty; worse still, in their eyes, they "enjoyed only from afar the glory" of conspiracy in defense.[18]

The women of Hashomer (and subsequent historical research) drew a distinction, with hindsight, between transient situations that forced them into circumstances in which they displayed personal courage and valor on a level that was certainly uncommon in the experience of women at the time, and the anecdotal dimension that was inextricably intertwined with them. As noted by the historian of Hashomer, Yaakov Goldstein, the heroic descriptions should not lead one to conclude that Hashomer underwent some revolutionary process of change in values and gender transformations concerning the relationship between the sexes.[19] At the same time, even the episodes that were recounted over and over for younger generations have a cumulative collective power that is compelling in its own right and acquires a validity that exceeds its weight at the time of the events themselves. This seems to be the case in the context of the multifaceted story of the women of Hashomer. An aura of legend surrounded the anthology of their experiences that was documented and memorialized in print, and the influence of this legend, which gradually acquired a mythical dimension, trickled down in a multitude of ways hidden from documented research on the chronicles of the Second Aliya and the events of the early days of Jewish pioneering, prior to the British conquest.

When the leader of the Hakibbutz Hameuhad, Yitzhak Tabenkin, stood before the members of the Hakibbutz Hameuhad Seminar in 1937 and analyzed the contribution of women to Hashomer, he noted that they represented a small percentage of the organization's membership, "but this small percentage was very active in guard duty." It was not historical truth and the obligation to state it accurately that guided him on that occasion, but rather the need to inculcate his young listeners with a legacy so that they would assimilate and convey the ramifications of this message to their peers. Tabenkin, as always with his face to the future, declared it a shame that the percentage of women members of

Hashomer who performed guard duty did not expand with time, "neither in quantity nor in quality." They continued to operate in the spirit of the conditions of terrorism and underground dangers they had imported with them from Czarist Russia, but "neither developed nor broadened the participation of women members in guard duty to the same extent that the participation of men was broadened."

According to Tabenkin, the trend toward specialization of activities and away from the possibility of them including broader masses, in the spirit of the organization's principled approach toward models of guard duty in the Yishuv, had a negative effect on the willingness to include increasing numbers of women members. In addition, the close contact between the men of Hashomer and the Arabs also made it difficult to include female members in guard duties, because "the presence of a woman would encourage and intensify the Arabs' audaciousness and aggression."[20] This argument, whose importance should not in any way be underestimated, was—according to Yisrael Shochat, leader of Hashomer—the main reason for "the inequality of women in Hashomer."[21] As we shall see below, this justification, which became canonized around the death of Devora Drachler at Tel Hai, would be raised by the Haganah professionals during the years of the Arab uprising as a central argument against the integration of women in guard duty.

Even outside Hashomer, the consciousness of the women affiliated with the workers' camp became accustomed to a reality in which the dangers of attack were an inbuilt element of life in Palestine, as part of what was entailed in creating communal life and the consolidation of the workers' parties. On October 28, 1910, Degania was founded. Four days later, one of its founding members, Tzvi Yehuda, arrived in Sejera to call upon Sara Malkin to join the group of founders who were without food, some of its members having fallen ill with malaria. On their way from Tiberias to the Sea of Galilee, Yehuda and Malkin were attacked by Arabs seeking to plunder the mule and donkey they were riding. Yehuda, "the most courageous guard among the collectives and farms outside of Hashomer," took out his handgun, aimed it at them, and "walked in front of me, while I rode after him," as Malkin describes the scene. "With a serious face, 'ready for anything,' we passed by the Bedouin. He lowered his gun, and we kept on going." This episode, reflecting a not-uncommon occurrence on the roads at the time, accompanied the first woman on her journey to join the first Kevutzah. "That woman was a Jeddah [strong, in Arabic]," one of the attackers ultimately

commented, and Malkin's friends recalled that in a previous incident she had sneaked behind to grab the weapon from the hands of a Bedouin who threatened them as they walked along the beach near Hadera.[22] "What was her great strength?" wondered Rabbi Binyamin (pseudonym of Yehoshua Radler-Feldman) after her death in 1949. He answered, "The fact of being a pioneer; seriousness; the legacy of the past and concern for the future; conscience and responsibility; and motherhood and the soul of the woman." Yosef Sprinzak, a senior member of the Ha-Po'el ha-Tza'ir party and first chairman of the Knesset, declared unequivocally upon her grave, "She was the Second Aliya."[23] Malkin left an indelible impression on all who came into contact with her. A hint of the esteem felt by those who immigrated during that period toward those who had arrived just a few years—sometimes only a few months—previously is apparent in the words of Eva Tabenkin, who came to Palestine toward the end of the Second Aliya, in April, 1912, with her husband, Yitzhak:

> When we arrived here and encountered the pioneers who had come before us, when we saw the sun-tanned faces of these women, each of us seemed to be asking herself, are you ready to give your face, your body, to this desolate land? Each asked and answered—Yes. And there was one woman amongst us who, upon arriving here and seeing the effects of the labor on the appearance of the women pioneers, cried for an entire day, but got up in the morning, put a white kerchief over her hair, and went off to work.[24]

Malkin, along with Miriam Baratz (the first woman to give birth in Degania) and the other women who lived in Degania in its earliest years, were a "tempestuous minority," as Muki Tzur calls them. They believed in "women's liberation," but were unclear as to what exactly this entailed in terms of family (intimate relationships, children) and work (branches of production vs. housework).[25] A quarter of a century after the start of the Second Aliya, in 1929, Hayuta Bussel outlined the view prevalent among the women pioneers during this period. On one hand, she described their scorn for accepted social manners toward women, which in effect "subjugated them spiritually and physically"—such as holding a woman's elbow so that she would not stumble while walking, and the "ridiculous" custom of allowing a woman to enter a room first. "That is how one treats children who are small and weak, too." On

the other hand, Bussel maintained that even if these outward manners, which stupefy a woman and blur her individual consciousness," were to disappear, the move to the opposite extreme during the period of the Second Aliya was a mistake, because it ignored the physical differences between women and men. Bussel asserted: "The women members thought that they had to show that they were equals to the men in everything, and that they could accomplish any type of difficult work in the home, in the field, in plowing and in guard duty."[26]

It was not the ability to express oneself or to analyze complicated ideological issues that were regarded as being worthy of esteem in this early society. "Silent members" such as Sara Malkin and Tanhum Tanpilov, founders of Degania, were held in great esteem among the workers of the Second Aliya. Eventually Tanpilov formulated the difficulty facing a historian in this regard: "Many commentators on the Kevutzah have arisen since then, and until today, and of course they rely on the primary sources and based themselves on what they—the early pioneers—thought and dreamed." And then Tanpilov added: "The early ones felt more than they thought."[27]

The phenomenon of muteness in public, which was prevalent among the workers and sometimes makes it difficult to understand, in retrospect, the balance of forces and the underground currents that ran among them, was especially common among the women. They found it difficult to express themselves in public and usually refrained from doing so—especially on general issues that exceeded the bounds of the individual or family context. This was one of the significant barriers that obstructed women from fighting over issues that were considered vital to them.[28] Occasionally there were breaks in this wall of muteness. In an article penned by Aharon Hermoni, acting editor of the Zionist Organization's journal, Ha-Olam, in January 1908, he reproached the heads of the Po'alei Tzion party: "Will you continue in the future, too, to extend the right to every chatterbox who considers herself a 'Miriam' or a 'Deborah' [the prophetesses] upon the 'barricades of Moscow,' to speak from the podiums in the towns of the Land of Yisrael, about whatever they feel like?"[29] The public speech by a woman was the immediate object of the attack. Perhaps we should not accept in a sweeping and absolute way the conventionally held view in the research literature that all the young pioneering women were struck dumb in public. At the same time, it must be emphasized that this is a onetime report, and we should not conclude from it that the role of women in molding the political life

of the groups of workers, in their myriad frameworks, has been omitted, for reasons of deliberate exclusion or otherwise.

The separate organization of women workers on a gender basis began at a women's meeting held at Kinneret in 1911 and continued with a string of conferences held between May 1914 and June 1918, addressing issues in the realms of work, family, and children's education. The conferences served as an instrument for the gradual creation of a separate realm of women's activity within the workers' camp.[30] Issues related to security aspects were not raised—nor were they at most gatherings of the men workers at the time. The conferences served as an encounter that lowered ideological and party barriers, and Malkin was depicted as an inspiration not only among Ha-Po'el ha-Tza'ir circles, but also among the women of Hashomer who, like her, sought ways to define the manner of their integration in labor and the manner of their contribution, on the economic and social levels, to advancing the national idea.

Jewish women in the Yishuv fought for the first time in public for their right to carry out security roles in 1918. The ideological climate in which their future struggle to volunteer for the Jewish Legion was to take place was nourished by the awakening of overt and covert dreams of an "independence for Jews in their homeland," as Rachel Yanait put it. These visions were revived, mostly latently, among Bar Giora and Hashomer.[31] Among Po'alei Tzion circles, it was Rachel Yanait who contributed to the dissemination of these desires early on, during the Second Aliya, as her own special contribution to nurturing the social and ideological environment in which Hashomer operated. On the personal level, this was apparent in the gradual adaptation of her name from Golda Lishansky to Rachel Yanait—inspired by Alexander Yanai and his wife, Shlomtzion,[32] and in her decision "to move as soon as possible, and without delay" to Palestine in the wake of her conversation with Michael Halperin in 1907, in which he told her of his dream to develop defense and to nurture Jewish valor.[33] Halperin's hypnotic imagination often made an impression on the young immigrants of the Second Aliya, even if they were not as enthusiastic as Yanait about using power. On one occasion, Halperin presented a group of young people in Jaffa with his plan to conquer land on the eastern side of the Jordan, which had been purchased by Baron Rothschild and was standing desolate. His descriptions, full of enthusiasm and pathos, of living in tents and making do with bare necessities enchanted his listeners. "Before him sat young, blonde Sara [Malkin]. Her face was lit up and her eyes burned with passion, as though she

was ready to get up and proceed directly to the site of conquest."[34] In the realm of ideas, the youngsters developed their own direction, and from this perspective the founding contribution of Yanait was significant. A few months prior to the establishment of Hashomer at Mes'ha (Kfar Tavor), on April 13, 1909, and her most irregular appointment as a regular member although she did not perform guard duty, she authored a pamphlet full of praise for the legendary Shimon Bar Kokhba. Yanait aspired to revive his legacy.[35] In her eyes, members of the organization such as Yehezkel Nisanov, Mendel Portugali, Tzvi Beker, and Alexander Zaid resembled that heroic Jewish character. "With affection and a sense of awe," as she put it, Yanait described his endeavor. Although she drew her information about him from sources that she located, she ultimately acknowledged, concerning her writing about Bar Kokhba: "I saw more than my imagination and I tried to include within it the message of our own rebellion."[36] The practical issue that occupied her in this composition was how and when new heroes would appear among the Jewish nation. In speaking of "heroes," Yanait unquestionably referred to fighters, military men. "Life then," in the time of Bar Kokhba, she wrote longingly, "produced great men." She went on to clarify:

> The chronicles record only individual heroes, giants, who headed the movements, while the great and broad masses who sacrificed their lives and bought victory with their blood—the memory of these tens of thousands, who fell in battle, is lost. But it is not individuals—as excellent as their talents may be—who create popular movements, nor single mortals who bring redemption; rather, it is the nation itself that redeems itself. And it is only when the people support them that the individual heroes, too, are able to achieve great things.[37]

The hierarchy and feedback that Yanait argues should prevail between the heroes and the masses from among whom they are destined to emerge arose from the roles that the workers' camp in Palestine set for major legendary historical characters. It is not the unique individuals who would decide the fate of the battle, but rather the masses through their day-to-day actions. The approach of the Socialists, which held the collective as more important than the wonder-working individual, did not render the uniqueness of the individual superfluous; rather, it subjected his manifestation and the degree of his success to the broader

framework from within which he was destined to appear. Dependence on the heroes who were counted about the Zionist historical pantheon, as noted by Anita Shapira, was reserved within this camp for nurturing patriotism and the national romance.[38] Sacrifice for the sake of the nation was for everyone, not for individuals. Hence, it was only as part of the activity of the masses that it was proper for the modern redeeming hero to appear and take his place on the stage of Zionist history.

If there was any Jewish woman who walked upon the ground of Palestine during the period of the Second Aliya, whose standing in the eyes of those around her recalled something of these longings for the appearance of Bar Kokhba as a concept and a symbol, it was Manya Shochat. Her canonical status in the consciousness of her contemporaries from the Labor movement—as a woman, first and foremost, and in categorical contrast to the distant attitude that scholarship has preferred to show toward the feminine aspects of her personality and her activity—finds its earliest expression in the anthology *Divrei Po'alot*, published in November 1929 with Rachel Katznelson-Rubashov (Shazar) as editor, to mark twenty-five years since the Second Aliya. The editor awarded Shochat the privilege of introducing the collection, which documented the stories of the women workers of the Second Aliya.[39] It is reasonable to assume that her selection was not incidental, or a matter of chronology, based on the fact that Manya had arrived in Palestine on January 2, 1904, at the very beginning of the Second Aliya. It was a conscious choice, expressing an awareness of Shochat's status as a well-known feminine figure, the most dominant and charismatic among the women of the Second Aliya and someone whose personal story represents a prominent symbol of the story of women of that period and their readiness for self-sacrifice for the sake of advancing the Zionist idea. Earlier than most of her companions, with the possible exception of Yosef Bussel (who drowned in the Sea of Galilee in July 1919) and the writer Yosef Haim Brenner (who was killed in the riots of May 1921 in Jaffa), and while still alive, Shochat became an historical heroine worthy of inclusion in the emerging Israeli national pantheon. As a woman, the spheres of her involvement in public life were unusual: they ranged from fundraising to weapons smuggling to involvement in the physical elimination of opponents. In both her youth and her adult life, she never hesitated to place her life in danger for the sake of what she viewed as service on behalf of the community. Despite this, she was not engraved in the collective memory as a heroic

feminine figure of a frontline fighter. Manya Shochat carefully camouflaged any hint at the influence of personal crises of an erotic nature on her public activity, thereby sparing herself the label of acting in this realm out of "personal tragedy" and a tangle of personal relations (although her life included such relations in abundance), as in the case of Sarah Aaronsohn, who committed suicide on October 9, 1917, at the age of twenty-seven, in order to escape torture at the hands of the Ottoman authorities who had captured her following her involvement in the Nili spying network.[40] Shochat's involvement in the realm of defense and her exceptional intrepidity were unusual among the masculine society at the time. When she and her friends recalled security-related events in which she had been involved, Shochat's exceptional character, her courage, and her innate adventurousness were illuminated. The heroic aspects of these incidents were left as mere illustration—also because she had escaped them without harm.[41] Her endless thirst for operations that would bring about change in the life of the community usually came at the expense of the "small print" of ideological dogma. She maintained an innocent approach concerning the power of the individual to influence the systems of the nation. For our purposes, suffice it to cite Katznelson-Shazar: "Among all the great characters who were Shochat's contemporaries, there was not a single one as surrounded by legend [as she was]."[42]

The aspiration and desire for the return of the "Jewish heroine" to the center of the national stage was not in the dark, under wraps at the beginning of the twentieth century. Nahum Sokolov, editor of *Ha-Olam* and secretary general of the World Zionist Organization, expressed his longing for her appearance in a fiery column that introduced in December 1907, crying out for the moment when the Greeks, Syrians, and Romans would be "confounded" in the face of the reappearance of the "Jewish heroine." In practice, a vast distance separated Zionist talk and the prose of Jewish Yishuv in Palestine at that time.[43] In terms of what was actually going on, the Yishuv was a weak player of minor significance, and this became painfully clear during the First World War. The ravages of hunger, the forced conscription for military service and forced labor, and the plagues that swept over the country between 1914 and 1918 testified to the very difficult reality facing the country's Jews under Ottoman rule. From time to time, women took part in the efforts to address the occasional eruptions of violence that occurred as part of the war situation, and the rapid disintegration of the sense

of personal safety. On February 26, 1915, the Melhamia (Menahemia) colony was attacked following a scuffle over pasture land. The women of the colony participated in the defense effort and helped to bring food and ammunition to the posts. Two years later, as part of the activity of the "Jaffa Group," which had been formed during the First World War in and around Jaffa to protect the Jews of the area, a group of female students and graduates of the Herzliya gymnasium was formed. The role of this group, which included Rivka Shertock (Hoz) and Tzippora Meirov (Sharett), was to collect medicine and materials that could be used for bandages and to establish a station that could provide first aid in case of emergencies. Yanait recounted that in conversations she held during this period with Rivka Shertok about Hashomer and its aspirations, she sometimes discerned a note of hurt in Rivka's words about how "in matters of security, not everything is made clear to the women members." However, the principal damage caused to the Yishuv during the war years was the expulsion of tens of thousands of Jews from the country by the Ottoman authorities, who suspected the loyalty of these foreign subjects to their rule.[44]

In March 1915, Yitzhak Ben-Zvi, Ben-Gurion, and Yisrael and Manya Shochat were expelled. On the eve of their departure, the Shochats asked Yanait to join the committee of Hashomer. At the first meeting of the committee in its new composition, Yisrael Giladi informed his colleagues that whatever he knew, he shared with his wife, Keila, and Yanait wrote in her memoirs: "How well I remember that small detail—more precious and simple that any fiery speech about women's rights is the attitude of devotion and loyalty of a member towards his wife." After living for a few months at Tel Adash with the members of Hashomer, Yanait did not find her place in the demanding women's work, and she moved to the center of the country. As a "parting gift" from the community, she went off to experience a night of guard duty in the fields, accompanied by her committee colleagues Shmuel Hefter and Zvi Nadav. As was the custom of Hashomer members on such occasions, the two of them staged an approach of thieves, and Yanait, who was terrified even after the ruse was explained to her, acknowledged in front of the women the next day: "We mustn't go with the men to do guard duty at night, for an encounter with thieves in the fields in a possibility—and what strength do we have, in relation to the strength of the members on guard duty?"[45]

Yanait was elected to the committee at a meeting of the organization in Yavne'el in September, and Uri Brenner estimates that her joining of the committee may have contributed in some way to the softening of the traditionally rigid position concerning women's membership in the organization. What is clear is that from this point onward, although Yanait would be implicated in the outer circles of the Nili spying ring in 1917, she was destined to be the woman most heavily involved in defense of the Yishuv for more than a decade, in the company of Manya Shochat, who would return from her exile in 1919. They were joined in 1920 by Rosa Cohen. Yanait had been a member of Po'alei Tzion while still in Russia and was one of the editors of their newspaper in Palestine, Ha-Ahdut. Her joining of the Hashomer committee was meant, inter alia, to strengthen the coordination between these two bodies.[46] An article she wrote a month after the outbreak of the First World War, devoted mainly to identification with the view of the Socialist International, which opposes war, concluded with the hope that "the blood that will now be spilled like water will rise up and purify the hearts of the masses, and the proletariat will return to its revolutionary soul." The catastrophe that was to befall mankind would bring about "a revolution that will purify and renew the face of humanity," she prophesized, in the spirit of the worldview prevalent among the Russian revolutionaries, without any basis for her hopes.[47] The years to come brought far-reaching change in her views on this subject. On the threshold of the new era in the history of Palestine heralded by the British conquest, Yanait foretold: "The primitive truth that the right to the land is acquired first and foremost with blood—this truth forces its power upon us at this historic moment, and it is this that indicates the paths of the future to those who will carry out the work."[48] Moshe Carmi, a student in the first class to graduate the Herzliya gymnasium and later a member of Ein Harod, asked Yanait later on, as volunteers signed up for the Jewish battalion in 1918, what had happened in the interim to the view of the Socialist International and its antiwar position. He recorded her response: "Rachel turned her head, looked into the distance, and said: 'Yes, for all time; right now, the question is completely different.'"[49] From the point of view of the end of her article cited above, what in 1914 had been an expression of the failure entailed in nurturing hopes for a revolutionary shake-up, and which in practice had been meant to encourage the members of her party at the beginning of a dark period, was eventually—in 1918—to

become an attraction that became the façade of everything. The obvious conclusion, in the new circumstances, seemed to be that anyone who did not spill blood would also not enjoy the fruits of the purifying and rejuvenating revolution that had now reached its active maturity in Palestine with the beginning of the British conquest. This also occasioned the opportunity to realize fully the desires for the appearance of heroic power on the Zionist stage.

Chapter 2

A Lost Battle

Women Volunteers for the Jewish Legion in 1918

"From labor, via arms, to labor."

—Rachel Yanait, 1918[1]

"To fight bearing arms, to fall in battle, and to leave graves for the future."
It was with these words, uttered at the Conference of Volunteers that
took place in Jaffa in mid-February 1918, that Moshe Smilansky defined
very clearly the aspirations of the youthful pioneers who sought to vol-
unteer for the British army toward the end of the First World War. The
aims of the Jewish Legion they sought to establish were to participate
in the liberation of the land and, in the process, to create the core of
a Jewish militia. But more important than the military vision, which
was only partially realized, was the purpose envisaged by Smilansky—a
representative of the First Aliya, a farmer from Rehovot, and later one
of the heads of the Farmers Association: the shedding of Jewish blood
upon the land.

This was intended to aid the implementation of the Balfour Dec-
laration (November 1917), which had recently been issued, but at the
same time also to serve as "an educational value for [future] generations.
The actions of the fathers are a sign for their descendants!"[2]

It was on the basis of this fundamental principle—the ideological
and educational value of enlistment, the motif of "bloodshed," and the
view of them as a sort of primal act in realizing the political aims of

27

Zionism—that there arose the demand on the part of young Jewish women, mostly from among the pioneering groups, to volunteer for the Jewish Legion in 1918. During the course of WWI, growing numbers of women among the nations at war stepped up to demonstrate patriotism. With enthusiasm that burgeoned during the war years, millions of women volunteered to carry out jobs that, until then, had been occupied mainly by males in the civilian economy.

They produced weapons and ammunitions in factories (as well as delivering mail, engaging in agricultural activities, and more); they served as nurses in hospitals on the home front and sometimes even in somewhat close proximity to the front lines (for example, some 12,000 nurses were enlisted in the American army in June 1918; of these, more than 5,000 served in Europe); and they served auxiliary roles in the fighting forces in such areas as communications, supplies, cooking, administration, and logistics (clothing, packaging, etc.). In so doing, the women freed more men for call-up to the battlefronts and demonstrated the necessity of their contribution to the national effort as well as their commitment to realizing their countries' national ideals. Income considerations, a sense of adventure, and curiosity for its own sake also were integral to the urge that led women to join the ranks of volunteers. At the same time, the recognition of the women's contribution during the era of total warfare was clouded somewhat—if only in outward appearance—by a feminist mood that was prevalent, prior to the war, on the fringes of public discourse in countries such as Britain and France. These trends were maligned during this period (sometimes with openly pacifist motivation), and against the backdrop of the new employment reality, as a potential threat to the stability of the traditional social gender order. Until that time, women had been expected during wartime, first and foremost, to show faith in the ruling political system, to remain quiet and confident, to preserve the family unit, and to be ready to sacrifice sons or spouses for the sake of the nation and the homeland. War conditions expanded the sphere of possibilities open to women to identify with their nations, and on this basis they reinforced their demand to be considered equal citizens, entitled inter alia to vote in parliamentary elections. However, the ongoing war eroded only slightly the validity of the claim that even while filling auxiliary military roles, the women's main contribution lay in the assistance they offer to men serving the nation.[3]

At the same time, thousands of women volunteered for first aid organizations (such as the Red Cross, the Salvation Army, and other

bodies motivated by religious and moral altruism) that offered medical support and assistance to the injured, with no direct link to their countries' institutionalized systems. These organizations operated on the basis of independent initiatives and private funding, and in the spirit of the prevalent image of the "great, caring mother" preserved from the days of the Crimean War (1854–56) in the form of the British nurse Florence Nightingale or, alternatively, in the ubiquitous form of nuns and angels, and Mary (mother of Jesus) from Christian mythology. The women's activity, in all its forms, brought together cultural, militarist, and feminist motifs of different shades and with varying emphases. Externally, they were expressed in the inculcation of habits of discipline and order usually associated with military bodies, along with uniforms (not necessarily military) and the manners of hierarchical subservience that, in many cases, led to the unregulated adoption of orders and power structures into the existing—essentially male—society.[4]

The most prominent and extreme demonstration of the adoption of these trends during the First World War was the establishment of all-women military units in Russia following the February Revolution in 1917. These units were meant to be integrated in the battle against the German army, and they operated for several months until they were disbanded following the October Bolshevik revolution. The women's units, which comprised some 6,000 members at their peak, served as a sort of propaganda tool wielded by the Revolutionary regime to prevent a weakening of resolve among the men, in view of the significant flagging of morale and discipline in the Russian army following the fall of the Czar. The patriotism, courage, and valor demonstrated by the women ready to go out to battle (there was even one instance in which one of these women's units, under the leadership of Maria Bochkareva, participated in the fighting) were tinged with a questioning of their readiness to provide backing for the violence and destruction entailed in war as a human phenomenon.

This aspect of the war that was raging in Europe affected the Yishuv at the time only slightly; it was a faraway reality, the details of which were few and fragmentary. The war situation in Palestine in 1918 provided Jewish women with other historical contexts—arising from the absence of any real sovereign power—in their battle to realize their aspirations for integration into the centers of activity that had been placed on the Zionist agenda in the circumstances. I would like to present the women's struggle to volunteer for the British army as a historical episode

worthy of being traced in all its convolutions, and I therefore focus on the internal behavior within the Yishuv. Rachel Yanait was the head of the "women's volunteer movement."[5]

In contrast to the conventional description of the women's struggle to volunteer as being woven into the same struggle by the men, I adopt the testimony of Yanait at the meeting of women volunteers that took place on August 31, 1918, almost two months after the men's enlistment into the British army. At this meeting, she stated that the activity of the movement of women volunteers had mainly begun after the men's enlistment.[6] This argument is presented, inter alia, as standing in clear contrast to what she wrote later in her memoirs, where she suggests that when the men boarded the carriages of the train on their way to training at the military camp in Egypt, the women volunteers were left behind "desolate and miserable." In her memoirs Yanait eternalized the sadness, disappointment, and mental and physical exhaustion,[7] but at the same time she chose to skip over the ongoing, futile battle she led for another five months with the hope of having the women volunteers join them.

The wielders of power and influence in the Yishuv took a dim view of Yanait's energetic efforts. Mordechai Ben-Hillel Hacohen, in his diary, refers to her angrily as "Deborah the prophetess" and as "the wife of Lapidoth," working hand in hand with "the son of Abinoam" (a reference to Moshe Smilansky) to encourage youngsters to sign up as volunteers for the Jewish Legion.[8] These appellations were not arbitrary. In an article that Smilansky wrote during the Second Aliya, he called for the establishment of an agricultural workers' union, in which "the granddaughters of Rachel, Deborah, [and] Esther could demand equal rights to the grandsons of Jacob, Barak and Mordecai!"[9] British writers at the time were similarly aware of the relevance of the mythical image surrounding the biblical prophetess, Deborah, to the historical circumstances in which more and more women were participating in endeavors bearing upon the war effort. Fryniwyd Tennyson-Jesse, a journalist, who visited France in 1918, wrote a book titled "The Sword of Deborah," offering a realistic, trenchant, and fascinating account of the British women who had enlisted and were serving as nurses there. Tennyson-Jesse, who shied away from feminism, borrowed her title from Shakespeare's *Henry VI*, in which the king of France, Charles VII, is defeated by Joan of Arc in single combat and tells her, "thou art an Amazon / And fightest with the sword of Deborah."[10] This pure warrior image is interwoven throughout the military roles of the British women

whom Tennyson-Jesse encountered. The combination of Joan of Arc and Deborah was no less relevant to the reality in Palestine during the First World War. Yanait herself made no mention of the feminist aspect at the first meeting, but this was not necessarily the result of lack of consciousness on her part. She described herself as never having been a "suffragette." The feminist drive that characterized contemporaries such as Ada Fishman (Maimon),[11] whose unabashed demand was "I want a revolution," did not dictate Yanait's order of priorities in public life. As someone whose entire adult life had been guided by a consciousness of national mission, Yanait sought to combine the struggle for women's advancement and its integration as an element in a feminist social reform that would aid the national struggle for the realization of Zionism. Her quest was realized at the gathering of the Committee of Volunteers in Jaffa on February 15–16. The participants represented—according to their own testimony—300 men and 200 women who wished to volunteer. (A different version puts the number of women at 150.)[12]

In one of the first organized national events held in Palestine after the Balfour Declaration and the British conquest of the southern part of the country up to the outskirts of Petah Tikva, the women were presented, deliberately and conspicuously, as having equal rights and equal obligations in what appeared, for a brief historical moment, as the opening of the gates of Zionist realization. The should be viewed as a landmark—albeit a largely symbolic one, lacking in any formal validity, but nevertheless of the sort that left an indelible impression on the consciousness of the generation participating in this unprecedented event in the history of Zionism.

Eliezer Yaffe, one of the most senior personalities in the agricultural workers' union, was a fierce opponent of enlistment in the British army. This position included a rejection of the wisdom and benefit of enlisting women. Yaffe, a leader of the Ha-Po'el ha-Tza'ir party and one of the most exemplary figures produced by the workers' camp during the Second Aliya period, was responsible for the harshest and most bitter messages directed at the women volunteers. At a party meeting that took place during the Passover festival, he said:

> As difficult as it is to hurt the feelings of our sisters who are joining in the tumult of volunteering, one cannot but comment on their shameful part in all of this "partying." Shameful—because in their regard it is all a lie—albeit a

conscious one—and deceit of themselves and others. For it is clear to our "volunteers" that they will not be sent to the frontlines, no matter if some or other terminology is added (how many "merciful sisters" who are actually British do we see in the British army camps here? And in the excavations at the front, how many?) The whole matter of "lists of volunteers" is not serious: if the men are becoming intoxicated with the wine of volunteering [. . .] the women will unfortunately become intoxicated on a mere whiff of the wine fumes [. . .] And while most of the women are innocent in this whole affair, what of their leaders? One is entitled to demand greater responsibility from the daughters of Yisrael on the verge of national revival; they must not fan the flames of a fire which their hands will not be put in.[13]

The most senior leader of these "daughters of Yisrael" was, of course, Yanait.

Following negotiations that had continued for several months and had been accelerated through the mediation of Chaim Weizmann, Zeev Jabotinsky, and Aaron Aaronsohn, on May 16 General Edmund Allenby received approval from the British War Office to enlist the volunteers in Palestine. Word of the approval spread over the next few weeks, and the mobilization began in mid-June, following Weizmann's return from his meeting with Emir Faisal Husseini on June 4. The British approval entailed shelving many of the demands that had been drawn up by the Committee of Volunteers, including the provision of a special budget to organize the mobilization, training of artillery and cavalry forces from among the recruits, military training in Palestine, and enlistment of women.[14] Smilansky noted in his memoirs: "We were forced to part from our women colleagues, and they did not hold us back."[15] Despite this general mood, seeking to delay the mobilization of the men until agreement could be reached concerning the women, no such condition was actually laid down.

The formal request that the British reconsider their position on enlistment of women had been conveyed a few days earlier, through Weizmann's mediation, to Brigadier-General Gilbert Falkingham Clayton, chief political officer of the British command in Egypt, and he had passed the matter on to the authorized personnel in London. The War Office, on behalf of the Army Council, responded to the British Foreign Office on June 25. The Council was pleased with the enthusiastic enlistment

of the Jews of Palestine to the Jewish battalions; as to the enlistment of Jewish women for service in an auxiliary military unit, the Army Council noted that the matter had already been discussed in the past, and "unfortunately" it would be impossible to approve it.[16]

This notification would seem to refer to a decision taken by the War Council the previous month. Britain's Jewish ambassador to the United States, Rufus Daniel Isaacs, earl of Reading, had submitted a request in this regard following an appeal by Jacob de Haas, secretary of the Federation of American Zionists. The ambassador had recommended examining the possibility of acceding to the wish of Jewish women seeking to enlist in an auxiliary women's unit that would serve in Palestine as part of the mobilization in the United States for the battalion that had been established there. The War Council had ruled that the suggestion of enlisting women was "impracticable."[17]

The women volunteers, unaware of what was happening behind the scenes, continued to ready themselves for a positive response. British officers contributed in part to the illusion. For instance, at a reception held at a girls' school in Jaffa on May 25, after watching the students perform gymnastics, Brigadier-General Clayton stated in his speech that "Maccabee men and Maccabee women alike are already primed for the Legion."[18] Jabotinsky, too, attached great importance to Clayton's promise "to lend his support to the request by the girls" to enlist.[19] On June 17, Bracha Habas, an eighteen-year-old girl living in Tel Aviv, wrote in her diary:

> Yesterday Dr. Weizmann came [following his return from the meeting with Faisal and his consultations in Egypt] with the final answer that girls, too, would be accepted into the Legion! What great news! A strong urge seized me, too, to go. But who knows if they'll accept me; I'm too young. We'll see.[20]

This web of rumors, devoid of any real basis, rocked the potential volunteers this way and that. Adding to the confusion, the Committee of Volunteers in Jaffa asked the Jerusalem branch to immediately issue a list of all the women seeking to enlist, with details including name, age, personal status, education, foreign languages spoken, current occupation, and desired military occupation—"nurses, miscellaneous auxiliary positions, cooks, stable-hands, office, chauffeurs, wagon drivers."[21] On June 25, Rachel Gutman, on behalf of the Jerusalem volunteers, informed the

Committee of Volunteers in Jaffa that "a great crowd of young women from all sectors are demanding, 'Accept us,'" but the Committee in Jerusalem requested that their names not be added to the list for fear that this would interfere with the enlistment of the men, which was the concrete matter on the agenda for the moment. Important workplaces in Jerusalem (schools, offices, banks) were being "emptied" of their young men, and they might be emptied of women employees, too. Gutman promised that Jerusalem could "provide 100 young women or more from all sectors" and sought the opinion of the Committee in Jaffa as to whether more women representing the range of ethnic backgrounds and social groups in the city should be registered, or whether the committee should "accept only intelligent women so as to diminish the responsibility that we are taking upon ourselves." In this connection she noted that James de Rothschild (the son of Baron de Rothschild, who was a member of the Council of Delegates and oversaw widespread propaganda in favor of volunteering) wanted to sign up hundreds of women, "and then they could be spread not only in our battalions, but throughout all the British battalions that are here. He is in favor of accepting even women of questionable morality, who will be purified in the Legion." On the other hand, Gutman promised that "We will maintain strict standards, and no woman will be accepted without due checking."[22] The question of whether it was appropriate to insist on the quality of the recruits, or to accept with open arms anyone willing to serve, regardless of whether she was supporting herself through such occupations as prostitution, remained purely theoretical in this regard. At the same time, the phenomenon of prostitution, in its wider contexts of gender, morality, and health, was indeed part of the process of women's assumption of auxiliary military roles during the First World War in Europe. It must be emphasized, however, that the gossip surrounding behavior that deviated from ethical codes and military norms exceeded by far the scope of actual incidents.[23]

So long as the men had not yet set off, the hope that the women would be joining them was kept aflame. The uncertainty and instability concerning the enlistment was reflected in Yanait's words at a meeting of the Po'alei Tzion central committee held on June 26 discussing the distribution of roles among party activists on the eve of the Legion's departure. Speaking of herself, she noted: "My participation in volunteer work from the outset, the great responsibility entailed in signing up women volunteers, leaves no room to speak or even to think that I might remain behind."[24]

The same vacillating may be discerned in other conferences held on the eve of the men's departure. At a general meeting of the women workers in the Judea region, held on June 24–27, and at the farewell gathering for the members of the agricultural union, held immediately afterward on June 27–29, Rachel Katznelson of the Non-Aligned Workers expressed her position against volunteering. With measured restraint—because, after all, the decision in favor of volunteering had already been taken, and some of her close friends, including her close friend Berl Katznelson, had already chosen to join the ranks—she expressed her reservations concerning the adoration of death and her loathing for blind discipline. These two poisonous qualities, to her mind, were spreading throughout the Yishuv, clouding the humanism and rejection of war that, until then, had prevailed among the workers. At the same time, with a sort of reconcilement with the choice of those women who wished to volunteer, and with the knowledge that at least they would be remaining in the country, Katznelson found it within herself to applaud the "value of women's participation in the Legion, the historical progress that this represents, as they go out alongside the men to war, a phenomenon unparalleled in Jewish history."[25]

The women's ambivalence on the eve of the men's departure was summed up by Ada Fishman, one of the most outspoken of the women opposed to volunteering, and a member of the second tier of leadership in the Ha-Po'el Ha-Tza'ir party:

> This worker's heart is fluttering right now out of a desire to participate in the Legion, to be part of the Jewish Legion, and at the same time her heart beats with love of labor and of the land, and there is a desire within her to continue her labor and to fill the places of the comrades who are leaving.[26]

Like women in other countries who had opposed the war from the outset, and who had attempted, without success, to nurture a pacifist mood, Fishman was aware that in the Palestinian context, too, she and her comrades had lost the main argument. However, among the women, the position opposed to volunteering had achieved some success. Admittedly, this was due less to their own efforts than to a decision by the British. Nevertheless, to reap the desired moral, organizational, and political benefit, it was now necessary to blur differences rather than highlight them. Katznelson's statement, uttered only in private in her diary, was

tortured and bitter: "No; we shall not have children. Over the course of the generations there sometimes comes one generation which takes for itself all the wellsprings of life that eternity has prepared for the sake of eternity, leaving nothing for the generation to come."[27] Her forecast turned out to be incorrect—inter alia because the men were not actually sent to the battlefront—but it does testify to the intensity of the pain and the terror of the moment for those who negated, with all their being, the necessity of volunteering.

The days preceding the departure of the volunteers were not only crammed with political meetings, but also characterized by passionate intimate encounters, as described by Bracha Habas:

> The girls were now pleasant and accommodating; clouds of discord—whether heavy or light—were dispersed, and offenses were forgotten [. . .] Each of them who was "in love" discovered that she was, indeed, "in love." [Late at night,] when the streets emptied and the groups dispersed, as though by magic the hills of sand—the expanses of sand planted with vines—were covered with couples. Kisses and caresses were exchanged, and the dunes absorbed words of affection and tenderness, words of love and trust. The abstinence of the days to come loomed large.[28]

Beyond the wonderful picture painted by Habas of the youngsters on the eve of their integration into army life, one might say that this was one of the only ways in which the women actually participated in the experience of volunteering for the Jewish Legion in 1918.

At the volunteers' farewell meeting, held by the Po'alei Tzion party on July 1, Yanait stated that the party now comprised three parts: the male members who were now leaving; the female members who would be leaving in the future; and the members who would remain. She emphasized that the women members of Po'alei Tzion were the only organized group from a party, among the women seeking to volunteer, and that this represented a significant innovation, because until 1918 no such women's organization had existed in the party. Yanait announced that she intended to go on fighting to realize the goal that they believed in—volunteering for the army and joining the men.[29]

At a ceremony held in Tel Aviv on July 3, Weizmann conveyed to the volunteers a flag that had been sewn by the women of Tel Aviv, and each

also received a symbolic gift of a silver coin that had been prepared at the Bezalel Academy of Arts. It imitated the style of the commemorative coins struck by the by Roman Emperor Vespasian to celebrate the destruction of Jerusalem by his son, Titus, in 71 CE, but his inscription, "*Judea Capta*," was replaced with the Hebrew inscription "*Yehuda haMishtahreret*" (Judea's liberation). The difference in the appearance of the two coins was described in the newspaper of the Ha-Po'el Ha-Tza'ir, *Ha'aretz Veha'avoda*: "On one coin there is a Hebrew woman in chains, crouched under a palm tree, with a Roman legionary standing proudly by her; on the other, the Hebrew woman stands proudly and severs her chains, while the Roman legionary takes flight." Beyond the popular iconography of national movements where a woman is often used as a passive national symbol—sometimes as a victim, other times as an incentive for enlistment—here, for the first time in Zionist history, the symbol of the "Hebrew woman" had concrete, immediate significance. Her appearance to express renewed national pride and freedom had, at least temporarily, and at least as it appeared then, a real basis. This was no mere romantic, artistic, mythological archetype reflecting visual traditions that were common in diverse cultures, such as "Marianne"—the allegorical and symbolic figure who represented the ideas of the French Revolution. The symbol was imbued with a new dimension of meaning thanks to the actual, real existence of women who wanted to volunteer for the Jewish Legion.

The same element that was featured on the coin was also prominent in a drawing by artist Zeev Raban, which was chosen by Yaakov Ben-Dov to appear on the cover of a collection of twenty postcards he had photographed on the theme of the Jewish battalions. It shows a young, confident Hebrew woman holding in one hand the flag of the Jewish battalions and in the other a shield engraved with the names of the twelve tribes of Israel. The spirit of the period was evident in these artistic choices, which arose from both the actual visible reality and an internalization of the ideological atmosphere in which the woman-army-nationalism-freedom combination was perceived as collectively representing an accurate and faithful expression of the story of Jewish revival.[30] The feminine presence in the molding of the emotional climate of the period of volunteering, as evident on the visual and artistic level, was paralleled only partially in the basic and elementary aspiration of the women volunteers: to receive uniforms and insignia and to join their comrades on the train heading southward to the military training camps in Egypt.

The Activity of the Committee of Women Volunteers

The train that departed from Tel Aviv on July 4 with the volunteers on board was delayed on its way to Lod when it was discovered that some women volunteers had sneaked in among the group. They were removed from the train, but continued to follow it on foot until they reached Lod, where the volunteers from Tel Aviv met up with those who had come from Jerusalem. In the evening, the freight trains headed for Egypt.[31] Five days later, in a letter dated July 9 and addressed to General Allenby, a new body calling itself the "Committee of Women Volunteers," demanded the establishment of a special military unit for Jewish women—the J.W.M.U. This was the first in a series of three letters dispatched by the Committee of Women Volunteers to Allenby that month. The committee's activity, expressing itself in the dispatch of more and more memoranda to the British military command, was a direct continuation of the format that had been adopted by the Committee of Volunteers. The first letter set forth four principles the women volunteers regarded as essential:

> All the Jewish women volunteers are to be concentrated in a single, complete, special military unit, with its own special Hebrew insignia. The women volunteers will work in their tasks in groups, in order that the group can stand as surety for each individual, and so that each individual will know and feel that she is entrusted with group responsibility.[32]

In fact, they sought to establish a specially defined unit with Jewish national characteristics, where service would be performed in groups rather than on an individual basis, so as to prevent behavior or conduct that was not suited to national needs. All of this was meant to create an organizational and social framework that would not necessarily respond to the aspirations of the individual (in terms of income, marital relations, adventure, etc.), but rather would consolidate a group with an ongoing commitment to the political aims in the name of which the women volunteers were enlisting for military service. This fundamental position adopted by the Committee of Women Volunteers was a contrast to the approach that had been expressed by women volunteers on different occasions, insisting that it made no different what they did in the army—"We must even shine our (men) soldiers' shoes" or "Let

him (even) play football; I will serve him."[33] In their letter, the women volunteers set forth at length the spheres of activity that they sought within the framework of the J.W.M.U.:

> Magen David Adom, with all related tasks. We want to take care of an injured soldier from the moment of injury until he is recovered and ready to return to the front: first aid on the battlefield as nurses. Nurses and workers in field hospitals, on the battlefront, and behind the frontlines. Nurses and workers at the central hospitals behind the frontlines. Wagon-drivers and workers in transport devoted to delivery of the wounded from the battlefield to hospitals and from place to place. Office work for the Jewish battalions—telephone, telegraph, etc. Work in different forms of food provision, as the military command may see fit. Various auxiliary positions, such as sewing and repair, and other kinds of work as the military command sees fit.[34]

The letter emphasized tasks in the medical sphere, reflecting the prevalent view at the time in Europe and the United States that this was the most prestigious among the range of possibilities for women's participation in the war effort. It allowed women to be located close to the battlefront but at a safe enough distance and to use their "natural" tendencies of compassion and help without challenging unduly the conventional gender roles. At the same time, the request as formulated in the letter revealed the degree to which the women volunteers were disconnected from the reality of medical roles for women in the British army. Women doctors and nurses, who had slowly become attached to the military forces since 1917 and were serving, for example, in France, Malta, Greece, and Egypt, did not usually enjoy the benefits of a regulated military status; they were certainly not included in the formal military hierarchy, with its insignia, uniforms, and other external trappings.[35] Thus, in contrast to the traditionally minded and conservative British hesitation, which had thawed only slightly in view of constraints that cropped up, the Committee of Women Volunteers declared that they numbered "only 200 right now, in Palestine," but that they had heard that Jewish women in the United States were volunteering along with men, and "when our aspiration starts to be realized, our sister-volunteers will multiply in the thousands in all countries of the world." The

Committee expressed the women's willingness to embark forthwith on preparations for their service, which would be carried out "in Palestine and in Egypt."[36] In other words, the women surrendered their original hope to serve solely in Palestine and agreed to subordinate themselves to the military needs and enlistment priorities that would be determined by the British. In July, as in February, the committee was speaking on behalf of 200 women volunteers—meaning that throughout the five months of extensive propaganda throughout the Yishuv in favor of enlistment, the number of women volunteers remained formally static. The number of men volunteers, in contrast, had tripled itself since the beginning of the Committee of Volunteers' activity in January. It must be remembered, however, that the women who registered for service at the start of the volunteering controversy represented about 20 percent of the women among the agricultural pioneers, who numbered at the time about 2,000 Jewish Socialist workers in Palestine, but part of which was now in territory under Turkish control in the north of the country. A minority of the women volunteers came from the Tel Aviv elite and from the Judean rural towns.[37]

The British command took its time in responding to the Committee. Two weeks later, on July 24, a cornerstone-laying ceremony was held on Mount Scopus, in Jerusalem, for the Hebrew University. Allenby honored the ceremony with his presence. Weizmann acceded to Yanait's pleas to take advantage of the reception that would be held for the honored guests at the event and to allow her to present directly, without the mediation of lower military rank, the women's request to enlist. Although Allenby was at the time one of the only senior commanders in the British army who attached any importance to the role of military medicine and the prevention of diseases among his soldiers,[38] it is doubtful that the Jewish women volunteers were aware of this dimension of his military persona. This time the women chose to set aside the matter of partnership with the men in building the land, attempting instead to soften the top British military authority by appealing to emotion. The letter that Yanait handed to Allenby read,

> We believe that it would be an unforgivable sin were we now
> to surrender and stand aside while the fate of the country is to
> be determined; we would be sinning twice—both towards our
> own people and towards Britain. How can we remain bystanders
> while women in England and in America are demonstrating

courage and commitment in coming all the way from their countries, putting their lives at risk, in order to offer their help? Why should this sacred obligation be withheld from us Jewish women? [. . .] Rejection in this matter would be so painful for us; it would pain us to the point where we would regard it as a blow to the national dignity of Jewish women.[39]

In her memoirs, Yanait records that Allenby looked at her "as though I was a combative suffragette demanding women's rights" and offhandedly gave a promise about serving in a military hospital. A few years later, Allenby was again visiting Jerusalem, this time no longer in military uniform (during 1919–25 he served as high commissioner for Egypt), and he told Yanait with a smile, "How strange you appeared to me; in the great wide world, every soldier looks forward to going home, while in this tiny country, even the young women were eager to head for the front. I believe that you were the first women in the world who ever wanted to go to the battlefront as combat soldiers."[40]

Indeed, Jabotinsky noted that some of the women who sought to enlist "longed to become Amazons." For a while, against the background of the general mobilization during the First World War, this image, drawn from the women warriors of Greek mythology, had nurtured false rumors of combat units of suffragette women, and on many occasions the women in Britain who maintained their daily routine during this time were referred to as the "new Amazons" who were now filling auxiliary positions in industry and combat. The image adopted by Jabotinsky in this context recalled the rumors reaching Palestine about the women soldiers in the Russian army in 1917; in the local context, too, it was not altogether detached from reality. Even if they knew that they would not be permitted to "go to the battlefront," Yanait proudly announced, "We demand this emphatically."[41]

The fault line in the women's struggle to volunteer in the Jewish Legion was indicated in a letter by the Committee of Women Volunteers to Allenby, dated July 30. It demonstrated a sharp turning point in the fundamentally military emphasis their efforts had adopted until that point. Apparently, it was Weizmann, with whom Yanait maintained close ties of trust at the time, who represented the main reason for the change in their approach. The Committee of Women Volunteers proposed that, in addition to the other tasks that had been listed in the past as functions of the Jewish women's unit, the volunteers would take upon themselves

"an important additional task: the cultivation and provision of vegetable produce for the army." For this purpose, they wrote, the Committee would be able to organize immediately a further 200 women, in addition to those whose tasks had already been set forth in the previous letters. The Committee proposed that it be allocated tracts of land, along with equipment, machinery, and the other requirements necessary for carrying out this task—including uniforms and the appropriate insignia. "Obviously, they will be counted as part of the Jewish Women's Military Unit." The Committee expressed its hope that in view of the fact that there were many candidates capable of working in this sphere, the project would turn out to be an "absolute success" and a vital contribution to the British military forces.[42] The readiness to serve in the realm of food provision had been noted on previous occasions as one of the secondary tracks for women's activity in their military unit, but now it was presented as a main option. It would appear that the Committee's readiness to forego its vision of enlistment into the medical corps as the main destination for the women's military service was based on the understanding that for the purposes of Zionist fulfillment right then, the political aim had to be civilian seizure of available land under the auspices of the British army. From this point of view, the medical experience and professional training that they would acquire during military service—despite their obvious usefulness in everyday life—were actually of marginal political effectiveness. Thus Yanait accepted Weizmann's view, and it was integrated into the updated program for women's enlistment. Clearly, Yanait's agronomical professional background, her experience in growing vegetables, the political interests of the Po'alei Tzion party, and the socialist ideals and values that she believed in all served to make this decision easier. Furthermore, from a certain perspective, this represented a meeting of interests between Weizmann and Yanait: she viewed his program as an opportunity to advance her aspiration to draw more and more women into agriculture, the realm that she viewed as "the soul of the labor movement."[43]

On August 2, the British Command's response to the letter of the Committee of Women Volunteers of July 9 was finally formulated. Brigadier-General Clayton wrote to Weizmann that, following a series of consultations, the Command had decided that for the time being the establishment of an auxiliary military unit of Jewish women was "not practicable." At the same time, he noted that there were various forms of work for which women were likely to be suited, and in which they

might be employed through the British military body responsible for provision of work. If the numbers were relatively small and the candidates possessed the necessary skills, they could also manage their affairs alone. The letter concluded with the words, "That is all that can be done at the moment concerning the establishment of a special Jewish women's unit."[44] Thus, the British expressed readiness to help with an income, of limited scope, for the women in the Yishuv—a matter not devoid of value in its own right, in view of the dearth of work, hunger, and illness prevalent at the time. There was no prospect of army enlistment, from their point of view, but for the first time they showed a willingness to address the organized integration of women into some sort of framework, even if only in the sphere of labor. Yanait, with Weizmann's backing, decided to exploit this tiny crack to launch a last, all-encompassing effort to reverse the British decision. This effort was consolidated in the form of a comprehensive program, which was presented toward the end of August, once again based to a considerable degree on Weizmann's hope to realize his land program.[45]

The public struggle of the women to volunteer for the British Army therefore reached its climax at the general assembly of women volunteers that took place on August 31. The drive for a "revival of the People of Israel in its Land," as Yanait presented it, was processed by the Committee of Women Volunteers, which she headed, in close coordination with Weizmann, into a readiness to volunteer for a type of activity that, truth be told, had nothing whatsoever to do with the army or fighting. Despite the angry responses of some participants at the gathering, such as Yehudit Idelman and Rivka Danit—who, a few years later, would be among the founders of Kibbutz Ein Harod—Yanait emphasized that in the existing situation what was important was "a general awakening, on a national basis, of the entire Jewish public to participate in everything related to liberation of the land." Any productive labor, she argued, would benefit the fighting forces and demonstrated the desire on the part of Jewish women to participate in the liberation of the land. Yanait declared that agricultural labor, if performed as part of the activity of a Jewish women's unit attached to the Jewish Legion, would be of greater value than repairing uniforms or office work for the British army. She recounted that in her contacts with the military, she had taken care to emphasize that 80 percent to 90 percent of the women volunteers wanted to serve as nurses, and that they were interested in joining the Jewish Legion rather than other legions of the British army (Australian, Indian,

and others) that were fighting in Palestine, but in the negotiations she had been told that the women could not present this as a condition for their enlistment. At the same time, she acknowledged that it was mainly the possibility of the women working in agriculture and providing vegetables for the soldiers that had appealed to the British officers and caused them to view favorably the issue of their enlistment.[46]

For some time, reports had circulated in Palestine about women's work battalions in Russia as a model that the local volunteering project should seek to emulate. The fierce controversy that erupted at the general assembly of the women volunteers because of the women's clear preference to serve as medics arose to a fair degree from their expectations of achieving personal and social gains in civilian life following the end of the war by virtue of the professional knowledge and training that they would have acquired. There were few women medics in Palestine at the time, the pressing medical needs were quite evident, and employment as nurses would be an opportunity for a fixed, rather than seasonal, source of income in a profession regarded as carrying some prestige. Although these aspirations were quite legitimate in their own right and were certainly consistent with the rather minor phenomenon of women's enlistment into other armies in auxiliary positions, especially in the nursing realm,[47] they coincided only slightly with Weizmann's order of priorities. Nevertheless, Yanait told the gathering that Weizmann had promised her, repeating himself three times, that prior to his departure from the country in the coming weeks, he would take care of the matter of establishing the women's unit.[48]

A memorandum dispatched the next day, September 1, in the name of the Committee of Women Volunteers to the British Command stated that the women sought to serve in groups rather than as individuals, and maintaining some connection with the administrative framework of the Jewish Legion. The memorandum listed once again the desired positions: provision of medical assistance, office work, and food production, and a detailed list was attached with the names of 155 volunteers. They were divided as follows: 107 volunteers for medical service (4 registered nurses, 14 nurses with experience in medical work, 69 seeking training as nurses, and 20 volunteers for general medical auxiliary work);10 volunteers to transport injured soldiers away from the frontlines and from one treatment facility to another; 10 volunteers for office work; and 28 volunteers for agricultural work including growing vegetables, and so forth. Yanait listed herself in this last category.[49]

On September 10, Weizmann left Palestine and headed for Egypt on his way back to London without fulfilling his promise to Yanait. A day earlier, one of the volunteers, Miriam Lubman, had written to Yanait. After conveying her New Year greetings—"May we all merit to see our heroes wreathed in victory laurels, and ourselves at their sides, as heroines aiding them in every way"—she asked how the British had responded to the last memorandum, noting, "Prof. Weizmann leaves today; who will take care of our cause?"[50] Yanait's response is unknown, nor is there clear evidence of how her involvement in the matter of the women volunteers came to an end, because it appears that she refrained from documenting it. What is known is that Yanait joined Weizmann's entourage and arrived with him, and under his patronage, in Cairo.[51] There, following three and a half years of enforced separation, she met up with her partner, Yitzhak Ben-Zvi, who was stationed at the training camp of the 39th American Jewish Legion. She also hurried to visit the soldier David Ben-Gurion, who had been hospitalized with an acute case of dysentery. It is reasonable to assume that it was more than just the opportunity to see her beloved that led Yanait to travel to Egypt, and that during the few days that she spent in Cairo she made a final effort to advance the idea of the women volunteers, but the details are not available.[52] What we do know is that this was the end of the ongoing struggle for the broad-based enlistment of Jewish women into a military unit of their own to be attached to the Jewish Legion.

Some 1,100 Jewish men volunteered for the Jewish Legion. In a letter that Allenby wrote to Henry Wilson, chief of the Imperial General Staff, he expressed quite frankly his professional opinion as to the military contribution that the two Jewish Legions, from England and the United States, were anticipated to offer: "A mixed multitude, such as the Jewish Legions and the Hottentot Legions, have a certain value; however, they do not determine the outcome of a war."[53] The volunteers of the Legion from Palestine set off for Egypt on July 4, 1918—American Independence Day. The women stayed behind. Symbolically, in one of history's inexplicable tricks, it was exactly eighteen years later, on July 4, 1936, that the first two women set off for guard duty in Ein Harod, thanks to the successful campaign by the women of that kibbutz to take an active part in defense of their community during the Arab rebellion. Here, too, they did not ultimately leave their mark as heroic leaders, in contrast to Yanait's rosy hopes in 1909, when she envisioned Zionism bringing about a renewal of the spirit of Bar Kokhba among the Jewish

people. Those who were to leave their mark in the sphere of defense and leadership on the battlefield in Palestine would still be men.

Many years later, Yitzhak Olshan, who had been involved in the activity of the Committee of Volunteers and would later serve as the second president of Israel's Supreme Court, stated that the members of the Committee of Volunteers had understood that there was no hope of the British accepting the women's demand to enlist, and that it was only because of Yanait's insistence, and as "a matter of principle," that they had been included in the list of those seeking to volunteer.[54] A similar view was expressed by Jabotinsky in his memoirs: in typically military style, he noted that "speaking to the English about 'Amazons' was, of course, pointless; they themselves did not treat the idea seriously."[55] But Eliyahu Golomb disagreed vehemently with this sober view expressed with hindsight. He maintained that "in a movement that arose out of a desire for an inner manifestation of self-sacrifice and an aspiration to build up the strength of the Jewish people, the place of women members could not be left vacant," but in this regard the women volunteers' movement did not succeed in overcoming "the traditional perceptions of conservative circles in the military command, as well as in the Yishuv, concerning women's roles."[56] As for the Amazons, the chairman of the Jewish National Fund, Menachem Ussishkin, later referred to Rosa Cohen as a "Tel Avivian Amazonka," in reference to the combative activity in the social life of the Yishuv by this most senior woman activist in the Haganah organization until her death in 1937.[57] Twenty-three years would pass, from the time of the women's struggle to volunteer for the Jewish Legion until the British finally agreed, on December 23, 1941, to permit their enlistment during the Second World War. An editorial published in *Davar*, addressing this occasion, noted: "During the previous war, when the women's movement to volunteer arose, the Jewish Legion was devoid of women. Their sacrifice was not wanted. Now a new direction has opened up. Men and women alike are being asked to serve. And men and women alike will acquiesce, and volunteer."[58]

Toward the end of the War of Independence, Ben-Gurion described the connection between defense and settlement as one of the foundations of Israeli security. Recalling the past, he spoke fondly of "Rachel Yanait, who demanded then [1918] participation of women, too, in the army, and expressed this concisely: 'We proceed from labor, via weapons, to labor.'"[59] This combination, dating back to the very beginnings of Hashomer, was not realized during the days of the Jewish Legion. Even

the leading opponent of women's volunteering, Rachel Katznelson, was able, by the end of the War of Independence, to find some merit in the struggle that had been thwarted: "It was an initial eruption—not of individual women, for individuals already served in the Haganah [a reference to Hashomer] before then, but rather of a movement."[60] The healing for the "spilling of blood" on behalf of the nation and the homeland, that goal of the young pioneers in Palestine expressed so starkly by Smilansky, was meant to be provided, first and foremost, by the young Jewish women who sought to enlist in the British army, principally as nurses, close to the battlefield, and on the home front. The historical reality of 1918 did not aid the young men and women in realizing what they viewed, with profound inner conviction and captivating idealistic fervor, as their calling. As Habas wrote, five years after this historical episode, "Each of the volunteers feels self-important; the center of God's world."[61] For the first time, the pioneers of the Second Aliya, along with their contemporaries in Palestine, truly felt like the nation's elite and that they were occupying a place destined for them. However, the feelings and the reality were deeply divided. The men who enlisted played a minor role in the fighting, while the women remained on the verge of joining the army without actually enlisting. With the sober perspective of hindsight, and taking into consideration what happened later, some might say that this was all for the best.

Chapter 3

The Women of Kibbutz Ein Harod as a Microcosm of the Women's Struggles

"One day I had two conversations about the anthology [*Divrei Po'alot*]—with Rachel Bluwstein, and with Rachel Zisaleh [Lavi]. Rachel [B.] told me, 'It's an absolute cultural masterpiece; there isn't a single word out of place,' etc. R. Z. commented innocently, 'The book is still weak.' I rejoiced with all my heart at R. Z.'s words. Not that I share her opinion of the book, but I felt encouraged, because so long as there are great demands, the work is interesting, and it's worth making the effort. I also thought—what lends importance to a person's life? A woman like R. Z. and her demands are superior to those of Rachel [B.]. When one lives an Ein Harod life, one approaches things differently. This I had known for a long time."

—Rachel Katznelson-Rubashov Shazar, December 7, 1929[1]

From the start, Ein Harod was one of the most prominent and dominant communities among the pioneers. The full range of the ideological, political, social, cultural, economic, and organizational desires, hopes, tensions, and crises experienced by the pioneers drained into this community in the Jezreel Valley, firing their existence and providing endless controversies within the labor movement, from the beginning of the 1920s until the 1950s. All that was put aside, camouflaged, and concealed elsewhere was addressed at Kibbutz Ein Harod in the most public, tempestuous, convoluted, confounding, and inspiring manner. Over the course of a few decades, in the conflicts that were battled out there, Ein Harod

managed to target with great precision the critical, pivotal elements in the molding of the revolutionary Zionist process in Palestine, and to reflect them at both their best and their worst.[2] The Jewish settlement in Ein Harod was founded during the Third Aliya. On September 22, 1921, a group of members of the Gdud Ha'avoda (Work Battalion), which had been established in 1920, settled near the Harod Spring; later, the group established the Ein Harod-Tel Yosef kibbutz on the basis of the "large kibbutz" program drawn up by Shlomo Lavi (Levkovitch). Following the ideological rift that divided the Gdud Ha'avoda in June 1923, Ein Harod became an independent community, and the national organization known as Kibbutz Ein Harod began to form, eventually becoming the basis for the establishment of the Hakibbutz Hameuhad movement in August 1927.[3] Ein Harod was the kibbutz home of Yitzhak Tabenkin, leader of the Hakibbutz Hameuhad movement. Other members with significant ideological, organizational, economic, or political influence included Lavi, Aharon Tzizling, Haim Sturman, Luba Levite, Reuven (Vinia) Cohen, David Meltz, and Gershon Ostrovsky. Neither women nor the defense sphere features in this group.

The sense of a security mission, as a central and decisive element in Jewish life in Palestine in general, and among the communal settlements in particular, was one of the most prominent and identifying characteristics of Hakibbutz Hameuhad—"a movement with a destiny," as Tzizling summarized one of its principles, and also of Ein Harod as a major player within that framework.[4] The tension of the defense challenge was their permanent companion, fed by their inner sense of being, in Sturman's words, "the casualties who take the lead."[5] The members of Ein Harod viewed themselves as an avant-garde leadership, ready at any moment to pay the greatest price. It is no wonder that some of the figures named above, who were among the leaders of the kibbutz, also became part of the broadening family of the bereaved. Both sons of Shlomo Lavi, Yeruba'al and Hillel, fell in the War of Independence. The same fate awaited Rafi Meltz, son of David Meltz, and Nimrod, the son of Luba Levite (who was killed toward the end of 1949), and Haim Sturman himself, who fell in 1938, his son Moshe, who was killed in the War of Independence, and his grandson, named after him, who fell in the War of Attrition. Coincidentally or not, two of the seven women who were considered official members of Hashomer—Esther Beker and Sara Kriegser—were sisters of Haim Sturman, and it was his wife, Atara, who led the first rebellion of the women of Hashomer.[6] The kibbutz itself, by

contrast, was largely spared the worst of the suffering and anguish arising from security incidents. Unlike other kibbutzim—such as Kfar Giladi, Hulda, Mishmar Haemek, Ramat Hakovesh, Hanita, Yagur, Negba, and Degania—no military halo surrounds its history. Although its proximity to the frontier and to nearby Arab towns was a permanent fact of life in Ein Harod, as was the deep involvement of its members in the Palmach (as evidenced by the violent search carried out by the British on-site during "Operation Agatha" ("Black Saturday" in 1946), in the collective memory of the chronicles of the Arab-Israeli conflict, there is no chapter devoted specially to Ein Harod. At the same time, it was here that the public battle of great importance and of lengthy duration concerning the molding of the nature of the Israeli defense system was ignited—centering mainly on the struggle over the place of women in the kibbutz's overall security activity.

Our fundamental proposition in this chapter is that one cannot approach a proper understanding of the sources of the inner strength of Ein Harod and its aptitude to help pave the path of the Labor movement, with the profound questions and bitter controversies that often accompanied this reality, without examining and analyzing the role of its women members. The gender aspect served as an essential component in the efforts of these women to integrate into the framework of communal life and to advance their personal and social status within it, along with the pioneering spirit and egalitarian values sanctified by the kibbutz.

At the same time, the women of Ein Harod sought to address the inflexible division of roles between the sexes in kibbutz society, which arose, inter alia, as noted by Sylvie Fogiel-Bijaoui in her groundbreaking article on kibbutz women, from the fact that the number of women members always remained lower than the number of men.[7] Significant change in women's personal and social status on the kibbutz can take place, on the basis of Fogiel-Bijaoui's research hypothesis, only where the numerical strength of women relative to men is more or less equal. Indeed, in Ein Harod of the 1930s, this situation was maintained: On December 1, 1931, the kibbutz membership included 125 men and 122 women. On June 1, 1933, there were 136 men and 134 women. By April 1936, the figures had climbed to 191 men and 190 women. On October 1938, there were 216 men and 219 women, and a year later the situation was almost unchanged: 216 men and 214 women.[8] These data point to a sustained effort on the part of Ein Harod to maintain equality of numbers between men and women. The women's activity on

the public and local front was a force motivating and accelerating the establishment of behavioral and policy norms whose effects extended far beyond Ein Harod itself, or even the Jezreel Valley.

The Jezreel Valley was an area of central importance during the first half of the 1920s, thanks to the arrival of thousands of Third Aliya (1919–1923) pioneers and the activity of Gdud ha-Avoda. The Gdud, as Anita Shapira notes, left its mark on "the pioneering elect, who sought to combine the vision of perfecting society—here and now—with the vision of the revival of Jewish society in Palestine." The tension between the "elevated nature of the vision and the miserable reality of its realization," which accompanied the workers in Palestine from the outset, reached its pinnacle in the Gdud. The settlement in Ein Harod was one of the most significant and long-lasting contributions of the Gdud to the labor movement. The Gdud was meant to serve as a platform from which Joseph Trumpeldor would go on to realize the political unification of the workers' camp and assure his place as one of its senior leaders.[9] But Trumpeldor had been killed six months earlier, on March 1, at Tel Hai. Along with him, on the same day, five more workers were killed, including Sara Chizik and Devora Drachler.

Chizik, twenty-three, sister of Efraim Chizik (who was killed during the riots of 1929, as he led the defense of Hulda) had apparently arrived in Tel Hai the day before the attack took place in response to Trumpeldor's call—"Why aren't any of the young women coming?" They were needed for cleaning, laundry, and preparing food for the workers. In view of the security situation at Tel Hai, Trumpeldor recorded, concerning the young women working there, that "obviously, at times of danger, we tried to put them in the safest places." In other words, they were not regarded as potential candidates to lend military aid during battle. Three questions concerning Drachler's death are pertinent, in several respects, to our discussion. First, regarding the sustained lack of clarity as to the number and identity of the women who were members, in some form or another, of Hashomer, we cannot establish with certainty whether Drachler was a member of the organization. In the records she is sometimes counted as a member, at other times not. Second, in the context of the circumstances that led Hashomer not to include women in the guard duty roster because of concern this would draw unnecessary negative responses on the part of the Arabs, the conventionally held version of the story is that it was the fact that Drachler was holding a pistol and refused to hand it over to Kamel Al-Hussein, leader of the

local Bedouins, that sparked the shooting incident at Tel Hai. Third, there is room to suspect that Drachler and Chizik were present at Tel Hai because two women who had been there previously refused to accept the decision of the Defense Committee at Tel Hai that during an attack, women members were not to be located on the front defense lines, but rather in the upper room, located in the courtyard and considered a safer location. Pinhas Schneorson, the most senior member of Hasho-mer at Tel Hai on the day of the incident, recounts that he joked with Drachler that "there's no unity among the women members. Had such a decision been taken with regard to the men, there would have been no 'strike-breakers.'" Because both were well aware of the "seditious letter" penned by Atara Sturman, Yehudit Horvitz, and Drachler in September 1918, the jibe alluded to the women's difficulty in integrating into a guard framework requiring rigid discipline as one of the primary reasons for their lack of acceptance as members of Hashomer.[10] These questions remain unanswered in the academic literature, but because the following fifteen years saw no further incidents in which Jewish women fell in battle over Zionism fulfillment in Palestine, the significance of the Tel Hai episode—even from the gender perspective—is to be sought on the level of commemoration and memory.

In this realm, it is interesting to note the testimony of Manya Shochat, repeated on several occasions, concerning the circumstances of Drachler's arrival in the Upper Galilee toward the end of 1919:

> I remember that at that time I was at Tel Adashim; I was responsible for organizing the dispatch of youth to help. And then Devora Drachler, of blessed memory, came to me. I said to her, "You don't know how to use a gun." She said, "Someone else will use it; I'll cook." I knew that she was in love with a boy who had left her [Hashomer member Shmuel Hefter], and I asked, "Devora, do you want to die?" She said, "No! I want to live." I knew [then] that I could send her, because only someone who wants to live is suited for defense.[11]

Through the agency of Manya Shochat—the woman most closely identi-fied with sacrifice for the sake of the homeland during the Yishuv period, Drachler's name was connected with the legend embodied in the words bequeathed by the dying hero of Tel Hai, Trumpeldor, "It is good to die for our country," along with the symbolic and ethical treasures bound up

with his memory and his legacy in Zionist ideological education. Thus, a direct connection was forged between the woman, fighter, heroine, and casualty, and the very essence of the ethos and legend that were forged at Tel Hai and handed down from generation to generation.[12]

The fact that women were an integral part of this canonical incident in the developing Zionist martyrology—not as widows or helpers, but as casualties of the battle—was admittedly most unusual. At the same time, from the point of view of the routine life of the pioneers, as reflected with great emphasis in innumerable books of memoirs by the women of Hashomer, the event at Tel Hai was simply an extreme example of a reality that was not so unusual. After all, in the past, too, pioneer women had encountered situations involving mortal danger as a regular part of their life in the outlying areas—Metula, Hamra, Tel Adash, and elsewhere. The deaths of Drachler and Chizik marked the point of departure—theoretical, abstract, and elusory, but also convenient, tangible, and undeniable—in the general consciousness concerning the question of the presence of women on the fighting front. This particular battle had commenced suddenly, with no prior planning, but the danger involved in staying at Tel Hai was known to all prior to the battle, and without any connection to the manner in which it erupted and was played out. The deaths of Drachler and Chizik did not change the reality of the Yishuv in terms of women's involvement in the sphere of guard duty and defense, but there was a new dimension of legitimacy to their commemoration in a sculpture created by Yaakov Dov Gordon in 1924, "The Galilee and Its Women Guards." The sculpture, which stood for decades below the room in which Drachler and Chizik were killed, showed the two young women standing firm and proud, holding rods displaying Stars of David as the symbol of national heroism. The sculptor sought to represent the "young Jewish women who fought and gave up their lives for the Galilee, conquered it, and handed it over to the Jewish people."[13] The artistic world of images was, in this respect, far ahead of the concrete reality in which there was a general, all-encompassing hesitation to include women in security activity beyond the realms of administering first aid, transporting weapons hidden beneath their clothing, and conducting routine agricultural and household activity to camouflage and hide military training exercises. Jabotinsky nevertheless offered his warm thanks to the Women's Union for Equal Rights for the "great assistance of the women and girls to the defense of Jerusalem" during the riots of April 1920, "and during our internment they cared

for us like mothers and sisters." Rosa Cohen, Rachel Yanait, and Manya Shochat made their own unique contribution in Jerusalem and in Jaffa during those riots and in those that broke out in May of the next year. However, the general preference was to direct the "new Jewish woman" to develop her unique essence and contribution to the realization of Zionism in other social, cultural, and economic realms.[14]

At the same time, there was an intensifying trend among the central figures within the women workers, most prominent among them Ada Fishman, to aim their energies toward separate activity from the men. One main reason for this was the founding meeting of the Histadrut (General Workers Union) in December 1920, in which only four women were elected (Yanait, her sister Sara Lishansky, Leah Meron, and Shochat), along with the eighty-six men, to represent their parties. All four were members of the Ahdut haAvoda party (of the party's thirty-seven representatives). The Ha-Po'el ha-Tza'ir party, which in an unprecedented move had called upon its members on the eve of the elections to the founding meeting to elect "suitable women representatives," had failed to include women among its twenty-six representatives. The women's rancor over their poor representation led to the founding of the Women Workers' Council as a body within the General Workers' Union, and its first conference took place on March 27, 1921. The other major reason for the separatist move was the tendency of the leadership of the developing workers' party, including Malkin, Fishman, and Yanait, to lessen their involvement in the politico-organizational sphere and invest their main energies in professional training in agriculture on women's farms and training farms.[15]

Far removed from all this turmoil, on July 14, 1921, there arrived the most prominent woman member of the Third Aliya—and perhaps of all Zionist women of the twentieth century—Golda Myerson (Meir), who would find herself at the helm of Israel's security decision-making forty-eight years later. During her early years in Palestine, she lived in Kibbutz Merhavia, worked in the chicken coop and in the kitchen, and aroused the ire of her colleagues when she wondered aloud, "How is it that women members [of the kibbutz] are happy to feed cows, but miserable when they have to feed their [male] colleagues?" This comment rankled for some time, Meir recounted in 1960, for it "undermined the theory" of the women workers movement in Palestine, but eventually she acknowledged that had the women been guided by this "simple logic," "it is doubtful whether the women workers would have attained

for themselves the position that they did."[16] She soon joined the Ahdut HaAvoda movement. In her public activity she was unique in a femininity that combined a gentle, kitchen-style motherliness with a stern, determined approach in her rhetoric—a combination that she managed, in her unmediated and sentimental way, to transform into a political asset that was at once inspiring and awesome.[17] The first among the leaders of Ahdut HaAvoda to be drawn in by her charms was Yitzhak Tabenkin, as reflected in the captivating description by Yehuda Shertok of the second Histadrut conference, which took place in February 1923:

> Golda Myerson is a creature of grace, and brings glory to the Ahdut Ha'avoda. Her attire is not like that of Hayuta Bussel or Rachel Yanait. [. . .] She dresses simply—but nevertheless wears an embroidered collar. She stands upright [. . .] and her lips move and her voice is heard and her eyes gaze directly. Drop your gaze to her feet, and then look again at the audience. Silence reigns in the hall. [. . .] Tabenkin radiates pride and basks in her glory but . . . it is too late. She is married.[18]

Hayuta Bussel, one of the founders of Kevutzat Degania and wife of Yosef Bussel, Degania's most central figure, described at that conference the difficulty of severing with the past in terms of the place and status of women within the family and social framework—a difficulty that had troubled the pioneering women from the outset.[19] She commented on the fact that in the census of members carried out by the Histadrut, the workers had been asked to note the country of origin of their father, not their mother. The resulting clamor among the women was answered with the claim that this was merely a "formality." Actually, this formality, included in the questionnaire in such a seemingly incidental and unthinking manner, testified better than endless speeches to the barrier facing the "Hebrew woman worker in Palestine," as the item was defined on the conference agenda. Despite the encouraging vision of a new relationship between men and women, the day-to-day operations of the Histadrut promised women only the status and role that had traditionally been reserved for them as the "helpers and armor-bearers" of society.[20] This patriarchal normative gender view prevailed also in the Hashomer Hatzair movement, whose members had begun arriving during the Third Aliya and achieved special prominence in the collection of essays, titled *Kehilatenu*, created by the movement's first pioneers in Beitania.[21] Even

where women were formally recognized as possessing equal value and rights, as in the Gdud Ha'avoda, Manya Shochat nevertheless remained almost the only prominent woman activist within the all-encompassing communal social framework—both aboveground, in Kfar Giladi and in the institutions of the Gdud, and underground, in the secret "Ha-Kibbutz" security body that had been established by former Hashomer members as a covert framework distinct from the Haganah.[22] The prevailing attitude toward women's work in the kibbutz, regardless of the various movement frameworks established during the second half of the 1920s (Hakibbutz Hameuhad and Hakibbutz Ha'artzi in 1927; Hever Hakevutzot in 1929) or the real and physical contribution of the women to the realization of the pioneering dreams, is expressed best in a popular saying quoted by Fania Artzi of Kevutzat Kinneret: "You can live with a girl, but not build with her."[23] Obviously, the idea of women as partners in defense was even further from their minds.

In an article that appeared a year after the events at Tel Hai, Alexander Zaid defined an aim for women's labor in the agricultural settlement enterprise, drawing a comparison with Germany during the First World War, where the women maintained the work in the fields, and Russia, where "the Cossack women managed the entire economy themselves. Admittedly, the Cossack women are physically stronger than our women, who grew up in the Diaspora: Jewish women who are urbanized, weak, short, narrow-chested—but the rural Yishuv should strive for its sons and daughters to be strong in body and in spirit." This would take time, Zaid acknowledged, but if the women remained "within their traditional spheres of work," nothing would ever change.[24] The shining example of women's military service at this time took the form of some 66,000 women soldiers among the ranks of the Soviet Red Army, which was waging a civil war in the wake of the Bolshevik Revolution. Fifteen percent of these women served on the battlefield, inter alia out of a belief that their military achievements would help shatter gender stereotypes and help to achieve equality between the sexes. The dominant approach among the Bolsheviks, however, was that the inclusion of women in the war was a temporary necessity that should not be nurtured on a long-term basis. In Bolshevik propaganda, the women's war contribution was usually presented in quite un-radical terms as an expression of the support of "women and sisters for the heroic soldiers of the Red Army." At the same time, women were gradually pushed out of the positions of influence they had held in the internal political hierarchy during

the period of underground activity that preceded the revolution.[25] Years later, at the height of the Second World War, Bassewitz—a product of this Soviet reality—expressed her wonder at the "healthy instinct" and vision reflected in Zaid's worldview.[26]

Bassewitz Expression on
Gender, Individual Needs, and Guard Duty

Lilia Bassewitz was the most prominent—not necessarily the most important or the most influential—feminine figure in Ein Harod, and she chose to place the "question of the women" at the focus of her political and social activity. I regard Bassewitz as one of the first women in the history of Hakibbutz Hameuhad to view the political sphere as a preferred arena for public activity, and it is from this perspective that I wish to analyze her views and actions. She is perhaps most accurately described in terms of "public activism" or "representation." As noted, research into the unique contribution of women affiliated with the labor movement in molding the different aspects of the Jewish woman in Palestine, her struggles, tribulations, and achievements, is constantly expanding. Books have been written on Hanna Meizel, Rachel Katznelson, and Miriam Baratz.[27] To some extent, our research here represents an addition to this corpus, but our emphasis here is not necessarily the biographical aspect, but rather a highlighting of Bassewitz's approach and path as indicators of major junctures in the molding of feminine gender identity among kibbutz society and as shaping the way in which women were perceived. The kibbutz movements included women who were better known and more influential: examples include Hayuta Bussel in the Hever Hakevutzot, Bat-Sheva Haikin and Huma Hayut in Hakibbutz Hameuhad, and Emma Levine-Talmi in Hakibbutz Ha'artzi. Nevertheless, although Bassewitz was not a senior politician in kibbutz life, she was the figure most clearly identified with a consistent, systematic, sustained battle over the status and involvement of women in kibbutz society during the period from the mid-1920s to the mid-1940s.

Some sort of indication of her formal status is reflected in Bassewitz's ranking on the eve of the national elections for Histadrut institutions: in anticipation of the elections for the fourth Women Workers Conference, which gathered at the beginning of 1932, Bassewitz was in fifth place on the Mapai list. Ahead of her were Ada Fishman, Rachel Katznelson,

Rachel Yanait-Ben-Zvi, and Hayuta Bussel. In other words, Bassewitz was the most senior representative of Hakibbutz Hameuhad and—no less important at that time—the highest-ranked woman who had not been part of the Second Aliya. In the elections after the establishment of the State, Bassewitz was ranked in 123rd place on the Mapam list for elections to the 7th Histadrut conference, with another fourteen women ahead of her.[28] Like other political figures in the Yishuv, Bassewitz left no special mark during the struggle against Britain and in the establishment of the state when she was relegated to the lower ranks of the political system.

Lilia Bassewitz, born in Ukraine in 1900 to a wealthy family, was educated at the Faculty for Cooperatives of the Institute of State Economy in Krakow. In 1920 she joined the Zionist-Socialist Party, where she met her future husband, Reuven (Vinia) Cohen; the couple married in a civil ceremony in 1923. They moved to Palestine in 1924 with the beginning of the Fourth Aliya.[29] Vinia, an agronomist, was initially advised to acquire some practical experience at the agriculture school in Mikveh Yisrael, but the couple made their decision unequivocally. As Bassewitz declared, "Ein Harod is the center—not Tel Aviv." She viewed Ein Harod as a socialist-Zionist cell, and it was as such that she sought, in time, to bequeath it to the next generation.[30]

The principal tools through which Bassewitz sought to advance her objectives were the internal kibbutz media: the newsletter and the journal. Not all of the kibbutzim in the 1920s and 1930s shared an awareness of the importance of such internal organs of communications. Yehuda Gothelf, a member of Kibbutz Ein ha-Horesh and later the editor of *Davar*, maintained that "The internal newspaper should be the bread and butter of every kibbutz," but this was not widely upheld.[31]

The striving to create an equality that was not mechanical but rather of the sort that would aspire to have every individual achieve his maximum potential for the benefit of the community as a whole was a desire of Bassewitz and her colleagues, who wanted to create a communal framework in which women would enjoy equal self-expression. For them, the question of whether the publication of the newsletter would remain a "sole flash of lightning" depended on the degree to which people would commit themselves to realizing the aspiration for self-expression and on the degree of will and ability to put this vehicle at the service of the aspirations of women in kibbutz society. In contrast to the dominant masculine perceptions prevailing in the workers' press, Bassewitz made skillful use of the media most easily accessible within her movement to

advance and reflect its social view of the differences between the sexes within kibbutz society.[32] She was perhaps "too intelligent," in terms of the perceptions of that time. However, thanks to her ability and her involvement in writing the underground newsletter produced by the Kiev branch of the Zionist-Socialist Party, Bassewitz was among the first of the political figures on the kibbutz to be aware and make effective use of the press and the advantages that it offered in the exposure, prominence, and success of public campaigns. Her faith in the power of the written word made her the "high priestess" of documentation of the organizations and struggles of women on the kibbutz. Documentation, for her, was a valuable practical and intellectual tool for molding consciousness. In carrying out this "holy task," as she referred to it, which she had taken upon herself,[33] Bassewitz also created a convenient platform for the commemoration of her contribution to kibbutz society in general, and in the nurturing of the involvement and status of women in the public sphere in particular.

In the introduction to an article published toward the end of 1929 in *Divrei Po'alot*, Bassewitz sheds light on her general approach to kibbutz life. She recalls a child who, in response to the usual complaint by the adults of the kibbutz—"You're such bad kids!"—retorted with some bitterness, "Where are there good kids?" Bassewitz offered the same response to the frequent criticism of the kevutzah and its ways. Like the child, she asked, "Where are things better?" We are constantly criticizing ourselves, she noted; we have an endless list of demands of ourselves as individuals and as a group. There is much in our lives that needs improving, but it is essential to see and appreciate the positive aspects, too.[34]

Bassewitz's fundamental position—the necessity of emphasizing the considerable good that existed in the kibbutz—was not just a philosophical approach to kibbutz life; it was also prompted by her position in the political realm. Bassewitz's struggle within the kibbutz cannot properly be understood without taking into account that hers was a struggle "from within." Upon arrival in Ein Harod—known for its ideological, organizational, personal and power struggles, and conflicts—Lilia and Vinia joined the "Ein Harod loyalists" group led by Yitzhak Tabenkin. For the rest of their lives, the couple remained part of the nucleus of what would soon become the leadership of Hakibbutz Hameuhad.[35] Bassewitz's vision for women on the kibbutz was radical and revolutionary by any yardstick—a function, inter alia, of her most central formative experience: the Bolshevik revolution.[36] In Ein Harod she slowly became

absorbed in the physical labor—which was, after all, the most lofty value and the foundation of kibbutz life at the time. Her limited agricultural skills certainly aided Bassewitz in her choice of public, political activity as the realm in which she would make her practical contribution to the realization of the kibbutz ideal, which she believed in with a great and profound passion. Having succeeded in surrounding the travails of her physical labor with a certain splendor, Bassewitz noted that the feeling among her revolutionary friends in the Soviet Union was that young people would be committing a terrible sin were they to invest themselves in their private lives only. She viewed academic study as a value because it awarded those who applied themselves to it the right to be considered worthy public servants.[37] While this aspiration certainly made sense in the Soviet revolutionary context, it became a heavy burden upon arrival in Palestine, where kibbutz society valued education but regarded labor as a greater value, investing it with a measure of sanctity. "Intelligent" was an insult in the reality of Ein Harod. Precious few individuals—Tabenkin among them—were widely regarded as worthy of devoting most of their time to intellectual and public affairs.[38] Bassewitz aspired to follow in Tabenkin's footsteps and to conduct her public kibbutz life, as a woman, in a way that paralleled his, to some extent, but this attracted the ire of many of her fellow kibbutz members. While the process of her acceptance as a member of Ein Harod was underway, Rivka Danit, one of the earliest members, announced loudly: "We don't need learned members; we need practical people!" To Bassewitz's view, practicality wasn't limited to the kitchen, childcare, laundry, and the agricultural activities in which she had engaged in her early days in Ein Harod.[39]

The Connection between Passivity in Public Life and Defense of the Home

During the 1920s and 1930s, the labor sphere was at the center of the pioneers' debate over the women's question. The matter of the lack of work for women in the various branches of agriculture, livestock, and artisanship, as well as the costs involved in training women to work in these occupations, appeared regularly on the agenda of kibbutz meetings. The lack of productive income was one of the signature features of this period of crisis introduced by the Fourth Aliya (1924–1926) in 1926. Its other aspect, of increasingly critical significance as the available women

workers diminished in number, was the preference to reserve permanent work positions (as opposed to temporary or occasional work) mainly for men, with a diminishing of the number of women absorbed into the kibbutz, along with their relegation to such traditional jobs as kitchen or laundry work or caring for children. Such work was looked down on as "non-productive" because it produced no financial income and did not represent the principles of conquering labor, the land, and guard duty. These jobs were consequently regarded as less valuable in a society that glorified the concept of "values."[40] The phenomenon itself was not new and had been manifest over and over, in varying circumstances, since the Second Aliya. The anger toward it and attempts to address it grew and intensified along with the growth and expansion of the Yishuv to the point that it became one of the defining characteristics of the pioneering society during the period of the British Mandate.[41]

Some inkling of the sense of discomfort that prevailed among the members of Kibbutz Ein Harod in view of the special attention devoted to the issue of the women, among the topics on the agenda of the developing cooperative society, is to be found in the first article to be published in the movement's journal, Mibifnim. Addressing the topic of work for women members, it concluded with the following words:

> Let the young women of the kibbutz come—not with complaints about the lack of work on the kibbutz, but rather with tangible requests and concrete proposals for different kibbutz activities and possibilities for organized training. Let them devote themselves to this, and the question of women on the kibbutz will come off the agenda.[42]

Of course, the key here is understanding this "coming off." It expressed more than just a dim hope that a problem in kibbutz life that had a solution—at least, so it seemed—would indeed be taken care of. It also expressed the desire that issues considered more important than this one would become the focus of social relations on the kibbutz, and that the "women's question," raised from time to time because of the helplessness and impatience of the women members, would be removed altogether from the public eye and relegated to the marginal status that it deserved.[43]

Like other pioneering women who sought to integrate into the political system in Palestine, Bassewitz found the preparations for the women workers conferences, which took place every few years, to be a

convenient starting point for her public activity. This was the time of the economic crisis that swept the country with the cutting short of the Fourth Aliya in 1926. Having devoted herself in the past, as a student in the Soviet Union, to eliminating illiteracy, Bassewitz recognized the need to help the weaker groups within society in Palestine, too. In one of her earliest articles, published in *Davar*, she described her experiences as a lecturer at a gathering of the Ahdut haAvoda party in Tel Aviv. The gathering was intended to recruit women who had immigrated from the Caucasus region to register as members of the Histadrut in anticipation of the approaching Conference of Women Workers. Women from these eastern regions had tried in the past, too, to draw the attention of the Histadrut to their problems, but without much success. For instance, *Davar* had reported just a few months previously:

> This morning a few dozen Caucasian women workers arrived at the Women Workers Department of the Labor Bureau, complaining that lately they have no work because the "ladies" are not employing them in housekeeping, laundry etc; giving these jobs instead to Arab women from the neighboring villages "who are healthier and stronger."[44]

Bassewitz, sensitive to poverty and injustice, felt a profound identification with the distress and "terrible loneliness" of the Caucasian mothers of large families from Neve Shaanan Street, who were busy from morning to night with laundry, cleaning, and caring for and educating their children with no institutional support. Brimming with empathy, she quoted in her article what one of the participants at the meeting had said to her at the end: "We live as though with our eyes closed; we need someone to come and open our eyes." She noted that these women did not know Hebrew and that this made life difficult for them; they wanted night classes—and all this they stated "vigorously but warmly, with an eastern temperament." She concluded her article with the question, "Can we find the way to their hearts? Can our organization also encompass all the eastern women in Palestine?" (Years later, all that Bassewitz noted of that meeting in her memoirs was that she had worn a scarf over her head, because the meeting had taken place in a synagogue, and it was this most unusual situation for her, as an avowedly secular woman, that was most deeply etched into her consciousness).[45] The practical political results of that meeting are attested to in the protocol of the Third

Conference of the Council of Women Workers, which took place in April 1926: "Rachel Yanait reads a letter from the eastern members (speaking Caucasian)." The essence of the letter was quoted in the report on the Conference in *Davar*:

> The attitude on the part of the Histadrut towards workers of the Caucasian groups is terrible. The Histadrut offers them no help. There is no work, there is illness, there is an absence of cultural activity. One woman member spoke about the organization of Arab workers, but there are a great many Jewish workers who treat them like Arabs. Workers neighborhoods and other [facilities] need to be organized not only for Ashkenazim, but also for members from the eastern communities.[46]

What is clear is that Bassewitz's rhetorical question had received no real answer. Nevertheless, like most of her colleagues in the movement and on the kibbutz, she too would eventually choose to devote herself to internal social and ideological activity within Ein Harod and similar circles.

In the years to come, Bassewitz would be less and less attuned to what was going on outside of the immediate circle of the Labor movement and opening the eyes of those who, according to her own testimony, had received her so warmly in the Tel Aviv suburbs. It was the women workers' organization, with an emphasis on the kibbutz sphere and the aspiration to improve the conditions and status of its women workers, that would define her social world from this point onward. The Caucasian women from Neve Shaanan, needless to say, were no longer part of her activity. She even demonstrated some degree of scorn toward one of their most typical occupations—housework. Two years after the conference, Bassewitz declared, with arrogant ideological elitism, "It is not our job in Palestine to undertake such work."[47] With hindsight, she prided herself on having been "active in public matters in Ein Harod, in Hakibbutz Hameuhad and in the movement, but I was not a "functionary" in the city—other than short-term recruitment during elections, or to lead seminars of the Council of Women Workers."[48] This manner of conduct, which also characterized other women pioneers who tended toward involvement in public life, was cause for concern among some central urban activists in the women workers' movement. Inter alia, this concern arose from the fact that, as Ada Fishman explained, kibbutz life was perceived as a source of inspiration for the women workers' move-

ment, and the kibbutz frameworks were often more flexible, in terms of the labor market, in their absorption of new immigrants.[49]

Bassewitz first adopted a public position concerning the position of women in Yishuv society in March 1926. Later she noted that she had acquired her awareness of the women's struggle for their rights in the Russian revolutionary movement and that she had arrived in Palestine "completely ready," from that point of view.[50] However, in a letter that she wrote at the beginning of that year to Tabenkin, who had been dispatched by the HaHalutz organization as an emissary to Poland, she reported an offer that she had received to join the Women Workers' Council. She commented, "Lately I have begun to involve myself in the women's problem. I've never in my life engaged in this, and now I've started." She told the leader of Ein Harod (who was himself deliberating his kibbutz future at that time) that she and her husband were receiving work offers outside the kibbutz, but "We tell them no. It's not a question of the [type of] work they're offering us, but rather a question of leaving Ein Harod. That's the only way to put the question."[51] In other words, they did not perceive social-political involvement as an opportunity to leave their kibbutz home and live a life that, from their point of view, deferred to their choice of occupation in the public sphere.

At the same time, the letter shows that Bassewitz had chosen for herself a field of social action she found well suited for the realization of her ability and talents, taking into account the circumstances and reality of life in Palestine at the time. The perception that her activity in women's issues drew on her experiences during the revolutionary period prior to the rise of the Bolsheviks to power had no real basis insofar as direct activity on behalf of and among women is concerned. On a different level, her activity was certainly nourished by the revolutionary way of life, as Bassewitz herself described it later on: "I never imaged that a woman with any awareness could be passive in public life. The reality of the beginning of a revolution forced women to operate in all areas."[52] The struggle against passivity is the key to understanding the manner in which Bassewitz sought to leave her personal stamp on the Zionist and kibbutz enterprise. It is therefore no wonder that the concrete sphere in which she chose to act—representation of women on the public front, following democratic rules—had only a very weak connection with the authoritarian mode of regime that was developing in the Soviet Union during the 1920s. Bassewitz's first attempt at political involvement in this sphere had been made some time earlier following a decision of

the Jewish National Council (Va'ad Leumi) in October 1925 to hold a referendum on the right of women to participate in the elections for the Assembly of Representatives (the elected parliamentary assembly of the Jewish community in Palestine, established in 1920). A column that she wrote, which she meant to appear in *Davar*, was turned down by the editorial board. In her article, Bassewitz decried the silence of equanimity—sometimes accompanied with a smile—with which everyone related to the referendum that was to be held concerning the right of women to vote. She compared it to a medieval debate over whether or not a woman has a soul, and argued that in the twentieth century, this meant "questioning whether a woman is actually a human being."[53] Eventually the referendum did not take place, and in academic circles little is made of the contribution of the workers' camp in Palestine to ensuring the right for women to vote in this critical gathering, and this is perhaps unjustified because of the political power of this sector. For our purposes, however, what we detect here is an initial hint at a field that Bassewitz would ultimately choose as one of the focuses of her activity in the gender sphere—the representation of women in the political system. Her approach was opposed to the dominant trend that prevailed throughout the workers' movement, viewing the integration of women in the labor market as the most important aim, with the right for women to vote occupying only secondary importance.[54] Bassewitz's view in this regard contrasted with that of the senior women in the women workers' movement at the time, such as Fishman and Yanait, who, in view of the economic crisis in 1926—but also in other, more salutary economic times—regarded the women's situation in the labor market as being of primary concern.[55] Moreover, with the appearance of the journal *Ha-Ishah*, someone took the trouble to note with a hint of pride, in the *Doar ha-Yom* newspaper, that while women had comprised only 4.5% of the representatives in the Assembly of Representatives elected in 1920, in the second Assembly, recently elected, "the women had achieved a complete victory," with "25 representatives, translating into 11.4 percent."[56]

Of special relevance for our discussion are the data pertaining to the Labor movement. At the first Assembly of Representatives in 1920, there were only 7 women among the 111 representatives of the Ahdut ha-Avoda and Ha-Po'el ha-Tza'ir parties (6.3%). At the second Assembly in 1925, 6 women were chosen among the 52 representatives

of these parties (11.5%). At the third Assembly, held in 1931, 4 women were included among the 27 representatives of Mapai, which had been established following the unification of the two parties in 1930 (14.8%). At the fourth Assembly, in 1944, there were 16 women among the 83 delegates representing Mapai and the LeAhdut haAvoda party, which had just split from it (19.2%).[57] The Labor delegation (Mapai and Hashomer Hatzair) to the 21st Zionist Congress, held in Geneva in August 1939, numbered 216 members, 23 of whom were women (10.6%).[58] The picture arising from these data is one of moderate, gradual, but continuous growth in women's representation over the course of this period. At the same time, the underrepresentation of women is integral to the picture, and it was often cause for concern among other elements in the Zionist movement. For instance, Puah Rakovsky, a groundbreaking activist in women's Zionist activity in Poland, lamented the fact that at the all-Polish Zionist Conference in 1925, the 200 delegates included only a handful of women:

> How strange it is that at this time, when in all countries of enlightened Europe and savage Asia—from England, where the women's fight for their human rights began, all the way to primitive Turkey—women are taking their place in national councils and parliaments, at this very time our own conferences have been emptied of women delegates, and they are nowhere to be found.[59]

A similar phenomenon characterized the workers' camp in Palestine. Hayuta Bussel noted that "even the most intelligent and advanced women members would hold back when all the members gathered together to discuss various questions that pertained to their [the women's] lives." To her mind, the solution was to be found in the insular model that had led to the establishment of the Women Workers' Council: organizing periodical separate women's meetings and conferences "to discuss separately all the issues, to assume responsibility, and to try to carry it out."[60] It was the challenge of dealing with the problem expressed by Rakovsky and Bussel—the need for political involvement by women, and the need for women to overcome their silence in the public sphere and their resulting passivity—that occupied Bassewitz from the mid-1920s until the end of World War II.

From 1929 to "the Third"

The articles of association of Kibbutz Ein Harod, consolidated in September 1923, included the following: "The kibbutz sees to the fitness and self-defense ability of all [male] members and female members." In the updated formulation of the articles, passed by the second extended council of Kibbutz Ein Harod in September 1924, the words "and female members" were omitted, but then reintroduced in the articles approved by the same body in May 1925. Notably, the only mention of gender distinction in the articles of association concerned the realm of defense.[61] It is not clear whether the matter of including or excluding the mention of women in this regard arose from controversy over the wording of this section, which was decided first one way and then the other, or whether it was simply a matter of semantics (because the word "members" covered women too), with the 1924 version aiming to eradicate any possible distinction in terms of rights and obligations between men and women on the kibbutz. What is clear is that, other than the definition of self-defense as one of the foundations of life on Kibbutz Ein Harod, which later became Hakibbutz Hameuhad, and the fluctuations concerning its application to women members, the subject did not play any major role in the life of the kibbutz until the 1929 riots.[62]

The deadly rampages that took place during the last week of August 1929 brought the national conflict between Arabs and Jews to Ein Harod, too, in a most immediate and tangible way. The violence, which first broke out in Jerusalem following a dispute over prayer at the Western Wall, spread the next day throughout the country and caught the outlying communities in the Jezreel Valley unprepared.[63] For the residents of Ein Harod, who, for the most part, lacked any direct exposure to the conflict and had experienced it mainly in the form of reports that reached them (whether in Palestine or while still in Europe) concerning the Second Aliya immigrants and the riots they had seen in 1920 and 1921, this was a formative collective experience. Information about the movement of a Bedouin tribe, some 1,000 strong, moving toward Ein Harod on August 24 led to an all-out mobilization of kibbutz members for what they perceived as a genuine physical, existential threat. At the time, the kibbutz was in the process of moving from its original location, close to the Harod Spring at the foot of the Gilboa mountain, to its permanent location just a few kilometers away, on a hill adjacent to the Arab village of Kumi. At the suggestion of Sturman, who was the

most senior security figure in Ein Harod, about a hundred people (sixty children and babies along with nursing mothers, caregivers, and parents) were moved on August 24 to Kumi Hill and housed in a cowshed, which had been evacuated for this purpose, and in concrete structures whose construction was not yet complete.[64] The women were not party to this decision, which impacted directly on their personal fate and that of their children. Yehudit Idelman shared her feelings on being denied the basic right to share in this seemingly fateful decision:

> When you [as a woman] ask about the situation, your male colleague gives a comforting response, as he would reply to his little girl. For we—the women members—must be treated carefully, with concern for our health, our nerves, so that we will be able to keep up our spirits.[65]

The women's sense of being viewed as creatures devoid of independent will and opinion, incapable of defending themselves, and of no use to consult with in the face of danger was exacerbated by the profound resentment felt by some of the mothers in view of the fact that a whooping-cough epidemic was raging, and housing healthy children together with those who were ill increased the danger of contagion. A few days later, when the danger had passed, the children and their escorts returned. Looking back on the episode, Lavi wrote: "We have passed a different test—not one that entailed heroism at war, but one that was more challenging than the battlefield. This test concerned mainly our women members and the children."[66] While courage in battle was not part of the Ein Harod experience, grappling with the difficult decisions occasioned by war certainly was.

Tabenkin, who regarded the 1929 riots as proof of his long-held conviction that the Jewish-Arab national conflict over Palestine would inevitably have to be resolved through force, penned an article at their conclusion in which spoke out forcefully against the prevailing attitude toward women in Ein Harod. He defined the downgrading of the women's status as full partners to one of passivity as "a disgrace to society, and a disgrace of non-fraternity among us." He argued that this was a mode of conduct that undermined and endangered the very existence of Hakıbbutz Hameuhad. It represented a severe violation of the value of "the collective," which was one of the main ideological foundations that he sought to inculcate in the movement, with the aspiration of

including any individual ready to join its ranks and expressing loyalty to its values and the realization of its mission and objectives. Within this sort of framework there was no room for any distinction between men and women, because "masculinity" and separation of the sexes on the basis of physical and traditional traits was not intrinsic to the willingness or capability of the individual—any individual—to exert devoted efforts to achieve the goals of the collective. He therefore believed that "fear, hysteria, physical and mental weakness are to be found among all of us—and likewise courage, heroism, and strength; and there is no justification for a separation of sexes in the defense ranks." As someone who viewed pioneering settlement as the key to solving the dilemmas of Zionism, he regarded what happened within this society as the clearest indicator of the Labor movement's direction in the realm of defense. Tabenkin concluded that part of the lesson to be drawn from the lapse of proper preparation by the Haganah during the riots was the need for a change in the status of women in this realm. He believed that it was essential that women be integrated into the defense system, with a view to extracting the maximal and optimal benefit from the manpower at the disposal of the Yishuv, as well as a means of highlighting the dimension of a common fate in Jewish survival in the land.[67]

Among the members of Hakibbutz Hameuhad, the most prominent standard-bearer of Tabenkin's vision concerning the integration of women in guard duty was Sarah Blumenkrantz, a member of the kibbutz neighboring Ein Harod—Tel Yosef. She had had her first experience of guard duty at Moshav Ein Hai (later to become Kfar Malal) in 1923, where she had stayed along with her kevutzah (collective agricultural group) during their period of training. Blumenkrantz's demand to participate in guard duty as part of the fulfillment of the ideal of equality between men and women in kibbutz society and of the structuring of the woman's egalitarian and independent status, as historian Deborah Bernstein puts it,[68] was not widely shared, but at the same time was not without precedent. Anda Karp (Ya'ari), for example, had demanded in 1920 that she be permitted to participate in night guarding of Beitania Illit. Despite the opposition of her kevutzah colleagues, Meir Ya'ari arranged for her to perform guard duty—but then, to be on the safe side, hid himself in a corner to ensure that she would come to no harm. "Anda returned from guard duty tense and shaking, and from then on made no further demands for equal rights in guard duty." (As recorded by Ya'ari's biographer, Aviva Halamish.)[69] Blumenkrantz showed greater determina-

tion in this area. With the approach of her turn for guard duty in Ein Hai on the night of November 2, which was already more tense than usual owing to the symbolic importance of the date, some of her fellow moshav members decided to play a practical joke: they removed the inner parts of the rifle that was supposed to be given to her and planned to scare her. But they overslept, waking only after her guard duty was over. They ended up startling the guard who relieved her, because they were sure that it was Sarah who was guarding the moshav. The guard tried to shoot in their direction, but the rifle—of course—did not fire. The next day, the schemers proudly recounted their joke all over the moshav. Blumenkrantz was bitter and angry, for even though the silly prank had mistakenly targeted someone else, "it was a genuine expression of the scornful attitude on the part of many kevutzah members towards the most hidden and daring dreams of the women members." During the 1929 riots, Blumenkrantz was entrusted with cooking for the guards and the Tel Yosef members who were awake at night, "as though I was thereby paying my guard-duty dues," she complained. In the early 1940s she stated that "the kernel of indignation that was sown in [my] heart then, in 1929, sprouted during the events of 1936."[70]

In order for the ground to be ready for the kernel to sprout, to borrow Blumenkrantz's metaphor, there had to be a prior process that would create the proper conditions for this to happen. An examination of this multifaceted process, whose direct connection with security matters was neither apparent nor relevant in the peaceful period that prevailed from this point until April 1936, requires that we shift our focus from the security context to other aspects of kibbutz life. From Bassewitz's unique perspective on the events of these years, the decisive juncture and the crowning glory of this multidimensional process in the gender realm in Ein Harod and in Hakibbutz Hameuhad was the struggle that she led together with her colleague Yocheved Bat-Rachel, with the backing of other women in Ein Harod, in favor of setting a defined quota of women representatives to serve in public bodies. On August 21, 1930, a meeting of the women members of Ein Harod was called, and Bassewitz voiced the demand that the kibbutz spearhead the implementation of the promise of a minimal representation quota for women, just as it had pioneered social innovations in other areas of life. Her demand appeared against the background of the bloody riots of August 1929, during which women had been forbidden from participating in the defense of Ein Harod, and the founding conference of Mapai, at the beginning of 1930, to which

not a single woman had been appointed as an Ein Harod delegate. "The women members," Bassewitz declared, "are mostly themselves to blame for their own lack of activism. The women members do not wish to be elected, since they fear accepting responsibility upon themselves." She argued that the kibbutz council (mo'etzet haMeshek—the elected body responsible for the everyday operations of the kibbutz) did not discuss issues that interested the women purely because of the absence of any proper feminine presence within this body, and that this needed to be remedied by a mandatory allotment of a third of the council seats to women. The women's meeting itself was attended by only ten participants—a fact reflecting to some extent the general unwillingness among the women of Ein Harod to actively push for change. At the general meeting of Ein Harod, which took place a few days later, Bassewitz presented her demand for women to occupy a certain percentage of the kibbutz council seats. Unlike the discussion at the women's meeting, where she maintained that the lack of women's participation was a result of their own passivity, at the general meeting she highlighted the men's lack of faith in their women colleagues and their abilities as the main reason why so few of them were involved in public life. Basse-witz even acknowledged that it was not the matter of representation, but rather the spheres of labor and the tracks for advancement at the various places of work that were a more fundamental problem in the lives of kibbutz women, but she argued that the way to deal with this reality was not by ignoring the unequal involvement of women within public kibbutz life. Her conclusion remained the same: it was essential that there be some formal, artificial, external mechanism to ensure that women would play an active part in the institutions in which decisions on public matters were taken. Rivka Danit argued in response that she, and many other women in Ein Harod, were opposed to a fixed proportion. "We are adults," she retorted, "and are able to weigh things up." To her view, if women members preferred to remain passive, they need not be elected to the council, with its active role, merely because they were women. The debate concluded with a vote of nineteen to nine in favor of the proposal that women represent a third of the members of the kibbutz council on a permanent basis.[71] Unbeknownst to those concerned at the time, the initiative concerning the "one third" accords with contemporary academic findings concerning the representation of minorities at the level of at least 30 percent as an indicator of a sort of "critical mass" dynamic allowing for a qualitative long-term change

in their status. The dilemma as to the necessity of this preset quota, on the other hand, is still subject to debate in Israeli public discourse even today, so many years later.[72]

In September 1930, at the initiative of Bassewitz and Yocheved Bat-Rachel, a similar resolution was passed by the Council of Hakibbutz Hameuhad, and the movement's kibbutzim were offered the possibility of adopting it within their internal institutions. During the discussion that took place prior to the passing of the resolution, Bassewitz emphasized that non-participation of women in public life, which contrasted sharply with their degree of participation in the productive and economic life of the kibbutz, created a situation of "women's subjugation" in this area. For her, the question of whether this situation resulted from men excluding women or from women excluding themselves was of little relevance. The result was the same, and it was essential that a reality be created that would lead to change.[73] Even after the decision was made, the debate surrounding its validity and necessity was not quieted. A few months later, Pessia Gorilik, from Kibbutz Givat Hashlosha, expressed outright opposition to the "quota system," arguing that it was "humiliating" for women, and announced openly that she would refrain from making any attempt to be elected to bodies that operated on this basis. Miriam Shlimowitz of Ein Harod, one of the leading proponents of the "quota system," reported that "there are women members who say, 'I participate in kibbutz work; I feel no guilt over not participating in public life.'" With obvious pain, she added, "this sort of thinking is gradually taking root amongst our community."[74] At the same time, for a brief moment it appeared that something momentous had happened in the social and political life of the agricultural pioneers and that this was a fundamental innovation in the area of gender equality and cooperation. Bassewitz reckoned that women's participation in the kibbutz and movement institutions was a precondition for change in the situation of women in kibbutz society, especially in the labor sphere. Her aim was to create a reality in which even if a woman member "stood stirring a pot of soup," she would feel that this was part of the realization of her destiny. To her view, if the woman was not integrated in public life, such that she was directly involved in the life of the working class and the Labor movement, her sense of "worthlessness," arising from her routine of "housework," would remain entrenched. At the same time, the leading figure in the Women Workers' Council until that time, Fishman, believed that the women workers' movement, like the Labor movement in general, "always

drew its vitality and substance" from the women and men members actually living on the kibbutz.[75] This awareness would become more firmly established with the processes of demographic growth in the kibbutz over the course of the 1930s. Attainment of recognition of the "one third" principle also served as an element in creating an institutional infrastructure to ensure the social status of women under conditions of accelerated demographic development.

On this basis, with a sense of achievement that could serve as a sort of innovative example for the Labor movement in general, Bat-Rachel and Bassewitz initiated the publication of special supplementary booklet of the journal *Mibifnim*, the organ of Hakibbutz Hameuhad, devoted to the subject of women in the kibbutz movement. A year earlier, a special booklet had appeared under the auspices of the eponymous journal of the Hashomer Hatzair movement. This movement was among the most prominent standard-bearers of a political approach that prided itself on moderate political and security views. It had been conceived during the Second Aliya—but in Galicia, not Palestine. The movement was founded in 1913, and at least some of the enthusiasm and vision that motivated Jewish youth in Eastern and Central Europe to join its ranks prior to, during, and following the First World War arose from goings-on in Palestine. Contrary to what one might have expected from a socialist humanist movement, these goings-on did not concern independent Jewish labor or the realm of the Hebrew cultural revival or even cooperative ideals, but rather the prosaic and fundamental sphere of defense. It was the activities of the Hashomer organization, and the booklet *Yizkor* (published at the end of 1911), commemorating some of the Jews who had fallen in conflicts with Arabs from the start of the twentieth century, that gave the Hashomer Hatzair movement its name.[76] Despite this obvious connection, the defense realm was not mentioned anywhere in any of the articles in the *Hashomer Hatzair* booklet that had been devoted to "the question of women and young ladies in our movement."[77]

The key article in the booklet was written by someone who was not even a member of the movement. Rather, it was the introduction by the Soviet professor Anton Nemilov of the University of Agriculture in Leningrad to his book, *The Biological Tragedy of Woman*. Nemilov maintained that this tragedy hindered the attainment of equality between the sexes, and his thesis became one of the foundations of the ideological approach that developed in Hakibbutz Ha'artzi with regard to the status of women. Hashomer Hatzair was exceptional for its time in the openness of its

discussions about sexuality and femininity (including its youth movement outside Israel), regarding this as part of its socialist worldview.[78] Among the slew of articles that appeared in *Hashomer Hatzair*, one prominent contribution was that of Gola Mire, a nineteen-year-old girl who had been active in the leadership of Hashomer Hatzair in Poland. Mire later would become a courageous fighter in the Krakow ghetto and was killed on April 29, 1943. Mire believed in 1930 that there was no need for any theoretical discussion about "whether a woman could become an Einstein, or whether an Einstein-woman would be as brilliant as an Einstein-man." The education of girls, she opined, had not yet reached the stage of clarifying their ability to scale intellectual heights; for the present, it was necessary to deal with the constraints that limited their ability to move forward. This should be done by inculcating in them a "desire to work, a desire to read books, a desire to write (articles or diaries), a desire for social discipline and loyalty."[79] With the courage and daring that she demonstrated at the end of her life, she proved that in the realm of valor and self-sacrifice, "Einsteinism" was certainly not reserved for men alone.

In the Hever Hakevutzot movement, too, not long after its establishment in 1929, meetings were held to discuss "the question of women in the kevutzah." David Swerdlov, a member of Kevutzat HaSharon, located at Ramat David, and one of the members of the Volunteers' Committee in 1918 along with Rachel Yanait, stated at one of these meetings that "everyone knows that this is the most decisive question in the life of the kevutzah." He added that while the household labors were entrusted to the women of the kevutzah, "such duties as guarding and defense are incumbent only on the men. There is a certain division of tasks in life." Miriam Baratz, one of the earliest members of Degania A who worked for some for decades in the cowshed while raising her seven children, wrote in an article at that time that women were living in a deep slumber and apathy in the kevutzah. She rejected the validity of the prevailing custom and discourse in the kibbutz, whereby tasks were divided into those that were "lucrative" and productive and others that entailed only expenses and the offering of services, with the women being pushed into the consuming and dependent roles. If the "women members' issue" was not solved, she warned, "the kevutzah will have no right to exist."[80] Baratz's sweeping and far-reaching statement sat well with Swerdlov's approach only with regard to the awareness that the women's issue was critical for kibbutz life. This fundamental

understanding served to motivate Bassewitz—who, we recall, had difficulty serving in the esteemed and prestigious occupations in Ein Harod—to try, intellectually and through organizational activity, to create solutions that would help to ensure the existence of a kibbutz society in which women would feel that they, too, were anchors.

This was the stated goal of the publication of the aforementioned booklet, *Mibifnim*, which appeared in 1931 and was one of the first topic-booklets of the journal, which was first published in 1923. The formal justification for the appearance of the booklet was the preparation for the fourth Conference of Women Workers, which was due to be held in January 1932. The booklet included two essays by Bassewitz. One reviewed the labor performed by women in the various branches of the kibbutz, and here Bassewitz sought to challenge the conventional view that regarded agricultural labor as the pinnacle of a kibbutz woman's dreams. She maintained that all the various occupations of the women should be considered "productive" and worthy of pride, including work in the kitchen, childcare, and laundry.[81] Her message should not be misinterpreted as a rejection—perhaps as a result of her own difficulties with physical labor—of women's work in agriculture. Some time prior to this publication she had vociferously argued with Enzo Sereni from Givat Brenner, who had described this aspiration as a "childish dream." She asserted, with some pathos, that his attempt to "lock [women] up in the kitchen" harmed the very "soul of the movement" and "endangered the kevutzah as a whole."[82]

Bassewitz's essay, which bore the title "Women Members in Kibbutz Labor,"[83] was republished, with some slight amendments, in *Davar*—but here a subtitle was added: "Based on the Ein Harod experience."[84] Aside from the technical reasons for this addition, no doubt arising from a desire to define the content, the subtitle had the effect of presenting Ein Harod as a microcosm of the situation of women's labor in the Labor movement as a whole. This sat well with the perception nurtured by Tabenkin and his loyalists in Hakibbutz Hameuhad concerning the role that Ein Harod should fulfill in the overall picture of the Labor movement—as a human and collective laboratory, and as the ethical, moral, and practical compass of the workers in Palestine in all spheres of life. Bassewitz went on to deliver the same essay, under the same title—"Women Members in Kibbutz Labor"—as one of the opening addresses at the fourth Conference of Women Workers in January 1932. The privilege of lecturing on this topic before the most senior women's

forum in the Labor movement was a faithful reflection of the status that she had attained by this stage—the climax, as it turned out later, of her political career. In her lecture she developed her view that despite the desire to engage in agriculture, the fact that "only half or a third or a quarter of women members" were actually working in this area required a change in approach:

> It is a mistake that women have, to date, not recognized the reality that the large number of children makes it necessary for a great number of women to be working outside of agriculture. It is untenable for there to be an inequality in the attitude towards different types of labor in the kevutzah.

In other words, some of the responsibility for the negative image of service labor in the kibbutz rested with the unrealistic dreams nurtured by female kibbutz society, which viewed agriculture as the loftiest form of labor. Bassewitz called for an end to the attitude of dissatisfaction toward "housework" (childcare, laundry, kitchen) and positive recognition of its qualities as productive labor. It was her long-held conviction that the solution to the problem of the situation of women in kibbutz society lay elsewhere: in meetings among the women themselves and in their participation in public activity so that "their participation would be not a privilege, but an obligation."[85] It was this sphere that represented the focus of Bassewitz's second article in *Mibifnim*.

The kibbutz, she noted here, seemingly offered women complete equality. The formal and accepted conditions were such that she was permitted full participation in public life. In practice, she acknowledged, men and women members alike had yet to free themselves from many "bourgeois" concepts: "We are not accustomed to seeing women politicians"; "We don't like them" as politicians "and tend to follow their activity with scorn. There is also a feeling that within the family, the man is unhappy if the woman devotes herself to the needs of the public." These were very revealing admissions concerning the innermost goings-on in the kibbutz, penetrating beyond the guise of an equality that was not actually attained owing to the women's passivity, their unwillingness to express themselves in public, and other such trivial arguments that were often invoked to explain the reasons for the paucity of feminine presence in the kibbutz public sphere. To this Bassewitz added the warning that the kibbutz children were absorbing the impression of the women's

absence from public life and internalizing it. This was discerned in the thoughts that they voiced from time to time, such as "Women don't speak at meetings; why do they attend them?" or "Mothers aren't on the Council, only fathers are." One little girl, attending a meeting, nudged her mother and asked, "When are the mothers going to start talking?"[86]

Dealing with the women's silence was what Bassewitz identified increasingly in the years to come as her main mission in kibbutz life. Her view of the importance of women's representation in public forums spread in a very limited way and made little impression even among her colleagues. For example, in a meeting between the leadership of the Women Workers' Council and members from the Jezreel Valley region, held in Nahalal on May 8–9, 1931, Rachel Katznelson omitted this issue altogether from her opening remarks, which presented a broad survey of the range of tasks that the Women Workers' Movement set for itself. Golda Myerson, who served at the time as secretary of Mapai, actually attacked Bassewitz's approach quite vehemently: "We should also not agree to the special distinction between men and women members in the public sphere. It is unthinkable that woman members should be elected not on the basis of their personal qualities, but rather because the number of women members *has to be* such-and-such percent." She complained that during the two years that had passed since the 1929 riots, which had been characterized by vibrant participation of kibbutz members in political debates, women members had refrained from making their voices heard. Bassewitz asserted that the paucity of women's representation in party forums resulted not from anyone's objection to their entry into public life, but rather from their own unwillingness to do so. Bassewitz, who received no support whatsoever from the participants in the discussion, in the face of this criticism coming from the most senior woman politician in the labor movement, yielded at the end of the meeting that "there is no need, at election time, to compare the weight of the women members to that of the men members."[87]

At an internal women's meeting held in Ein Harod on November 13, 1932, the speakers likewise preferred to focus on labor issues and the lack of recognition of the women's contribution to the economic life of the kibbutz and refrained from attaching any real value to participation in local public life.[88] And thus, as the initiative to encourage women to play an active role in public life made its very slow progress, arousing a fair degree of incredulity and scorn among the ranks of Hakibbutz Hameuhad and its sister movements, such as Hakibbutz Ha'artzi,[89] Bassewitz shifted

her focus over the course of the first half of the 1930s to some of the more prominent defects of kibbutz life at the time.

At the meeting of the Council of Hakibbutz Hameuhad in mid-1933, Sarah Blumenkrantz, from Kibbutz Tel Yosef, stated that she did not believe that kibbutz society would be a "just society" unless the "question of women members of the kibbutz" was addressed. She angrily asked why, in the socialist society that was created in the kibbutz, women members were always working in a more difficult work environment, with minimal sanitary conditions, and why the branches in which women members were employed had the lowest level of technical sophistication.[90] Her words met with no response, and the frustration that she expressed received no attention whatsoever in the resolutions passed at this Council meeting.

The Place of the Individual in Kibbutz Society

During the relatively tranquil period that separated the riots of 1929 from the bloody clashes of 1936, the initiative to provide women with defense training was relegated to the sidelines. Hakibbutz Hameuhad, as the chosen avant-garde executive arm of the Labor Union (Histadrut Haovdim) and Mapai, devoted most of its efforts during these years to absorbing the Fifth Aliya. Ein Harod, which prided itself on being a "large and growing kibbutz," bore the social burden entailed in broadening the ranks. During this period, a third of the members of Hakibbutz Hameuhad were living in tents or lacked any place of their own at all.[91]

A fundamental question the kibbutz had grappled with since its inception concerned the desired standard of living in terms of ideology and kibbutz reality. In the ongoing debate about satisfying the needs of the individual, asceticism was rejected in principle, as noted by historian Henry Near, but there was a certain unspoken agreement concerning the need for frugality for the time being. In the earliest days of Hakibbutz Hameuhad, in the late 1920s, Enzo Sereni and Bassewitz had stood as two of the movement's most prominent proponents of raising the standard of living—both as a legitimate need of the individual on the kibbutz and as a positive social factor that would help in the absorption of new members and diminish the phenomenon of members leaving the kibbutz.[92] This approach toward kibbutz reality did not always sit well with the general task-oriented mobilization that was among the fundamental elements in molding the worldview of Hakibbutz Hameuhad and that was based, inter

alia, on the members immersing themselves in labor and in the creation of the kibbutz and socialist-Zionist economy in Palestine. The women, in particular, suffered from the deficient physical conditions. Bassewitz maintained that this immersion in labor devalued social activity on the kibbutz and, in particular, eroded the value of the individual, who had to maintain a private life within the collective kibbutz system. This was clearly visible, she noted, in the fact that after work hours, "It's as though we're all walking around in uniform (even if that uniform is of our own style—a 'halutzkah' (dress with puffed short sleeves) or pinafore for the girls, khaki pants and a white shirt for boys)."[93] With the arrival of the Fifth Aliya, Hakibbutz Hameuhad became a "huge camp, split between those on their way in and those on their way out." Thousands joined, but many hundreds left after a very short time. The prevailing atmosphere of constant change made it difficult for those seeking to settle down in a home that would replace the one they had left behind in Eastern Europe.[94] In sketching the character of the socialist-Zionist project at the time, Bassewitz defined it as a "faceless endeavor," one that was being carried out by masses of anonymous people:

> The individual who realizes [the Zionist vision], although he invests considerable inner energy in bringing about the great transformation in his life and in his essence—to become a Jewish laborer—and undergoes profound experiences, he himself remains hidden. The enterprise, with its great national and human power, overshadows the individual and sometimes blurs his value, as it were. And the individual is in great danger of becoming a faceless soldier.[95]

As Bassewitz saw it, the lack of attention to the life of the individual on the kibbutz stood in complete contrast to the fact that the kibbutz, as a society, aspired to create a new life in every sense and in every sphere: "We tell a person how he must live, how he must conduct himself in life, how to live a life of labor and culture"—while the private sphere was being relegated to an inferior status.[96] One of the main areas in which the apathy toward the individual in kibbutz life was most acutely felt was the matter of housing. Berl Katznelson had noted as early as 1918, in his programmatic speech, "In Anticipation of the Period that Awaits," an increasingly routine phenomenon in the life of the workers' camp in Palestine: "The most radical frugality is always practiced in the

realm of housing. [Improved conditions here] are always postponed for 'when we expand.' And for the time being, they manage, 'somehow.'" This situation, he maintained, "leaves its harsh impression on all of life in Palestine."[97] Bassewitz addressed this problem in the best known of all her essays—unquestionably one of the most poignant and heart-wrenching essays written over the course of the century of the kibbutz's existence: "*Shelishi*" (the Third). In preliminary consultations that preceded its appearance, Tabenkin expressed his concern regarding the publication of the essay.[98]

The genre of essays was popular at the time as a means of sharing an individual, subjective experience that was perceived at the time of its occurrence as expressing and representing the "collective soul" of the kibbutz system.[99] The essence of Bassewitz's essay was a pain-filled description of the human situation in which a couple living in kibbutz society tries to conduct their intimate relations while being forced to live in one room together with another person ("the Third") with nothing but a cloth divider between them—and all this in service of the command to absorb immigration and increase the population living an egalitarian Zionist-socialist life on the kibbutz. The desecration of love is the sacrifice demanded of the individual in order to fulfill the "holy commandment" of absorbing immigrants. Bassewitz challenges the potential crossing of this boundary of human life, arguing:

> My land, my kibbutz—I will never betray you; my life here is the epitome of my beliefs; but is this suffering what you demand of me? I shall live only once, and I shall love only once. Will my love always, forever, be so crushed, so deficient? Shall I live always in this distress? I am not myself.[100]

The essay was published under a pseudonym and elicited numerous responses.[101]

The following booklet of the journal *Mibifnim* included an essay on the same topic by Reuven Cohen, Bassewitz's husband, who served at the time as secretary of Hakibbutz Hameuhad. As an experienced professional in the sphere of economics, he introduced his essay with a review of the factual reality of kibbutz housing. Of the approximately 3,600 members of the movement, 400 lacked "human housing" and were living in chicken coops and incubation rooms, above stables and barns, in huts constructed out of woven mats, and as "thirds" in rooms

inhabited by families. Of the 780 families of Hakibbutz Hameuhad, 80 hosted a "third" in their rooms. In other words, every tenth family in Hakibbutz Hameuhad had a "tenant" in its room—whose average size was twelve square meters. Cohen demanded immediate mobilization to construct huts on the kibbutzim because the housing crisis was leading to a situation in which "the new person in our midst is being destroyed; he is suffering needlessly and [ultimately] will move away."[102] It appears that what inspired the couple in writing these two essays was the simple longing for living conditions that would allow intimacy its proper human place within collective life. Seven years later, Bassewitz again addressed the matter of housing conditions, this time at a conference of Hakibbutz Hameuhad, and stated that in this area the kibbutz had descended "beneath the human minimum." She angrily declared that the phenomenon of "the third" and adaptation to a situation in which two families were forced to live in a single room on the kibbutz was degrading, and this represented a failure of the kibbutz for which even the absorption of new immigrants could not serve as justification.[103]

On this occasion she recalled that when she had arrived in Palestine, any youth who wore spectacles was called a "culture-lover," and he usually worked in the groves. Boys with spectacles did not work with the field-crops; there were no "culture-lovers" to be found there.[104] Bassewitz's connection between these two issues—the housing crisis and the place of psychological and emotional experience and expression in kibbutz society—was no coincidence. As she saw it, these were different elements within the same system, which incentivized a focus on labor and production, suppressing and ignoring anything that did not contribute directly to this lofty goal. From this perspective, the scorn for "culture-lovers" and for work in the groves served as symbolic images for the inferior place of gentler artistic, literary, and poetical occupations in kibbutz life as opposed to the "prose that devours us hungrily" in the form of the resilience and strength needed for the prestigious labor in the field crops. As a result, the individual on the kibbutz was often cast into such loneliness that he sometimes felt "as though he was walking in the streets of a large and foreign city."[105] As she saw it, another aspect of the same reality was the fact that the institutions of Hakibbutz Hameuhad could force a certain kibbutz to plant a vineyard or establish a bakery but lacked the ability to force the kibbutzim to allow their members annual leave.[106] This situation was illustrated in an episode that she herself had experienced. One day in 1933, at the

train station in Haifa, she met two friends from a Hakibbutz Hameuhad community in the Judean region who were on their way home from a short vacation that they had spent on Kibbutz Yagur. The two of them had walked on foot from Yagur in the soaking rain and were sitting, shivering with cold, barefoot, and clutching a pita that was to be their meal, waiting for the train to Tel Aviv. Bassewitz, who was active at the time in the Secretariat of Hakibbutz Hameuhad, purchased a cup of tea and some sardines for them with the "public funds" that she was carrying and listened as they told their story. One of them had been in Palestine for a few years already; this was the first "vacation" granted to him, and he had received twenty *grushim* [cents] for expenses—a sum that was meant to cover their travel in both directions as well as provisions for the way. The friends had rejoiced over the rides they had managed to hitch on the way to Yagur, but Bassewitz noted for herself—and later shared with the readers of the Ein Harod newsletter—that "they were so pitiful in their happiness over this, and I together with them. It seemed to me that the God of the kevutzah was burying His face in the ground with shame."[107]

Such a vast chasm separated the vision of creating a "new society," a "new Jew" and the much-discussed bond with the Zionist whole, and the tiny happiness of the waterlogged worker who, even on vacation, found himself in a material situation that did not accurately reflect the economic capacity of Hakibbutz Hameuhad. This reality arose mainly from the ideology of thrift and the task orientation that guided the movement, expressed inter alia in widespread and uncontrolled absorption of immigrants, with most of the resources devoted to investment in branches of production, with no attention to the needs of the individual and of consumption. This ideology was sometimes also accompanied by a somewhat contemptuous attitude toward a person's private life—that which was conducted separately from the movement's ideas, values, and principles. As mentioned before, it was not for nothing that Bassewitz noted, years later, that Tabenkin had feared that her essay "The Third," discussing the problem of housing in the communities of Hakibbutz Hameuhad, "would hurt the kibbutz."[108]

The concern over "what people will say," which characterized kibbutz society, existed in permanent tension—as Bassewitz saw it—with the need to bring about a change in the women's situation, not necessarily in the professional realm, but rather on the level of awareness. She believed that the *Dvar ha-Po'elet* newsletter of the Women Workers' Council,

published under the auspices of the Histadrut, represented, from the mid-1930s onward, a significant tool in the service of this aim. In March 1935, at the end of the newsletter's first year of existence, she wrote:

> While each one of us lives her life in Palestine, as she becomes more involved in labor, in the kibbutz economy, in social life, and in family life—she feels that a new image of woman is gradually coming into being. And with increasing maturity comes increased longing for this image in one's own psyche, and in the psyche of one's colleagues. [. . .] We want to see this new Jewish woman.[109]

Bassewitz believed that "the kibbutz woman is the bearer of the revolution that is transforming the human being in kibbutz life, and she is the symbol of the perfection of a new type of person, who right now is as full of contradictions as a pomegranate [is full of seeds]."[110] This new Jewish woman laborer type of person was not, to Bassewitz's view, the type of woman who aspired to resemble a man, or who denied her maternal tendencies to engage in public activity, neglecting her appearance and ignoring her femininity.[111]

In her soul-searching on behalf of the Women Workers' movement, twenty years after the Conference of Women Workers held in Merhavia in 1914, Rachel Katznelson repeated the thought that she had uttered more than once in the past:

> We were always a movement, and even though we didn't add the word "revolutionary," we were a revolutionary movement. [. . .] Within the Labor Union we weren't suffragettes; our demands were always more in-depth: we focused on labor demands, not on the demand to participate in the movement's institutions.

Katznelson, who had recently taken on editorship of *Dvar ha-Po'elet*, hurried to acknowledge the critical mistake made by the nationwide Women Workers' movement in this regard, adding that in the present, "There is perhaps nowhere among civilized countries" a workers' movement that limited the participation of women members in its institutions as the Workers' Union in Palestine did. To illustrate the point, she recalled that twenty-two women had recently been elected to serve on

the London municipality, out of a total of sixty-five British Labor Party representatives. Katznelson repeated once again to her colleagues, gathered at the tenth session of the Women Workers' Council in June 1934, that the women workers' movement was first and foremost an educational movement, and this was its main raison d'etre.[112] Hence, resignation to deficient representation in the political arena contributed to the inferior and powerless status of women in the Yishuv. In contrast, Beba Idelson, who had served as secretary of the Women Workers' Council since 1931, emphasized that the main role of the body under her leadership was ensuring work for women workers.

In 1935, the Women Workers' Council began commemorating International Women Workers' Day. At the focus of the events, held over April 5–6, was the battle against fascism in Germany, as well as the battle against "Jewish fascism"—that is, Revisionism, which threatened to destroy the achievements of the Labor movement.[113] In the fiery rhetoric arising from the fascist seizure of Austria and sentiment in the wake of the murder of Haim Arlozoroff, the distinctions between political struggle and existential threat became blurred. Both *Dvar ha-Po'elet* and International Women Workers' day were fortified as organizational, educational and ideological vessels during the Fifth Aliya in view of the aspiration to create new channels for spreading the messages of the Women Workers' Council. Although they developed in directions that were not altogether focused on creating a distinct, feminist public sphere, and the radical aspect of their effect in the gender context was thereby diminished, they did serve to strengthen and broaden the foundation for women's involvement in matters that went beyond concern to create income for women and nurtured legitimacy for their participation as an organized and challenging element in matters pertaining to the general community. These aspects would assume critical importance in 1936 in preventing the immediate suppression of the struggle by the women of Ein Harod and its relegation to the narrow confines of a local incident of little significance or value.

Along with "*l'Internationale*" and Hayyim Nahman Bialik's "*Tehezakna*" (*Birkat Am*) that introduced and concluded the regional gathering marking International Women Worker's Day, which took place in Ein Harod on April 6, 1935, there was also a recitation of Nathan Alterman's poem "Don't Give Them Guns" and Rachel's "I Haven't Sung to You, My Country."[114] This demonstrates that there certainly was an awareness of the defense element as one aspect of women's public activity in the Labor

movement. Questions of economic and social equality between men and women were, of course, granted a central place, but the call that echoed among the Communist and Socialist circles in Europe during the first half of the 1930s, "War against war," made itself heard, too. At the same time, Rachel Katznelson saw fit to comment that in recent years there had been a change, which should not be ignored, concerning "equality in war obligations" between men and women. She mentioned Japan and the Soviet Union, where intensified activities were underway to train women to participate in war, "with enthusiasm, with devotion, with a concentration of will." Sadly, she added: "The special logic of history, which knows so well how to abuse us and our definitions, has given a new interpretation to the emancipation of women."[115] She had no idea how accurate her prophecy would turn out to be.

In August 1935, in commemoration of the sixth anniversary of the 1929 riots, *Dvar ha-Po'elet* published an excerpt of Tabenkin's aforementioned article, published in the wake of the Arab riots and decrying the attitude toward women, as well as an article from the same period by Yehudit Idelman of Ein Harod, who protested the practice of not updating women about the security threats that the kibbutz members were facing.[116] The aim in publishing these articles during a quiet time in terms of security threats was not to raise awareness of women's involvement in security matters or to encourage women to join the Haganah. Rather, the aim was to contribute an educational dimension to the revolutionary impact of the women workers' movement on life in the Yishuv alongside its activities in the economic, social, and cultural realms.

On International Women Workers' Day the following year, commemorated in the Jezreel Valley on April 12, 1936, the journal of Kevutzat Huggim (the original name of Kibbutz Beit Hashita) noted that "the car went out for Women Workers' Day, which was celebrated in Tel Yosef. It wasn't full. The rebellion against the Women Workers' Council [the shrinking from organization on a gender basis] and apathy have done their job."[117] At the ceremony, the representative of the Women Workers' Council, Rachel Katznelson, emphasized "our obligation to find a path of rapprochement and help to the Arab women—the primitive and subjugated neighbors living alongside us."[118] It was not only socialist sensitivity that prompted this statement, but also an arrogant paternalism and alienation from the experiences and problems of these "neighbors," who would release their fearsome fury just a short while later.

Some time previously, a first public stirring had made itself heard, calling for profound soul-searching concerning the lifestyle and involvement of women on the kibbutz. It had come in the form of an article published in *Hedim*, the social affairs journal of Hakibbutz Ha'artzi Movement, the first issue of which had appeared in December 1935. The article published in 1936 concerned internal kibbutz matters, but its content testified to growing discontent beneath the surface concerning the woman's experience of kibbutz life. Hela Mozes, wife of Yehuda Gothelf and a member of Kibbutz Ein ha-Horesh, wrote that the kibbutz conducted itself in the same manner as the rest of the world, with the stamp of masculinity pervading all aspects of life. "Women here are merely a sort of numerical addition, devoid of special value." Instead of developing special values for themselves, "they, too, seek that which is regarded as masculine." No free cooperative society would come into existence, she declared, "so long as all its members are not equal and free."[119] The next issue of *Hedim*, published about a month later, included a response of barely concealed glee by Meir Ya'ari, leader of Hakibbutz Ha'artzi, who was closely attuned and sensitive to goings-on in the movement:

> Finally, the women members of our kibbutzim have opened their mouths. They are starting to talk about the bitterness, the longings, and the efforts. From between the lines there emerges a protest—a forgiving and whispered one, it should be said. I had expected a stronger attack, for there are people who deserve to be brought to justice. We're not too late, but what we have caused to ourselves will not be repaired so quickly. 50% of the members of Hakibbutz Ha'artzi are women, and they have been pushed to the margins. Whether the margins are warm or cold is of no importance, for they are dark and unlit.[120]

Ya'ari's image was not selected arbitrarily. In the same issue of *Hedim* that had included Mozes's article, another article had been written by Emma Levine-Talmi, the main social activist in Hakibbutz Ha'artzi and a member of Kibbutz Mishmar Haemek, introduced with the following words: "Light and shadow are wherever we go. Shadow is related to light. Light casts a shadow. And there is an area of life in which shadow casts itself over the light continuously—the question of the woman."[121]

Levine-Talmi noted that although all areas of life in the kibbutz were subject to laws and regulations created by the socialist society, one area remained subject to "spontaneous misfortune," as though "awaiting the Messiah." In the area in question, the ultimate goal was absolute equality between men and women, but no real attempt was being made to connect this lofty goal to the day-to-day reality, and no intermediate "stations" on the path to achieving this aim were established.[122] Ya'ari rejected Mozes's claim (and, by extension, also that of Talmi) that this "misfortune" had befallen the women "only because the men took the power for themselves." As was his custom, he praised the Soviet example, which included women pilots, women drivers of tractors and trains, and women officers and engineers, and he called upon the women of Hakibbutz Ha'artzi to play a more active role: "If a women workers' movement can exist in Russia, perhaps our women members could let go of some of their pride and take their fate into their own hands in our country, too." He proposed that "it would be more productive for them to direct criticism towards themselves" and recommended that they start to play an active role in political life, for then it would become clear that all the "chatter about the narrowness of their horizons and their tragic biological fate was decadent rhetoric."[123] But Ya'ari had conveyed exactly the same message about the necessity of women's involvement at the world congress of Hashomer Hatzair in 1930 and at a meeting of his own Kibbutz Merhavia in 1931.[124] As his biographer, Aviva Halamish, so eloquently points out, even in an area that was so directly open to his influence—the representation of women in the institutions of his movement—he did not translate this vision into action.[125] It remained empty rhetoric. Gothelf, similarly, described hearing from a woman kibbutz member that the status of women on the kibbutz was not just "the fault of the men," but rather the result of the lack of mutual support among the women. The problem was not jealousy over clothes, housing, lovers, or the like, Gothelf hasted to explain on April 15, 1936, but rather a "sublimation of jealousy." Many women tended to respond coldly and with a lack of support and faith to the statements of their fellow women kibbutz members in public, and although they formally supported the advancement of women's status, in day-to-day life they undermined their own self-interest.[126] The time for the empty rhetoric to be filled with real content would arrive suddenly, just a few days later.

On the other side of the of the Labor movement leadership, two episodes from the years preceding the eruption of the Arab Revolt shed

light on the rather gloomy state of women public officials. In December 1931, Rachel Katznelson recorded in her diary a meeting of the Women Workers' Council leadership—Ada Fishman, Beba Idelson, Elisheva Kaplan, and herself—with members of the Mapai secretariat—David Ben-Gurion, Eliezer Kaplan, Yosef Sprinzak, Zalman Aharonovitch (Aran), and David Remez. The meeting addressed the women's issues and was held in anticipation of the fourth conference of the Women Workers' Council. Katznelson wrote:

> When we parted, I thought: We're actually enemies; sworn enemies. And too adult not to know it. Therefore there is no possibility of open discussion as though that which is necessary and important to us should be necessary and important to them, too; as though belonging to the same party can cover over the real relations between men and women. I sat at the meeting and did an accounting of the private life of each of the four women members, and for some reason I had the impression that the others were thinking the same thing: our family frameworks are falling apart. The men were thinking that all is well with them—Sprinzak, Ben-Gurion, and Kaplan; that if things were okay for the four of us [women] at home, we wouldn't be sitting with them now at a meeting. And what was Remez thinking? I don't want to say something that would dishonor the women workers' movement. Because our lives, which have gone off the natural track, have only one appearance in this movement. These are the fruits of (national) revival.[127]

These would appear to be the strongest and most critical words written about women's public activity in Yishuv society as part of the process of the realization of a Zionist vision that included an aspiration to reposition the status of women in society as a whole. For the purposes of our present discussion, the point is that the perspective expressed by Katznelson—that the capability of listening on the human level between men and women in senior leadership positions in Mapai—was lost. The same impression arises from a description of an encounter between the extended secretariat of the Women Workers' Council and the chairman of the Jewish Agency Executive, Ben-Gurion, on February 6, 1936. While the women tried to share their plight with this senior Zionist and socialist

leader, Ben-Gurion gave them the feeling—in the words of Bassewitz—
that "we were a movement living its life in isolation within the general
[Labor] movement." Ben-Gurion's attendance at the meeting had not
been planned; he happened to attend, and his response to the women
was brusque: "Women must not forget the natural inequality between
them and men; the special roles in life which nature has entrusted to
them." Bassewitz noted that his words "did not express opposition to our
position, and we ourselves are not far from understanding what he said,
and yet—the struggle is ours alone."[128] This impression was published in
a special supplement to the newsletter of Kibbutz Ein Harod, of which
Bassewitz had become the editor shortly before the incident took place.
This was the first significant occasion on which she made use of the local
media platform at her disposal to disseminate the women's activity on
a wide scale. The searing but clear conclusion that she drew from the
brief encounter with Ben-Gurion—"The struggle is ours alone"—served,
by chance, as the spark that would ignite the "women's rebellion" in Ein
Harod a few months later and create the foundation for a new perception
of women's contribution to the sphere of defense.

To understand the social reality within which there raged the
debate of women's participation in guard duty in Ein Harod in 1936,
it is necessary that we take into account two of the prominent charac-
teristics of the kibbutz's public life: a sense of select chosenness and an
urge to debate and argue. These lines had been drawn by Bat-Rachel
and Bassewitz in 1935—in other words, not long before the controversy
that is the subject of our current discussion, although in contexts that
are unrelated to it. They help us understand the mood and temperament
that usually evade historical documentation, but reflect and delineate
the boundaries of the specific discussion and its significance within the
kibbutz experience. A study of conflict that raged within this system
requires that we recall that this was a social arena that encompassed a
broad range of different aspects and derivatives whose roots were not
grounded in this particular issue. Concerning the dimension of chosen-
ness, Bat-Rachel had written in her diary:

> Once upon a time we thought about a merging and shar-
> ing of intellectual assets among us. This was the idea of a
> non-selective kibbutz: to elevate those members whose lives
> had not offered them possibilities for education and social

development. Are we realizing this principle? Or are there some who are haughty, considering themselves to be "chosen" . . . ? Does all the bitterness and hostility in its different forms among quite a large number of members of Ein Harod not flow from the same source of a sense of inferiority in relation to those who are always chosen, and who are to be found in all affairs: in the kibbutz [the institutions of Hakibbutz Hameuhad], in labor, in society, in the party, in the Workers' Union and in the institutions of the Yishuv, they being the "salt of the earth?"[129]

Bat-Rachel's description indicates that alongside the implementation of the idea of the "larger kibbutz," there developed in Ein Harod the perception that responsibility for various areas of life were gradually becoming the private property, as it were, of certain members, who felt that only they had the requisite level of authority and insight to handle them properly. This applied to the sphere of defense, too, as we shall see later on. To this trend there was added the tendency to argue—the fruit of internal tensions surrounding important ideological issues, as well as matters of everyday routine, which drove Ein Harod three times to the brink of splitting and beyond during the first decades of its existence. One of the explosive issues in Ein Harod during the 1930s was the question of a joint school with the neighboring Kibbutz Tel Yosef. In this context, Bassewitz noted in a private letter:

> In Ein Harod things are heating up over the matter of the joint school. I haven't attended all of the meetings, but people say that there's already a feeling there like there was then [the split of 1923] in Ein Harod. It's so troublesome! What the communal energy and strength is being spent on! If Ein Harod were to invest the same energy that it spends on arguments—an area in which it excels—on positive activities, we would achieve great things. What a terrible waste![130]

Hence, the social reality prevailing in Ein Harod serves as one of the keys for decoding the convolutions of the dispute that raged in the kibbutz when the significance of the changes in the situation wrought by the Arab Revolt began to make itself apparent.

Chapter 4

Kibbutz Women and Guard Duty during the First Wave of the Arab Revolt in 1936

"Women are carrying guns!"—in these words, a mixture of amazement and shock, the children of Kibbutz Ein Harod in the Jezreel Valley described the sight revealed to them in the evening of July 4, 1936. Earlier that evening, the daily newsletter of the kibbutz reported, many men and women members had visited "the first two female guards, Miriam Kelner and Shulamit Zhernovskaya." The restrained style of the report could not hide the festive tone of achievement and success with which this event was perpetuated in the annals of Ein Harod, the Jezreel Valley, the kibbutz movement, the pre-State defense organizations, and the struggle of women for equality and recognition of their status and rights as part of the revolutionary Zionist process in Palestine.

A few hours earlier, Eliyahu Golomb, who headed the Haganah (the main defense organization of the Jews in Palestine until 1948), delivered a lecture in Ein Harod on "The Current Situation in Palestine." Golomb supported the participation of women in guard duty.[1] This was the time of the first wave of the Arab Revolt of 1936–39 (April–October 1936). The inclusion of women among the guards on the 160th anniversary of the American Declaration of Independence—which had proclaimed that "We hold these truths to be self-evident, that all people are created equal"—was a breakthrough, albeit largely symbolic, in the history of Jewish women's struggle in the pre-State period to take an active part in defense and guard activities. They considered it a central component in a broader ideology that viewed women as having equal rights with

respect to the duties and burdens, as well as the rewards, involved in the building of the Jewish national home in Palestine.

The kibbutz movement numbered, on the eve of the Arab Revolt, 10,635 members. Of these, 5,386 belonged to Hakibbutz Hameuhad, about 47 percent of whom were women; 2,835 belonged to Hakibbutz Ha'artzi; and 1,407 belonged to Hever Hakevutzot. By the outbreak of World War II, the Kibbutz Movement had 17,839 members (an increase of about 60 percent in less than four years). Hakibbutz Hameuhad now had 8,687 members (about 46 percent of them women), Hakibbutz Ha'artzi numbered 4,685 members, and Hever Hakevutzot 2,862 members. The three kibbutz movements incorporated, at that time, 117 settlements, 35 belonging to Hakibbutz Hameuhad, 36 to Hakibbutz Ha'artzi, and 29 to Hever Hakevutzot.[2] In the second half of the 1930s, the kibbutz newsletter of each settlement became an important means of expression of the kibbutz experience, because the rapid demographic growth caused a loss of the sense of intimacy among the members, necessitating the use of media that could facilitate rapid, large-scale dissemination of information while fostering the common bonds of social and ideological identity in a period of dramatic events and turmoil. The news items, stories, and editorials published in these newsletters, together with the events that took place every year to mark International Working Women's Day, women's conventions, ideological seminars, and the meetings of the Women Workers' Council, reveal the transformations that occurred in the role of women in security matters in kibbutz life during the Arab Revolt.

The Beginning of the Women's Struggle in 1936

The Arab Revolt erupted on April 19 with the murder of sixteen Jews in Jaffa within two days and a declaration of an Arab general strike throughout the country six days later. The revolt soon spread to the periphery, and the Jewish community felt gravely threatened.[3] Fields, grain barns, and woods were set on fire; trees were cut down; agricultural property was damaged; and people were ambushed and shot at. The spontaneous reaction of the rural settlements, the main victims of these hostile acts, was to allocate more and more members to guarding, security, and being on standby. In Ein Harod, for example, forty-five members (about a quarter of all the members) were stationed every night at various guard posts around the kibbutz. Throughout the kibbutz movement, whenever

there was shooting or fire, the women were usually ordered to gather in the darkened dining hall and the children's houses and take cover under the tables and beds until the all-clear signal was given. The feeling of helplessness combined with the passivity imposed on them made them angry and deeply frustrated. The fact that this experience recurred night after night, for weeks on end, gradually intensified their feeling of being weak and unworthy of sharing the burden of defense alongside the men. This situation was diametrically opposed to the ideal of equality as a fundamental element in the social life of the kibbutz. The situation of dependence in which these women found themselves trapped became the focus for all the frustration they had accumulated throughout their years of communal life with regard to gender equality. They felt as though they had been cut off from their revolutionary Zionist life and cast back to the fate of the timid Jews of the diaspora shtetl against which they had rebelled and from which they had wanted to detach themselves. This frame of mind led to growing agitation among the women with regard to their role during this military conflict, whose end was nowhere in sight. More than anything, they were aggrieved by their male comrades' almost automatic disregard for them, reflecting their doubt in women's ability to play a meaningful role and share the common burden and be of real use in coping with the security risks and challenges.[4]

The standard of rebellion was first raised by the women of Kibbutz Mishmar Haemek (one of the leading kibbutzim in Hakibbutz Ha'artzi). For about two weeks, the kibbutz had suffered repeated attacks and acts of arson, with about 1,500 trees cut down and set on fire. The following item, titled "The Right to Defend," was published in the kibbutz newsletter on May 10:

> Every night we are summoned and shocked by the flames bursting from the midst of the grove [near the kibbutz]. Every night, and sometimes a few times a night, the old Chevrolet crosses the hilly tracks, taking the guys, two and three times, to put out the fire. The firefighters are armed with wet sacks and hoes. A line of defenders stands guard over them. The firefighters' work requires just some strength and a little bit of courage. Women are not part of this rescue operation. They are driven away, when they come to offer some strength and a little bit of courage of their own. This is a time of emergency. It is not the time for arguments by the smoking

flames. The women are left behind, to enjoy the rights of the emperor Nero [watching the fire]—a hard and insulting right. It takes a large amount of discipline and effort to stay passive at such a time. Is it really impossible to let a few women participate in the work of putting out the fire? Is it impossible to arrange and organize that in advance? Precisely now, when we have been given a little respite, for us and for our grove, for us and for our fields, this should be organized. The organizing institutions have distinguished themselves in their action [putting out the fire] this time. With a little bit of understanding and will, they will also know how to put an end to this injustice.[5]

This basic feeling, which gradually spread throughout the kibbutzim, was completely different from the situation that had been prevalent until then and had been accepted even by the activists of the Women Workers' Council. For example, an editorial in *Dvar ha-Po'elet*, published on May 10, three weeks after the beginning of the violence, defined the role of the female members of the Histadrut in those days. The women were called upon to exhibit calmness and self-control in difficult moments, to help the wounded and the Jewish refugees who had fled their homes in Arab towns, such as Jaffa, and to devote themselves to the production of agricultural crops in the farming settlements and to the consumption of products made by Jews. As far as the Women Workers' Council was concerned, women's roles at that time had no connection to the domain of security.[6]

The first barrier preventing women from participating in defense activities was the local guard committee in each settlement, which consisted exclusively of men who were considered by themselves and others as "professionals," with absolute and unquestioned authority in this sensitive and critical area. They responded to the women's demands to participate in guard duty with the following arguments: women are not capable of acquiring the skills needed in order to operate weapons; they are tense and nervous and therefore will not be able to adjust to the stress of a security alert; they lack experience; there is a shortage of women to perform the "female" jobs; moreover, the confidence of the man who is forced to guard with them will be undermined, and instead of guarding his post his attention will be diverted to the need to protect the woman at his side.[7]

To overcome the steadfast opposition of the professionals who were in charge of managing the security sphere—among them Israel Ben-Eliyahu, the commander of Gush Harod, the regional section of the Haganah, and Haim Sturman, one of the veterans of Hashomer and the prominent security figure in the Jezreel Valley—the kibbutz women took advantage of two organizational tools: the prevalent custom on the kibbutzim to hold meetings to discuss problems troubling the members, and the publication of articles and information in the kibbutz newsletters, which were usually edited by women, because this was not considered productive work requiring physical effort. Under the leadership of Eva Tabenkin, the women of Ein Harod adroitly moved the discussion and resolution of their demand to participate in defense activities from the closed bodies of the professionals to the arena of the general assembly. The tradition since the late 1920s of occasionally holding meetings for women only helped in preparing this move. At one of these gatherings, which took place on June 10, Shulamit Zhernovskaya declared that "the woman who came here not as a man's wife, but, rather, as a creator and builder of the economy and society, will not merely resign herself to the passive feeling of deep indignation. This experience, which now encompasses half of the public, has to be expressed and actively satisfied." She asserted firmly that "the absence of women from the guarding front" amounted to demeaning them and depriving them of the right to participate in the resolution of a crucial matter in kibbutz life.[8] Shifting the crux of the controversy over women's participation in guard duty from the security domain to that of socialist-collective principles neutralized the chauvinistic arguments expressed by the members of the guard committee behind closed doors. These arguments vanished on the floor of the general assembly, where ideological tenets, including the utopian vision of a life of equality between the two sexes, had played a central role since the early days of the kibbutz.

On June 14, Mordechai Hadash, a member of Kevutzat Kinneret and one of the main activists in security matters in the Jordan Valley, wrote to Aharon Tzizling, the secretary of Ein Harod (and later one of the founders of the Palmah, the elite force of the Haganah) that "the rebellion of the female members in Ein Harod" was not just a welcome effort to renew the norms of collective life, but also the opening of a new era in the guarding and defense system. Not "the idea of women's liberation," he said, was his main concern, but rather the benefit of training more and more people to bear arms, which also had an

educational dimension, because it meant adapting women to risk their body and soul in acts of defense. If a woman became used to behaving passively during an attack, lying helplessly on the floor, then, when the time came, "she wouldn't accept her son's going to battle. She would protect him with all her strength and with all the means of a loving mother, and pull him, instinctively, down onto the floor."[9] In this case, too, children were the criterion for evaluating women's status woman in kibbutz life, although this time from the male point of view. Defining the events of those weeks in Ein Harod as "a rebellion" was in keeping with the language long used by activists in the Women Workers' Movement in Palestine. For example, in 1933, Ada Fishman, one of the leaders of the movement, who headed a training farm for young women at Ayanot (near Ness Ziona), defined the institution she had founded as "a station of rebellion," which, rather than encouraging women to shirk obligations, trained them to shoulder the burden, assume responsibility for their life, and be involved in the society within which they lived.[10]

On June 22, 1936, the Women Workers' Council sent a letter to various bodies affiliated with it throughout the country (committees of women workers, organizations of working mothers, female members of kibbutzim and moshavim), in which it reported that there was information from various settlements regarding "the small part of women members in guard duty." The council promised to help women in the settlements in their efforts to join guarding activities and called on women in the cities and rural towns to join the semi-underground organizations affiliated with the Haganah (Hapo'el, Hasadran) and assist in public activity as required.[11] Concurrently, the women received the backing of two of the top leaders of the kibbutz movement: Yitzhak Tabenkin of Hakibbutz Hameuhad and Ya'akov Hazan (a member of Mishmar Haemek) of Hakibbutz Ha'artzi. At a meeting of the Executive Committee of Hakibbutz Ha'artzi on May 12, a few weeks after the riots began, Hazan asserted that not integrating women in security activities on the kibbutzim was "a mistake."[12] At the general assembly of Ein Harod in June 1936, Tabenkin mustered all his rhetorical power and social influence to tip the scales in favor of letting women participate in guard duty without delay. To make clear how determined he was about it, Tabenkin sponsored a resolution, which was passed by the extended executive of Hakibbutz Hameuhad on June 29, to convene for the first time ever a special assembly of women representatives from all the kibbutzim of the movement to discuss the work of women on the kibbutz.[13]

Two days later, on July 1, the women of Ein Harod gained their first victory in the struggle to take part in guarding activities when the general assembly of the kibbutz confirmed that two women would participate on a regular basis in guard duty, a third of the members of the guard council would be women, and women would be trained to bear arms.[14] On July 4, the newsletter of Kibbutz Mishmar Haemek reported that it had been decided as of that day to train women for guard duty. On this occasion, the newsletter did not fail to mention that no women had been allowed to participate in putting out the last two field fires.[15]

The achievement of the women of Ein Harod aroused great interest in the contemporary kibbutz press, and with the help of the monthly *Dvar ha-Po'elet* and the backing of the Women Workers' Council, the news spread among women's circles throughout the country. More and more kibbutz newsletters started publishing articles by women demanding their right to participate in guard duty. Thus, a kind of "covert competition" developed between the women of Mishmar Haemek and those of Merhavia (Meir Ya'ari's Kibbutz in the Jezreel Valley) over which kibbutz would be the first to implement the reform. The newsletter of Mishmar Haemek boasted that its women members had joined the guard before those in Merhavia, but at the same time lamented that the latter were guarding not just the living quarters, but also the vineyard outside the kibbutz.[16] While recognizing that the women's struggle had a chance to succeed, Emma Levine-Talmi, a member of Mishmar Haemek, reminded her readers that women had been denied the right to guard and put out field fires "quite spontaneously and as a matter of course." She noted that the question of guard duties was "a new shadow" that "had been added to the other shadows in the life of women on the kibbutz." Connecting the present struggle over guard duty to the wider context, she lamented:

> Every day we realize the "utopia"—the kibbutz. But we postpone the utopia of a life of complete equality between male and female members to a distant future. Our children have a great share in that future. They see everything, ask and wonder: why the fathers, the men, go to put out the fire, and the mothers, the women, are cowards?! Is that so?! Today they just wonder, but, gradually, if they get used to it, they will adapt to it, and everything will become a matter of course, and the grandmotherly [diaspora] style will come back in everything.[17]

Once again, children were evoked in the women's discourse, for it was under their gaze and for their sake that women were called upon to join the struggle for their right to participate in guard duty. Their centrality in the discourse stemmed from the fact that children were generally perceived as the "sacred" crowning achievement of kibbutz life, as living proof that this was the right ideological path and as the justification for the daily sacrifices, and the embodiment of all the hopes for a better and just future.

Not only men opposed the women's organizational activities. Many women also objected to organization on the basis of gender to promote gender-related goals, even though it was meant to change the relations between the sexes and the practices of kibbutz society in general. Disagreement with the proposed changes was expressed with a glance, with silence, or by evading participation in meetings, and, in most cases, without expressing their opinion in a documented forum.[18]

In an assembly of Kibbutz Givat Brenner held on August 8, 1936, one of the members, Geula Shertok (the younger sister of Moshe Shertok), described "the exhausting, futile negotiation" she had conducted with the guard committee of her kibbutz regarding the training of a group of female members for participation in guard duty. She related how she had encountered reactions of disdain, belittlement, and mistrust. The derision and humiliation she experienced in these talks were "strange, distorted, and unesthetic," but "in the flash of gunfire, there is no choice for the weak but to say 'I am strong.'" Not all men on the kibbutz were skilled warriors, she said sarcastically, and wondered: "are there no cases of failure in the realm of the other sex?" From this she concluded that "it is uncomradely, immodest, ridiculous, and pitiful when someone who is weak mocks and disdains someone who is weaker" and stated with barely contained anger:

> I do not want and will not allow others to risk their lives because of me. I forever despise and abhor a life of forced parasitism, a life of charity, not molded by my own hands. I do not want and will not allow anyone, however much stronger and more beautiful than I, to usurp my sacred possessions, to uproot and detach me from my native soil, to trample my love for my homeland, and to block my way to that plot of land on which people determine their fate for life or death.[19]

The assembly eventually decided, by majority vote, to obligate the guard committee "to let the women participate in guard duty and defense posts."[20]

In the neighboring Kibbutz Na'anah (Na'an) a fierce dispute also erupted among the women members over the right to perform guard duty, but, unlike in other kibbutzim, the opposition was openly expressed in writing. A report published in the kibbutz newsletter on August 17 noted sarcastically that "at long last Na'anah has taken a step forward in the war for women's liberation and equal rights and has sent its first woman member to participate in guard duty." The anonymous author recognized the need to train women members to defend themselves but drew a clear distinction between "defense" and "guard duty." Guarding meant ongoing military activity, which demanded physical strength that women did not possess. She argued that women should not waste "all their sharp weapons and heavy artillery of equal rights and social justice and a war of liberation" on the demand for equal participation in military activity merely because of romantic enthusiasm for rhetoric such as "we daughters of a reborn nation know how to conquer our place in all fields of work and life," which in fact stemmed from an understandable and artificial sense of inferiority.[21]

A day before this article was published, Haya Freund of Kibbutz Ramat Hakovesh, not far from Kfar Saba, had been killed while on guard duty. On numerous kibbutzim, the women adopted methods of struggle that had succeeded in Ein Harod, but on Ramat Hakovesh they had carried it to an extreme and boycotted the kibbutz assembly on August 9 in protest against the refusal to allow them to participate in guard duty. Their demand had been accepted. Ramat Hakovesh was the kibbutz with the most casualties during the Arab Revolt, losing sixteen of its inhabitants. Freund, who was shot to death during an Arab attack on the kibbutz on the second night of her guard duty, while she was standing at an observation post on top of the water tower, was the first casualty of Ramat Hakovesh in that period. Speaking at her graveside, Tabenkin declared: "This is not the last victim. Haya'le knew it too. This was what she fought for, already in the second month of the riots. We will be heroes against our will."[22] In her last letter to her brother in Poland, Freund wrote:

> To write to you about our life here, on Ramat Hakovesh? This is a very difficult matter. In the city [i.e., Tel Aviv], for example, you will not notice anything. Some go to the

theater and others to a concert. Different things fill the hearts of many, many people. But here it is different. After a day of work in the burning heat, before we get a chance to see each other, or read a newspaper (let alone a book), it's already dark. You cannot turn on a lamp, and if we cover the windows it is stifling. So we sit in the dark, and wait for the shots. That's the way it is, my dear, and who knows what the future will bring?[23]

Hakibbutz Hameuhad did not regard Freund as an exemplary model of a bold heroine, nor was she an outstanding fighter for women's liberation. Her friend wrote that Freund was not "publicly prominent"; rather, "she seemed average, one of the people." But she refused to stay inside and lie on the floor during shooting, because it seemed to her humiliating and insulting.[24] At the end of the first wave of the revolt, in October, Rachel Katznelson determined that Freund's figure had become "a symbol for the entire movement of women workers," like Drachler and Chizik, who had been killed at Tel Hai. She "was just one," and they "were only two, but we live by this symbol."[25] More than commending the fact that the movement had found a symbol that would give it worthiness and pride, Katznelson seemed to be implying that she was pleased that only a few women had been killed while on guard, expressing her long-standing reservations about the integration of women in security activities.

Esther Kramer from Givat Brenner noted that there were indeed male members who condemned the fear demonstrated by many women, but, she maintained, there were many other women who could carry out heroic deeds just as well as the young Russian women during the revolution and the civil war. "Are we less capable of preparing for acts of heroism than an Arab woman who has not yet removed the veil from her face?"[26] During the Arab Revolt, the Hebrew press occasionally published news about the political activity of Arab women. In June 1936, an article in *Dvar ha-Po'elet* reported demonstrations and processions of women—adults, girl scouts, and schoolgirls—that took place in the cities of Jenin, Tulkarem, Jaffa, Gaza, Nablus, and Jerusalem. In their ardent speeches at those rallies, "ridiculous statements" were sometimes made, "such as that of the Women's Committee of Jerusalem who threatened the High Commissioner with the great danger the government faced from the Arab women joining the battlefield, or the declaration made by one woman at a women's meeting that everyone should be told that

Arab women rocked the cradle with one hand, and the whole world with the other."[27]

At a meeting of the Mapai political committee, Moshe Shertok, director of the Jewish Agency's political department, told the participants that Arab military operations included women—especially Christians—and explained that their participation was "accompanied by all the trappings of revolutionary movements; they are drawn by the magical aura of conspiracy, and there are also romantic ties between the young men and women, which inject cohesion into the [Arab national] movement."[28]

Singling out the women of the adversarial camp as an integral part of the spreading battle between the two nations over control of the land became a common phenomenon at the time. This reality was described in an article published in *Dvar ha-Po'elet* in a style that conducted a dialogue of sorts with Rachel and Laban in the biblical period:

> And in the midst of these days of anxiety over what awaits, behold—I set out, and on the way are some Arabs walking in silence to bring water to the village. And in front of the nursery sit the women of the village Kumi, washing linen and clothing. They know that no evil will befall them, no-one will touch them, nor raise a hand against them. Had I myself wished, on that very day, to go up to their village and have a look around, it would have been dangerous. Not one of us would go down, on foot, to Hugim [the original site of Beit ha-Shita) to enjoy the shady forest or the cool water of the spring, on the Sabbath or on a day off work, for we do not trust the neighbors among whom we have dwelled for years already. And so I am jealous of you, the women of Kufr Kumi, for you can put your faith in us and trust us with your lives. For you, the roads are safe. But for us, for all of us—for how long?[29]

The involvement of Arab women in the operations of the Arab Revolt was addressed on several occasions in the Hebrew media. For example, at the beginning of May, reports described a protest march of some 800 Arab women from East Jerusalem; later reports covered the telegrams of protest dispatched to the king of England and the donations collected for victims of the revolt. In particular, the press voiced complaints about the exemption of women from body searches by British policemen owing to

strict rules of "women's honor," while in fact Arab women were "walking stashes of handguns, rifles, and bullets."[30] These reports were intended not only as descriptions of what was going on among the Arabs, but also as motivation to Jewish women to participate in a similar way on behalf of Jewish national interests. Another significant aspect of these reports was the emotional and moral targeting of different sectors among Arab society as committing acts of violence against Jewish presence in the land even if they were not actually pointing guns at Jews and depicting Arab women as full partners in the treacherous scheme to cause physical harm to Jews and their survival in Palestine.

A hate-filled response to the Arabs as such indicated the consolidation of these underlying currents within the ideological and educational bosom of the Labor movement, as well as a willingness to award them open recognition. This was something new. Moshe Beilinson, the senior publicist of *Davar*, felt it necessary to note that in the Arab camp, too, mothers wept in the night, and their children, too, "were terrified by nightmares in which there appeared a 'murderer'—not in the form of an 'Arab,' but rather in the form of a 'Jew.'" This psychological fact, he warned, would in the future become a political, social, and national fact. Although this column was one of Beilinson's most emotional articles, the need to publish it indicates the extent to which the demonization of the "other side" clouded the ability of Jews and Arabs to coexist.[31] The most prominent example of this phenomenon actually involved women. It occurred following the attempt to set fire to a children's daycare center in the Bak'a Illit neighborhood in Jerusalem, which accommodated some 100 infants (ranging in age from newborns to two years) on June 20. An announcement published in the Hebrew press in the name of "The Jewish Women in the Land of Yisrael" carried an arrogant appeal addressed to Arab mothers, asserting they needed to influence their husbands and sons to refrain from actions that would "poison their souls and hearts."[32] The announcement was an early indication of a new body on the women's scene in Palestine—"The Council of Jewish Women's Organizations in the Land of Yisrael." This body, established—according to its founders—"spontaneously upon the eruption of the riots" (although in fact it was established on July 31) with a view to representing Jewish women both internally and outwardly, was made up of the Zionist Women's Federation (the local branch of WIZO), the Council of Women Workers, Mizrahi Women, the Women's Union for Equal Rights, the Hadassah Women's Organization, and the Jewish Pioneer Women in

America.[33] In response to this poster, Arab women in Nablus published an announcement of their own at the beginning of July in which they denounced any attempt to cause loss of life among children or women, rejected the claim that Arabs were responsible for the incident, and demanded that the Jewish women denounce "their husbands' actions."[34] Prior to the publication of this second poster, the spirit that had motivated the first was echoed powerfully and with restrained bellicosity in a poem by Anda Pinkerfeld (Amir), published in *Davar*:

> Rejoice, O daughter of Arabia; rejoice and sing / over the blood of a young girl / who lived for four springs / your heroic sons hurt her [. . .] / We shall not repay / a threshing floor for a threshing floor / a fire for a fire / a murder for a murder / Therefore rejoice / O daughter of Arabia / for your heroic sons / who arise in the dark of night / ten against one / shooting their arrows from their ambush / burning helpless trees. / But another day will come / and you, O daughter of Arabia, surely looking on / will weep when you behold your wild sons / you will hide your face in shame and disgrace / your rejoicing suddenly silent.[35]

The publication of the poem did not pass without criticism. Mordechai Kushnir (Snir), a member of the Second Aliya and director of the Histadrut Archive, called for a setting of boundaries for poems published in *Davar* since the outbreak of the riots, especially the poems by Shaul Tshernihovsky, which—in contrast to that of Pinkerfeld—represented "a balm for our bleeding wounds; pure poetry." Kushnir asserted that "the Jewish woman, worker and mother in this country, has the power to speak in a different voice, in a completely different tone, to other women. This is her obligation; it is also her privilege." The question of whether the exalted poetic form would be harnessed for the expression of dark impulses, as Kushnir feared, remained unresolved. Despite the criticism, the poem was reprinted a few months later in the *Book of the (1936) Riots*, edited by Bracha Habas, with the approval of Berl Katznelson.[36]

On July 23, shots were fired at the Yemenite Torah School on Kalischer Street in the Yemenite neighborhood in Tel Aviv, causing light injuries to nine children aged eight to thirteen. The next day, the Council of Women's Organizations sent a telegram to the British Colonial Minister and to the Federation of Women in England, noting

that the Arab leadership and its press had not bothered to denounce the shooting at children in Jerusalem and in Tel Aviv, and declared, "Let no-one imagine that the degree of barbarity and terrorist methods testify to the justice of the cause, which is being upheld by terrorists." The Women Workers Council went a step further, dispatching a harsh telegram to the Women's Department of the British Labor Party and the Women's Department of the Socialist International, demanding that they voice their opposition to these criminal and horrific acts, which are unparalleled even in times of war and likely to polarize the relations between the two nations even more, especially with regard to poisoning the souls of the younger generation and introducing a spirit of racist hatred and barbaric methods of fighting.[37] The target of the shooting and the wording of the telegrams in response to it would seem to suggest that the racist hatred was mutual and that barbaric methods of fighting were no longer shrouded in the mists of future possibilities.

A different question, no less important from the point of view of the women in kibbutz society, concerned the contribution of women to the war effort and the recognition granted it. In the view of the greatest poet of the era, Shaul Tshernihovsky, the woman's role was clear, as expressed in two of his best-known poems of that period. They were composed in the days following the poet's miraculous deliverance from shots fired by Arabs at the bus in which he was traveling near Beit Dagon. With restrained satisfaction, the report in *Davar* described how the bullet passed between the poet's face and the newspaper that he was reading. On May 18, *Davar* carried his poem "*BaMishmar*" (On Guard), and a week later, "*Shir Eres*" (Lullaby). In both poems, the woman maintains her traditional role of childbearing and waiting with hope tinged with anxiety for the return of her loved one from the battlefield. These roles that Tshernihovsky assigned to pioneer women remained fixed even as the Arab Revolt continued. A poem that he wrote on August 30 opened with the description of a young widow sitting at the window of a hut. An editorial published in *Davar*, following Tshernihovsky's deliverance, stated:

> New fruit trees, more beautiful [than those destroyed in the rioters flames] will grow in Tel Yosef and in Mishmar Hae-mek; new, richer fields of produce will arise in Ein Harod and in Herzliya. Shaul Tchernihovsky remains with us, and Hebrew poetry will be magnified and sanctified by the bullet's treacherous whistle.[38]

Nevertheless, his poems failed to give expression and to respond to the dissatisfaction of the pioneer women. A different verdict might be awarded to the most significant of that era's poems about women, "I am the daughter," composed by Fania Bergstein of Kibbutz Gevat in 1936. The poem effectively announced the arrival of the new version of the Jewish woman:

> I am the daughter / of generations of Jews stooped, bowing / under the burden of heavy days [. . .] / I am a sister / to all who go out day by day to meet death / [. . .] I am the mother. / To all these little children, / of whom no-one will demand / the valor to forgive, nor the valor to remain silent / nor the valor to die [. . .].[39]

On the day following Freund's death, two Jewish nurses, Nechama Tzedek and Marta Fink, were murdered on their way to work at the government hospital in Arab Jaffa. This murder shocked the Yishuv more than any other during the first wave of the Arab Revolt, in which eighty Jews were murdered. On the same day, August 17, Jessie Sampter completed an article bearing the self-explanatory title "Watchwoman," which later appeared in the U.S. Labor Movement's monthly *Jewish Frontier*. Sampter, an American-Jewish poetess, who had arrived in Palestine in 1919, had moved to Givat Brenner in 1934 and established a vegetarian guest house, which soon became one of the most coveted destinations for members of the Labor Movement across the country. "The wise woman from Givat Brenner," as she was eulogized when she died in November 1938—and who, on her deathbed, authored her most original and poignant article, in favor of the unification of the kibbutz movement, which was realized only sixty-one years later—was also a pacifist and an advocate of a dialogue with the Arabs. Nevertheless, following the riots of 1929, and again in light of the events of August 1936, she acknowledged the necessity of defense. In the abovementioned article, Sampter reviewed, extensively and with deep empathy, the history of the struggle of women to play an active role in the realization of Zionism. The article opened with a description of the efforts of Manya Shochat and her female comrades, whom Sampter described as "armed amazons," endowed with a "quality as of bronze," to take an active part in the defense activities during the time of Hashomer, and it ended with a series of rhetorical questions of deep concern to women at that time:

Shall half of the community protect the other half? Shall half lie on the floor while the other half is facing the shots? What will our children say? What will our daughters say when they grow up and are differentiated from the little boys with whom until now they shared everything? Will a mother send her fifteen years old boy to go on guard while she hides in the concentration room?

Addressing her readers, especially women, among US Jewry, the well-liked poetess promised and pledged:

The pioneer Jewish woman must stand by her man at this hour in defense, and at a later hour attain in the work of cooperation and peaceful up building. The little girls who came from Germany last year are already bronzed by the sun; they have the same color and speak the same Hebrew as the little girls born in Jerusalem or Warsaw. There stands one on the hillock, against the rising sun, a white kerchief on her head, wearing a deep blue sleeveless blouse, short black bloomers, high over sandaled feet. She is brown and straight as a young tree, a lonely tree standing guard on a hillock. The wind blows her brown curls and her hand shades her eyes against the rising sun.[40]

It was in these historical circumstances that Hakibbutz Hameuhad held a Conference on the Question of Women's Work, which took place on Kibbutz Givat Hashlosha on July 13, attended by thirty-six women from the twenty-one kibbutzim of the movement. The issue of women's work had occupied the kibbutz for quite a while and was aggravated both by the demographic growth experienced by the kibbutz movements and by the first signs of the economic recession in Palestine. The female sector, which had always been seen as a vulnerable element in the kibbutz labor market, no less than in the towns, suffered from widespread overt and covert unemployment. During the conference, Yocheved Bat-Rachel, a member of Ein Harod, presented the participation of women in guard duty as a right based on the principle of mutual partnership that should exist between men and women in all areas of life. This right had been denied them, and the aim of the public struggle taking place then was to protest that denial. Sarah Blumenkrantz from Tel Yosef argued, on

the contrary, that guarding was not a right but an obligation, and that recognition of this had to be instilled in every woman on the kibbutz. She was joined by Yehudit Simchonit, also from Tel Yosef, who related how, on her kibbutz, women were afraid to enter a room unless a man entered before them, and she added:

> We have stopped restraining all our instincts. We once knew how to go together with men, and now we have reached such a terrible situation. The obligation of defense should be imposed on every woman, and not just on a few. I have a six-year-old child. His father is a guard. He told me: "I saw someone with a gun that you wouldn't have been able to carry, because I couldn't carry it either."[41]

However, in spite of her revolutionary tone concerning guard duty, on the issue of work, Simchonit declared that "fortunately, it has not been advocated here that men should be sent to the kitchen, and women—to pick grapes. The women who work responsibly in the house feel good about it. A person should work anywhere, and not feel inferior about doing housework."[42] At the end of the conference, for the first time in Hakibbutz Hameuhad, a department was established within the executive of the movement to handle matters related to women. Its members were Bassewitz, Blumenkrantz, and Bracha Rechtman. The resolutions of the conference determined that "the executive of the movement should demand of its units (Hakibbutz Hame'uhad settlements and groups affiliated with it in the cities) to fully realize the equal rights and obligations of female and male members in the sphere of defense."[43]

The children, too, were often an obstacle to mothers engaging in defense. Shifra Haikin of Ein Harod recalled, many years later, that during one of the shooting attacks she hurried to her guard post, and her children promptly jumped out of bed and ran off to find her. They were sent back to their rooms by kibbutz members who found them wandering about, and upon her return in the morning she found them waiting at the door: "We thought you would never come back, Mom," they told her. Haikin admitted that the terror that her children expressed at that moment would haunt her for many years.[44]

The organizational volatility of the women of Ein Harod was felt in different ways throughout kibbutz society. The general meeting of Tel Yosef held on August 19, 1936, discussed sending Blumenkrantz to

work in the Committee for Women Members' Labor Issues at Hakibbutz Hameuhad. Following the accepted procedure, a representative of Hakibbutz Hameuhad, Avraham Shechter, had come to present the request that the kibbutz release Blumenkrantz for the purpose of movement activity. But Blumenkrantz was a dominant professional figure in the groves where many trees had been hacked down in repeated Arab attacks on Tel Yosef's agricultural property, and the appeal was opposed by several members who felt that the orchard issues were more pressing. Shehter accused them of paying lip service to the needs of Zionist realization while in practice caring only about themselves and refusing to release members for public activity. Eventually it was agreed that Blumenkrantz would be sent to work at the Committee for Women Members, but the Secretariats of Tel Yosef and of Hakibbutz Hameuhad would jointly determine the timing.[45]

Ten days later, the same body discussed the issue of women members and defense. The discussion was held over two meetings in the absence of the members of the committee for guard duty, who pleaded various excuses. As in Ein Harod, here too it was claimed repeatedly that because of the women's lack of professionalism, they would not be capable of carrying out guard duties, and physiological and psychological reasons were also voiced. The women did not deny that they were afraid to carry weapons and were anxious that at the critical moment they would falter, but they argued that the obligation of being able to defend themselves should not be withheld from them. Ruth Haktin—later to become secretary of Hakibbutz Hameuhad and an MK—stated that just as she worked and earned an income, so she should defend herself: "I feel greatly offended if someone else is required to defend me, while I myself must lie flat on the floor and wait, defenseless." She acknowledged that she did not view defense as an easy task: "I do not envy myself on the night I'll go off to guard." Haktin noted that she was speaking as a woman who was not fearful in a work environment (although in her autobiography she admitted that when she had to perform guard duty she was "tense all day"). She noted that there are men who are fearful, too, and that it was "not right" that in winter, in the mud and the rain, women would not be sent to stand guard. "How is it, then, that women are sent off in winter to work in the orchard, in the vineyard?" One of the men countered that he was not prepared to countenance women standing guard in the orchards and vineyards: "I will always be plagued with the question of what will happen to women members who

fall, alive, into the hands of murderers." The Tel Yosef newsletter that appeared in between these two meetings noted that a course in guard duty and defense for women who were to serve in instructional roles in the Jezreel Valley region had just concluded. The three-week course had been attended by fifteen women from the nearby settlements, and it had been "intensive work. There was dedication, meticulousness, and amazing discipline." At the same time, those responsible for the course emphasized that these women members must not neglect the roles that they had fulfilled until then in the realms of first aid, communications, signaling, and so forth, because "these are no less important than actual fighting." During the first shooting incident at Tel Yosef, Yisraelik Eliav, head of security on the kibbutz, had instructed women members to enter the rooms and lie under the beds. Thus, the course represented a revolution in the attitude toward the women in this regard. So it was viewed by Rachel Shalon (Friedland) of Haifa, commander of the course and later a professor of building engineering at the Technion (the first professor at this elitist institution).[46]

Sara Amster, of Kibbutz Merhavia, in her effort to demonstrate that fear was not an innate feminine quality, pointed out that the number of women who attacked members of the ruling class in tsarist Russia was no smaller than that of men. Compared to the women who had come to Palestine from Russia or Poland and found it natural to become fighters in their new country as well, women like her, who had come from other countries, did not appreciate enough "the fact that Palestine, which is surrounded by deserts, with their uncivilized inhabitants, will impose on us the task of guarding well and defending our lives for a long time." She admitted that the willingness to train women for guard duty did not ensure that, at the moment of truth, it would be possible to predict how they would behave, "but even the men have not yet guaranteed that they will always act like heroes. The women should be given 'credit,' and, at the right time, we will know how to pay it back in full."[47]

Emma Levine-Talmi, who worked in the social department of Hakibbutz Ha'artzi, initiated a number of regional conferences for the women members of the movement. The first one took place toward the end of August 1936 and was attended by about fifty women from the kibbutzim of the Jezreel and Zevulun valleys. Thirty Jews had been murdered during that month, which was the most difficult one of the first wave of the Arab Revolt. It was a "unique conference," as Ya'akov Hazan proclaimed enthusiastically in his opening remarks, because it

was the first women-only conference in the history of Hashomer Hatzair. As in the conference of women members of Hakibbutz Hameuhad in Givat Hashlosha, the discussions here also dealt mainly with the relation between service jobs and agricultural work, the difficulties involved in integrating women in the latter, and the paucity of their expression and influence in public life. Nevertheless, it was obvious, and mentioned time and again by the speakers, that the guarding issue had provided the impetus for holding the conference. One of the topics discussed was, once again, as in 1930, Nemilov's thesis about "the biological tragedy of women." Hazan was sarcastic about the central place accorded to Nemilov's arguments and said that even though more male than female members of Hashomer Hatzair read science books, "I am sure this phenomenon has no biological reasons." At the same time, he admitted that equality between the sexes was hampered by the fact that "we are, ourselves, all of us, a generation of transition, almost the wilderness generation, whose entire education was grounded in bourgeois and petit-bourgeois society, with its 'male culture.' We carry with us, unwittingly, the burden of this legacy." The resolutions of the conference determined that the kibbutz movement, which had aspired to create exemplary models of the future socialist society, in which there would be complete equality between the members, had failed to carry out its task adequately. The participants in the conference demanded the establishment of a women's committee, which would promote and develop women's activities in the kibbutzim of the region, and insisted on their right to participate in guard duty in peaceful times as well. Another demand was to set fixed quotas for women in the general institutions of Hakibbutz Ha'artzi,[48] which was a sharp reversal of the long-standing contempt of Hashomer Hatzair toward the resolution of Hakibbutz Hameuhad on this matter in the early 1930s.

The demand was not adopted by the institutions of Hakibbutz Ha'artzi. However, a different proposal, raised by Levine-Talmi at a regional gathering of the women members of the Hashomer Hatzair kibbutzim of the Shomron and Emek Hefer regions, which took place at Kibbutz Gan Shmuel toward the end of October, was realized. The gathering proposed holding, "at the earliest opportunity, a seminar instructing women members for public and educational activity in Palestine and in the Diaspora." As befitting an opposition movement to the Histadrut and the leadership of the Women Workers Council, the discussions among the women of Hakibbutz Ha'artzi included criticism of the Histadrut leadership. For example, Feige Hindes (Ilanit) of Gan Shmuel found evidence of the

inferior status of women members in the Histadrut in the fact that "the Histadrut membership book is full of rules and regulations, instructions, and so forth, and at the end there is a sentence that reads, 'All of the above applies equally to women members.'" Following the custom of the movement that hallowed the realization of Marxist theory, Rivka Gorfine of Kibbutz Ein Shemer announced, at the conclusion of the gathering, that through its discussions, the participants had succeeded in "getting at the root of the evil," exposing the elements combining to silence women and "put them in the shade": these included the laws of nature, education over many generations, the "needs of a deceitful and conniving regime," and so on.[49] It is no wonder, in light of this loaded jargon, that when the plan for the seminar aimed at "women emissaries and public figures" was brought up for approval at the Executive Committee of Hakibbutz Ha'artzi, Ya'ari announced cynically, "Every woman will emerge from there a Rosa Luxemburg." Needless to say, all twelve instructors for the seminar were to be men (except for one lecture on the Women Workers' Movement, which was reserved for a representative of the Women Workers' Council), for it was the men who were "entrusted" with inculcating the "proper" ethical and ideological approach.[50]

And indeed, the kibbutz women of the time were not Rosa Luxemburgs, as is evident from the description by one participant from Ramat Hakovesh, who documented what she witnessed during one of the kibbutz meetings held in 1936:

Who, in fact, were the daring women fighters at the time? It was a cold evening, each of them sat wrapped in a sweater, a coat, huddled with cold and fatigue. They had just sat down to relax after a long and tiring day of work. Yet even now the hands did not rest: most were knitting sweaters for a child, for a friend. One yawned, another was almost asleep and struggling to listen, to disperse the webs of fatigue. This is what the "heroines," as they are called today, actually looked like.[51]

In 1936, the prevailing crisis happened to offer the women of Ein Harod an opportunity in the form of guard duty, which served to advance their views of women's status and abilities, in the public sphere. For a few months, women in Ein Harod were indeed "at the lookout," in the words of the poet, and also fulfilled other security-related tasks. Afterward the security situation changed, and the blessed quiet that prevailed for several

long months, until the next wave of the Revolt, in September 1937, represented something of a setback for the women's struggle. Everyday needs pushed the women back into their previous frameworks. The precedent and opening that had been created by virtue of the Ein Harod women's struggle in 1936 came, with time, to express and offer tangible proof of their ability to overcome obstacles presented by male society. In the collective memory of the women—and, indeed, of the membership of Ein Harod and kibbutz society in general—there was now an awareness that in times of crisis, and perhaps even in incidental circumstances where necessary, the possibility of including the women in the security realm could be considered. It may be that their tangible achievement at that time was extremely limited, and its relative importance need not be overstated. At the same time, with hindsight, the women's struggle of 1936 was a historical junction and landmark that women pioneers would refer back to during later struggles, drawing strength for their efforts in realizing the aspiration to participate actively in the defense of the private, collective, and national home.

Chapter 5

Gender, Defense, and the Public Status of Women, 1937–39

The episode of the women's participation in guard duty during the first round of the Arab Revolt was raised for discussion and summed up at a conference of security activists held by Hakibbutz Hameuhad on February 14, 1937. The conference had been called to define—within a professional framework of experts, senior political figures in the movement, and representatives of its kibbutzim—the security lessons to be learned from "the Riots of 1936" and set down a series of guidelines that would inform the activists' approach in this area from this point onward. By virtue of the definition of the subjects under discussion, the perspective from which the women's participation was examined was the question of the extent to which they were able to assimilate and internalize the training provided, and the ramifications with regard to their integration in the defense forces. Tabenkin maintained that, in principle, the equal rights of women should extend "to all forms of defense, and to all weapons of defense." At the same time, he qualified his remarks by noting that this approach would be subject to the practical consideration of "their own capability, which would become apparent during their training."

Despite the call by Blumenkrantz and Eva Tabenkin to invest efforts in training women for guard duty, the dominant view in the discussions was that a distinction should be drawn between the desire to nurture values of partnership and equality on the ideological, collective level, and the reality of what was possible on the professional level. It was estimated that as the training grew more demanding, both physically and in terms of adapting patterns of defense to military needs, as dictated by

the forms of attack by the Arabs, the ability to integrate women would be eroded. This perception found symbolic expression in the fact that despite the organizers' request that each of the movement's kibbutzim send a male and female representative, about a quarter chose to send men only. The same perception was expressed in the words of Yosef Levy of Kibbutz Na'an, who described the difficulties of military course instruction for women members. Lessons on execution of movement and field exercises, he noted, encountered "a brick wall." This suggests that the prevailing assumption was that the trend of military professionalism in defense activity, with increasingly military emphases, would necessarily send women back to the periphery in this area. At the same time, the main emphasis on the women's activity was placed on acquiring proficiency in holding and operating weapons so they could perform guard duty within fenced communities. Under these circumstances, there was room to hope that, for the time being, it would suffice to adopt the organizational resolution passed in Ein Harod—that a third of the members of the guard-duty council on each kibbutz would be women—and reaffirm the ideological and educational decision that had been taken even earlier, at the gathering of women members at Givat Hashlosha and at the Hakibbutz Hameuhad Council in Yagur, that "the right and duty to participate in the line of defense extended to every male and female member equally."[1]

At least on the ideological level—a matter of no small significance in the molding of consciousness and practice in kibbutz society at the time—what had originally been perceived as a sort of whimsical caprice on the part of a few shrill women who could almost be ignored had become, over the course of eight months of public struggle, spreading from Ein Harod throughout the kibbutzim, a principle integral to the life of the movement. Even the security experts of Hakibbutz Hameuhad could not permit themselves to dismiss the matter out of hand. On the other hand, even without reference to the gender dimension, the military professionalism of the overall security arrangements in the kibbutzim at the time should not be overstated.

The Status of Women in Conferences Held during the Lull in the Revolt

The women's conferences in the kibbutzim, together with the numerous articles published in kibbutz organs and the Labor movement press

before and after these conferences, led to increasing manifestations of women's activism in 1936–39, as demonstrated by the numerous political assemblies that took place during the lull in the Arab Revolt between October 1936 and September 1937 (at the time of the British Royal Commission of Inquiry headed by Lord William Peel) and the seminars that were held throughout the Labor Movement in 1937. However, Hever Hakevutzot was notably absent from this activity, as women's organized activity was almost nonexistent in this movement, even though their status in it was no less problematic than in the other two kibbutz movements. This can be learned, for example, from the comment made by Haya Tanpilov (the wife of Tanhum Tanpilov, one of the founders of Degania), which was published in the newsletter of Degania Alef in March 1937: "Degania has acted in all areas of economics and life, but with regard to the issue of women members, it has not lifted a finger. There is great neglect of almost half of our society."[2] A month earlier, Degania, "the Mother of the *Kevutzot*," had had to resort to asking Eva Tabenkin to open an assembly of women members on the role of women in guarding and security. Tabenkin noted that the deep resentment against the dismal situation of women in this area had blurred all the disagreements between women with different political affiliations in their respective kibbutz movements and created among them "complete unity in their willingness to fight" to change their situation. Under the provocative title "Is the Woman Member Doomed to Impotence?" Fania Artzi described the situation in Degania in regard to guarding. Those in charge of security on the kibbutz were willing to let the women participate in guard duty, but only two women actually did because they were reluctant to relieve one another at work. Artzi assumed that the relative indifference the women of Degania exhibited toward this issue was partly due to the fact that the kibbutz had been left "in the rear" during the violence, from which the Jordan Valley region had suffered far less than the Jezreel and Hefer valleys. She considered that the local commanders' ready acceptance of the women's demand to participate in guard duty was, in this case, detrimental, because the women had no reason to organize and fight for their rights and obligations as part of the overall struggle to improve their status on the kibbutz.[3] In Ein Harod, a struggle had been necessary and had therefore spread to other kibbutzim and had a far-reaching effect on Hakibbutz Hameuhad.

The event that launched the series of sociopolitical discussions on the status of women in the Labor movement was the first open, public conference on security issues in the history of Hakibbutz Hameuhad and,

in fact, in the history of the Yishuv, which took place at the eleventh convention of the movement, held on Kibbutz Yagur on October 2–7, 1936 (a few days before the end of the first wave of the Arab Revolt).[4] Eva Tabenkin, the separated wife of Yitzhak Tabenkin, the leader of Hakibbutz Hameuhad, who was known throughout the movement as the standard bearer of "the women's rebellion" in Ein Harod (their fight to participate in guard duty), declared that, for women on the kibbutz, "the lights and their splendor are not coming closer, but, rather receding further and further into the distance, and sometimes seem to have been extinguished altogether." With regard to the timing of the rebellion, during such a turbulent period of extreme security threats, she asserted that the reason for starting the women's public struggle had not been either jealousy of men or a feeling of inferiority toward them but, rather, the fact that "the public phenomenon revealed here was so outrageous that it was impossible to ignore it." The "women's rebellion," she argued, had followed the traditional path of the kibbutz since the days of the Second Aliya: "first we acted and then we interpreted and summarized." In other words, in the same way in which the Histadrut, the small settlements, and the kibbutzim had started—first by "building," and only then by aspiring to "socialism" and "Zionism"—so now, too, the achievement of participating, with equal rights, in guard duty had come first, and only later was it defined as a stage in the war for women's liberation, feminism, and so forth.[5] Blumenkrantz, a member of the movement's committee for women's affairs, warned in her speech at the convention that discrimination against women in guard duty had not yet ended. "The 'numerus clausus' is still in force. The number of women who are sent for guard duty is based on a percentage of the total number of guards, and when that number declines [following the apparent lull in the revolt], the number of women guards drops to zero." It was impossible, she admitted, "to constantly live a life of war," and women gradually fell silent and accepted the fact that their struggle for achieving "their rights and obligations in defense and guard duty" had been concluded. The convention of Hakibbutz Hameuhad fully ratified the resolutions of the women's conference in Givat Hashlosha and instructed the movement's executive to demand that its kibbutzim "truly realize the equal rights and obligations of male and female members in defense."[6]

The Histadrut granted its approval for the kibbutz women's struggle to participate in guard duty at the conference of the Women Workers' Council, which took place on December 22–24. Eva Tabenkin demanded

that a woman be included in the Haganah headquarters to reinforce the achievements of the women's struggle and create an institutional anchor that would make it harder to undermine those achievements over time. And indeed, when the extended executive of the Haganah was established in April 1937, Bat-Sheva Haikin, of Kibbutz Yagur, was elected by the Executive Committee of the Histadrut as one of its eight representatives in this body, probably because of the intervention of Yitzhak Tabenkin.[7]

International Working Women's Day, which was observed on March 12–13, 1937, was used on Ein Harod for holding a special ceremony for its own children and those of Tel Yosef. The legitimacy of holding such an event was based entirely on the prominence that the status of women had gained at that time throughout the Jezreel Valley. Of special interest, in this context, was a volume dedicated to Working Women's Day, edited by Lilia Bassevitz, which included moving descriptions by eleven women from Tel Yosef and Ein Harod of their guard duty experiences.[8] An announcement issued by the Women Workers' Council on the occasion of International Working Women's Day said:

It is hard to accept this certainty, that in the whole world the woman will reach equality on the battlefield before she reaches it in her working, productive life. But when we have to defend life and freedom, and protect human rights from their desecrators and oppressors, the working woman will not stand aloof. We know that here, in Palestine, too. The woman has emerged from the test of the riots imbued with a sense of responsibility and a desire for full participation in guarding and in positions of danger. Both her political awareness and her sense of self-worth, both in days of peace and in times of trial, have increased.[9]

The constant, growing tension between the prevalent self-image of the Jews as moral, peace-loving people and the principle of defending their life and dignity in Palestine, both of which were formative elements of the Zionist movement, was a prominent feature of that period.[10]

The seminar for women members of Hashomer Hatzair opened, after a few delays, on April 6, 1937, in Hadera, and lasted for about three weeks, until April 25. The purpose of the seminar, which was headed by Emma Levine-Talmi, was to provide potential emissaries of Hashomer Hatzair in Palestine, but mostly overseas, with ideological and

educational training, and it was attended by twenty-seven women from twenty-five kibbutzim. Two goals were set for the seminar: the first one was to form a cadre of women who would undertake to carry out public missions, in Palestine or abroad, "whenever necessary." The second one was to facilitate informal acquaintance between the male activists of the movement and women members who were willing and able to serve as its emissaries. "The woman," explained a letter sent to the kibbutzim to inform them about the program of the seminar, is "diffident by nature. We do not know her, outside of the boundaries of the kibbutz. There are few women who make themselves available for wider activities, and still fewer who are called upon for work by our institutions, since they do not know who they are, they are not familiar with them." The fact that the seminar was intended for women only was, in itself, an innovation in kibbutz practice, which was ideologically committed to eliminating the differences between the sexes. The twenty-two speakers at the seminar were all men. The only occasions on which women also lectured were the "party" for women on the kibbutz and moshav, and a lecture by Hindes on the Spanish Civil War. It is reasonable to assume that the security situation in Palestine, including the women's wish to participate in guard duty, was also discussed at the seminar, but it was not mentioned in the titles of the lectures.[11]

At the convention of Hakibbutz Ha'artzi, which was held a few weeks before the seminar opened, Ya'ari declared that it was a stage in "the policy of activating the women." He lauded the large number of women participating in the convention, which he saw as proof that the barriers between the sexes could fall in the area of political consciousness too, and added, somewhat bombastically: "I believe that our dream will come true and that the crooked shall be made straight." Needless to say, at the next convention of the movement, which took place in July and dealt with the partition plan of the Peel Commission, only one of the thirty speakers in the debate was a woman—Rega Varshaviak, of Kibbutz Mizra.[12] Aside from the seminar's influence on the continued involvement of the women of Hakibbutz Ha'artzi in the public life of their movement (as emissaries and in organized activities of women in various areas), which warrants a separate, detailed examination, it seems that the main impact was left by the absence of the leader, Ya'ari, who suffered from poor health at that time. The participants in the seminar wrote him a letter with heartfelt wishes for his recovery, and Ya'ari, touched by the gesture, answered them in a letter of his own (which

he took care to have published in Hedim, the movement's journal), in which he related that he always "breathed" the fate of many thousands of people, because "no private life is richer than a life that merges with a large community," and wished them to benefit from this "outstanding gift" in their activity.[13]

The first seminar for women initiated by the Women Workers' Council, attended by pioneers along with women from the cities, was held at Brenner House (the Women Workers' Council building) in Tel Aviv on June 6–26, 1937. Seventy women participated. The deliberations among the kibbutzim as to whether to send women members to so extraordinary an event as a Women Workers' seminar are exemplified in the discussions held at Givat Brenner to select the representatives who would attend. At a general meeting held on May 22, it was reported that five women were expected to participate as representatives of Hakibbutz Hameuhad, and the movement's institutions had requested that a Givat Brenner member be one of them. Eight members were proposed as possible candidates, and eventually it was decided that the kibbutz would send two representatives. A week later, the night before the commencement of the seminar on May 30, the subject was raised once again for discussion at a general meeting after the secretariat of the kibbutz decided that no representatives would be sent, owing to the kibbutz's financial straits. (Aside from a per diem allowance of two and a half lira, there were expenses entailed in removing a member from the work roster for three weeks.) One member argued that sending representatives to the seminar would come "at the expense of the newspaper and food" for the other kibbutz members; another claimed that the representatives who had been selected were incapable of initiating and organizing women's activity in the political realm, and hence there was no point in sending them. In a vote that was held at the meeting, it was finally decided that a single delegate would be sent, and at the express request of the organizer of the seminar, Rachel Katznelson, Yehudit Levin was chosen.[14]

In her opening remarks at the seminar, Katznelson repeated the familiar axioms, declaring: "The Women Workers' movement, from its inception in this country, was not an imitation of the suffragettes. We always regarded ourselves as an organic and inseparable part of the Socialist Zionist movement."[15] The seminar offered a range of lectures about the Histadrut, the family, and "the woman in the liberation movement" and also included "an address on issues of defense in the Land of Yisrael" by Yisrael Galili of the Haganah central committee. It is doubtful whether

the organizers of the seminar would ever have dreamed of inviting him to speak before this forum had it not been for the women's revolt the previous year. According to the seminar program, even more senior personnel were originally slated to speak on this topic: on June 12, a panel was meant to be held "with the participation of Shaul and Eliyahu"—a reference to Shaul Meirov (Avigur) and Eliyahu Golomb, the heads of the Haganah. Galili, who ended up attending in their stead a week after the date originally scheduled, refrained from obsequiousness toward his audience, going only so far as to mention the question of "women's inclusion" in the Haganah as one of the issues to which attention should be given in the security context.[16] The most conspicuous feature of the seminar was the fact that of the total of fifty-four lecturers, no fewer than twenty-three were women.[17] Two of them are worthy of discussion in their own right. The seminar was open to women unaffiliated with the movement, one of whom was "a strange one," as Katznelson referred to her, who attended all the lectures to "get to know the women workers of the Land of Yisrael at close hand." During the course of the seminar, seventy-two-year-old Puah Rakovsky acquiesced to the request of other participants and recounted her life story. She had moved to Palestine two years previously, having been one of the earliest Zionist activists in Poland, one of the first Hebrew teachers in Warsaw, and founder of a girl's school. Above all, she is remembered in the collective memory of her contemporaries as the founder of the Women's Zionist Movement and the Union for Equal Rights for Jewish Women in Poland. "The archetype of the first generation of Jewish women in Eastern Europe who acquired citizenship with equal rights and obligations within their nation's movement of renewal," as Katznelson described her.[18] Rakovsky told the other seminar participants of the women's involvement in the earliest stages of Zionism:

> In the early days of the Zionist movement, the women were quite apathetic. Many even prevented their husbands from participating in the movement. Nor did they attend the lectures that were organized for them. This situation continued up until the First [Zionist] Congress [held in 1897]. Herzl awarded women the right to vote at the Congress, and maintained complete equality. He said, "The woman in our movement is nothing, but she can be everything." Very few women took advantage of the rights extended to them. The

women who came to the Congress were wives of Zionists who wanted to join their husbands. Their participation took the form of organizing parties and baking cakes.[19]

Something of Rakovsky's combative, revolutionary spirit is evident in her response to the proposal by Rabbi Yaakov Moshe Toledano, in 1931, to reinstate within normative Judaism the institution of the concubine, which had existed during the biblical period of the Judges and the monarchy. Rakovsky was furious and declared that women should be active in their communities in order to be able to influence the rabbis, for "who knows what else they might institute without our knowledge. This is scandalous!" She set forth the women's demands:

> We demand that a bride betroth the groom, rather than the custom up until now, that the groom betroths the bride. We demand that a woman have the right to cast a "get" (writ of divorce) at her husband, just as she might throw a lamp, a pot, a chair, and so on, at his head.[20]

The bellicosity that oozed from Rakovsky's life story was what captivated Katznelson more than anything else, and she wanted something of Rakovsky's vitality and the live example that she represented to carry over to the other participants. She later recalled that it seemed to the participants that "we had heard the choked voice of a generation of women who had no-one to redeem them—neither poets nor historians."[21] On June 20, prior to Galili's talk, Manya Shochat told the seminar participants about the role of women in Hashomer. Katznelson reworked her speech into an article that she published on this subject: "The woman in Hashomer." Between the lines, and against the reality of 1937 and the growing awareness of the importance of integrating women in guard duty, Shochat expressed regret about the marginalization of women in this area during the Second Aliya period.[22]

In the closing address, Zalman Rubashov (Shazar) stated that the aspiration of the Women Workers' movement in Palestine was not for equality in the realms of economics, politics, religion, or love relationships: these were areas in which either women had not been discriminated against in Jewish life, or the movement was powerless to change the situation. He did not bother to mention the security realm. To his view, "The unique curse" burdening Jewish women was their having

been excluded for hundreds of years from "the Jewish library." Whether Rubashov's diagnosis connected with the inner longings of his listeners, perhaps bringing the historical reality of his times to justice, or whether he was speaking from his own heart about matters that concerned mainly himself, it is clear that it was not for this purpose that he had been invited to the Women Workers' seminar. We may assume that had this theme been the motivation and objective of the gathering, it would never have taken place. Just prior to the seminar, the participants were requested to bring two books with them: the collection of prayers by the poetess Rachel, and *Divrei Po'alot*, which had appeared in late 1929.[23] In many respects, these works remain—even eighty years on—the top two items in the canon of women's literature during the period of the Yishuv and the establishment of the state. In summing up the Women Workers' seminar, Rubashov's wife, Rachel Katznelson, chose—in contrast to her husband—to emphasize the feminine leadership dimension, noting the powerful impression made by Rakovsky and the example she inspired.[24]

In spite of Tabenkin's great sensitivity to the status and value of women in kibbutz society, including the importance of integrating them in the security sphere, which he regarded as increasingly essential during the Arab Revolt, in the seminar of Hakibbutz Hameuhad, which he initiated in early November 1936 and eventually headed, only four of the more than seventy lecturers were women. The seminar, which took place in Ein Harod and Tel Yosef from May 2 to October 11, 1937, was attended by eighty-two members of Hakibbutz Hameuhad, of whom twenty-three were women, apparently because of Tabenkin's intense involvement in selecting the participants. The kibbutzim of the movement had been told in advance that "a considerable number of women" would attend the seminar. Another sign of the time was the fact that, when completing the questionnaire they were given at the beginning of the seminar, none of the women failed to mention that they served in the Haganah.[25] Although the guideline laid down by Hakibbutz Hameuhad that a third of the members of its institutions should be women was not fully implemented, the fact that 28 percent of the participants in this prestigious activity, lasting for five consecutive months, in which many wanted to take part, were women was undoubtedly an exceptional achievement in the conditions of those days. During the seminar, a memorial service was held to mark the anniversary of Freund's death. One of the participants, Haim Fish (Dan), a member of Ramat Hakovesh, described Freund's background in one of the poor alleys of Poritzk, a shtetl in the region of

Volyn (in Poland, now in Ukraine), and added: "The story of her life, to her last day, was that of stages of overcoming the concepts and lifestyle of a provincial town, natural weakness, and inferiority. All her life she strove to be worthy of standing with the first in line, always—until her very last night."[26] Freund's almost built-in "inferiority" as a woman was actually reversed, and, with the stroke of a few words, she became the "ideal type" that Hakibbutz Hameuhad wanted to present as a symbol and exemplary model—"always first in line" (in the spirit of "we are always first," in the words of the future anthem of the Palmah), ready for a pioneering life in the homeland.

The women's struggle in Hakibbutz Ha'artzi movement was also seen when, in July 1937, Kibbutz Ein Hashofet was established according to the *Homah u-Migdal* (Tower and Stockade) method of quickly erecting and fortifying new settlements. Initially, no woman was supposed to be included in the first group of thirty members who were to settle the land. Rachel, a member of the kibbutz, related that this step was justified by one word—"security," which had turned into "a magic word, silencing rightful and just demands. We seemed to be hearing yet again: A woman does not join the *minyan*. Her place is not by the Holy Ark." Following heavy pressure exerted by the women, it was finally decided that five of the sixty women who belonged to the kibbutz about to be established would join the men in starting the new settlement.[27] A few months later, the commanders of Ein Hashofet made a point of denying that "they oppose, in principle, the inclusion of women in guard duty. Our demand is that those considered will be qualified for it."[28] Needless to say, such a demand was not made of the men.

Gender, Defense, and the Public Status of Women during the Last Years of the Revolt

With the renewal of the Arab Revolt in September 1937, after the Palestinians, backed by the Arab countries, rejected the partition plan proposed by the Peel Commission, the Haganah began to shift its strategy from a defensive ethos to an offensive approach. Moreover, the settlements gradually ceased to be the main target of the Arab attacks, which were increasingly directed against Jews living in the cities. These changes made it more difficult for women to be actively involved in the military clashes and somewhat undermined their initial success in penetrating spheres of

activity that had been closed to them. The emergence of new military bodies within the Haganah—the Field Companies in 1937, Orde Wingate's Special Night Squads in 1938, and the Special Operations Units in 1939—all of which were offensive combat units that acquired some glory on the battlefield and were lauded as manifestations of the emergence of heroic fighters among the youth of Palestine,[29] reduced the importance of women's participation in security activities and diverted attention from this issue in some of the kibbutzim.[30] In a meeting of security activists of Hakibbutz Hameuhad in late July 1938, Bat-Sheva Haikin, a member of the Haganah headquarters, observed that although the legal military cooperation with the British security authorities opened many operational possibilities for the organization, it had to be taken into account that this situation would change some day. In particular, she noted that the overreliance on security activity enjoying official British backing actually prevented women from participating, because the British were opposed. Haikin did not deny the importance of cooperating with the British, but maintained that to prepare for other times, women should be trained to perform tasks in the security area.[31]

In 1937–39, the involvement of women in kibbutz security gradually became a routine matter involving a limited number of women, while, as noted, the focus of the conflict moved elsewhere to the roads and the cities. Although kibbutzim such as Ramat Yohanan to the east of Haifa, Ein Hashofet, and Ramat Hakovesh suffered from repeated attacks, the feeling of being in the "rear," at a safe distance from the "front," characterized many of the settlements located in the Jezreel and Jordan valleys, which set the tone in the kibbutz discourse. This was reflected, among other things, in the diminished interest exhibited by the kibbutz population, especially the women, in taking an active part in security matters.[32] For example, although the security issue was at the center of the discussions at the Histadrut convention that took place on July 25–26, 1938, the speakers made no mention, even indirectly, to the question of women's military service.[33] Nevertheless, throughout 1938, the strengthened status of women, result from the "women's rebellion" on Ein Harod in 1936, became more visible in the public sphere of the Labor movement.

Over the course of 1938, the results of the strengthening of women's status that had started with the "women members' revolt" in Ein Harod in 1936 became increasingly apparent. One example was an incident that at first involved only the close circle of former Hashomer

members. On January 28, 1938, the Mishmeret HaGvul (Border Guard) organization was established at a meeting of about twenty veterans of Hashomer held in the home of Yisrael Shochat in Tel Aviv. The aims of the new organization were to protect the borders by setting up points of settlement, developing neighborly relations on both sides of the border, and settlement activities on both sides of the border. The executive committee consisted of Yisrael Shochat, Manya Shochat, Yosef Nahmani, Nahum Horwitz, and Yosef Harit. Mishmeret HaGevul is the story of the last public initiative of the Hashomer members—an initiative that was halted for unknown reasons. Underlying the establishment of the organization was a twofold assumption: the need to give priority to the security needs of the growing Jewish society in Palestine, and the necessity of developing good neighborly relations with the Arabs. Mishmeret HaGvul was established at a time when borders were a pressing issue, in the wake of the Peel Commission's Partition Plan, issued in the midst of the Arab Revolt, while the Yishuv's institutions were endeavoring, by means of "tower and stockade" settlements, to ensure a Jewish presence and control in areas that were considered strategically important. The Hashomer veterans sought to be part of the settlement endeavor in the outlying areas and to be part of the general Zionist "tower and stockade" project, without relinquishing their separate, independent aims, which differed from the central Yishuv trend. During the same period, the British decided to invest efforts in preventing Arab fighters from infiltrating via the northern border by means of a fence along the border with Syria and Lebanon ("Tegart's wall," erected May–August 1938). The theoretical approach guiding the founders of Mishmeret HaGvul, by contrast, was based on their view that an open border and dialogue, rather than fences and physical obstacles, could lay the foundations for orderly relations between Jews and Arabs and bringing calm. The organization was founded in the spirit of the Hashomer ideology, which attached great value to settlement throughout the country.[34]

The awareness, both among Hashomer members and outside the movement, that its members were pioneers in the endeavor of rapprochement with the Arabs is well documented. For instance, Yitzhak Tabenkin stated at a seminar of Hakibbutz Hameuhad in 1937: "It is a fact that Hashomer, which was first to raise the banner of defense against the Arabs, was also a pioneer in the rapprochement and ties with them." From the continuation of Tabenkin's speech at the seminar, it seems that the matter of rapprochement with the Arabs was generally reduced to the

principle of "knowing thine enemy" and a focus on folklore elements.[35] It is therefore no wonder that later on, Yanait Ben-Zvi commented on the second part of the dual assumption above: "Many in the Yishuv did not understand this political thinking of Hashomer."[36] Mishmeret ha-Gvul was established under a cloak of secrecy. Its members intended to use it as a platform to draw the Hahomer loyalists, most of whom had been elbowed out of positions of influence in the Yishuv, back into the centers of activity and involvement. In other words, the organization was also meant to serve as a way of attracting them back into the security and defense realm, against the backdrop of their criticism of the Haganah policy in its struggle against the Arab Revolt. The immediate cause of the halt in Mishmeret ha-Gvul activity just a month after its founding was the intention of Shochat and Harit not to include women in a study course on the Arab question, which was supposed to open under the auspices of the organization. In response, Manya Shochat wrote them a scathing letter:

> I was astonished to hear that your intention is not to include women in the course in Tel Aviv that you're about to open. There are some fundamental differences of opinion between me and you, but they do not hamper me in our cooperation. In this matter you have taken a position which, if you will not change it, leaves me only one option: to leave the organization. I do not understand your position at all. You know as well as I do that even the Arab leaders are now including Arab women in political action, both in urban areas and in the villages, and even they are helping the gangs. You know what role English women are playing in the [Middle] East among the Arabs, because they are able to enter women's spaces where men are unable to operate and influence. You know that in a modest place like Kfar Giladi, Tova Portugali helped to create serious neighborly relations with the Arabs no less than Moshe Eliovitch did, and in some instances was even more successful than he was. Now, with this seminar offering an opportunity to expand our reach on the Arab question, and to create a cadre of people who are better prepared than has been the case until now, instead of understanding that that it is necessary to seek a few women among us who will study the language and prepare themselves for the role of neighborly relations—instead, specifically in this instance,

you think that there is no place for a woman at the seminar? I don't understand it at all! However, I must notify you that if you will not change your position, I will be forced to leave the organization in order not to cause internal conflict.[37]

On earlier and later occasions, Manya Shochat was able to defend the barriers that separated men's and women's activities in Hashomer, in terms of the operations themselves and knowledge about them.[38] In contexts not directly related to defense matters, she upheld an egalitarian approach that involved neither feminist struggle nor feminist pretention, and considered the women of Hashomer as a foundation of the organization's existence and one of the secrets of its success. Against this backdrop, she decided on this occasion to take a stand. Her departure would deal a critical blow to the young organization because of her capability and skills. The documentation in our possession concerning Mishmeret ha-Gvul concludes at this point. In the absence of further information, we can only assume that the disagreement that arose over the question of women's participation served as a catalyst that led, presumably in conjunction with other unknown factors, to the organization's demise.

An inkling of the role that Manya Shochat sought to sketch for Jewish women in nurturing neighborly relations is hinted at in a brief article by Leah Lichtental of Ramatayim. It was written in the wake of a terrible accident that occurred about a month after Manya wrote her letter—on March 29, when a five-year-old Arab girl was run over by a train in Haifa, and her mother, who rushed to save her from between the train wheels, lost both her hands. Lichtental wrote that while famous artists had painted hands of fearful mothers reaching out to protect their children, no artist had ever painted such a terrible scene as the one that had played itself out in Haifa. She concluded, "[Even] if the sons of that mother are among those who set fire to our children's houses [as occurred in 1936], and [even] if they, too, are among those who ambush and kill our best boys, who stand defending our homeland—this bereaved mother is dear to me."[39] It seems that such a sentiment could be expressed only by a woman. Although we might certainly question the extent to which Lichtental's feelings were shared by other women, her words certainly do indicate the potential for the sort of human contact and empathy that Zionism has not always used to its benefit.

The simmering defense/gender issue was already creating ripples in new spheres, although not always in a consistent and well-defined direction. For example, there was an appeal by the chairman of the National

Council executive, Yitzhak Ben-Zvi, husband of Rachel Yanait and a senior Mapai figure, to the secretary of the Women Workers' Council, Beba Idelson, concerning the dress code of "the women and girls in the Land of Yisrael." In a letter dated January 26, Ben-Zvi noted that the short pants popular among the women workers, especially on the kibbutzim, offended the sense of modesty and aroused opposition among British circles, both in Palestine and in London, as well as among Arabs "who are not among our enemies." Their impression was that "these short clothes are a sort of national fashion for Jewish women." He described this fashion as unbecoming and harmful and proposed that the Women Workers' Council demand of the bodies with which it liaised that these clothes be replaced with a look better suited to the health and climate conditions of Palestine, the accepted Middle Eastern norms, and the manners of "other cultured countries." Idelson replied that long pants had been issued to the kibbutz women at the beginning of the year (in other words, in the winter) and promised that the change that was being introduced in their clothing would influence the other women workers in both urban and rural areas.[40] It is not so much the matter of dress and the related cultural and health aspects that are relevant to our discussion, as rather the view of the woman as a figure whose behavior and manners had an impact on the condition, status, and national image of the Yishuv. This estimation had not always been self-evident.

The signs of discontent that had been fermenting beneath the surface appeared during 1938 in new places. On the occasion of International Working Women's Day, Degania Alef published a special issue of its newsletter, which contained a prophetic article by Fania Tomashov:

> Although the ideological foundations of our movement have mainly been laid by men, the realization of the way and ideas, day by day, hour after hour, has mainly been determined and will be determined by women. Gone are the days of superficial suffragism, fighting for "rights" and claiming that the main enemy of women is men, who "do not let her take her place," but, on the other hand, it is a fateful mistake to think that our mere way of life, which opens the gates of creativity before us, will redeem us. Redemption can only come from within!

The obstacles hindering the woman were inside her, she asserted.[41] In a different vein, Hayuta Bussel, the most senior among the standard-

bearers of the struggle for women's rights in Hever Hakevutzot, sounded the alarm: "We have been seized by a deep sleep."[42] This situation was not apparent in the Histadrut newspaper, *Davar*. For the first time, an advertisement spread across its entire front page informed its readers about the approaching International Working Women's Day on April 1, 1938. Contrary to the situation in most kibbutzim at that time, the announcement of the Women Workers' Council, which was also very prominently displayed there, pointed out its contribution "to the molding of a Hebrew working woman, unknown in the diaspora, who fights alongside the working man for Jewish labor as well as for protecting the worker's dignity and standard of living, and, in nights of danger, knows how to guard and defend." The announcement also presented the desirable model of imitation for the Jewish working woman: "We have aspired to combine in our movement the defensive power of the woman in Spain, the organizational skill of the English working woman, and the drive to do any kind of work of the Russian one."[43] A year later, *Dvar ha-Po'elet* reported with satisfaction that "integrating women in the defense of the country, which already exists, to a great extent, in Finland, will now be implemented in Sweden, as well."[44] Women's conferences at that time expressed abundant praise for the women who were fighting with the Republicans in the Spanish Civil War, led, of course, by Dolores Ibárruri Gómez, "La Pasionaria." Their heroism and self-sacrifice were perceived as a model for imitation and as a symbol of uncompromising commitment to the realization of socialist values, as well as of women's potential to play an active and effective role in the military area.[45]

The women's initiative to increase their involvement in the public sphere, which was substantially energized by their struggle to participate in guard duty when the Arab Revolt broke out, sought new areas in which to expand their influence and improve their status in kibbutz society. An opportunity presented itself in the form of the "jewelry drive" organized by the Kofer ha-Yishuv ("Community Ransom"), established in 1938 to raise funds for the expenses involved in security and defense. Like the campaign that had run some time previously to encourage consumption of "local produce" for economic, cultural, social, and security reasons, the "jewelry drive" similarly served the processes of feminine politicization of the national struggle, broadening the boundaries of women's activity in the public sphere with an emphasis on creating an autonomous area in which they played the central role.[46] The "local produce" and the "jewelry drive" were initiatives in which, more than in any other

situation in the history of the Yishuv, women in their thousands, and over a prolonged period, were central actors in the attempt to achieve national independence. Miriam Baratz, who managed the cowshed on Degania for decades, urged the city women:

> Is it true what we're hearing—that you mothers, you house-wives, are the reason that Jewish agricultural produce is not occupying the place it should on your tables? [. . .] It is you who play the decisive role in this matter. The household management is in your hands; the fate of Jewish produce is in your hands.[47]

The "jewelry drive" was a spontaneous, grassroots initiative that arose in 1938, led mostly by women whose financial situation made it difficult for them to contribute to the Community Ransom, but who nevertheless sought some means of personal expression and participation in funding defense. Women were generous in donating various silver and golden wares that were mementos from their parents' homes in Europe, along with wedding rings, chains, earrings, goblets, fountain pens, and more. The spontaneous gesture was soon adopted by the Yishuv establishment. A Women Workers' Council advertisement encouraged working women and mothers to contribute their share to the ongoing effort of thousands of pioneer women performing labor in dangerous places, fulfilling their role in agricultural output while guarding human lives and property. Women were encouraged to "part with the keepsake from her parents and loved ones" and thereby play their part "in the defense of the country and the war for our future in it."[48] The message was also disseminated via *Dvar ha-Po'elet*: "The form of defense currently practiced in the country does not allow for extensive participation of women members, and while in the rural areas hundreds of our women members are spending their nights performing guard duty, in the cities the scope is smaller. A [city] woman member's contribution is literally a ransom." Yisrael Rokach, mayor of Tel Aviv, who headed the Community Ransom, noted on December 13, 1938, that in the cities, some 9,000 items had been collected; in the six largest colonies, 2,000; and in the seventy-three agricultural settlements, 4,600. Aharon Tzizling of Ein Harod, commenting on these data, pointed out that one item per approximately thirty-six people was donated in the cities, while the ratio for the kibbutzim was one item per four people.[49]

Two years after the outbreak of the Arab Revolt, Gute Luria, a member of Kibbutz Ein Shemer of Hakibbutz Ha'artzi, who worked there as a teacher, recalled the reaction of the children she taught when they first saw a woman on guard duty, carrying a gun. They looked at her with distrust and mocked her: "Is that your gun? No, it isn't. It belongs to your boyfriend. You just took it." A common saying among children at the time that "the mothers are cowards" contributed to what Luria described as a "storm of conscience" throughout the movement that sought to change the prevalent attitude toward women in kibbutz society. It took great efforts to convince the children that they were wrong and to enable them to perceive the new sight of a woman carrying a weapon as "something" granting the woman "value and dignity, uplifting both her and the little girl—the little woman member" of the future.[50]

The situation in Hakibbutz Ha'artzi at that time was summarized in a blunt, poignant article by Feige Hindes (Ilanit), which described how two years earlier women members had assembled spontaneously to express their concern about their status in work, public representation, and security. But, despite their protest, they were unable to change this status, "which some consider normal, *a racist theory, of sorts*: this sex and its ability in these areas; that sex and its ability." One year before World War II, with the increasing Nazi persecution of the Jews in Germany, based on racist ideology, Hindes chose these harsh words to describe the relations between men and women in the socialist kibbutz society, which prided itself on its goal of equality between the sexes. "The male culture" existing on the kibbutz, she warned, was not hidden from its children, making them skeptical about "any new conquest of the woman in work, guard duty, or social life." Hindes, whose son, Uri Ilan, would later be captured and commit suicide in a Syrian prison in 1954, stressed that children saw, understood, and internalized the division of labor prevalent on the kibbutz: "who carries a gun and who commands, who manages the work and who is the youth leader, who addresses the public at a celebration and who eulogizes the dead."[51] A woman member of Kibbutz Sarid in the Jezreel Valley confessed that in Hashomer Hatzair "it is not appropriate now to bring up the women's question and deliberate it openly," fearing it might tarnish the idyllic outer appearance of the movement. She mentioned how, in the early 1930s, her movement had been skeptical of Hakibbutz Hameuhad and criticized it harshly for adopting a fixed quota for women in its institutions, and admitted that

experience had proved that, without compulsory organizational structures, a suitable "idea" was not in itself sufficient to change the women's situation on the kibbutz.[52]

However, it would be incorrect to say that Hakibbutz Ha'artzi did not do anything with regard to the status of women. A Committee for Women's Affairs had been established by the movement in 1937, among whose members were Emma Levine-Talmi, Rivka Gurfein, Feige Hindes, and Yona Ben-Yaakov. Regional committees operated alongside it and encouraged organization in typical female occupations on the kibbutz, such as kitchen work, supplies, laundry, and health. This indicated the women's desire to find new avenues for their involvement in public life in areas in which they had always been dominant and thus use their activity for the benefit of the kibbutz. There was increasing awareness of the importance of establishing organizational tools that would facilitate the realization of women's desires in the kibbutz, including the need "to create a cadre of women members, who would turn this activity into their 'profession,'" as Hindes defined it.[53]

The assembly of the Women Workers' Council that convened on December 18–20, 1938, was entirely devoted to organizational questions, and it was apparently only for the record that its resolutions included the following item: "The assembly points out the need to increase the efforts of the Women Workers' Council to facilitate the integration of women members in guard and security roles. The assembly encourages the women in their endeavors, since the onset of the riots [the Arab Revolt in 1936], to take part in the self-defense enterprise of the Jewish community in Palestine, and calls on them to continue and persevere on this path."[54] But this statement bears evidence of an ongoing process of routinization whose importance should not be underestimated, because it enabled members to become accustomed to women's participation in guard duty, which became an integral part of the official, standard goals of the Women Workers' Movement in Palestine. Dvora Dayan, from Nahalal—one of the most senior activists in the Labor movement and the mother of Moshe Dayan, who had just started serving in the Field Companies and who, together with Yigal Paicovich (Allon) from Ginosar, was among the young followers of Yitzhak Sadeh, the most dynamic military figure of the Haganah—summarized succinctly, in one sentence, her concern about the upheavals the younger generation was experiencing in those days: "A generation is growing on arms, on

brandishing swords. Is there no fear that the whistling of the bullet will erase more sublime melodies?"[55] Such apprehensions were not addressed, at that time or later, to women in the kibbutzim.

The Women Workers' Council met again three months later. The political circumstances had changed dramatically: the St. James Conference, convened by the British, had failed to reach a compromise between the Arabs and the Jews; the British showed signs of intending to abandon their policy of encouraging the establishment of a national home for the Jews in Palestine; and the situation in Europe had deteriorated following Germany's invasion of Czechoslovakia. Rachel Katznelson described the atmosphere as follows: "Human beings, who had been the basis for building a regime of equality, justice, and a desire to develop the spiritual resources inherent in us, have suddenly been revealed to us in a horrible form, more frightening than a wild beast, since animals lack consciousness. This sacrifice is no less painful and injurious than the bloody sacrifices we have had to make." The official agenda of the proceedings, which took place on March 26–27, 1939, was how International Working Women's Day should be celebrated a week later. But, because of the circumstances, the discussions actually focused on women's participation in guarding and defense. The representatives of the urban sector admitted that their contribution in this sphere had been, until then, strikingly modest. Bruria Goldberg from Kfar Saba, for example, related that, compared to the women of the kibbutzim and moshavim, the dozens of women she was meeting and talking to every day were not yet imbued with a "sense of homeland," and she added: "in a time of emergency, our camp [in the city] feels like a herd when a wolf approaches it. There is no feeling of readiness for battle." Based on her own experience, Rivka Aizenberg from Tel Aviv described how urban women stayed at home and did not feel the strength of people who had the ability to unite and resist. "It seems to her that some kind of fate oppresses her. I would say that this is the biological tragedy of the woman."

The women of Hakibbutz Ha'artzi had long ceased to regard this terminology as a useful way of addressing women's problems. Feige Hindes from Gan Shmuel urged her female comrades to "raise again the banner" of women's participation in defense as a central goal of the Women Workers' Movement in Palestine. She reported that although guard duty and the heavy responsibility it involved had been hard for women

at first, "now they all do guard duty. They won't give it up under any circumstances." Hindes may have exaggerated, but she did admit that the women of the kibbutz movement could not, on their own, establish a solid enough basis for women's right to participate in guard duty. She asserted that unless all the women of the Histadrut understood that if they did not participate in defense activities they would seem to be "running away from the front," the goal would not be achieved. Hindes explained that the "bourgeois woman" had already recognized the need to give first aid and assist the fighters, but that was not the main thing at that time: "Dozens and hundreds of women are ready to stand in defense within the line, and we have to take this step forward!"[56] The expression "within the line" was the code name used at that time for active participation as fighters with appropriate military training. The time had not yet come for that, and it would gradually happen later in the Palmach, but the political discourse and the contemporary situation of women were already primed for the expression of such demands. The announcement of the Women Workers' Council published on the occasion of International Working Women's Day on April 3 included only one reference to the issue of defense: "We shall fight over the place of the working woman in the defense of our enterprise."[57] This brief sentence was pregnant with meaning.

The place of the women workers (and of women in general) in the next stage of Zionist history was not at all assured, despite the developments set out above. The central organizational body that formally represented Jewish women was the Council of Jewish Women's Organizations. This body would later play a leading role in Jewish women's enlistment into the British army, as we shall see in the next chapter. However, during the years of the Arab Revolt, the Council failed to carry out its function as the representative of the Yishuv women, charged with initiating, organizing, and giving expression to their activity within and contribution to Yishuv society and the Zionist spectrum. The internal squabbles among the various constituent organizations, in the latter half of 1938 and the earlier half of 1939, concerning such issues as the wording of posters (which ultimately were never printed), or the question of whether the Council Secretariat should be located in Jerusalem or Tel Aviv, suffice as evidence of the failure of the framework that was meant to serve as a united front for Jewish women committed to the realization of Zionism.[58]

The Jewish Women's Struggle against
McDonald White Paper

It was with this sorry representation that the women approached the significant test that confronted them, along with other sectors of the Yishuv and Zionists in general, from May 17, 1939, until the end of the Second World War. On May 17, the British published the McDonald White Paper, named for the British secretary of state for the colonies. It stated that the British government had fulfilled its commitment to establish a national home for the Jews in Palestine; that an independent state would be established in Palestine within ten years; that Jewish immigration would be limited to 75,000 over the next five years, with further immigration dependent on Arab consent; and that Jews would be able to purchase land only within a narrow area of the coastal plain. The next day, and continuing for a week, mass demonstrations and outbursts of Jewish fury toward the British occurred throughout the country. Youth and women played a major part in these demonstrations, many of which were organized behind the scenes at the initiative and under the auspices of the Haganah.[59]

Prominent among the demonstrations was a series of furious protests by Jewish women in Jerusalem. On May 23, some ten thousand women representing a range of ethnic backgrounds and ages held a march, as reported in *Davar*: "Discipline was tight, and the rows of demonstrators appeared ready for anything. Masses of women marched—Germans alongside Yeminites, Kurds alongside English; some well-dressed, others in work clothes and carrying shopping baskets." Addressing the crowd of thousands, Rachel Yanait declared: "The Yishuv and the nation fear for the fate of the Third Commonwealth, and will not quieten until the danger has passed." Yanait led the procession, together with Sarah Herzog (wife of Ashkenazi Chief Rabbi Yitzhak Isaac HaLevy Herzog), Itta Yellin, and Sarah Azaryahu. The demonstrators passed through the lower end of King George Street and headed for the King David Hotel, where the offices of the British administration were located. This was the first time that Jewish women held a political demonstration in the very midst of Jerusalem's Arab population. A delegation that included the leaders of the march as well as Esther Zemora and Zahava (Goldie) Yosef met with the chief secretary of the Mandatory administration (the prime minister), handing him a memorandum on behalf of Palestine's

Jewish women, decrying the injustice to their people. Yanait declared, "We came to this country to build. Jewish mothers want a life of labor and peace. Why are you forcing us to take up arms?"[60] There is nothing special about the first part of this declaration; slogans of this sort had long been part of Zionist discourse and were widely used. Rather more remarkable is the willingness of the women—which was on clear display, with great tumult and anger—to take an active part in a fierce battle against the British. At a meeting summarizing the previous days' events, held by the Council of Jewish Women's Organizations on May 26, there was much congratulation over the great energy that had fired up the masses. It was noted that many Sephardic women had attended, and also many women who were pregnant. At the same time, there was disagreement among those present over the need for local committees in the larger cities and the colonies that would be affiliated with the Council, whose establishment was approved with a distinct lack of enthusiasm.[61] Behind the disagreement lay a rather bleak reality on the organizational level, as the members of the Council saw it, testifying to the frailty of their central framework. To compensate, they were forced to reconcile themselves to the appearance of parallel local frameworks that now sprung up all at once amid the general mood of outrage, with no connection or commitment to the Council.

The next day, a meeting of some fifty women was held at the home of Zahava Yosef (wife of Dov Yosef, a second-tier Mapai leader and legal advisor to the Jewish Agency) in Jerusalem. The spontaneous demonstrations in the city were reviewed and the dominance of the women noted, and an attempt was made to sketch some future directions of activity. The first speaker at the meeting was Rachel Yanait. Her senior status in matters of security in the Jerusalem context had been acquired over two decades of continuous activity on the local Haganah committee; over the course of this time she had helped to guide the organization and to recruit women members and train them in signaling, first aid, and more.[62] "A woman," Yanait announced with her usual pathos, "if she is capable, will lead." She defined two roles for women: the first was to turn the "local produce" slogan into a lever that would deal a blow to the Mandatory government's income from food imports and allow internal resources to be directed to the creation of new sources of employment in the cities, rather than paying for merchandise purchased by the British government or manufactured by the Arab sector in Palestine. To illustrate her intention, she told her audience: "We will create the home in

its entirety from local produce. [. . .] Whatever we cannot obtain here, we will manage without. We will create a national dress code in a new Jewish spirit. [. . .] We will give new substance to the Jewish home. It is unthinkable that we will live in Arab houses. 'By your blood shall you live'—that is the way. [. . .] A healthy, constructive way." And then she repeated a line that she claimed to have told a gathering of men, too: "We need children. We must all, happily and devotedly, help and encourage natural growth." (The fifty-four-year-old Yanait had two sons; one would be killed in battle during the War of Independence.) The other role that she assigned to the women was "rebellious defense" (civil disobedience), starting with the withholding of payment of municipal taxes (the water bill, she noted, had to be paid), with the demand that a Jewish mayor be appointed in Jerusalem, which had a Jewish majority. In response to these measures, she noted, all the participants at the meeting, who would spearhead this rebellion, were likely to be imprisoned. Yanait demanded that a committee be appointed to lead the municipal battle. As expected, most of the discussion was focused less on Yanait's suggestions for the struggle and more on the organizational aspects. Representatives of the Council of Jewish Women's Organizations who lived in Jerusalem, such as Sarah Eshbal and Sarah Azaryahu of the Women's Union for Equal Rights, along with Etel Agronsky, argued that the national organization, which was an umbrella framework for the women's organizations, should lead the struggle. By the end of the meeting, it was decided that Yanait would hold a meeting at her home the next day with representatives of the women's organizations in Jerusalem that were affiliated with the Council.[63] About six weeks later Yanait was able to announce, in *Dvar ha-Po'elet*, that Jerusalem women were joining the struggle in record numbers. Five committees were established: a finance committee tasked with "helping to introduce a 'local produce' policy into the city"; an organizational committee to initiate women's meetings on a sectorial basis; a housing committee that would compile information about Jewish families living in Arab buildings and about available apartments in Jewish buildings; a clothing committee that was meant to "introduce the concept of local produce clothing among all women's circles, starting at the top" (meaning, Jerusalem's socioeconomic elite); and a youth committee that would guide the youngsters to refrain from throwing stones and destroying property during mass demonstrations. "When we started our operations," Yanait noted, "they would ask us, 'What is your name? Who is behind you?'" But within a week, an extensive system

had been organized. "There is much ferment; there are many plans and a thirst for action."[64]

While the outburst of Yishuv women into active, independent action for national objectives had come about at a moment of crisis, it was unprecedented in its scope and political and public force. It seems that processes that had gradually been taking place far beneath the surface throughout the Mandate period were now maturing. It was a singular moment, similar to the ultimately unsuccessful struggle to volunteer for the Jewish Legion. Then as now, Yanait turned out to be the most prominent feminine figure, whose fiery enthusiasm succeeded in shaking up norms and conventions. Then as now, her campaign failed. Following the women's demonstration on May 23, the Mandate authorities announced that they would oppose any demonstration or procession on Jaffa Street, Jerusalem's central thoroughfare—and the demonstrations ceased.[65] Moreover, Ben-Gurion, chairman of the Jewish Agency Executive, who was leading the Yishuv's struggle against the White Paper, chose not the women but rather the youth, in all their various groups and movements, to play the central role in "combatant Zionism" against the British. Despite the success of the mass protest of the women of Jerusalem, which had passed through the busy Arab streets, too, Ben-Gurion held a meeting the next day with representatives of the youth organizations and warned the Jerusalemite youngsters: "Take care not to offend the feelings of a different people and the symbols of a different religion. The voice of Jerusalem is heard from one end of the world to the other. What happens here can shake the entire world—more than what happens elsewhere in the country." If Ben-Gurion met with Yanait at this time and she offered the women assistance in the struggle, he did not bother to note it in his diary. These two figures had maintained close ties since the beginning of the Second Aliya, and it is quite possible that such a meeting did indeed take place. What is clear is that a day before Yanait's article appeared in *Dvar ha-Po'elet*, Ben-Gurion met in Jerusalem with a delegation of women consisting of representatives of the various organizations comprising the Council of Jewish Women's Organizations. The name of the umbrella organization is not noted in his diary, but he did take pains to write: "I warned them against zealousness devoid of tact and common sense. It makes no sense to prohibit the purchase of bananas, when there are no Jewish(-grown) bananas on the market."[66] The gap between Yanait's ambitious words at the gathering held at the Yosef family home on May 24 and the nonexistent bananas would seem

a most accurate reflection of the readiness of the Zionist leadership to view women as a real factor in the struggle against the British White Paper. At the same time, on a different level, it is indicative of the bleak status of women in the Yishuv public sphere. The preparations by the top leadership of the Council of Jewish Women's Organizations to stand at the forefront of the struggle against the White Paper—whether by establishing local branches or through random efforts to subjugate local initiatives to their authority—were taking place at a time when many Yishuv bodies (the most prominent among them being the "Covenant of Produce Loyalists," set up by the Jewish National Council) claimed this role for themselves. The situation is reflected in a rather ludicrous light in the report by Sarah Eshbal, at a CJWO meeting held on June 12, about the organization of "a group of men" in Jerusalem who were "engaged in negotiations with Tenuva and with the Union for Local Produce. The men's committee has not yet come to an agreement with the women's committee. The negotiations continue." The next day, they wrote to the executives of the Jewish National Council and Jewish Agency executives: "We draw your attention to the fact that you should view our Council as a major public actor that is capable of aiding the Yishuv as a whole in its just battle."[67] The opinion of Ben-Gurion, who was leading the struggle, has already been noted.

The identity of the most immediate enemy was not clear: was it the British, who had just published the White Paper that sought to abort the "state in the making?" Was it the neighboring population, engaged in the Arab Revolt? Perhaps the most pressing need was preparation for battle against the Nazis, on the eve of a World War in which Jews would be a main target.

Two weeks before the outbreak of World War II, *Dvar ha-Po'elet* published a summary of a women's discussion under the heading "The Woman in Self-Defense." The exact forum and date of the talk are not known, nor is the identity of the speakers, other than Rachel Katznelson, who signed the article. Many of the prominent women mentioned above probably voiced their thoughts at this meeting. The identity of the immediate enemy at that time was unclear: was it the neighboring population engaged in the Arab Revolt; the British, who had published "the White Paper" that sought to put an end to the "state in the making"; or maybe the Germans, on the eve of the war in which the Jews were to be the main victim? In any case, the participants in the meeting concluded that if they did not present "a concrete plan" of how their

contribution could be used, then "with regard to the woman, merely economic tasks will be offered her." The prevalent feeling among them was that although the Yishuv was on the verge of an era that would require exploiting all the human resources available to it, appropriate ways of integrating women in the imminent struggle according to their abilities would not be found without "a push for comprehensive action," initiated by the Women Workers' Council.[68]

While it seemed for a time that the magic of the women's struggle to participate in guard duty had worn off and that its relevance had been eroded as the security situation in the country changed, the impression that it left in the collective memory of many women of the kibbutz movement remained a powerful one. At the same time, it served as evidence that a successful social struggle for their status in a certain sphere could project outward and help to achieve real objectives in other areas, despite the ups and downs along the way. The Second World War would soon be approaching, providing new, immeasurably stronger and broader momentum to the ongoing struggle of the pioneer women to take an active part in defense. This time, women from the colonies and the cities would join them in considerable numbers.

Another major principle that was consolidated within the Labor movement over the years of the Arab Revolt was the educational and ideological concept encapsulated in the term "purity of arms." The internal Yishuv debate concerning the proper forms of struggle against the Arabs was heightened in the wake of the adoption of offensive measures by the Haganah and the ongoing effort to distinguish these from the offensive operations of the Etzel (Irgun), which was not meticulous in avoiding bloodshed among the civilian Arab population.[69] Against this background, a pamphlet titled *Against Terrorism* was published in August 1939. It presented a series of articles and advertisements that demanded avoidance of harm to innocent Arabs. The collection concluded with an article by Puah Rakovsky—a fact that testified to her respected status among certain circles of the social elite on the dovish site of the Yishuv political spectrum. Under the heading "A Jewish Woman's Voice," Rakovsky asserted that it was not "through fire and blood" but rather with a motto of "the religion of labor" that the pioneers were realizing the building of the national home "on foundations of justice and integrity." She demanded of "Jewish women and mothers" that they persuade the youth not to be drawn after those who harmed Arabs. Even after the appearance of the White Paper, she warned, "We dare not lose our

senses, becoming wild and predatory like the inflamed, riotous gangs of murderers."[70] Rakovsky's call was a complete contrast to the belligerent tone that, we recall, had been evident in the poem by Anda Pinkerfeld. In both instances, the woman was depicted as a figure possessing a unique voice in the struggle for the molding of public opinion: a voice with its own special quality, and as such, worthy of being heard loud and clear in public. "Animals in human form," as Rakovsky mentioned a few weeks prior to the outbreak of the Second World War, certainly existed—but in central Europe rather than in Palestine.[71]

Chapter 6

The Debate on Jewish Women's Enlistment into the British Army during WWII

The Early War Years

The vigilance that characterized the women's organizations in the Yishuv over the course of the summer of 1939 was manifest in the speedy change in direction of their orientation from dealing with the Arab Revolt and the White Paper to preparations for the Second World War. On August 30, two days before the German invasion of Poland, the Tel Aviv branch of the Council of Women's Organizations drew up an emergency action plan. Its core was a call to establish civilian service for women aged thirty-five to fifty to assist municipal institutions in supplying food to the markets, maintaining public security, and increasing agricultural production in available plots in and around the city. At the same time, women were called upon to present themselves at twenty-two registration stations to receive basic instruction in first aid and treating victims of poison gas attacks. Within two days, 3,000 women had responded to the call—an unprecedented number that testified eloquently to the high level of tension at the outbreak of WWII.[1]

On September 3, the day that Britain declared war on Nazi Germany following the invasion of Poland, the directors of the Jewish Agency and the Jewish National Council decided to hold a "countrywide census of volunteers in service of the homeland." The stated objectives of the census were mobilization to strengthen the Yishuv economy, to defend the Jewish Yishuv in Palestine, and to serve in the British army when the time came. As at the time of volunteering for the Jewish Legion,

Moshe Smilansky was quick to respond, announcing, "Once again we will do what we did in 1918 [. . .]: we will fight, die, and emerge victorious on the battlefront for justice and freedom." According to British data, the population of the country on June 30, 1939, stood at around 1,466,536 souls. Aside from the nomadic tribes whose numbers were estimated at around 66,000, the population comprised about 848,000 Muslims (60 percent of the population), 424,000 Jews (30 percent), and 114,000 Christians (8 percent). In the Yishuv census that began a week later and continued over ten days (with Rosh Hashana, the Jewish New Year, falling in between), some 136,000 individuals aged eighteen to fifty reported to the registration bureaus, including 50,000 women (some 42 percent of the female Jewish population in that age group). Seemingly, these data had no special importance or value because the Hagana failed in its attempt, following the census, to add masses of activists to its ranks, and the British turned a cold shoulder toward this Zionist initiative that opposed the policy of the White Paper. Nevertheless, the level of response among the Jewish public to the census testified to a powerful cohesiveness and volunteering spirit that animated the Yishuv, as well as the degree of willingness to respond to a call by the political institutions. The relative scope of response among the men was higher—some 85,000 men, representing about 70 percent of the total men within the relevant age group,[2] but the data clearly indicate a real breakthrough in the attitude toward women and the home and the kitchen as their "natural" and "proper" place at times of crisis and existential threat. The numbers also show that the major response came not from the avant-garde proponents of the "new Jew" as conceived by the socialist-Zionist pioneering ideology, but rather from the mainstream, and it was this general public that was at the forefront of selfless commitment from this stage onward. This was not a sign that the kibbutz was being relegated to the sidelines, but rather evidence that its task-oriented approach and ethos of volunteering in crises had seeped into the broader Jewish population.

The main branch of the Haganah, in Tel Aviv, used the census and massive registration for membership in the organization to establish its first women's brigade, under the command of Nyota (Hanna) Halperin. The event was regarded as "a dream come true and the realization of a vision," and the organization's Tel Aviv office publication, BaMachaneh, waxed poetic in its description of the roll call where the women's brigade was officially announced: "What are they thinking, these uniformed figures, as they march like that up the hill? What are they thinking, as

they stand like that in rows upon rows, floodlights shining in their eyes? [. . .] For years and years we have awaited this moment, and now—it has arrived!"[3] Chairman of the Jewish Agency Executive Ben-Gurion, who proclaimed at the same time in a speech he delivered before the senior Haganah command that the aim of the Jews during the Second World War would be to bring about the establishment of a Jewish State, and that "the first requirement to this end is the establishment of a Jewish army,"[4] was forced to make do, for the time being, with the establishment of the women's brigade.

In any event, encouraged by the enthusiastic response to the census he had initiated, Ben-Gurion now redrew for a small group of senior Haganah personnel the aims to which the new recruits from the census would be directed: first, training personnel for service in the British army; second, security needs of the Yishuv; third, "conquest of the land"—no less. A discussion was held with the aim of defining the role to be played by each sector among the volunteers, with a clear hierarchy established in accordance with the degree of their security contribution, from the least to the most significant. The discussion first focused on the women who had signed up. It was suggested that they receive a partial military training, with an emphasis on signaling, first aid, and medical units. Thus it was decided that "a number of women will receive technical instruction [in areas] such as driving, [and] radioing" and that they would "serve as substitutes for kibbutz members who were mobilized." Ben-Gurion wrote in his diary that it was agreed at the meeting that the issue of women's mobilization would also be clarified in greater detail with representatives of the Women Workers' Council, WIZO, Hadassah, and the women's unions. Participants at the meeting included Yaakov Dostrovsky (Dori), the Haganah chief of staff; Yohanan Ratner, former head of the national Haganah headquarters; Dov Hoz, head of the Security Committee of the Workers' Union; Yisrael Galili, a member of the Haganah national headquarters secretariat and the most senior member of the movement representing Hakibbutz Hameuhad; and Dov Yosef, legal advisor to the Jewish Agency.[5] The participants are listed here in order to emphasize the need to adjust the prevailing scholarly view that it was the Council of Women's Organizations that initiated the recruitment of Jewish women for the British army in 1941 and led the initiative during WWII.[6] The forum that decided that this body would be a party to the discussion of women's recruitment included the Yishuv's most senior personnel in the realm of security, headed by Ben-Gurion. It was they who awarded

the Council of Women's Organizations its leading status in this area during the very first month of the war, as part of the process of dele-gating authority and making security arrangements for the Yishuv during wartime. This chapter focuses on struggles to expand the women's roles on the economic level as an introduction to the discussion of women's recruitment for the British army, with a focus on the recruitment itself rather than on their military service. Thereafter, attention is paid to the question of women joining the Palmach. All of this is viewed within the broader perspective of the conscious, deliberate activity on the part of women so as to play a meaningful role in the Yishuv's security effort during the years of WWII.

At the end of the first month of the war, there was a procession through the streets of Tel Aviv by those who had responded to the call of the national institutions. Some 6,000 young men and women, aged eighteen to thirty, marched before tens of thousands of onlookers. They marched in threes, dressed in khaki and wearing tropical hats, men and women separately. Thus, three special brigades of young women wearing Magen David Adom first-aid ribbons also participated in the march. Some days later, just a few hours before Yom Kippur (the Day of Atonement), thousands of members of the Civil Guard marched in Tel Aviv. This represented the end of the period of demonstrations and processions that had begun in February 1939 and served in that year as the main expression of the Yishuv's public struggle.[7] The period of the Arab Revolt was over. Another circle was closed, too: a day prior to the Civil Guard march, the British hanged Al-Abd Daoud Muhsein, from the Jabaliya neighborhood in Jaffa, for having shot at another Arab. It appears that he was the same Muhsein who had murdered the nurses Fink and Tzedek in 1936.[8]

The dilemma as to how women's participation in dealing with the crisis should find expression arose both from the desire to play an active role in preparations for the anticipated dangers of the war and from an awareness that the war circumstances now offered the women an oppor-tunity to improve their professional, economic, and social status. After all, at the beginning of the war the frontlines lay far from Palestine's borders, and enlistment into the army was not on the immediate agenda. Attention was directed mainly toward economic arrangements and orga-nization on the civil and municipal level—areas in which women had a relative advantage. They had accumulated experience in responsible public involvement as part of their commitment to dealing with economic

difficulties and in the effort to achieve economic independence for the kibbutzim under the emergency conditions of the Arab Revolt. Although during the census in September the Women Workers' Council and WIZO had taken the trouble to notify their members that "all announcements by the Council of Women's Organizations" urging women to sign up "are our announcements, too," there were some areas of disagreement between them. From the perspective of the Workers' Union activists, WIZO was aiming only for informational and public-relations activity, such as promoting local produce. The militant activists of the Union, on the other hand, wished to be active on the ground to ensure that such advertisements would in fact have their intended impact in stores and marketplaces. They felt that the WIZO women were, in various ways, obstructing the realization of their initiatives.[9] The different temperaments of the two largest women's organizations only exacerbated the fact that the Women Workers' Council viewed the emergency conditions as permitting them to display their full power in the Jewish women's arena. "Amongst our ranks there is a large percentage of young women who have been toughened by work and training, and they are capable of fulfilling a responsible role in defense of the land and the people," declared one of the Women Workers' Council posters, published at the outbreak of the war, with unabashed pride.[10] The organization did not suffice with generalized statements, but aspired to translate them into concrete steps.

The naive illusion that a woman, qua woman, could stand up and to and halt the progress of the evil war machine had not yet been shattered. Sara Gafni of Ein Harod was shocked by news dribbling in from Europe about children crammed into railway cars "like a herd of frightened sheep:" "Shall the International Women Workers' Movement not rise up against that? Can a worker-mother not stand in the way of these children's carriages?"[11] In a slightly more practical vein than Gafni's ultimately empty poetics, the secretary of the Women Workers' Council, Beba Idelson, approached the directors of the Jewish Agency and the National Council Executives, as well as the Executive Committee of the Workers' Union, demanding that they put together a joint plan, together with the Women Workers' Movement, to deal with the challenges of the hour in two main realms—economy and security. While the economic realm was almost self-evident, first and foremost on the consumer level, the presentation (first discreetly, later in public) of the security realm as an area in which women had the possibility

of making a unique and vital contribution was something new. Idelson viewed both areas jointly as an opportunity to integrate huge numbers of women in new spheres of activity. In the economic realm, she called for thousands of women to be trained in occupations: drivers, telephone and telegraph operators, electricians, mechanics, construction workers, factory workers, tractor drivers, communal kitchen managers, and more. In the security realm, she proposed that women be integrated into guard duty, military industry, first aid, defense against attacks, police work (civil militias, caring for children during attacks, evacuating the population from areas under bombardment), working to keep prices down and to promote local produce, and so forth.[12] From a security standpoint, these activities remained mainly on the civilian level, but in the attempt to define a long list of frameworks in which women would function during emergencies, there is a noticeable change in the way in which the Women Workers' Council viewed its tasks within society. The sweeping commitment to advance national goals arose from the prosaic desire to survive. At the same time, the approach advanced by Idelson indicates that the Council's commitment to the national enterprise was absolute and not open to the slightest doubt. The crisis following the outbreak of the war was viewed by the organization's leadership as an opportunity to display the women's ability and readiness to contribute meaningfully to the efforts to deal with the challenges facing the Yishuv, as well as an opportunity to remove some obstacles and shatter some glass ceilings in the gender context.

It was amid these historical circumstances that in 1940 the Council of Women's Organizations first presented its demand that Jewish women be enlisted for service in the British army. This stands in contrast to the prevailing view in the historical literature according to which this step came only in March 1941.[13] In their meeting with representatives of the Jewish National Council executive on July 12, 1940, the members of the Women Workers' Council asked that their organization's main office be located within the offices of the JNC in Jerusalem; that the process of training the women for the professional roles in the Yishuv economy held by men, who were gradually being mobilized into the ranks of the British army; and that the Council be integrated within the preparations for defense in such areas as first aid and the establishment of a women's militia to maintain civil order during air attacks. In fact, Idelson wanted to transform the Council of Women's Organizations into a regular department of the JNC, but her proposal met with a cool response and was

even attacked by some fellow members of the Council itself. The most that the JNC was willing to do was to commit that representatives of the Council would be included in the discussions of some of the committees dealing with various aspects of the emergency measures, and to extend formal recognition to the Council of Women's Organizations as the representative of the women's sector of the Yishuv.[14] More importantly for our discussion, on July 24 the Council held a meeting with Shertok, head of the political department of the Jewish Agency. At this meeting the representatives wanted more than just to request that women be trained for economic positions held by men. They also spoke with Shertok about "including women in future mobilizations in different positions" (sanitary nurses, pharmacists, cooks, telephone operators, etc.). They demanded that he present the issue at the next meeting with the British military headquarters. It should be emphasized that the Women Workers' Council also took care to publicize the contents of its appeal to Shertok in the organizations newspaper, *Dvar ha-Po'elet*, as well as in *Davar*. For the meantime, the only concrete result of these contacts was the invitation extended to the Council to participate in a public committee established by the Executives of the Jewish Agency and the JNC to deal with the needs of the Jewish soldiers and their families.[15]

The watershed with regard to the war, the way in which it would be approached, and the woman's role within it from a Jewish-Hebrew-feminine perspective was masterfully drawn by Rachel Katznelson. In a speech she delivered to members of the Women Workers' Council in Tel Aviv in November 1940, she stated that the advance of the war toward the country's borders (following the bombardment of Tel Aviv in September, resulting in 117 casualties) had forced a psychological adaptation to a situation of "anticipation; anticipation of death, and anticipation of dangers worse than death"—in other words, annihilation of the Yishuv. "Following the annihilation of Warsaw and Lodz, we are profoundly aware: whoever fails to defend himself, will end up humiliated in life and in death. So long as we feel the difference between dishonor and honor, we know our role at this time." As someone known in pioneering and women's circles as having preached—up to this time—avoidance of force, Katznelson now predicted: "We will perhaps be seeing scenes of women participating in battle, the likes of which were seen only in the earliest periods of human history."[16]

At the end of 1941, a ceremony was held marking the eightieth anniversary of the birth of Henrietta Szold, who had headed the Youth

Aliya project and was the most widely recognized Jewish woman in Palestine.[17] In honor of the event, the inner front cover of *Dvar ha-Po'elet* featured, alongside a photograph of Szold, a poem by Jessie Sampter, "The Mother," which had been dedicated to Szold. Szold, who belonged to the most extremely moderate Yishuv circles—first "Brit Shalom" and later the "Ihud" organization, both of which advocated a binational state—was certainly not too pleased with the new meaning that was attached, from late 1941 onward, to the opening stanza: "Another mother in Israel / defending the frontlines / Deborah and Jael, / Hannah and Judith."[18] The figures that Sampter chose when composing the poem now assumed a different, more immediate meaning, with heroines from the biblical and Hasmonean past serving not just as inspiring figures but also as models of practical feminine heroism to be emulated.

The effects of the struggle that raged in North Africa between the soldiers of the British Empire and the Italian and German forces in 1941–42 on the thinking and conduct of Jewish women in Palestine should not be underestimated. The growing fear that the Nazis would occupy Palestine hung over the pioneers throughout this time. Against the background of the fall of Yugoslavia and the British retreat from Greece, the nineteen-year-old Hannah Szenes wrote in her diary on April 23, 1941: "Everyone knows that the front is drawing nearer, and no-one dares utter the question: What will become of us if the Germans reach us. They are simple words, written on paper, but when one closes one's eyes for a moment and listens only to the heart, one hears it beating in fear."[19]

At a meeting of the Women Workers' Council held in May, Bassewitz noted that "every one of us is now living a double life: we are thinking about action and are busy doing something, but at the same time our thoughts and feelings are in another world, into which fate might cast us."[20] There were two main trends among the women in addressing the threat: enlisting in work and enlisting in the army. Ada Fishman led the first group. In a tone recalling the days of volunteering debate in 1918, and using the classic slogan of the *Ha-Po'el Ha-Tza'ir* party, her early political home, she demanded: "We have to know how to defend what already exists, and sometimes that is more important than worrying about new things." Her approach, upholding the importance of "defending what exists," matched the openly declared but unfulfilled aspiration of the women to fill the workplaces vacated by the men who were being mobilized and also sat well with a mode of activity that was prevalent

at the time among women of the British Isles. Fishman proposed "organizing, first and foremost, a 'women's agricultural army'—a Land Army, like the English model."[21]

The first concrete military step was taken in February 1941. As during WWI, the focus was first on the enlistment of nurses and medical aides for service in the British army. Hadassah Samuel, chairman of WIZO and of the Council of Women's Organizations, would seem to have assumed that after some data collection on the number of women candidates willing to enlist, "the Council of Women's Organizations will appeal to the authorities to include the Jewish women of Palestine in the war effort." Following a discussion held at the Jewish Agency offices on February 16, she initiated a census by the Jewish Agency's statistical department, which located 1,190 Jewish nurses, about half of whom expressed willingness to serve in the army—some in Palestine itself, others in neighboring countries, too. But while the preparations for the census were already underway, the initiative was halted, whether because it became clear that the British were not eager to enlist Jewish nurses or because of opposition on the part of the medical system, as expressed in a letter that Dr. Chaim Yassky, director of the Hadassah Hospital, addressed to Shertok, expressing his fears that mass enlistment of nurses for military service would impair his institution's ability to function. He emphasized that in this regard, "quality must be preferred over quantity," and noted "the necessity of extreme care in choosing the candidates so as not to besmirch the good name of Jewish nurses."[22] Given the circumstances, Samuel appears to have chosen to try a different approach. On March 30, she approached the headquarters of the British army in Palestine with a direct request to enlist Jewish women. There is insufficient documentation of the process leading up to the letter that Samuel addressed, on behalf of the Council of Women's Organizations, to Brigadier W. N. Beddington, an officer at the British headquarters in Jerusalem. We may assume that the letter was preceded by meetings that Samuel held with the Jewish Agency and especially with Shertok (because the appeal probably would have been made in coordination with him), and internal meetings with colleagues in the Council of Women's Organizations. What is clear is that Samuel's proactive nature and her cultural familiarity with the intricacies of the British administration in Jerusalem—which she had acquired over the course of her marriage to Edwin Samuel, son of the first high commissioner—played a considerable role in the consolidation and execution of the women's enlistment

project. As a first stage, the British headquarters promised to examine the idea and evaluate how it could be advanced. Six months later, the idea began to ripen in the wake of the British decision to establish a Women's Auxiliary Force in the Middle East.[23]

Negotiations with the British

On October 4, 1941, the British army issued a positive response concerning the establishment of an auxiliary women's force along the lines of the women's service that already existed in Britain. The agreement in principle was kept under wraps for the time being, until recruitment and service guidelines could be drawn up. Three days later, Hadassah Samuel announced, at a gathering of volunteers that took place at the Ohel Shem auditorium in Tel Aviv, that the Council of Women's Organizations had submitted a proposal to the government for recruitment of women in auxiliary military positions; that the proposal was awaiting approval (because the details had not yet been finalized); and that when this happened, "Jewish women will carry out their obligation in the people's war with all their strength."[24] This was the first public acknowledgment of the advanced discussions with the British in this regard. The women meanwhile encouraged men to enlist in view of the campaign that was now launched for a second round of volunteers, following the 10,000 who were already signed up. The press portrayed the women as holding the key to the enlistment target figures through urging the men to fulfill their national obligation and offering no defense for evasion of service. The women's organizations accordingly crafted an appeal to maternal emotions in the desired direction. At an enlistment meeting held on October 12 at the Orion hall in Jerusalem, Rachel Yanait, whose eldest son, Amram, had enlisted in the British army, urged for the "sense of honor and obligation of every young Jewish man." At a meeting the previous evening, a member of the Jewish Women's Union for Equal Rights, Yehudit Katinka, had acknowledged her great anguish as a mother with the enlistment of her son, Shmuel, but at the same time spoke of the "great shame" of any mother who saw her son sitting by her at this time.[25]

The first political forum to be presented with the issue of women's enlistment was the Workers' Union Council. At a meeting of this body held on October 19, Beba Idelson, secretary of the Women Workers'

Council, described the negotiations as almost complete. She did not hide the fact that some of the Yishuv's security personnel scoffed at the idea of mobilizing women. She emphasized that while the Union maintained a generally positive view of equality and inclusion of women, the reality on the ground was different, and enlisting women might serve, inter alia, as a way of advancing change in this area. Idelson demanded that the Union ensure that at least 30 percent of the women enlisted come from its ranks and that they serve as a "nucleus" that would ensure the quality of the "human material" to be enlisted. None of this aroused any discussion of the idea of enlisting women, and Shertok's presentation of the idea to the Jewish Agency Executive on October 26 met with a similarly apathetic response. Other than a statement by the representative of HaPo'el HaMizrahi, Moshe Shapira, on behalf of the religious Zionists that they would refuse "to force women to enlist," no discussion whatsoever followed.[26] In view of the storm of emotions that the issue aroused among various circles in the months that followed, one might explain the lack of any debate in October in different ways. Perhaps because of the general disinterest in and dismissal of the idea, its revolutionary character was not appreciated; perhaps chauvinist ideas played a role. However, it seems more reasonable to posit that the proposed enlistment was not yet perceived as requiring any sort of action, and therefore the initial response was negligible. A seemingly unrelated event took place in the middle of the same month: the annual memorial ceremony for Sarah Aaronsohn. About a thousand participants from Zikhron Yaakov and the right wing of the Yishuv attended. The ceremony was held under the slogan "Sarah Aaronsohn's blood calls out: enlist!" Historian Billie Melman maintains that the militarization of the Nili heroine and the blurring of her sexuality (and femininity) were then at their peak. One might have concluded that Aaronson's heroic self-sacrifice therefore prompted men to enlist into the British army. However, it should be remembered that it was exactly at that time that there came the great breach in the barrier that, until that time, had prevented hundreds of women in the Yishuv from being part of what Melman refers to as the "apotheosis of national liberation"—that is, participating in the war.[27]

Approximately two and a half million women served in the four major regular armies that engaged in fighting in Europe during WWII: Germany, Britain, the Soviet Union, and the United States. To these we must add some 200,000 women partisans who took part in guerilla operations that were integral to the war. The main objective of women's

service in the regular forces was twofold: in the national realm, it was meant to display unity and readiness for self-sacrifice for the sake of victory; in the military realm, it freed men from home-front tasks, enabling more of them to fight on the frontlines. In Germany, Britain, and the United States, women filled mainly logistical and administrative positions, mostly civilian in nature. The main military role that women played in Britain and in Germany was in anti-aircraft combat. In the Soviet Union, on the other hand, the boundaries between the frontlines and the home front soon became blurred, and the number of women enlisted in the Red Army rose from 1,000 at the commencement of Operation Barbarossa on June 21, 1941, to about a million women in military roles by the end of the war. They served in nursing and transportation roles; as snipers and gunners; in tanks and planes, anti-aircraft combat, and intelligence; as radio operators; and more. Soviet propaganda weaved countless legends around such courageous heroines as Nina Onilova, a gunner who fought at Odessa and was killed in the battle of Sevastopol, or the nurse Valeria Gnarovskaya, who threw herself under the tracks of an advancing German tank, detonating the hand grenades she was holding, thereby sacrificing her own life to save a nursing station with the seventy-odd injured soldiers housed in it. In the United States, as in the Soviet Union, the real push to mobilize women came in the wake of the Japanese attack on Pearl Harbor in December 1941, which prompted the United States to enter the war. In other words, it was military needs and the dramatic change in the civil agenda that dictated and catalyzed, to a significant extent, the inclusion of women in the ranks of the military. Paralleling the developments in the two great democracies, Britain and the United States, in Palestine too the political involvement of women helped to break through limits and prohibitions that had, in the past, left women outside the military framework.[28]

In the months preceding the British agreement in principle to enlistment of Jewish women into the military, and in the two months that followed, negotiations were conducted between the Political Department of the Jewish Agency and Hadassah Samuel on behalf of the Council of Women's Organizations and the British Middle East Command in Cairo (which consulted with the decision makers in London) regarding the conditions for enlistment and service. Three basic assumptions set the boundaries of the discussion based on preliminary commitments that the Zionists made to the British: the women would not serve exclusively in Palestine, the numerical target was approximately 5,000 recruits, and

there would be no political restrictions regarding identity of the recruits as a result of internal Yishuv disputes (for example, with Revisionists).[29] Clarification was needed on a few points: first, how would the enlistment actually be carried out? The British wanted to announce a target of 5,000 women recruits—2,000 right away, with another 3,000 sometime later. It was eventually agreed that there would be an officers' course for the personnel who would be training the women and commanding them. Upon completion of the course, an initial group of 500 women would be enlisted, with another few hundred each month. Second, who would oversee the enlistment? The Jewish Agency demanded that its own recruitment bureaus be given exclusive authority "out of concern for the selection of suitable human material." Third, what would a woman soldier's wages be?[30]

While the discussions about the procedures for enlistment were going on, it was necessary to prepare public opinion in the Yishuv for the idea. It is reasonable to assume that the body whose principled stand on the issue had the power to influence the fate of the initiative one way or the other was the Council of Women's Workers. It numbered 52,000 members at the time, representing 47 percent of the membership of the Workers' Union. The 22nd countrywide session of the Council took place on November 3–4, 1941, at the Ohel Shem auditorium in Tel Aviv, and was devoted mainly to the issue of women's enlistment. In her opening remarks, Idelson stated that the enlistment of women was the product of negotiations that had been held between the Jewish Agency's Political Department, "with the participation of representatives of the Council of Women's Workers," and the British Army. Hadassah Samuel's post facto attempts to appropriate the leading role in managing these contacts reflect a good measure of the truth, and it would be fair to say that her entrepreneurial approach is what motivated and spurred the process, with the backing of Shertok, who was at first somewhat skeptical as to the possibility of persuading the British.[31] From the moment the British indicated a positive response, Shertok placed himself squarely at the forefront of those promoting the idea and repelling efforts to sabotage it; he became its spokesman in the political arena. It is no coincidence that he had originally been meant to represent the Zionist institutions at the session of the Council of Women's Workers, although ultimately the role was filled by his brother-in-law and partner in the public struggle for women's enlistment, the unofficial commander of the Haganah—Golomb.

Idelson declared, during the discussions at the session of the Council, that the aim was to enlist between 2,000 and 5,000 women, taking into consideration the shortage of workers in the agricultural sphere, industry, and service; and the guiding principle in the enlistment of men: "some to the economy, some to arms." The role of the women members of the Workers' Union, she emphasized, was to serve as "pioneers" in the general enlistment of the women; in this way they could also "ensure the [quality of the] human material." It was not for nothing that this point was emphasized over and over. Concern for the honor and morality of Jewish women, and fears of improper sexual behavior that might stain the Zionist movement in general, were regarded as critical right from the outset. Shertok told the Youth Aliya bureau that inquired on behalf of its women students about enlistment that volunteers would be accepted only "by recommendation of the authorized institutions, in order to ensure moral quality." In his introductory words to the session of the Women Workers Council, Golomb described the concrete circumstances within which the women were being asked to enlist based on information that had recently been obtained concerning the situation of the Jews in Romania: thousands were being slaughtered with no possibility of defending themselves; hundreds of Jews were being gassed in railway cars; they would suffocate and lose their minds because of the lack of air, and if they stuck their hands out of the cars to collect drops of rain or snowflakes, they were shot at. He demanded that every participant ask herself, "How will we ourselves stand, with the frontlines approaching, and with reports of this sort reaching us from the frontlines in the areas previously occupied?" He stated openly that "a war of annihilation" had been declared against the Jews. In view of this reality, which was not always spelled out in such clear and frightening terms as Golomb used on this occasion, he called upon them to enlist. As a member of the Committee of Volunteers from WWI, he recalled those earlier years and noted that, relatively speaking, the women volunteers had been far more active in the volunteering effort than they were now. But this time their struggle to join the armed forces was successful—and it happened more easily than they could have imagined. The session of the Women Workers Council expressed support for the enlistment of Jewish women into the British army, along with mobilization for "internal security services [i.e., the Haganah and the police force], and for assisting in agricultural activities," but there were limitations: the recruits, it was stipulated, had to serve in Jewish units and had to fulfil their roles as work groups rather

than as individuals; they had to receive approval from the Recruitment Department of the Jewish Agency; they had to be between the ages of twenty and forty-five, with emphasis on the more mature women; they could not be recruited for service as drivers of army officers, and their salary had to be equal to the salary paid to women recruits in Britain or to the salaries of men enlisted in Palestine.[32]

This list of demands had been accepted, for the most part, during the initial negotiations over conditions of enlistment, but because of the sensitivity and secretive nature of the negotiations with the British, it was published only about three months later, when the whole country became caught up in the debate over enlistment. This detracted from the significance of these points in the public sphere, and an opportunity for the Women Workers' Council to portray itself as the bearer of an innovative message was lost.

The negotiations over women's enlistment were completed after the arrival in Palestine on December 15 of Lieut. Col. Audrey Chitty, commander of the Auxiliary Territorial Service (ATS) of the British Army in the Middle East. The conditions were set down as follows: enlistment would be open to women volunteers, both Jewish and of other religions, aged twenty to forty-five, single or married. They would serve in auxiliary positions in hospitals (as secretaries, cooks, dietitians, inventory managers, nurses' assistants, masseuses, radiographers, lab workers, pharmacists, and ambulance drivers); as drivers (of new cars from the stations to the camps, returning repaired cars from garages to the camps, drivers of officers' cars); and at warehouses (managing clothing and vehicle parts warehouses, as warehouse secretaries, as clerks for lists of warehouses and repairs). The nursing profession was not included within the scope of the women's auxiliary corps. The women would serve in Palestine and throughout the Middle East in keeping with the war needs. Jewish women would serve in company frameworks that, in time, would become battalions. A cadre squad course would be held for sixty handpicked women: forty would be chosen by the Jewish Agency's Enlistment Department; the remainder would be chosen by the British. Approximately 500 women volunteers would be enlisted each month, with the aim of reaching a total of about 5,000. Each woman recruit would receive three-quarters of the salary of a soldier in Palestine. The uniform would be that of the ATS, with the addition of the letter "P" (for Palestine). This addition was quickly abandoned by the British for fear of placing undue emphasis on an independent national identity in

the country. The women's training camp would be located at Sarafand (Tzrifin).[33]

The British announced the plan officially on December 24, and two notices were published in the daily press—one by the Jewish Agency and the JNC, the other by the Council of Women's Organizations. The enlistment process was divided into three stages: registration of volunteers starting on December 26, 1941; the training course starting on January 18, 1942; and the mobilization of the first group of women soldiers on March 15–16. During the first two days of registration, some 300 women arrived at the stations, including the two daughters of Avraham Shapira, the fabled guard of Petah Tikva during the First Aliya.[34] An editorial in *Davar* presented this development as a further stage in the Yishuv's war effort and its participation in the World War. At the same time, it noted that "our volunteering is not being carried out in an atmosphere of 'taking things too far'" because, in contrast to the situation among other peoples, Jewish women were not being permitted to serve in Jewish men's units. The newspaper expressed hope that the women's response would motivate more men to enlist because the volunteer figures had recently slackened. It noted that ultimately women had not served as volunteers in the Jewish Legion during the First World War because "their willingness was not accepted." Now, it suggested, "the way is open."[35] However, there were still many obstacles along the way, with considerable opposition at home.

The Debate Rages

Three days before the public announcement concerning women's enlistment, on December 24, 1941, there came the first significant attempt to sabotage this development. At a meeting of the Jewish Agency Executive, there were some participants who sought—each in his own way—to put a spoke in the wheels. They included Emil Shmorak of the General Zionists; Yehuda Leib Fishman of Mizrahi; Werner Senator, representing the non-Zionists; and Adv. Dov Yosef of Mapai, who was Shertok's deputy in the Political Department. Their arguments, ranging from sweeping opposition to women's enlistment via a preference for first enlisting all available men, to a condition that women would serve only in Palestine, were all rejected firmly by Shertok. He explained to his colleagues that from the British perspective, enlistment of women

would "answer a practical need in this war," and the decision to proceed at this time did not reflect recognition of "a just demand on the part of the women of Palestine"; rather, the British had "begun replacing men in the army with women" on various fronts. As in Australia, South Africa, and elsewhere, in the Middle East, too, men were now being transferred from home-front positions to combat positions on the frontlines or were engaged in activities requiring greater physical stamina. The essence of the debate was sidelined when Yosef announced, just a moment after Shertok left the meeting to fulfill some other commitment: "I know what those battalions were [like] in England in the last war. I wouldn't allow my daughter to enlist, even if there'd be thirty [Jewish women] all together in the same place." With rhetorical skill, he noted that "the Welfare Department of Tel Aviv municipality has a list of 650 women who make their living in aberrant ways," and said that he would be happy about women's enlistment if he knew that the candidates involved would be the girls sitting in cafés, doing nothing productive, but could not muster any enthusiasm about enlisting girls who were working in agriculture, such they could be sent to the army to wash hospital floors. The Jewish Agency Executive authorized three of its members to make a decision about women's enlistment, and the next day the matter was decided in favor at a joint meeting of representatives of the Jewish Agency Executive, the JNC, and the Council of Women's Organizations.[36]

Among the early supporters of the idea were Chaim Weizmann and his wife, Vera, who said, "If only I was younger and could enlist with you."[37] On January 8, 1942, the Mapai Central Committee addressed the issue. Shertok maintained in principle that a woman had the right to demand to participate actively in the war, and she "need not stand here on a lower level; she is a citizen, just like a man." As head of the Jewish Agency Political Department, Shertok removed from the agenda any special political motivation for enlisting women, other than the fact that this was yet another manifestation that there existed in the country an organized Jewish public that behaved as a nation; and it testified to the existence of Jewish women who were a body with social responsibility and with political responsibility toward the Zionist collective. As a senior figure who viewed politics as a device for molding society and its trends, Shertok's support was based on social considerations pertaining to the consolidation of the structure and character of the Yishuv and of the Zionist enterprise as bearing a modern identity and message, in which it was essential that women be educated "to an awareness of her

full citizenship," and that men be educated to an awareness of the full citizenship of women. Tactically, to relieve some of the personal responsibility that rested with him, Shertok described the women's enlistment as arising from a demand by their representative bodies—the Council of Women's Organizations, including the Women Workers' Council—and said that, under the circumstances, the Council of Women's Organizations had been chosen to appear before the British army as "a women's movement demanding its rights and its place, and highlighting itself and its capability." As to the occupations in which the women would serve, the head of the Political Department stated that the British army preferred to take English and Australian nurses because it did not have full confidence in the nurses from Palestine: the injured soldiers would perceive them as foreign, and a large number of potential candidates were not fluent enough in English to perform routine functions or provide emotional support. On the other hand, he rejected the opposition to women soldiers serving as drivers for officers, arguing that this was a military job like any other and not a matter of subjugation. The fears of "national humiliation" arising from improper personal ties between Jewish women and English soldiers would depend on the women's behavior and the living conditions in each place. Anyone who wished to avoid any sort of contact, he commented, would do well to oppose women's enlistment—but should take into account that the same sort of fraternizing was taking place in everyday life in Palestine in any event. The two most senior political figures in Mapai at the time (in the absence of Ben-Gurion, who was in the United States), Berl Katznelson and secretary of the Workers' Union David Remez, had no comment. Their silence was evidence of their reservations, but in political terms it left Shertok to handle the battle on the public front alone. Accepting the proposal of Pinhas Lubianiker (Lavon), the Mapai Central Committee decided to support women's enlistment, thereby awarding the initiative the approval of the strongest political body in Yishuv society.[38]

The discussion in the Committee was troubled by an objection to women's enlistment that had been expressed by the Council of Hakibbutz Hameuhad a week and a half earlier, on December 28, 1941, preceded by an objection by the Secretariat of the Hakibbutz Ha'artzi. Although Lubianiker, the most prominent political figure among these groups, expressed support, his movement—like the other kibbutz movements—was not reconciled to the idea until Shertok warned them that

failure to take up this challenge would harm the status of the Kibbutz Movement: "Pioneering is not a right that is acquired through a single act, by virtue of which it exists forever. Pioneering is always required to stand the test of every emergency situation anew."[39] While until then it had been generally accepted that the Labor movement took an active and leading role in every complicated task or especially demanding mission, when it came to women's enlistment there were a good number of senior kibbutz and moshav members who took a negative view. Rachel Tannait, who participated in the selection of the candidates for officers' positions, testified at the Mapai Central Committee that she felt that "the pioneering girls are missing" from the initiative; "the farming girls, the girls from the movement, from the kibbutzim, are missing."[40]

At the end of December 1941, the Council of Hakibbutz Hameuhad at Givat Haim decided that "women kibbutz members will be enlisted exclusively into Jewish units that are attached to Jewish army units." What this decision signified, in concrete terms, was a sweeping opposition to women's enlistment because it went against the agreements entered into with the British. Practically speaking, attaching the women to the Jewish men's units meant enlisting only 100 to 200 women, owing to the limited administrative needs of these units. Opposition to women's enlistment was led by Tabenkin, who maintained that if a woman kibbutz member wished to enlist, she should not be prevented from doing so, but the movement's institutions should not organize the enlistment. In terms of the accepted codes in Hakibbutz Hameuhad, his approach meant that in the absence of support from the movement's institutions, a woman who enlisted would in fact be cutting herself off from her kibbutz. Tabenkin's colleague in leading the movement and at Ein Harod, Tzizling, disagreed vehemently with Tabenkin and headed the pro-enlistment camp among Hakibbutz Hameuhad. He rejected the attempt to evade expressing a position on the question, arguing that "the kibbutz must have its say—in favor or against. The individual cannot be left alone and abandoned, because the implications of this go against our entire [collective] essence." Tzizling's view, as noted, was rejected by Hakibbutz Hameuhad Council in December 1941. The seething internal debate did not subside, and Tzizling proposed that the movement organize the enlistment (thereby imposing an enlistment quota on its kibbutzim) of about forty women members from among the first 1,000 ATS recruits, proportionate to the relative size of the quota for men's enlistment (Hakibbutz Hameuhad

actually supplied three times the required number). Once again his view was rejected, by a majority of thirty-nine to twenty-eight, at Hakibbutz Hameuhad Council that met in Yagur on February 6–7, 1942.[41]

On the morning of the gathering, February 6, an unusual notice appeared in the newsletter of Hakibbutz Hameuhad, *Tzror Mikhtavim*. It announced that the movement's Council would commence that day in Yagur; "On the agenda: army enlistment for women members." These few words signified a revolution in the lives of Jewish women in Palestine in the twentieth century. As in any substantial conflict in kibbutz life, the members of Ein Harod found themselves at the focus of the controversy. Seemingly without connection to this debate, an article about Ein Harod appeared in *Dvar ha-Po'elet* in January 1942, written by Yocheved Bat-Rachel. In it, she stated that the women members of Ein Harod had often displayed "a high level of fraternity and public responsibility," and as an example she cited their initiative in struggling over their place in the defense of the kibbutz. She praised the phenomenon of the kibbutz as an extended family, which had first appeared in its all-encompassing form in Ein Harod, and lauded Ein Harod's innovativeness in "paving the way to communal education." At the same time, Bat-Rachel stated that Ein Harod society had no need for "worship of the woman" or "worship of the mother," nor any special consideration for her; all that was required was that she be permitted to appear in public "in her full human stature."[42]

Tabenkin, the most prominent figure in Ein Harod and leader of Hakibbutz Hameuhad, did not view the matter of women's enlistment into the British army as an issue in its own right. In his unique associative style, he chose to express the full intensity of the opposition that he wished to inspire in the movement by alluding to the matriarch Rachel (of all the famous women of Jewish history) and the emotional opening line of the poem "Rachel," composed by the eponymous poetess of the Labor movement: "Indeed, her blood flows in my own."[43] Harboring a mistrust of gentiles in general and the British Mandatory power in particular, Tabenkin deliberately twisted the meaning of Rachel's poem, using its biblical narrative context to express his fear for the fate of women kibbutz members who would enlist in the British army, recalling the fate of Jewish women who had been raped in pogroms in the Diaspora. Tabenkin appealed to the darkest primal fears of his generation, which yearned to free itself of its humiliating past and sought in all its endeavors to create the "new Jew."

True to the pattern established through ideological conflicts reaching back to the early days of the kibbutz enterprise, Tabenkin was opposed by his colleague from Kinneret during WWI—Rachel Katznelson. She participated in the discussion held by the Council of Hakibbutz Hameuhad in Yagur as representative of the Women Workers' Council. Katznelson, it will be recalled, had been fiercely opposed to volunteering for the Jewish Legion in 1918. She maintained that a woman who took up arms during wartime would invest the same measure of devotion and seriousness with which she approached the other tasks that she took upon herself, and would "excel at murdering." Katznelson therefore acknowledged that her reconcilement to the present need for women's enlistment did not come easily to her but rather with "tremendous upset," in view of the danger indicated by Tabenkin. However, based on her discussions with the volunteers, she expressed her confidence that these women would be able to maintain their honor. The main issue that occupied her in the prevailing circumstances, so far as the gender context was involved—and after emphasizing that this was not the only point that concerned her and that she regarded as decisive—was the fact that through this process of clarification, "the women has been placed at the center [. . .], with her desire to be liberated and with her fear of being liberated." From this specific perspective, she insisted, the present enlistment "determines the issue of women workers in Palestine, and the issue of women in the Yishuv." In the absence of support by Hakibbutz Hameuhad—the task-oriented ideological body whose proper, moral guiding principles the urban Union members had come to look up to—the women workers now felt "a sense of orphanhood." It would seem that what tipped the scales for Rachel Katznelson in favor of enlistment at this point—to some extent as it had for Berl Katznelson during the debate over volunteering in 1918—was the romantic dimension of spontaneity that was inseparably tied up with public leadership. She told the gathering in Yagur, "There are things that we, as leaders, make an accounting for. But we cannot completely ignore the things that are spontaneous. We, as upholders of democracy, cannot ignore this—even when this spontaneous idea manifests itself in a woman of Yemenite origin, or in a woman who does not belong to some or other particular political stream." During the struggle against the White Paper in 1939, she recalled, she had seen how the faces of women from the suburbs of Jerusalem and Tel Aviv had "lighted up" when the Women Workers' Council had called upon them to be part of the confrontation with the British. She concluded, "It may be that I

am better than some other member at analyzing the matter, but I must take into account her spontaneous feeling. If I do not take into account the enthusiasm of the masses, and the intuition of the masses, and the emotion of the masses, then with whom am I building the movement? That is the foundation! That is what we are building upon."[44]

Tabenkin, who was focused at the time on building up the independent Jewish military force at the disposal of the national institutions and nurturing an activist mood, is sometimes portrayed as having been blind to the value of enlistment into the ranks of the British army during WWII. From a certain perspective this blindness was fortuitous, in historical terms, because it would appear that only by virtue of this sort of blindness and almost complete immersion in the glorification of the Palmach and what it represented and expressed in Yishuv society that the unit survived during the years 1941–48. That single-minded devotion made it possible to deal with the difficulties that hindered its expansion and to prevent its closure through the combination of work and training, thereby nurturing the Palmach as the primary military body protecting Jewish survival and realizing the Zionist aim in the War of Independence. The Palmach was one of the most original and daring creations by virtue of which Tabenkin, through his dominant involvement, acquired his place in Zionist and Israeli history.[45] The crux of the debate at this time between Shertok and Golomb, on the one hand, and Tabenkin, on the other, concerned the question of where the main efforts in developing the Yishuv's military capability should be invested in anticipation of the struggle that would follow the World War. The issue of women's enlistment was a secondary function of this debate. Only in this context is it possible to understand accurately the collision between the different views held by the personalities responsible for security on the subject of enlistment into the British army. This debate joined a list of other inner tensions (unification of the youth movements, unification of the kibbutz movements, the existence of independent parties, etc.) that weighed down on Mapai during 1941–42, eventually leading to a political schism, the conference at Kfar Vitkin in October 1942, and the removal of Hakibbutz Hameuhad from the party in 1944.[46] In the discussions of Hakibbutz Hameuhad Council in Yagur, Golomb stated that his approach to the issue was slightly different from that of Rachel Katznelson. Women's liberation was very important, he noted, and so was their status in Yishuv life and their impact on the molding of the Yishuv's social structure. Nevertheless, the decisive factor, outweighing anything

else, to his view, was concern for the Yishuv's ability to maintain itself right now and to prepare it for the struggle over Zionist actualization at the end of the war. Therefore, Golomb concluded, it was essential to ensure that as many Jews as possible would fight in the ranks of the British army, for this would determine the fate of Zionism one way or the other, and this effort required the enlistment of women, too.[47]

Lest there be any doubt, it must be emphasized that service in the British army was perceived throughout Hakibbutz Hameuhad as a valuable endeavor. In September 1941, just prior to the controversy concerning women's enlistment, there were 862 members of Hakibbutz Hameuhad serving in the defense realm, of them 605 in the British army, 162 as policemen, and 95 in the Palmach (which had been established six months previously). The number of members and candidates for membership in Hakibbutz Hameuhad at the time was 9,080,[48] meaning that about 10 percent of the movement's members were already taking an active part in the defense burden. The top item on the agenda of Hakibbutz Hameuhad Council held at Givat Brenner on April 15–16 was the demand by the national institutions that the movement recruit another 600 of its members for the various defense frameworks. At the opening of the discussions, Yisrael Galili, a member of Kibbutz Na'an and representative of Hakibbutz Hameuhad in the Haganah national headquarters, presented the demand that the movement finance the continued existence of the Palmach by means of work and training camps, because no other body in the Yishuv was willing to bear this burden. The war in North Africa was turning in favor of the German army, under Erwin Rommel's command, and over the next few months it seemed at times that the Germans were about to invade Palestine. Tabenkin declared at the Council, "We must not speak in fancy language about saving the remnant of Israel. The Jewish society of the Yishuv is the remnant of Israel only to the extent that it is in the Land of Yisrael." He rejected out of hand the ideas that were being floated at the time about withdrawing from Palestine. In nurturing the sweeping, fiery faith in the Yishuv's steadfastness, Tabenkin had no equal in the Labor movement. On this basis, then, and as part of the movement's response to the range of defense tasks that now faced it, it toned down its resistance to enlistment of women from Hakibbutz Hameuhad into the British army. At the conclusion of its discussions, the Council at Givat Brenner decided to abandon the movement's previous stand, which had supported enlistment of women only if they were to be attached

to Jewish units in the British army, and which had made the national institutions responsible for the enlistment—an approach whose concrete implications meant a negation of the whole idea. Hakibbutz Hameuhad agreed to "respond to the demand and to organize the participation of women kibbutz members in the enlistment" as part of the necessity of "giving women members roles in guard duty and defense, and training them quickly for these roles."[49] For Tabenkin, the most enthusiastic supporter among the top leadership of the Labor movement of women's integration in the Haganah, it was the second part of the resolution, rather than enlistment into the British army, that was of primary importance.

At Hakibbutz Hameuhad Council in Yagur there were also various women who also expressed views opposing enlistment of the movement's women into the British army. These included Senetta Yoseftal, who had immigrated from Germany in 1938 and was intimately familiar with the fate of German Jewry; Tabenkin's partner, Chuma Chayut; and Shulamit Zhernovskaya, who was the first woman to perform guard duty in Ein Harod in 1936.[50] All three women mentioned supported activism. Thus we may state that Tabenkin's attempt to present the controversy as a "war of the sexes," and to glorify what he described as an instinctive recoiling on the men's part from what the women who served in the army might expect, was in fact a distraction tactic. It was the fruit of a conscious choice to avoid revealing and conducting in the public view the fierce debate that raged among the heads of Mapai over priorities in the area of defense. In this context we may adopt the evaluation of historian Yoav Gelber, who asserts that under the disguise of emotional speeches about the covenant between the importance of enlistment into the police force, the Palmach, and the British army, on the one hand, and taking care of the general needs of the Yishuv, on the other, Hakibbutz Hameuhad placed its emphasis on enlisting in the Palmach.[51] One of the prices of this emphasis was permitting women from Hakibbutz Hameuhad to enlist in the British army, which served to camouflage and blur the intentions and defense priorities of Tabenkin and Galili.

At the beginning of 1943, Tabenkin alluded to a positive aspect of Jewish women's service in the British army, and in his usual style, he did so in an associative way. At his movement's Council, he recounted the story of a member of Hakibbutz Hameuhad serving as a soldier in a hospital in Egypt. When a black soldier fighting in the American or British army was hospitalized, "the nurse he hopes will approach him is the Jewish nurse." Tabenkin explained to the participants in the

Council that these black soldiers were hospitalized in a separate tent and did not eat together with everyone else. They were partners in the war, the Nazis despised their race and therefore would not bring them any salvation, "but nevertheless—they were alone in this war. And the kibbutz member, the Jewish nurse, is glad and proud that a mulatto has greater faith in her [than in the other nurses]." Tabenkin concluded: "I feel myself related to those blacks."

He had preceded this story with a difficult acknowledgment: "It is not true that we did not know what was happening to European Jewry. We knew everything! And now we're seeking the guilty party among ourselves! That is an expression of appalling helplessness"—because the guilty Nazis would be difficult to punish, and instead the Yishuv sought culprits in its midst.[52] Although for rhetorical purposes Tabenkin painted an especially severe picture of the scope of knowledge in Palestine concerning the annihilation of European Jewry during the first half of 1942, when the phenomenon of seeking culprits began to appear, it is clear that while he headed the lengthy polemic against women's enlistment, Tabenkin had been well aware that hundreds of thousands of Jews—children, women, and the elderly—had been physically harmed and executed in a variety of horribly violent ways. And yet the leader of a public that was guided by pioneering and self-sacrifice had appeared in discussion after discussion, over a period of five months, taking the debate within the movement to an extreme, amplifying the horror at the thought that a British or Australian soldier might, heaven forbid, harm a young kibbutz woman from Ein Harod or Yagur. In the historical literature about the Holocaust and the period preceding it, there is a popular style of discussion that seeks, for the sake of dramatization and to serve needs that preclude well-considered and focused study, to identify expressions of Jewish blindness and failure to see the reality in Europe for what it was. While it is advisable that historians, enjoying the benefit of hindsight, adopt a judgmental attitude toward the subject of their study only in the rarest of instances, when it comes to the issue of women's enlistment, it is all but impossible to avoid condemning the leadership. As we view it, the approach taken by Hakibbutz Hameuhad up to the decisions of the Council at Givat Brenner, and Tabenkin's conduct in this matter in particular, are a blot on the movement and the man who led it.

While Hakibbutz Hameuhad was arguing backward and forward concerning women's enlistment, the Fifth Conference of the Women

Workers' Council met on February 22, 1942, ten years after the previous Congress. The Conference represented 52,694 members, a substantial increase from the 12,000 members comprising the organization in the early 1930s. That the Women Workers' Council was no longer considered a sort of stepchild of the Labor movement is attested to by an editorial that appeared in *Davar* at the opening of the Conference: "There is no Jewish movement today—nor has there been any Jewish movement until now—that has enjoyed such extensive, such active, such responsible participation by its women members as the workers' movement in Palestine."[53] The veracity of this statement was immediately illustrated when, in the midst of the Conference, it was announced that the illegal immigration ship *Struma* had sunk in the Black Sea with more than 760 Jewish refugees from Romania on board. The discussions were halted, and hundreds of delegates to the conference joined a quasi-spontaneous protest march through the streets of Tel Aviv. Bat-Sheva Haikin, who—as representative of Hakibbutz Hameuhad—delivered a speech at the session of the Conference devoted to women in the pioneering enterprise, acknowledged openly that the "one third" representation rule that Bassewitz had initiated and Haikin had opposed had helped increase the level of women's representation in the movement's various public institutions. At the same time, she added, because "everyone knows that in life, practice is more powerful than law, we hope that this law will not need to exist forever."[54] The timing of this gathering of the Women Workers' Conference had no direct connection to the controversy over enlistment, but the topic featured as one of the burning issues on the agenda of the women of the Workers' Union. The keynote address was delivered by Shertok, who defined women's enlistment as a "courageous" and innovative step, because Jewish women soldiers had never existed and Jewish women had never yet worn army uniforms, and therefore "many men and women alike are reluctant to take this leap into uncharted waters." Rachel Friedland, who headed the Haganah administration of women's enlistment for the British army, reproached those who belittled the value of women serving because they were not permitted to bear arms: "Can we demand of the conservative British army that which we have not managed to obtain from our own colleagues?"[55]

Davar reported that the discussion about women's enlistment at the Conference reached its climax with a speech by Rivka Guber, a member of Moshav Kfar Bilu and a mother of three, because "no artist, using the finest of materials, could have transfixed the Congress as she

did, molding the figure of a pioneer woman obeying her conscience" and responding to the call to enlist. Her modesty moved those present: "I am not a heroine. I am not Joan of Arc, but when I am called upon to lend a hand to the company of defenders—can I fail to respond? My age and family situation suffice to show that I am not seeking adventure." Guber—who came to be known as "the brothers' mother"—told the representatives at the Congress that her fourteen-year-old son (Efraim, who would be killed during the War of Independence, just a few months before his younger brother, Zvi, was also killed) had said that he knew that if women were to be recruited, his mother would certainly be the first to enlist. What she failed to mention was included in a letter than Efraim sent to a friend, in which he wrote that since learning of his mother's intention to enlist, "no-one sets foot in our home [. . .] Everyone seems to be avoiding us [. . .] It appears that everyone considers Mother's act as some sort of crime." In contrast, the Russian revolutionary Xenia Pampilova, who became a member of Kibbutz Na'an, was rapturous: "This is a perfect mingling of woman citizen and mother."[56] The resolutions of the Fifth Conference of Women Workers on the subject of women's enlistment aimed to highlight the military dimension and stated that the objective was to allow an opportunity for women to display "their full ability, not just in auxiliary service, but also in combat positions, just as they have succeeded in building together with men." Women's enlistment was compared to the professed egalitarian partnership in the settlement enterprise and as a station—just like the enlistment of men— on the road to establishing a Jewish army. Both ideas, along with the demand that women soldiers be trained in the use of weapons in order to be able to defend themselves in dangerous situations, were supported by the activist spirit with which the women representatives of Hakibbutz Hameuhad sought to inspire the resolutions of the Congress. At the same time, the Congress declared that the Women Workers' Movement "demanded" of women members "of the kibbutzim, the colonies and the cities" to volunteer.[57] Although the imposition of an obligation on the women to enlist—like that imposed on the men—was merely declaratory at this stage, the terminology was not coincidental, but rather a result of the ongoing debate on the issue among the pioneers. The Moshav movement decided, at the end of April, that it "encouraged the enlistment of women in Palestine to the [British] army, the police force, and other security services" and determined that a woman would be included on the recruitment committees of the movement and of each moshav.

Most importantly, it declared that "when any woman member of a moshav enlists in the army, the moshav—along with the movement as a whole—is responsible for maintaining her farmstead and her family's living standard."[58]

Enlistment in the Shadow of the Ongoing Debate

While the internal debate was raging, the women's enlistment proceeded in accordance with the guidelines that Samuel and Shertok had coordinated with the British commanders. The Council of Women's Organizations played a central role in the first six months of the initiative. The sensitive issues—obtaining permission to enlist nurses, training women as drivers of British officers, the age of conscripts, the need to investigate the women's moral standards, the coordination with the Haganah and referral of some of the volunteers to its ranks, the attachment of the women to Jewish units, and the preference that they remain in Palestine—were clarified first in discussions of the Council of Women's Organizations. The Recruitment Department of the Jewish Agency was authorized to carry out its role in full cooperation with the Council of Women's Organizations with the approval of the two most senior personnel in the Haganah—Moshe Kleinbaum (Sneh), head of the military headquarters, and Golomb.[59] In a meeting held on February 4 between the Haganah leadership and women members of the organization, as well as selected women participants from the commanders' course whose loyalty seemed assured, Golomb made it clear that their organizational and military commitment was first and foremost to the Haganah and to the national institutions guiding its activities. It was only on the basis of decisions taken by these bodies that they had been enlisted in the British army, he told them, and they were to serve as a nucleus dedicated to nurturing a Zionist outlook and to develop the Jewish defense capability and right among the women who would enlist after them. He demanded that they act to mold the image of the women's units that would be established in the British army in a spirit that was not isolationist but rather welcoming, in keeping with the principles of the Haganah.[60] From his point of view, the women's enlistment served to increase the Yishuv's military power and as a factor contributing to the readiness for the critical political and defense moment that would come about once the war was over.

The degree of Haganah involvement in the regulation of the enlist-ment into the British army was expressed in the appointment of Rachel Friedland as the organization's nationwide recruiter along with regional recruiters (for Tel Aviv, Jerusalem, Haifa, and the colonies), and it was these women who were actually responsible for executing the process. The question of whether the loyalty of these recruiters lay with the Haganah or the Council of Women's Organizations was the root of bitter friction between Friedland and the members of the Council, and this may be one of the reasons for Friedland's replacement by a Haganah member from Tel Aviv—Sonia Idelberg—at the beginning of March 1942. The members of the Council of Women's Organizations feared that, following the success of the initial stages of the idea of women's enlistment, they would now be excluded from involvement in and influence over the process, and that the defense interest would supersede and sideline the feminist interest.[61] It is specifically the fact that this tension arose among the women themselves, with the men—at least formally—remaining outside the picture—that serves to illuminate the dilemma accompanying the enlistment process and the women's service: was the main aim an outspokenly feminist one, with the objective being to promote equality between the sexes, or was it the security needs and the existential threat facing the Jews that were the real priority? The dilemma was not depicted as a black-or-white issue, but rather as fundamentally a question of the proper combination of these elements. Rachel Yanait and Ada Fishman, who during the controversy over women's enlistment in 1918 had held opposing views, now stood together in favor of highlighting the value of including women's organizations in the enlistment. This was an expression of a lengthy process over the course of which it had generally come to be recognized that women's participation in the defense and security of the kibbutzim was essential in its own right, as well as an important factor in establishing their status in society. At the same time, the joint position of Yanait and Fishman also testified to the view of participation in the defense realm as essential in the structuring of femininity in Palestine as it was developing in the Zionist historical circumstances and for depiction of enlistment as a sphere of public activity from which women dared not exclude themselves. Yanait, who was at the same time a central activist in the Haganah in Jerusalem, emphasized to the recruiters: "It's true that you've been sent by your organization [the Haganah], but it's clear that you have to work together with us [the Council of Women's Organizations]."[62]

Beyond the mundane power struggles and competition for credit, it is clear from the description thus far which three institutional bodies in Yishuv society were committed to women's enlistment and worked to advance it: the Council of Women's Organizations (based on WIZO and the Women Workers' Council), the Haganah, and the Jewish Agency (along with the JNC). Thanks to the positive approach and energetic activity of these bodies, 3,836 Jewish women joined the ranks of the British army during the years 1942–45 (3,265 within the framework of ATS and 571 as part of the WAAF—Women's Auxiliary Air Force).[63] They represented about 10 percent of the 35,000 Jews in Palestine who enlisted in the various military forces during the war, of them 30,000 in the British army. During the same period, some 6,000 volunteers joined the police force and another 1,500 joined the Palmach. In addition, some 11,000 Jewish workers (including, by January 1943, about 1,800 women) were engaged in various logistical tasks (such as building storehouses and fortifications, paving transport lines, and communications) at military bases.[64] These are general figures; in practice, the process of enlistment and the later release from the various military frameworks took place gradually over the course of the war period, and likewise the employment of men and women working on the bases.

The women's enlistment commenced, as noted, on January 18, 1942, with the opening of the officers' course. The participants included fifty-four Jewish women (thirty-two of them recommended by the Haganah representatives, the rest chosen by a British military selection committee) and six Arab women (about 300 Arab women had enlisted in the British army by the end of the war). At the time, about 11,000 male Jewish recruits from Palestine were serving in the British forces. A week after the officers' course ended, the actual enlistment was opened, preceded by registration at the Jewish Agency recruitment bureaus and interviews at the British military bureaus to evaluate suitability. Some 2,000 women were enlisted over the course of 1942.[65] The terms in which their service was described were often evocative of glorious periods in Jewish history, as highlighted in the ATS anthem: "The homeland calls to us once again / once again we rise up from the Bible."[66]

On March 15–16, the first group of recruits, numbering 519 women, set off for the military camp at Sarafand. About a hundred of them marched through Tel Aviv on their way to the recruitment bureau. Thousands of bystanders gathered in the streets and "witnessed a sight that they would not soon forget," as reported by *Davar*. Rivka Alterman, one of the

recruits, stated: "This is the first time in Jewish history that the Jewish woman has ceased being a biblical 'woman of valor' and has actually donned military uniform. Now she passes through the street. And you look at her with curiosity: who is she? Perhaps she isn't a Jewish woman at all?" Many wept with emotion, and a moment before the convoy set off, a rendition of HaTikva (Israel's national anthem) burst forth, and all movement on the road came to a standstill.[67] In a poem published in *BaMahaneh*, Leah Goldberg described for the Haganah readership in Tel Aviv the sight of the women volunteers in language recalling the psalmist's description of the Exodus from Egypt: "When the daughters of Israel went out to Egypt / the women of Jacob heading yonder / We accompanied them, their eyes blazing / marching in beautiful and confident unison. / They proceeded, the girls, the girls in uniform / A fiery march like the east wind. / Young men stood at the roadside / gazing upon the women's uniforms. / Look and see, here are Tamar and Rachel: / We have been fortunate to see heroines of Israel!"[68] *Davar*'s caricaturist Aryeh Navon captured the moment in his usual witty style by drawing the women's procession in the street receiving polite applause from the men watching from the surrounding balconies, with the caption: "Fair division of the war effort."[69]

International Women Workers' Day fell on May 8, and the Women Workers Council predicted that "recognition of women's equality will increase during this war." Alongside a photograph printed on the front page of *Dvar ha-Po'elet* showing a few dozen women in ATS uniform engaged in discussions at the Women Workers Council, it was predicted that this year would go down in the history of the Women Workers movement and the international movement for women's emancipation as "the year of enlistment." With great pathos it was submitted that "it is not individual heroines who have volunteered for war against the enemy, but rather camps of trained women who are fulfilling their role with devotion. In Russia, England, the United States, and China, women—constituting half of the nation—have enlisted. They have enlisted as workers, as increasers of production, as aids to the fighters, and—in the case of those with the ability—as fighters themselves."[70] Presenting the ideal of army enlistment as a top priority of the Women Workers' Movement in Palestine on this date, which, in previous years, had been devoted to the woman's professional struggles and concern for her social status, was something new. However, this moment could not have been reached without the decades-long process described thus far.

Morals in the Army

The psychological aspect was integral to the issue of women's enlistment into the British army. The poisonous atmosphere of innuendo that surrounded the discussion from the outset did subside to some extent as increasing numbers of women signed up for military service,[71] but from time to time rumors circulated concerning lax morals—with an emphasis on sexual promiscuity and intimate relationships developing between Jewish women soldiers and British men soldiers. Objections to the idea of women soldiers on the basis of possible licentiousness in fact accompanied women's military service throughout the twentieth century, transcending cultural, religious, national and socioeconomic boundaries. In our case, rumormongers included Jewish men soldiers serving in Egypt as well as certain elements within the religious sector. These groups made great fanfare of obscure reports of a female soldier who was pregnant, of inappropriate behavior during social encounters, and of fistfights that broke out over the possibility that the women's chastity was being compromised. Whether these stories—for the most part utterly baseless—were disseminated with a view to besmirching the project to bring about its demise or whether the human circumstances prevailing in the military by nature offer endless opportunities for vapid chatter of this sort, the result was the same: an erosion of the degree of public legitimacy awarded to women's enlistment and of the willingness of more women to join the military ranks.[72] Preserving national honor was a fundamental component in consolidating the ethos of power and molding the image of the fighter who embodied the vision of the "new Jew" and was viewed as one of the most notable achievements of practical Zionism. At the same time, this idea had patriarchal and chauvinist aspects, supported by the modern European ideal of masculinity and the nurturing of a national glory suited to the needs of Zionist realization.[73] The fear of possible harm to the honor of Jewish women once they found themselves in a military environment in a foreign country, the "sexual starvation" characterizing the military reality, as described by Shertok, who had served as a soldier in the Turkish army during the First World War, was a potential threat to the validity of this ethos and played to deeply seated memories among that generation, on both the individual and public levels.

In view of these circumstances, supporters of women's enlistment tried in various ways to dismiss rumors of immoral behavior on the part

of Jewish women soldiers. Bracha Habas, who had been one of the first to demand women's enlistment in 1941 and was active in promoting the issue on behalf of the Council of Women's Organizations, along with her work at *Davar*, published a mordant attack on the disseminators of such "cheap provincial gossip." Their worthless prattling, she asserted, cast aspersions on "courageous and proud sisters" who had enlisted for military service from different sectors within the Yishuv, and their allegations were effectively blackening the image of the Yishuv as a whole.[74] Ruth Berman, who had been appointed as one of the first four Jewish women officers at the end of the training course, recounted, in a meeting with the Secretariat of the Executive Committee of the Workers' Union and the Council Women Workers held in August, that the rumors reaching the women soldiers from Palestine and from Egypt caused them great pain. As the most senior Jewish woman commander at the base where more than 300 women soldiers from Palestine were serving, at Tel el-Kabir (opposite the city of Ismailia, about forty kilometers south of the Suez Canal), she testified that no one dared harm them. The British, she claimed, treated them with proper respect, and, addressing the issue that worried them more than any other, she reported that the only thing that the women soldiers had asked of her before her departure to take part in the meeting was "not to give speeches and not to call upon women to enlist, but rather to report that we have not stained Jewish honor, nor will we do so in the future."[75] The editorial board of *Dvar ha-Po'elet*, headed by Rachel Katznelson, Devora Dayan, and Bassewitz, and the coordinating Secretariat of the Council of Women's Workers headed by Beba Idelson, urged the Council of Women's Organizations to print a flyer that would be disseminated in thousands of copies among both men and women soldiers and throughout the Yishuv, with a view to mounting an "open public battle against the libels concerning Jewish women soldiers."[76] However, Hadassah Samuel preferred to try to quell the false rumors through more discreet means, including meeting with rabbis and other influential religious figures who had taken it upon themselves to investigate the matter, with the clear intention off casting aspersions on the women recruits while presenting themselves as fierce guardians of the purity of Jewish girls. At the same time, there were also rabbis who supported women's enlistment, including Rabbi Yaakov Lipschitz, who served as chaplain at Saratand (later to become the chaplain of the Jewish Brigade), who asserted, at a public gathering held on October 13 in the Ohel Shem auditorium in Tel Aviv, that the source of this

arrogant attitude toward women had its source in "the exilic ghetto, which relegated women to the margins of self-nullification and inactivity."[77]

The most emotional response among the women soldiers, in view of the ugly waves of moral turpitude that were crashing around them, was published in a Workers' Union newsletter edited by Yosef Baratz, "Update for Men and Women Soldiers," a thousand copies of which were distributed in Palestine and in Egypt. It read as follows:

> Greetings from an anonymous female soldier to an anonymous male soldier! My fellow soldier—somewhere in Palestine, somewhere in the world; whether you know me or whether I'm a stranger to you, my request to you is—ease up! Ease up on the gossip, which pursues me while in the camp, fulfilling my duty, and makes me miserable during my free time, going about my business or at home. You, who have "seen" with your own eyes, and whose friend "heard" that an acquaintance of his "saw" an ATS woman soldier—you, with your mercy and your morals; you, responsible for the purity of the nation—be silent! Don't love me excessively with the love of bleary-eyed, zealous husbands, who afflict the love of their lives over every real or imagined thing. Allow me to fulfill the role I have taken upon myself—as a stores manager, as a driver, as a cook, as a nurse—as it should be fulfilled! And allow me to enjoy my leisure as I please [. . .] And remember: there are among us a great many dear, loyal, pure women who are devoted with all their being and all their consciousness to their great task. Do not violate their honor through the spreading of libel and perverse speech. Moral people—be careful with your words! Examine yourselves before you examine others.[78]

The struggle over the good name of the women soldiers was taken up by two of the leading proponents of women's enlistment among the Jews and among the British. Lieut. Col. Chitty noted that the invented stories about women soldiers from Palestine were familiar wherever ATS was active, and that such rumors were likewise directed against Cypriot, Greek, British, and Arab women soldiers, too. She compared the disseminators of such stories to "fifth column" traitors. At the same time, following a tour in August through the military bases in Egypt where the women were serving, Shertok emphasized to the Jewish Agency Executive and

the Council of the Workers' Union how impressed the British were by the work of the Jewish women. He told his listeners that not one of the 1,800 women there was serving as a driver of a British officer—a scenario that had been presented by opponents just six months earlier as a good reason to cancel the entire project. He also expressed the bitterness of the women soldiers toward the Jewish men soldiers who supposed that "only men are moral and they have a monopoly on moral behavior." The decisive point in the conclusions that Shertok drew from his visit was that these women soldiers had "become essential" for the routine functioning of the British army in Egypt.[79]

Call-up Notices for Women and Evasion of Service

Despite the repeated use of the term "enlistment," the Jews of Palestine—men and women alike—actually "volunteered" for the British army during the Second World War. The British did not enforce military service, and the institutions of the Yishuv establishment, which operated on a voluntary basis, lacked any coercive legal power; they were formally able to encourage enlistment mainly through their public influence and the informational, occupational, and organizational levers at their disposal. The national institutions—the Jewish Agency and JNC Executives—published several call-up orders over the course of the war, imposing "mandatory enlistment" in accordance with three parameters: sex, age, and family status. This obligation was mainly a moral one and served as another indicator of belonging to the Jewish national entity that was coming into existence. It was based on a sense of solidarity with the Jews of Europe, who were being slaughtered (some of whom were family members of the volunteers) and with the desire to nurture the building of Zionism in Palestine. The call-up orders expressed the degree of concern for the fate of the Yishuv in view of war developments as well as the longing to fight against the Nazi enemy, along with an aspiration to enhance the fighting ability of the Jewish population of Palestine and to strengthen the power of its institutions. The need to publish call-up orders, whose validity was fundamentally rhetorical with no legal authority for enforcement, arose from the exhaustion of the potential for enlistment based on appeal to emotion and a sense of inner commitment or on consideration of income and a variety of personal motives. It signified a recognition of the need to use institutional and

organizational resources to breathe new life into the yearning to join the fighting forces.

On May 2, 1941, the first call-up notice was published, obligating all unmarried men aged twenty to thirty to enlist. No mention was made of women in this notice, which appeared at a time when 8,000 Jews had already enlisted for military service in the wake of the fall of Greece, the pro-Nazi rebellion in Iraq, and the collapse of the British defenses at Tobruk. The second call-up was published on March 27, 1942, in response to indications that the numbers of men enlisting for service were decreasing. It was only by virtue of the women's enlistment, which started that month, that the number of volunteers from the Jewish sector exceeded the number from the Arab sector. A month later, Shertok reported to a contracted Zionist Executive Council meeting that from January until mid-April 1942, some 630 Jewish men and 800 women had enlisted, corresponding to 1,200 Arab men and about 20 women. In other words, it was only the massive women's enlistment that blurred the fact—with political significance in terms of identifying with Britain in its war—that the figure among Arab men was double that of the Jews during this period (in contrast to preceding periods, when the numbers of Jewish volunteers sometimes exceeded Arab figures by a three-to-one margin). The second call-up was extended to included married men aged twenty to thirty who did not have children. For the first time, mention was made of women, with the announcement that, hand in hand with the men's enlistment, the campaign would be broadened to include "thousands" of women, and a call for "the entire Yishuv, men and women alike, to respond to the needs of the hour." By this time, women's enlistment was presented on a regular basis in the daily media as a factor that was intended to accelerate enlistment among the men, too.[80]

At a meeting that the Recruitment Coordination Unit of the Jewish Agency held with the Secretariat of the Council of Women's Organizations two days prior to the publication of the notice, Idelberg, the national head of recruitment, demanded that mandatory enlistment of women be announced and predicted that in the absence of such a move the number of women volunteers would not reach even 2,000. A few weeks earlier she had described the call-up notice as an act of desperation. Golomb rejected her proposal out of hand, explaining that it was better not to demand that women leave their workplaces in order to enlist because "the women's professional work is an achievement that

cannot easily be relinquished." In other words, Golomb believed that the order of priorities in terms of gender required careful thought and a broad perspective, even concerning an issue that, on the face of it, was of profound significance to him. Idelberg, on the other hand, told Shertok that many of the women viewed the absence of any mandatory call-up for them as resulting from "discrimination between men and women."[81] The tension surrounding target enlistment figures for women was becoming acute. In a conversation with Haganah commanders, Tabenkin protested: "Until now, one of our women who leaves her place of work for the fighting forces has benefitted only the British, since the women's enlistment is being directed only to the British army's auxiliary units. The five hundred women driving vehicles and tractors [here in the Yishuv] count for more than 500 women going to Egypt as an auxiliary force." He demanded that the Haganah leadership give the women roles in the defense of the Yishuv, and shouted that "the will of our women members to join the Haganah dare not be strangled."[82]

On June 21, the third call-up notice appeared. The same day marked the fall of the Libyan port city of Tobruk, near Egypt, to Rommel's forces. Some 30,000 British soldiers were captured; the Nazi forces proceeded toward Alexandria and were halted at Al-Alamein. The terror of the situation is manifest in an entry in Hannah Szenes's diary from early July: "There are days when it appears that the end is near—the end of our enterprise, and the question is in what manner we will finish and conclude our legacy. The Germans are at the gates of Alexandria. From whence the false hope that we can escape?"[83] The call-up notice stated that women aged twenty to thirty, either single or married without children, were "especially needed to volunteer for the army." The rather clumsy expression in Hebrew attempted to compensate for the fact that men aged twenty to thirty were said to be "obligated to enlist for the army." These differences in terminology testified to the debate that was being conducted behind the scenes. On the one hand, the Council of Women's Organizations was demanding that the same call-up specifications be applied to men and women and went so far as to suggest that "women aged 20–45 must enlist for the army and defense services [Haganah, Magen David Adom, and the Civil Guard], except for mothers whose children are still of elementary-school age." On the other hand, the Yishuv institutions believed that the urgency of and need for enlistment should not be presented on the same level for both sexes. Ultimately, the notice stated that women aged seventeen to

nineteen were "obligated to enlist for work and training" in the realms of agriculture and industry, while those aged twenty to forty-five "who are not enlisting for the army, are obligated to enlist for either defense services or for farm labor, as per their choice. There is no obligation for mothers caring for their children." Idelberg believed that the clause directing women to agriculture and the war effort in industry had the effect of "defanging" the notice.[84] The debate as to the definition of the women's contribution to the overall war effort paralleled the struggles over their representation on the Yishuv defense committee and over the status of the Council of Women's Organizations in the enlistment process in view of the establishment of the recruitment center as the body authorized by the Jewish Agency to oversee the entire project. These organizational conflicts ended with the recognition awarded in August to the Council of Women's Organizations as a formal body aiding the recruitment center in handling the women's recruitment and their service, as well as the awarding of Samuel and Idelson the right to an advisory role in discussions of the Yishuv defense committee on matters of women's enlistment.[85]

The detailed attention to women in the third call-up, and the consideration awarded to the status of their representatives in the relevant defense forums, was a most significant development. As distinct from the declarative language that had characterized the attention to women in the second notice, they were now perceived as an integral part of the Yishuv labor and fighting force. The critical situation on the ground seems to explain, more than any other factor, the institutional turnaround—in less than a year—concerning the women's role and possible contribution in dealing with the approaching Nazi enemy. To award binding validity to the notice, the Secretariat of the Women Workers' Council decided that that it would "view any member who did not fulfill the directives of the recruitment commitment, in accordance with the call-up, as evading service." Seven months after the opening of enlistment to the ATS, 1,729 Jewish women were serving in the British army. Of these, 250 were drivers—the most popular, highly regarded, and challenging job among the women, while the rest served in warehousing, administrative, cooking, and caretaking roles, among others. Among the 809 women who had signed up at the Jewish Agency bureaus by the end of July (the rest enlisted directly via the military bureaus), 600 were from cities (led by Tel Aviv—249 women) and 115 from colonies (led by Hadera—19

women), while 88 were from kibbutzim (41 from Hakibbutz Hameuhad, and only 2 from Hakibbutz Ha'artzi).[86]

The climax of the turnaround in the perception of the woman's status in defense among Yishuv society came on December 4, 1942, with the publication of the fourth call-up notice. "The big news" in this notice, according to *Davar*, was its imposition of "obligatory enlistment for women" aged twenty-one to twenty-nine and unmarried. The main headline spread over the entire width of the front page of *Davar* on the day the notice was approved explained its rationale quite openly: "The reports concerning the annihilation of the Jews of Europe are unequivocally confirmed."[87] It may be asserted that it was neither the gender struggle nor the volunteers' military achievements—although these unquestionably had an impact—that brought about the change in attitude, but rather the powerful sense of shared destiny in view of the horrors of the raging annihilation of European Jewry. The editorial of the Workers' Union newspaper was quick to commemorate and celebrate the attainment of equality between the sexes in the defense realm:

> This is the first time a call-up has been issued for the women of the Yishuv. The Jewish liberation movement and the enterprise of Jewish building in the Land of Yisrael, have learned to impose all obligations—including the obligations of defense—upon women and men equally. Equality of rights and equality of obligations to society amongst men and women have been one of the most prominent innovations of the Jewish liberation movement, and many hundreds of women acted before they were ordered to in this war, too. The time has come to impose a formal obligation and to bring thousands more young Jewish women into the circle of the Jewish war effort—in the army, in labor, in agriculture, in industry, and in service.[88]

Grandiose writing at different historical junctions was a central factor in the molding of the Yishuv period as one that excelled at nurturing equality between the sexes—or at least was constantly striving to attain this aim. In practice, however, while the call-up notice did indeed impose the obligation of enlisting on women aged twenty-one to twenty-nine, it allowed them to choose between three tracks: "the women's auxiliary

corps (ATS), or agricultural work, or work in the war industry." Married women within the same age group who did not have children were obligated to enlist "for work in agriculture or in the war industry," with the choice between these branches of service left to personal preference.[89]

From the radical perspective of the Council of Women's Organizations activists, the fourth call-up notice was still unsatisfactory, although they viewed it as another step on the road to recognition of a woman's civic status as sharing equal rights and equal obligations. Its substance was the result of a struggle that had lasted more than four months. It arose not only from the desire to achieve equality, but also from the unmediated sense on the part of the women soldiers who were already serving on British army bases that they had been left to fight the gender battle alone, because the promises that a great many women would be following in their footsteps would not be realized without a proper effort on the part of the Yishuv institutions, including the Council of Women's Organizations with both its major components—WIZO and the Women Workers' Council. The tone in determining the substance of the notice had been set by the head of the political department of the Workers' Union, Golda Myerson, who—to the consternation of Idelberg and Idelson—proposed its outline at the Union Council that had been held in September, such that it would combine three tracks for serving the needs of the Yishuv, without military service being presented as the only—or even the main—option. This outline also took into consideration the opposition of the Haganah offices in the cities and the colonies (as opposed to the organization's most senior officers) to the idea that military enlistment was something that was essential to mandate and to apply in an order addressed to women. It should be remembered that the Haganah was characterized by dominance of the local branch in day-to-day life and also represented elements from the right-wing socioeconomic end of the Zionist political spectrum. This was expressed inter alia in the fact that only about 300 of the 1,846 women who enlisted in the army at the end of September were openly declared members of the Haganah. The order of gender priorities that Myerson had had in mind matched the prevalent priorities among the Workers' Union leadership; it was adopted by Shertok and provided a reasonable response to the complex, multilayered, and voluntary structure of the organized Yishuv. It did not satisfy the leadership of the Council of Women's Organizations, which sought to present military enlistment as the key to improving the woman's status in Yishuv society and the high

road to participation in the war effort and highlighting the woman's part in it. However, it was only the path consolidated by Myerson and Shertok that made it possible to prevail over the negative view of most of the members of the Jewish Agency leadership and members of the Yishuv defense committee concerning a binding call-up notice for women.[90]

One of the factors that decided the matter in favor of issuing the notice was Idelberg's warning that because the months of September and October had seen the number of women volunteers dwindle to 80 at a camp equipped to absorb 500 recruits per month, and because the British needed another 3,000 women "and the Yishuv is not supplying them, they will seek other solutions; they are ready to bring Sudanese." If a call-up notice was not issued to counter the drop in volunteer numbers, Idelberg warned Shertok, the training camp at Sarafand would be closed and "we will conclude this precious and important enterprise in a most humiliating manner." Of course, she did not forget to attach the gender claim: "Since the women have proved that their capability in the army is no less than that of men, they should be treated in all matters as equal to men, regarding both rights and obligations."[91] However, a more serious danger loomed: the specter of the women's enlistment project ending in a political and social fiasco, whose political ramifications would harm the image of the Yishuv as being completely committed to vanquishing Nazism and, more importantly, would erode the Yishuv's real contribution and decisive commitment to bringing victory.

On February 10, 1943, the celebrations marking a year of women's enlistment reached a climax at an event titled "Women Fighters' Day," organized by the Council of Women's Organizations. A convoy of military vehicles driven by Jewish women soldiers departed from Petah Tikva, drove through Ramat Gan, and arrived in the streets of Tel Aviv. A crowd of thousands greeted the convoy with applause, cakes, and flowers. The roads were decorated with slogans of support, and the Civil Guard band played. Later in the evening there was a large gathering at the Ohel Shem auditorium, concluding with a "soldiers' ball," part of which was broadcast over the radio. Idelson, who delivered the final speech at the event, said that it was "a response to that Jewish community which had lost ninety-three of its daughters in sanctification of God's Name"—alluding to a report circulating at the time, which later turned out to be unsubstantiated, concerning ninety-three young women from the Beit Yaakov religious school in the Krakow ghetto who chose suicide rather than being subjected to sexual assault and rape.[92]

At the same time, the main purpose of the event was to introduce new momentum into the enlistment for the ATS, which in March 1943 had numbered 2,702 women. Of these, 1,961 were from the cities (with Tel Aviv—951 volunteers—in the lead), 231 from the colonies (36 of them from Rehovot), 69 from moshavim (10 women from Kfar Yehezkel), and 69 from the kibbutzim (with Ashdot Yaakov in first place, with 9 volunteers). Among the 2,500 women soldiers who were already serving in different occupations, 400 were drivers, 1,300 were fulfilling various functions in hospitals, 250 were performing administrative work, 500 were working in warehouses, and 50 were serving in kitchens.[93] An internal newsletter published by one of the ATS companies in May announced, "It is not through tales of heroism and an array of battles [echoing the opening lines of Rachel Bluwstein's poem "El Artzi"] that we shall glorify the name of our nation and our land. The task we have been given is work that is difficult, tiring, and sometimes boring; most of us—let's admit it openly—are not used to it."[94] The Jewish women soldiers were dispersed in groups that in some instances numbered up to 200 to 300, in others only 10 or 20, together comprising more than a quarter of the 8,000 ATS recruits in the Middle East. Most of the women in British army uniform serving in the region were British (mainly nurses), Polish, and South Africans. Alongside them were women from Czechoslovakia, Greece, and Cyprus. The Jewish women were spread over twenty-nine ATS companies in Palestine and Egypt; three companies served in Lebanon.[95]

The elation shared by supporters of women's enlistment during its first year with regard to the women soldiers' conduct in matters of proper relations between the sexes persisted as the project continued. Invoking authorized professional backing to disprove the "gossip-mongers," the journal Ma'arakhot published the main conclusions of a British investigative committee that examined the conditions of the ATS corps and described the various claims regarding licentiousness, drunkenness, and pregnancy among the women soldiers as a collection of tasteless inventions. Nevertheless, as the project continued, relationships did form, quite naturally, between Jewish women soldiers and British men.[96] The subject ceased to provide degrading headlines that cast a shadow on women's army service, but it did cause a certain amount of worry to those overseeing women's enlistment. Evidence of this—far from the public eye—was a discreet visit that Beba Idelson, secretary of the Women Workers' Council, paid to the women's company serving at a hospital near Beirut in May 1943. Visits of this sort were conducted from time to time, mainly in Egypt,

as part of an attempt to convey a sense of solidarity and warmth. The proximate cause of Idelson's visit in this instance was that among the twenty-four women serving in the company, sixteen were involved in romantic relationships with British soldiers. Idelson recounted, in her report to the Secretariat of the Women Workers' Council, that she had assumed that the women concerned could have "had the same happen to them" even in Palestine, but had been struck a "great blow" when she discovered that "there wasn't a girl among them that I didn't know; they were good girls."[97]

On April 22, 1943, a new military track opened for Jewish women: the Women's Auxiliary Air Force (WAAF). The occupations offered by WAAF included work in aircraft factories, in photography and radio, as nurses' aides, and more. The Council of Women's Organizations, which in 1943 had absorbed the Women's Union for Equal Rights, called upon "available" women aged twenty to forty to join the new track or the ATS. The Jewish national identity of the women joining the WAAF was less pronounced than in the ATS. The precondition that volunteers have a good command of English and that they possess "sufficient intelligence" matched the elitist self-image of those serving in the Air Force—as in any air force—and the women were quick to detect it. Idelson complained about the WAAF volunteers: "This is material that has no connection to Zionism. [. . .] The Levantine snobbism is evident in every word that comes out of their mouths." About six months after enlistment had opened, 413 Jewish women were serving in the WAAF (compared to 3,153 in the ATS), mostly on bases in Egypt. Enlistment in the WAAF came, to a considerable extent, at the expense of enlistment in the ATS, which was portrayed as less attractive and prestigious.[98]

After a few months, during which it seemed that women's enlistment numbers were again on the rise, the enthusiasm died down and the drudgery of service devoid of the aura of battle set in. The Council of Women's Organizations was edged out of its involvement in the project, and in May 1944, Idelberg's position as national recruiter was terminated owing to "constraints at the recruitment center." Attention was increasingly turned to persuading the women already serving to remain committed to the realization of Zionism after their discharge, whether by joining kibbutzim or through professional integration in the spheres in which they had acquired expertise during their service.[99] Even the transfer of some 400 women soldiers to Italy in mid-1944 to serve as ambulance drivers, nurses' aides, and administrative staff had no major

impact on the women in Palestine. Twenty-four Jewish women died during their service in the British army—half in road accidents, the other half in other circumstances (illness, suicide, and other instances that are not entirely clear). Not one of them, it appears, was killed as a result of an enemy attack.[100] Yehudit Simchonit sums up, in retrospect, the dual face of Jewish women's enlistment in the British forces: on the one hand, "for the first time in Jewish history, Jewish women were wearing military uniform," while on the other hand their service was "first and foremost a work test, because the women soldiers were, in truth, workers" who provided auxiliary services for the military activity on the frontlines.[101]

Rachel Katznelson was honest enough to acknowledge that it had been the "courageous steadfastness" of the Jewish Agency's political department, "with faith in the women in Palestine" and "with confidence that this would be a glorious enterprise—even during moments when we were hesitant," that had made the entire project possible.[102] In an ideological political movement in which an individual was not usually praised explicitly and in public, this was the most that could be said about Moshe Shertok.

It seems that the scope and intensity of the turnaround in the Yishuv's attitude toward enlistment of women for military service in terms of principles and values from the Second Aliya period with the controversy over volunteering for the Jewish Brigade until the years of the Second World War, and the depth of the recognition among all ideological parties and streams concerning their right to enlist and the necessity of their service, is best summed up in a scene that took place at a Conference of the Moshav Movement in Nahalal on October 9, 1942. A Jewish woman officer and a woman sergeant told the participants that they were presently "unemployed" because they were supposed to train Jewish women, and at that time they had no one to train owing to the slowdown in enlistment. They then added, "We come as soldiers who are in favor of Jewish labor." At a public event marking thirty days since the death of Eliezer Yaffe, originator of the concept of the moshav, these women chose to turn on its head the most precious of the values that had been nurtured and fought for by the Second Aliya: Jewish labor. For these women, the focus of the concept was no longer on agriculture, but rather on defense and security. Yosef Sprinzak, the most prominent of the moderate Mapai leaders, who had also been the most vehement opponent of volunteering in 1918, noted with amazement that the sergeant (whose identity is unknown)—whose genealogy in a certain city

in Germany could be traced back to the fourteenth century—had suc-
ceeded, in a most cultural and profound way, to depict, 500 years later,
the modern meaning of the essence of the "question of Jewish labor."[103]
Rachel Katznelson, who earlier had shared his views, went on to recount,
at a Workers' Union conference held at the beginning of 1945, that a
member had approached her with a question: why, in recent years, was
there so much attention given by the Women Workers' Movement—at
its rallies and in *Dvar ha-Po'elet*—to "the *heroic* actions of the women
worker, of women in general, as though we no longer appreciated the
charm of routine, responsible day-to-day labor"—whether in the realm
of the kibbutzim, or the salaried worker, or the mother working at home
and taking care of her children. Katznelson wondered, "How could our
focus, during those years, not have been—first and foremost—on those
women members who displayed great courage and readiness to fight
and to defend?" She acknowledged that, as in "the women's movement
throughout the world," for the Jewish Women Workers' Movement the
years of the Second World War and the Holocaust of European Jewry
had been "years of manifestations of heroism, of readiness for self-sacrifice
for the sake of the nation, for the sake of the movement."[104]

Chapter 7

"There"—Heroes of the Holocaust, "Here"— Fighters in the Palmach

"There"—Holocaust

A conference of the pioneering youth movements was held over the weekend of January 15–16, 1943, on the subject of "Jewish Youth in Palestine in View of the Diaspora Holocaust." Over the conference loomed the main heading of *Davar* ten days previously: "Annihilation of 75% of European Jewry." Four days later, on January 8, Hannah Szenes wrote in her diary, "This week has shaken me. I suddenly got this idea that I should go to Hungary, to be there at this time, to lend a hand to the Youth Aliya organization and bring my mother, too. Although the absurdity of the idea was clear to me, it seems nevertheless possible and necessary, and I have decided to act upon it."[1] The gathering of the youth movement activists was held at Kevutzat Sedot Yam, which was located at the time in Kiryat Hayim and was in the initial stages of moving over to its permanent site near Caesarea. The most senior speaker at the gathering was Tabenkin. He recounted:

> This week there were two items in the newspaper about Jewish women who attacked the murderers of their children, defended themselves, and even banished them—assuredly, for no more than half an hour, until the machine guns arrived. I would have printed this item in letters larger than the reports about Stalingrad, because the Russians have weapons, machines, culture and education, whereas this Jewish woman has, since

191

childhood, been taught nothing but despair and submission, and I view this steadfastness as a sign of heroism. "Why shall we fear death, while its angel leans over our shoulder?' she declared, defying the Nazi. If I were young like you, I would grasp this item as a consolation of honor and as a directive for behavior."[2]

The reports to which Tabenkin referred had appeared in *Davar* on the morning that the conference began. Above them, the main headline read: "Latvian Jewry is no more!" and the subheading: "Is Prof. Simon Dubnow [a foremost Jewish historian in Eastern Europe] still alive?" One report stated that on October 4, 1942, a group of Jewish women in Lubliniec, in Poland, had revolted against Gestapo policemen who had brought all the residents to the market square and ordered them to strip so that their clothes could be given to German soldiers; the attackers had been driven away.[3] These heroic Jewish women remained nameless for the Yishuv, and according to historian Sharon Geva, it was only in the 1950s that women bearing arms would be awarded representative status, symbolizing the armed resistance during the Holocaust. Nevertheless, Tabenkin's words testify to a mythic anticipation of the appearance of a Jewish heroine, of Jewish heroes—including women—sacrificing themselves in heroic ways, symbolizing in their valor the national destiny and serving, through their defiance even in final, desperate moments, as models of devotion in the service of the nation's revival. This expectation was part of the atmosphere of the time, and the attempts to coax it—consciously or, more often, unconsciously—from the scraps of information and fragmented impressions trickling in as to what was happening in Europe, recalled the expectation of Jewish heroism that had pervaded the Yishuv discourse on the eve of the battle at Tel-Hai and in its wake.[4] Tangible testimony to this expectation was evident in *Davar* on March 21, 1943, where the headline reported—without any real information—on a rebellion that had broken out in several ghettos in Poland. The editorial added: "In our innermost hearts, many of us knew—with a sort of certainly that requires no documentation and is not disproved in the absence of documentation—that not all our brethren there were led like sheep to the slaughter." The linking between what was going on "there" and what was happening "here," in Palestine, was unequivocal: "We are with them in their revolt. We are required to continue it."[5]

Indeed, the following months would go on to provide a number of heroines worthy of the Pantheon of Jewish women fighters in the Holo-

caust, whom the Labor movement honored and praised even before the exact details of their courageous escapades were known. Before discussing them, it is worth lingering on one woman whose praises were not sung in Palestine. On April 29, 1943, Gola Mire was killed while attempting to escape from prison in Krakow. Gola had been removed from the Polish Hashomer Hatzair leadership in 1932 because of her radical left-wing views, and she joined the Polish Communist Party. During the war she was a central figure in the "Iskra" movement, which operated as a Jewish group within the Polish Communist underground, and maintained links with the Hashomer Hatzair underground in Krakow—HaHalutz HaLohem. Her ideological and political severance from the socialist-Zionist youth movement nullified her eligibility to serve as an icon of heroism and indirectly testified to the sometimes sectorial and ideological nature of the heroism and heroes of this period. Gola's commitment to the dream of revival in Palestine was admittedly mixed with Communist ideology, but she used to tell her aunt, "I am a Communist but I am Jewish, and we will all meet in the Land of Yisrael—but our Land of Yisrael will perhaps be the way that I dream of it." On the road to realizing her dream, she joined forces with Justyna Draenger (Gusta Davidson, whose account of the Krakow Jewish resistance was published as *Justyna's Narrative*) in an attempt to escape from prison, during which she was killed. Only gradually would Gola achieve legitimacy, with her picture advertising an exhibition of women's activity during the Holocaust at the Hashomer Hatzair museum at Givat Haviva, and a focus on her death as a Jewish woman fighter. Eventually she was included in the educational materials about the power of the Jewish women's struggle, as eloquently expressed in a poem that she composed after undergoing torture in Krakow prison:

> I know
> that machine guns are stronger than the fieriest words,
> and ranks of soldiers better than the finest poetry. [. . .]
> May all my poems
> That burst forth from my tortured being
> Be directed, like arms embracing the machine gun,
> To battle! To battle![6]

The Warsaw Ghetto uprising broke out on April 19 and was finally quelled on May 16. An article published the next day in *Dvar Ha-Po'elet*, under the heading "Jewish Women Fighters," emphasized that, as distinct from other heroic episodes in Jewish history in which individual women

had displayed self-sacrifice and had died in sanctification of God's Name, in the Second World War the phenomenon encompassed "masses of women." Along with the heroism of women in Lubliniec and in Adamow, mentioned by Tabenkin at the youth convention in January, the article also mentioned some Jewish women partisans who had excelled in guerilla warfare against the Nazis in Lithuania.[7] There was growing anticipation of displays of heroism by women.

By April 22, the Yishuv was already aware of an uprising in the Warsaw Ghetto following the entry of German forces charged with eradicating the ghetto. Fragments of unsubstantiated reports began arriving with details of the battles and the casualties. On June 1, a black-framed notice appeared at the top of the front page of *Davar* announcing the deaths of Zivia Lubetkin and Tosia Altman, two "leaders of the socialist Zionist underground in Poland." The Reuters press agency reported a few days later that "two Joan of Arcs" of the Zionist pioneering underground in Poland, Zivia Lubetkin (twenty-nine) and Tosia Altman (twenty-five), had fallen in defense of the Warsaw Ghetto. The news served as a spark that, all at once, ignited the flame of Jewish heroism in the Holocaust. From the ideological perspective of realization of the socialist-Zionist vision in Palestine, these were casualties of the "right" sort. Zivia and Tosia had long featured in the ongoing correspondence between the Polish underground and representatives from Palestine, not just as individual women, but also as code names for their respective movements (Hakibbutz Hameuhad and Hashomer Hatzair). In a symbolic sense, their status paralleled the code names "Ya'ari" and "Tabenkin" in Palestine. Lubetkin was a prominent figure in the leadership of the Dror-HeHalutz youth movement, identified with Hakibbutz Hameuhad. Altman, amongst the top leadership of Hashomer Hatzair in Poland and the first among the members of the movement's executive to be saved from the German invasion in 1939, returned and reentered the territory under German occupation toward the end of the year. She was a central figure in the Hashomer Hatzair party and underground activities in the ghettos of Poland, especially in Warsaw. The historic truth is that these two women, who, at the time of the rebellion, were aiding the activities of the commander of the Jewish Combat Organization (ZOB)—the underground movement comprising members of Hashomer Hatzair, Dror, and Akiva and Warsaw under the leadership of Mordechai Anielewicz—managed to flee the ruins of the ghetto after the suppression of the revolt via the sewer system. Zivia was saved and, after arriving in Palestine in 1946,

went on to play a central role in Holocaust commemoration. Tosia was killed in May 24 after a fire broke out in her factory attic hiding place and she was discovered.[8]

Even before the facts were properly known, a series of events was held in early June to commemorate the women. Ya'ari, the leader of Hashomer Hatzair, declared: "Tosia and Zivia are now already legends." At a meeting of the Executive Committee of Hakibbutz Ha'artzi, which happened to be held on the day that the report appeared in *Davar*, Ya'ari said that "Tosia was hewn from the very core of our movement. We know that she wasn't the only one. Hundreds of Tosias have walked among us. Hundreds of Tosias might arise in our midst to follow her life's path." At the beginning of 1943, twenty-two Hashomer Hatzair women in Palestine were serving in the ATS. Ya'ari, who had not been entirely accurate six months earlier in claiming "we placed [Tosia] at the head of our organization in Poland," chose on this occasion too to emphasize—erroneously—that "the underground was headed by a woman member" and stated upon her death that socialist-Zionist pioneering women represented the pinnacle of self-sacrifice and solidarity with the masses.[9]

At the various memorial events, there was a clear willingness to award the two women a sort of Trumpeldorian status, as expressing through their lives and in their deaths an absolute commitment to the values of Zionist realization in Palestine. Luba Levite, a member of Ein Harod and one of the most fascinating and dogmatic of the Hakibbutz Hameuhad ideologues, announced at a special memorial meeting held on June 4 with about 4,000 attendees that "the simple, humble heroes of this battle are being transformed before our eyes into legends and symbols that from now on will flutter at the pinnacles of Jewish history and the wars waged by Jews for their dignity, survival and future." On the podium at a gathering held on the Sabbath eve in the dining hall of Kibbutz Yagur, a wooden board covered in black displayed photographs of Zivia and Tosia alongside a red flag and a blue-and-white one. On the same morning, the "seventh column" in *Davar* had featured the poem "Jewish Girl," which Alterman dedicated to the two women. One line was a clear departure from the conventional view of the Yishuv toward Jewish girls in the Diaspora: "And on nights with no alternative you stood / the barrel pressed against your cheek."[10] The admiration for a pioneering woman who pressed the machine gun to her cheek in defense of her own life and her family was a defining historical moment for women in the Labor movements. Rachel Katznelson stated, at a special session of

the Women Workers' Council that was dedicated to the memory of the fallen of the Warsaw Ghetto:

> The day we opened the newspaper and saw the photographs of the two women members—a Divine spirit passed through the camp. There was a general feeling that something great and nameless, that we could not express, had come with their deaths. Not their death so much as the actions that had preceded and brought their deaths. There was a sense in the air amongst our movement that day, and in the days to follow, that something great was happening. It was as though the defense of Warsaw itself, which restored to us that which it did, was not enough; within that defense there was another lofty, unexpected aspect that went beyond what could be imagined: the story of Zivia and Tosia. They stand at the head; alongside them are other women whose names we know, and whose names we do not know. There was recognition that the Jewish Women Workers' Movement is, with the death of Zivia and Tosia, concluding a stage. Right now, at this moment, we cannot sum up this path, but one thing is clear to all of us: it is the supreme stage. Whatever the Jewish Women Workers' Movement will go on to do, whatever it will create and whatever it will achieve—it will never rise higher than this stage.[11]

The "Paratroopers"

Within Palestine, the "supreme stage" of commitment to fighting the Nazis was expressed in the enlistment of three women kibbutz members into a group of thirty-seven members of the Haganah who volunteered to parachute behind the German lines in Europe as part of the intelligence cooperation between Yishuv institutions and the British army during WWII. The aims of the parachuting activity in 1943–44 were to aid the partisans, make contact with Jewish communities in Europe with the hope of helping to save as many as possible, and give both tangible and symbolic expression to the Yishuv's commitment to maintaining the connection between "there" and "here." The paratrooper activity was under Golomb's command, but the concrete considerations

that led the Haganah leadership to include women in the campaign are not known. The volunteers were chosen in a selection process out of 250 candidates, but it is not clear which specific criteria gave these three women an advantage over any others. In these circumstances it is difficult to estimate the thinking of the decision makers who included these women, whose physical vulnerability in comparison with the men was balanced by their ability to integrate into a foreign environment using their unique qualities and the fact that women fighters were not a rarity among the partisans in Europe. What is clear is that, at least in principle, there was a connection between the willingness to recruit Jewish women into the British army and the willingness to include women among the paratrooper volunteers, and that the Palmach, as a military framework training women for military roles, served as a melting pot for parachutists too.[12]

In the wake of the decision in mid-April 1942 by Hakibbutz Hameuhad to organize enlistment of the movement's women to the ranks of the ATS, Szenes deliberated over whether it was better to enlist in the British army or in the police force as a ghaffir, wondering at the same time whether the "labor front" that she was already engaged in was any less important. A few weeks later, the decision was made when a meeting of the kibbutz (still located in Kiryat Hayim) approved her candidacy to enlist in the Palmach (although ultimately she did not follow this course). It was only a year later, in June 1943, that she was enlisted as part of a group of emissaries from Palestine who would be parachuted into Europe by the British.[13] Her Hungarian background was clearly a consideration in her selection for the mission. On March 15, 1944, Szenes parachuted into Croatia and was captured when she crossed the Hungarian border in June. She was imprisoned in her homeland as a spy, underwent terrible torture in prison in Budapest, and was executed by the Hungarians on November 7. Szenes was twenty-three years old. Thanks to her diary, with its admittedly fragmented portrayal, and the poetry she left behind, this heroine emerged from her anonymity. The Yishuv's anticipation of a heroine who would appear on the stage of the Zionist battle was fulfilled wholly and utterly. A fellow member of her kibbutz, Aharon Meged, wrote: "Jewish heroism bursts forth in every generation in its own way, choosing its heroes, the figures that embody the essence of the wishes of the generation, its finest spirit. Hannah's generation [. . .] chose as its hero the pioneer emissary who put her life in danger by journeying from Palestine to foreign lands to redeem her

brethren from the clutches of death."[14] The "pioneer emissary" replaced the anonymous "refugee" whom Berl Katznelson had declared the new Zionist hero at the 21st Congress, held in August 1939.

On the day that Szenes wrote in her diary that the kibbutz had approved her joining the Palmach, May 16, 1942, a meeting of Kibbutz Ma'anit, of Hakibbutz Ha'artzi, had issued similar approval for Haviva Reik. Unlike Szenes, within two seeks Reik was already serving in the Palmach. During her furloughs she lived as a "third" in a room with friends in Ma'anit—an accepted fact of kibbutz life because of the housing shortage, which remained a problem. The twenty-eight-year-old Reik, who had immigrated from Slovakia in December 1939, was one of the oldest women to join the Palmach at that time. In December 1942, Reik took the first squad commanders' course offered by the Palmach, lasting six months. After the final stage of the course, which was held in the summer of 1943, Reik joined the group of paratroopers in January 1944. Although she had completed parachuting practice successfully, Reik was ultimately not parachuted into Europe. Because the weather conditions mandated a "blind jump"—in other words, with no signal from the ground and no one waiting to receive them on the ground—the British forbade Reik from jumping together with her fellow paratroopers Haim Hermesh, Rafi Reiss, and Zvi Ben-Yaakov, explaining that if the Germans caught her, she would be considered a spy and would immediately be executed, while the others would be considered prisoners of war and would be saved. Instead, Reik was attached to a British-American military delegation that brought equipment to Czech partisans, and flew in an American military plane that took off from Bari in Italy and landed at the Tri Duby airport near Sliač in Slovakia on September 17. Reik joined her colleagues who had parachuted into the area two days previously, and they joined the Jewish resistance in the city of Banská Bystricam, where Reik had grown up. On October 30, Reik was captured by the Ukrainian auxiliary forces after she fought with her colleagues Reiss, Ben-Yaakov, and a group of about twenty local Jews who organized themselves as a resistance near the village of Pohronský Bukovec in the Tatra mountains. A few days previously, she had unwillingly agreed to deposit in an improvised hiding place in the ground the book Haverot ba-Kibbutz (Membership in a Kibbutz), which she had read during her training for the mission and which she took with her to Slovakia. After the war, the book that had been hidden, along with a transceiver and other equipment, was found by a Jewish fighter who had survived, and it was brought back to

Kibbutz Ma'anit. On November 19, the Germans executed Reik along with Reiss and about 250 other Jews near the village of Kremnička. Years later, Yitzhak Sadeh would report a conversation that he had had with Reik a few days before she set off on the journey from which she would never return: "When I return, I'll go back to being a woman. Is man created for war? Is a woman made to engage in battle? I shall return to my kevutza. I'll have a family, I'll have children."[15] In the missions she participated in until her death, Reik was the finest woman fighter that the Jewish community in Palestine placed on the battlefields of the Second World War.

The third woman in the group of paratroopers was Sara (Surika) Braverman of Kibbutz Shamir, who had immigrated from Romania in 1938. In the preparatory training for the mission she had been afraid to jump and had not overcome her fear even when the leader of Hakibbutz Ha'artzi, Ya'ari, explained to her the importance of her mission for the movement and its ideology. Instead, Braverman was landed by a British plane among the partisans in Yugoslavia in August 1944. She spent about three weeks with them and then, finding that she would not be able to help save Jews, returned to Italy. She returned to Palestine on October 28. Braverman joined the Palmach in June 1942 and was one of the first women in her unit.[16]

"Here"—Palmach

The Palmach was established on May 19, 1941, as the fighting force of the Haganah, and during the first year of its existence it enjoyed British patronage. About two months after its founding, while its two first companies were commencing their training, Palmach commander Yitzhak Sadeh proposed enlisting women, too, and demanded that the company commanders, Yigal Allon and Meir Davidson (the latter having replaced Moshe Dayan, who was injured in a campaign in Syria), who were responsible for signing up candidates for their companies, implement this policy. As Allon testified a decade later, the company commanders viewed this as going against the whole point of the new unit and questioned, "How can girls—even the best among them—be integrated into the difficult tasks of a brigade [as the Palmach was called] that is supposed to be an elite 'commando' force?" Some viewed the enlistment of women as a recipe for disturbances of army camp life, along with

other doubts and fears. Because of the company commanders' misgivings and fears of a blow to the professional quality of the unit and sexual tension that would hinder military performance, the idea of integrating women into the Palmach was shelved for the meantime. According to later testimonies, Sadeh had actually opposed enlistment of women in the first place, while Allon had supported the idea. However, the documentation from that period does not solve the question decisively. To this there was added the opposition of the chief of staff, Dostrovsky, who forbade enlistment of women because, "to his view, there was no room for girls in a partisan force," as deputy commander of the Palmach in its early day, Giora Shenan, reported. What is clear is that the first stage in the unit's existence did not include women, except for Shosh Spector, headquarters secretary (and later on personnel management officer).[17]

Yisrael Libertovsky, commander of F Company in the Palmach, which, since its inception in September 1941, had conveyed the image of comprising city dwellers—a somewhat unusual phenomenon in the kibbutznik Palmach environment—decided on his own authority to enlist six young women from Jerusalem in the early months of 1942. Women's enlistment into the ATS, which had just begun, and the difficulty of recruiting men in the Jerusalem region were factors that influenced this decision. The move was regarded as so altogether extraordinary that the women were summoned to an internal trial by the Jerusalem region commander, Nahum Shadmi, for "illegal entry into the Palmach."[18] In principle, Libertovsky's decision had not contradicted the formal guidelines of the Haganah national headquarters, which had been formulated along with the decision to establish the Palmach. These stated, "The organization is open to any Jew (or Jewess) who is prepared and able to fulfill the obligation of national defense. Membership in the organization, as both the obligation and right of every Jewish man and woman, is based, in practice, on the personal decision of the individual, out of voluntarism and free will."[19] However, in practice, women were not enlisted in the Palmach. The turning point came on March 24, 1942, as Yisrael Galili, a member of the Palmach national headquarters, wrote to his wife: "Today, at an executive meeting, we decided on a change in methods for women's training: To place a woman in this role as part of the General Staff; to instruct that women members be included in guard forces; to hold training camps for women leaders in Glilot."[20]

On the face of it, there was no explicit mention of the Palmach, but in practice, this decision signified a change in the overall Haganah

attitude toward the military tasks assigned to women in the organization. In its wake, on July 19, Shulamit Klivanov would be appointed chief officer for women's affairs. This role was created at the initiative of the Women Workers' Council, and Klivanov, who was a member of its Secretariat, was appointed to the position at her own suggestion following a meeting with Rachel Katznelson and Yisrael Galili.[21] Even earlier, in May, women had started enlisting in the Palmach, mainly because of the change in the attitude of Hakibbutz Hameuhad concerning women's service in defense.

There is a clear connection between the start of women joining the Palmach and the willingness of Hakibbutz Hameuhad to permit their joining the ATS. In this instance we might say, even in the absence of authorized documentation, that from Tabenkin's point of view the acceptance of women into the Palmach was a precondition for their enlistment in the ATS. Thus, the decision taken by Hakibbutz Hameuhad at Yagur on April 16, permitting women to join the British army, went hand in hand—covertly but inseparably—with the agreement by the Haganah and Palmach top command that women would be included in the organization's fighting force, which, from the beginning of June, would become independent after the British removed their patronage. The challenge was twofold: to meet recruitment targets for quality personnel seeking to fulfill a military role, and to mold the image and character of the Haganah within the Yishuv. This duality found immediate expression in the decision taken, as noted, at the gathering at Kibbutz Ein Harod in early May concerning the enlistment of individual women members into both the ATS and the Palmach. When the Palmach faced an existential crisis in August, prompting a resolution by the Hakibbutz Hameuhad Council, on August 23, to prevent its collapse by creating "work and training camps," and by providing loans for this purpose to replace the British funding that had ceased, it was also decided "to include women members in advanced training."[22] This was a code word for the Palmach.

In the weeks that followed, when meetings of the security committee of Hakibbutz Hameuhad discussed ways of implementing the council's decisions on integrating Palmach platoons on kibbutzim, Tabenkin said: "We have a decision to take in a total of 1,500, and to provide a loan. I suggest that we recruit one-third women members—500 women—who will volunteer for the Palmach." From his perspective, inclusion of women would serve as a guarantee that the Palmach would not turn into a "professional army," and as an element in building the Palmach and defining

its defense role: "The Palmach is a national fighting force, not just a commando, so it will be possible to bring in more women members." His intention to introduce women into the unit not individually and selectively but rather in large numbers undermined the aim of some Palmach commanders to turn it into a framework of elite soldiers. Tabenkin explained, "When there are 500 women knocking on Yitzhak Sadeh's door—they'll make a way for themselves." A large women's presence would ensure that the Palmach would remain a body that did not view fighting and militarism as its sole raison d'être and would inculcate a unique popular, pioneering character. From the outset, Tabenkin was aware of the slogan "The Palmach is the Red Army of Hakibbutz Hameuhad" and believed that "the fact that people think that the Palmach belongs only to Hakibbutz Hameuhad is not good." To his mind, the portrayal of the Palmach as a unit that was identified completely with one particular sector of the Yishuv endangered its long-term survival, and one of the ways in which he sought to ensure its continued viability was to have it continually growing, with a certain blurring of its kibbutz identity. In these circumstances, Tabenkin viewed the women as an essential element of security for the Palmach, going beyond his long-held support for their integration into the Hanagah.[23] His position was not easily accepted, and the idea that the Palmach involved labor and not just training was difficult to digest. The internal dissatisfaction aroused by the decision to combine work and training was shared by women members, and at a meeting of Company B, Braverman declared: "I joined the Palmach to be taught a partisan's life," adding that "our demand must be for 30 days' training per month."[24] Tabenkin countered this with a rebuke: "What will we gain from having these thousand trained seven times better? What if all one thousand could be professors of military academies, and each so heavily armed that he couldn't move? If a front opens up, what will you need—more training or more people? You have three hundred squad commanders; where are your three thousand trainees?"[25] More than pressing hard for women's enlistment into the Palmach for reasons of gender equality, Tabenkin was motivated by the desire to build the Palmach into a broad-based force, which, to his mind, would serve its defense role more effectively. The Palmach/ATS selection was conducted in accordance with the movement's preferences, but there is no reliable specific documentation in this regard.

The high number of women that Tabenkin set as a goal for the Palmach met the "one third" quota that had been set years earlier for

women's representation in institutions of Hakibbutz Hameuhad, but it did not square with the decision of the Haganah General Staff, which decided on June 7 that the quota of women enlisting in the Palmach would stand at ninety—in other words, about 10 percent of the overall number.[26] The internal newsletter of the Women Workers' Council, *Yedi'ot*, was quick to heap praise on this achievement: "Special mention is made of the participation of women members in the internal active units, where the women have undergone training that is identical to that of the men, and passed the test in a manner that aroused admiration all around." The newsletter noted that the inclusion of women had value "from the point of view of the unit's [Palmach's] social life, too," but the Women Workers' Council maintained the same line propounded by the Haganah Chief of Staff Dostrovsky, with the head of the Jewish Agency Executive, Ben-Gurion, declaring firmly that "with all of that, the center of gravity dare not deviate from the question of army enlistment."[27]

One of the immediate ramifications of the new trend of women's enlistment in the Palmach pertained to the manner of their distribution among the platoons (the most common organizational framework in the Palmach) and the nature of the training they would undergo. The first thirty to forty women entered the Palmach as it was transitioning from irregular busts of activity lasting up to ten days of the month to unbroken, continuous service. After the fact, it turned out that their entry was a factor in the process of the Palmach becoming a permanently mobilized unit. At this intermediate stage in its organization, entry was reserved for a small number of "elite" women in terms of physical fitness and a willingness to take on the physical and psychological effort required to withstand rigorous military training and a male environment. They were dispersed among the various platoons and underwent the same training as the men did, in squads that were sometimes separate and sometimes mixed. The dilemma was whether to train the women as regular fighters such that they could be placed in any platoon and treated as men, or whether it would be better to concentrate them in separate squads where they would specialize in accordance with their aptitude and capabilities. Ruth Haktin, who was in charge of the women members' department in the Hakibbutz Hameuhad Secretariat, reported that it was specifically the older women volunteers (in their late twenties) who excelled, while the younger women "failed the test." The exhausting regime was a sometimes unbearable burden. In the mixed units, the women "did not dare to lag behind," according to Allon, and always exerted themselves to be among

the first, even at the expense of their health. During a training session at Kibbutz Negba, the trainees were learning to jump from a considerable height, and the instructor barred the women from jumping, but they insisted on their right to receive equal training, and "the episode ended with broken legs and broken spirits." In a squad commanders' course that some of the women participated in, the women had trouble displaying authority toward their male colleagues. Zvia Katznelson was pained by her fellow trainees: "Through their lack of faith in my ability, they weaken me." With hindsight, Braverman recounted, "We feared that if we failed, girls would no longer be enlisted in the Palmach."[28] Benny Maharshak, who started out as a recruiter seeking new volunteers for the Palmach in November 1942, acknowledged that "amongst the Palmach leadership there is concern that the training [level] will fall with an increase in the percentage of women in the Palmach."[29]

Tabenkin was unhappy with the quota of women set for the Palmach and demanded that it be doubled, at the very least—from 10 percent to 20 percent. As to the training policy, his view was that "they themselves will discover what they are capable of and what they must do. Their physiology will decide the matter; we'll introduce a considerable percentage of women and we'll let them determine their study conditions." As usual, it was the Soviets who served as his model: "There are millions of women in the Russian army—in transport, in the air force, partisans. We are just a half a million Jews, half of whom are out of the picture [a reference to the ultra-Orthodox, the elderly, children, and the ill]. Can we forgo the women? Of course they will fail if they comprise only ten percent."[30]

After a year of women's service in the Palmach, a gathering of the women members was held at Mishmar Haemek. The gathering was preceded by clarification carried out by the Women Workers' Council with Sadeh and Dostrovsky concerning the issue of mixed or separate-sex units. Sadeh expressed opposition "to any separation between girls and boys," while Dostrovsky ruled out mixed units. The willingness of the Palmach commander and Haganah chief of staff to hold a professional discussion within this forum was not a trivial matter; it testified to acknowledgment of the sound judgment of the Women Workers' Council representatives and to the mutual trust between them and the senior Haganah personnel.[31] Following this meeting, the gathering of women Palmach members was held in September 1943, with the participation of some commanders, to discuss models of training and the roles for

which women in the Palmach should be trained. Among the Palmach leadership there was some controversy between those who opposed integration of women in combat positions, preferring to train them for auxiliary roles in such areas as quartermastership, radio operators, and administration, and those who favored their training in combat. At the gathering, Braverman expressed herself vehemently against identical training for men and women because of the discrepancies in physical strength. She demanded an uprooting of "the fallacious ideology that seeks to imitate boys." Zvia Katznelson, who had joined the Palmach from the Immigrant Camps Movement and would become, a few years later, a member of Sedot Yam, agreed that "we cannot, and should not want to, be equal to the boys," explaining that she had no desire to "jump out of herself" and abandon her femininity. At the same time, this did not mean that she wished to give up her fight to defend the land, which was identical to the right of any young man, even if they would serve in different roles. Following the gathering, the Palmach headquarters decided to separate the women's training from the men's; to train a group of women commanders to train the women members, and to train the women in a range of combat support roles, including radio operations, first aid, transportation, scouting, and administration.[32]

Under the conditions in Palestine and within the Palmach situation, these occupations were meant to provide the fighting forces with close support—in both geographical and tangible terms, in contrast to the situation in the ATS, for example, at the time. Basic physical and weapons training remained part of the course set down for women as legitimate members of the Palmach. Reflecting the Palmach reality—at least up until the outbreak of the War of Independence, the various roles and level of actual involvement of women in combat positions remained open to ongoing struggle on the ground, subject to the local conditions in each platoon and company, the initiatives and transient needs of commanders, and the degree of firmness with which the women demanded to take on a certain role.

The direction that suggested itself at that meeting was one step in a broader move that defined the roles and training policy for women in the Haganah. An order of the chief of staff in 1943, based on Klivanov's extensive activity as joint staff officer for women's affairs, having also initiated the gathering of women members of the Palmach at Mishmar Haemek, stipulated that women members would be charged with two types of roles: defensive activity, entailing guard duty, and offensive activity,

including auxiliary roles in various services, work at headquarters, and the like. Training and instruction of women members to fulfill their roles would be carried out in women-only units, which would spare them a constant sense of competition with the men. Advanced training and tactical practice would be carried out in mixed units. In practice, this was treated as merely a recommendation; it was generally not implemented. At the same time, however, it was stipulated that training courses for squad commanders and platoon commanders should be mixed, but the women would form a separate training group in the course.[33]

The conclusions drawn from the gathering at Mishmar Haemek served as the foundation for widespread and non-selective acceptance of women into the Palmach with the consolidation of the "enlisted preparation" program that combined agricultural work with military training. This track was first suggested in October 1942, and it came into existence gradually over the course of 1943–44, such that preparation for kibbutz life was inculcated along with two years of Palmach service. The track was meant for graduates of youth movements in the cities in their late teens who wanted to prepare themselves for pioneering work. Included in its scope were graduates of the immigrant camp youth movements, Gordonia-Young Maccabi, Scouts, Hanoar Haoved, and Hashomer Hatzair. The preparation groups, by nature collective enterprises nurturing egalitarian movement values, aspired to maintain a mixed social framework in the process of their integration into the kibbutz and the army, too. Military training needs did not overlap with the social needs of the groups, and the relatively high number of female participants—between 30 percent and 40 percent (alongside boys with low physical fitness) inevitably brought about change in the makeup of the Palmach. The fact that the operational activity element was secondary in the Palmach until the end of 1945 blunted the tension between the underground Ie that was prevalent in the unit and the civil format in which the lively group of youth conducted its communal life within the kibbutz framework. The bonds connecting the members of the group and the close quarters they shared between the brief and demanding training periods were generally viewed by the female participants as the essence of the program. A minority insisted on its right to regular training, "like the men," but most made their military contribution in the nurturing of "Palmach pride" and an "atmosphere of togetherness."[34]

At the Hakibbutz Hameuhad Conference that took place in January 1944, Sarah Blumenkrantz of Tel Yosef blasted the participation of the

movement's women members in Haganah training that took place from time to time and their exclusion from the system of guard duty in the kibbutzim. However, the relative weight of her rightful grievance, which was more relevant to times gone by, was balanced with the service of 78 women members of Hakibbutz Hameuhad in the British army, and—even more so—the service of 104 women members (including some from youth preparation groups) in the Palmach. Yigal Allon, deputy commander of the Palmach, gave a professional military and public affirmation of the success of the experimental integration of women as regular Palmach fighters. With a certain degree of exaggeration, he noted that they had been assigned "various command positions" and that "today there are women members are very good commanders, as well as excellent instructors, who are also skilled in their occupation and, in addition, trained for combat." In battle conditions, he reckoned, they would overcome the physical difficulties that weighed down in routine circumstances. Relying on the implementation of the enlistment track of the preparatory programs, Alon promised: "Our door is therefore open to any girl, and there are no limitations on women's enlistment." Later on he would ensure commemoration of the legendary war escapades of the "devil with golden braids"—Netiva Ben-Yehuda—during the War of Independence.[35] At a gathering marking the third anniversary of the founding of the Palmach, Zerubavel Gilad promised that in the future there would be no repetition of the situation where "dozens of worthy women members who came to enlist a year and a half ago [. . .] were rejected only because they were women." He also used this auspicious occasion to "cast a stone," in his words, at the Palmach members who had joined the British army, calling them "deserters."[36] In these circumstances it is no wonder that when the decision was made that the Palmach's underground activity would be expanded, at the end of 1944—a move signaled, inter alia, by the removal of the unit's name from its anthem, the opportunity was used to introduce a new line: "Every worthy young man—to arms / [every] worthy young woman (instead of "young man")—at his post!" The change was short-lived and failed to dent the Palmach atmosphere, which remained predominantly masculine.[37]

The decisivI moment in the Palmach consciousness when legitimacy was granted to women as an inseparable part of the unit came in February 1944 with the publication of a special edition of *Alon ha-Palmach* titled "Women Members in Our Units," featuring an eponymous introductory article by Yitzhak Sadeh. Just as the topic booklets published by the organs

of Hakibbutz Ha'artzi and Hakibbutz Hameuhad that had addressed the issue of women members in collective life in the early 1930s had treated it as an issue in its own right and one worthy of ideological delibera-tion and public discussion, so it was now, too. However, in the present case, the appearance of the pamphlet served as a stamp of approval for women's membership in the Palmach. The question was now no longer "the problem of women in the Haganah" or "the question of women members," but rather a more positive formulation, as Sadeh defined it: "How to make best use of the girls' capabilities and special qualities?" The fundamental dilemma that occupied many of the writers in the pamphlet was what the woman's role would be in a time of battle. There was a conspicuous reliance on images of Jewish women fighters from the past. The role models presented were "Deborah, Judith and the daughters of Jerusalem who passed catapult stones to the soldiers stationed upon the walls, and who poured boiling oil onto the heads of the enemy from atop the wall." However, in the absence of practical experience of functioning in battle, all that could be concluded from the accumulated experience in training was that it was not clear how maximum benefit could be extracted from the women fighters in a battle situation involv-ing mobility and movement. In the consciousness of the writers in Alon ha-Palmach, the only incident in the Palestine context from which any real insight could be drawn concerning the women's contribution was the search for weapons at Ramat Hakovesh. Hava Tolmatzky (Admon), who would later become one of the first three Palmach participants in the Haganah platoon commanders' course—along with Elka Brosh (Dror) and Braverman in 1943—wrote that there was no way of knowing in advance which abilities and aptitudes the young women would display. As an example, she cited the conduct of the women members of Ramat Hakovesh two months after the women's gathering, which "showed us that a woman is liable to carry out acts which, had there been prior discussion of them, it certainly would have been decided that she was not capable of carrying them out."[38]

The recognition that the uniqueness of the women in the Palmach was manifest not in the physical realm but rather by virtue of "their impeccable spirit" was what led Sadeh to insist most forcefully that they be included. At the same time, he did not conceal his expectation that when the moment of truth came, the women would show the same "supreme valor of Jewish women" that was being displayed in the war against the Nazis in Europe. As Anita Shapira notes, Sadeh "deliberately

and knowingly" nurtured the "the legend of the bond between the fights 'there' and 'here.'" The ghetto fighters "were presented as born-and-bred Palmach fighters."[39] This view was advanced not because the Palmach fighters were seasoned fighters, but rather as part of the ongoing aim of preparing them for the moment when they would be needed. This was one of the factors behind the duality that characterized the place of women partisan fighters in public discourse in Palestine. As Sharon Geva notes, this duality was evident in the fact that the women's activity was sometimes presented in the Hebrew masculine form, with emphasis on masculine characteristics such as physical strength, initiative, and leadership.[40]

In an article published a few months earlier in the book *Haverot ba-Kikbbutz*, parts of which were reprinted in *Alon ha-Palmach* in February 1944, Zvia Katznelson wrote: "Reading all these stories of the Warsaw ghetto, the heart is fearful but filled with pride" over "these chosen women of Israel, daughters of the Diaspora." She was amazed "not just by the sight of their great personal strength, but also by the sense of hidden power backing them," and wondered whether, in the final hours of their lives, the Land of Yisrael represented for them a "source of steadfastness." The historiographic response to this question, as Dina Porat shows, is that the basic attitude toward Palestine as an aspiration remained in full force. However, in view of the Jewish tragedy, the graduates of the pioneering youth movements in the ghettos awarded preference to self-defense and the survival of a remnant of the Jewish People that was being annihilated. Life "there," in far-off Palestine, was an abstract matter for "tomorrow"; its place was taken by "fighting here and now," in Europe.[41] The practical issue that occupied Zvia Katznelson was less a matter of Jewish life that was being exterminated "there," and more a Palestine-centered aspiration to highlight the women "there" as having been killed in a way that shattered the image prevalent in Yishuv discourse of "sheep to the slaughter." She wondered: "Since when were they trained in weapons, and since when did fighting become the substance of their lives? We never know who will stand up to the test, and what strengths lie in a person's heart. They were just the first in line; behind them is a long line of HaHalutz members, yeshiva students, ghetto women and children." The immediate lesson drawn from the parallel between the Palmach women and the women partisans was, to her view, that the capabilities displayed at the critical moment by the women "there" shone a different light on "the pointless discussions here

about the roles of women in our situation: whether she has a combat role; whether she is capable of fighting or not; whether she could be more than a paramedic, offering aid to the injured. You came and woke them [the Palmach men] up! There are times when even the laws of nature are broken."[42] The editor of *Alon ha-Palmach*, Zerubavel Gilad, chose to include, as the last article in the mainly optimistic topic booklet devoted to Palmach women fighters, which was introduced with excerpts from the biblical "Song of Deborah," with the image of the last moments in the life of Frumka in the Bendzin ghetto: "As she lay flat on the ground [. . .] they lifted her head, she began to say something. One of the Nazis approached and said, 'Let her speak; we'll learn something we haven't yet heard.' But afterwards he said, 'No'—and trampled her with his feet, as the rest had been trampled."[43] Whether she said, "It is good to die for our country" or something else, we will never know.

Frumka Plotnitzka, a member of the Dror movement and one of the leaders of the underground Jewish Combat Organization, died along with her friends and colleagues in Bendzin on August 3, 1943. Gilad became aware of her and other activists in the socialist-Zionist youth movements during 1937–39, when he spent nineteen months as an educational emissary for the HeHalutz movement in Poland. He was one of the most articulate and complex figures of the Palmach generation, and in contrast to most of his peers, he had unmediated experience of the Diaspora reality just prior to its destruction. It seems that when Yitzhak Tabenkin and the other leaders of Hakibbutz Hameuhad approached Gilad to serve as one of the emissaries of their movement in Poland, there was a concealed desire to inculcate in the Labor movement youth in Palestine "Jewish human sensitivity" and "a greater sense of love for Jews," with the help of someone who was perhaps the most talented writer among the Jewish youth in Palestine.[44] Following the death in battle of Frumka, her sister Hantche, and other HeHalutz members, Gilad fulfilled his commitment to create a bridge of words and feelings between "here" and "there"; between the youth in Palestine and the potential pioneers in the Diaspora who had lived and now were no more. Beyond his prolific writing for newspapers in Palestine during the time he spent in Poland, when the war broke out he authored a column titled "Girls in HeHalutz," which presented some of the mosaic of the Polish reality. Inter alia he wrote about the great excitement that had seized Frumka when she read excerpts from the writings and letters of Geula Shertok, which were published posthumously in *Davar* and *Dvar ha-Po'elet* in

1939. His article also sought to show that despite the distance and the world of imagery that was also far removed, there was a human closeness that bound up the stormy emotions and world of values of Geula and Frumka, two ideal models of women—the Palestine woman "here" and the HeHalutz partisan from "there." Along with his Palmach activity, Gilad also edited a book of letters written by Hantche and Frumka and took care to include photographs of Frumka and Tosia on the front page of the *Alon ha-Palmach* booklets.[45]

On December 12, 1944, the first representative of the Zionist youth movements that had taken part in the uprisings against the Nazis arrived in Palestine. Ruzkha Korczak, a member of Hashomer Hatzair, came from Vilna. The mission she had taken upon herself was to spread awareness of the Zionist underground and its exploits among Yishuv society. Shortly after her arrival, she met with Sadeh, who invited her to speak at a ceremony at Kibbutz Sedot Yam where a Palmach platoon would be sworn in and receive its weapons. Based on Ruzka's description, Sadeh spoke of how, with a combination of "majestic valor" and "Jewish daring," "three Jewish girls" had carried out reconnaissance on the ground prior to a mission in which a German military train was blown up, and added that when Ruzhka mentioned the girls' names—"Frumka, Tosia [. . .] it was a voice from afar, from the Diaspora, from the past, but now there was a different tone to it, a festive tone."[46] Ruzhka met with members of the Women Workers' Council in February 1945 and concluded her words to them by saying that in the "new legend" of revival, labor, and building that was being created in Palestine, "and in the new and free song that will take form here, this tone must not be lost." By this "tone" she referred to the role of the partisan women coordinators who carried the idea of uprising and rebellion from place to place throughout Poland, despite the constant physical danger and the certain knowledge that if they were caught, they would be shot. Speaking of the courage of these women, she spoke of feats that "they never would have thought themselves capable of performing." As an example, she recounted the heroism of Vitka Kampner (Kovner) during the attack on the German train, reporting that even under fire "everything was fine; this girl aimed her shots no less well than any boy; not for a moment was there any sign that she felt fear; she did not appear confused—she did not fall short, perhaps she even superseded, all the boys who were with her." Even if this was an exaggeration, her main message to the members of the Women Workers' Council was that the activity of the women partisans in Europe,

"immersed in blood and bravery," was "the fruit of the values that we have created"; "we" meaning the socialist-Zionist Labor movement in Palestine. The partisan women had received a "pioneering education" and "had to remember those who were here, those to whom they were close in heart—many times there they thought about Palestine, and what the country is."[47]

In view of the improvised but genuine connection that Ruzhka created between "there" and "here," a more prosaic view is in order. Lilia Bassewitz had in the past written her famous piece "The Third" about the "primus"—the single kibbutz member who would be housed together with a couple because of the housing shortage on the kibbutz. Speaking at the Workers' Union Congress on February 1, 1945, just a few hours before Ruzhka spoke at the same forum, she demanded a resolution "obligating Union members to set aside the extra space in their dwellings" to absorb Holocaust refugees. Her demand was voted down. There were 422 representatives at the Congress. Of the 400 who filled in questionnaires that were intended for statistical purposes, 352 were men and only 48 were women—meaning that women comprised just 12 percent of the participants. To the view of the authors of the Congress protocol, this ratio reflected the degree of women's participation in the Union's public life.[48] An article published in *Davar* that summed up the key moments of the Congress omitted any mention of Bassewitz's proposal concerning absorption of Holocaust refugees. With regard to the women participants, it stated that "the number of women members at the Congress—in other words, delegates—was certainly not proportionate to the half that they represent in our midst." Few women delegates spoke, "but it would not be accurate to define the face of the Congress as a masculine one. At the high moments of the Congress—and there were such—it was specifically the women who stood out." The reference here was to the words of Golda Myerson, which excelled in "healthy common sense and moral force," and of Ruzhka, who spoke in Yiddish, causing Ben-Gurion to comment that her words were "grating"—thereby provoking an uproar that ensured that the speech would long be remembered. Ben-Gurion's reaction (the precise wording of which is a matter of controversy) did not in any way detract from the exceptional nature of Ruzhka's message. When she spoke in Yiddish before Palmach fighters in Sedot Yam, it was Gilad who served as interpreter, and it is of course no coincidence that excerpts from her speech to the Women Workers' Council were reprinted in *Alon ha-Palmach*.[49] Braverman, the woman

paratrooper who returned to Palestine and met with Ruzhka through Sadeh's mediation, invited her to speak with the participants in the Haganah's countrywide course for women instructors in light weapons, which was being held at Kibbutz Ruhama, as well as at meetings with women Haganah members who were serving as officers in the British army. In these encounters, Braverman also served as interpreter for those women who did not speak Yiddish.[50]

After her return from Europe, Braverman also served as a senior figure in the Haganah system of women's training because, by virtue of the experience she had gained during her military training and her stay in Yugoslavia, she was considered an authority of sorts in this realm. She was the only woman to participate actively in the most comprehensive theoretical professional discussion to be documented on the subject during the Yishuv period. It was held in the wake of a lecture by Yitzhak Dubnow ("Yoav") on "Trends in our Training" as part of a Palmach platoon commanders' training course. Dubnow, a member of Negba and the Palmach's chief instruction officer, focused on the emphases of platoon training, but in the discussion that developed after his speech, most of the participants chose to address the issue of women's training. The exact date of the event is not clear; it would appear to have been sometime in November 1944 (following Braverman's return, but before the Haganah decision to curb the Irgun insurgency against the British) or early 1945. The fact that it was specifically within a Palmach forum and specifically at that time that a proper clarification of the subject was undertaken indicates that the question was now ripe for discussion on the professional level on the basis of accumulated experience in the field and a need to draw conclusions.[51]

The first speaker in the discussion was Yitzhak Rabin, deputy commander of Battalion C. In his analytical and slightly ungrammatical style, he criticized the absence of various elements from the training program, including the training of women: "It is clear that the girls' squads will fall behind, and the platoons will not be able to maintain a real combat standard." This statement set the tone and the framework for the rest of the discussion, which then became centered around objectives and methods of training for women in the Palmach. Joseph Tabenkin, oldest son of Eva and Yitzhak and a senior instructor at Palmach headquarters in his own right, opined that it was best to define special roles for women and give them the feeling that they were doing something necessary and important rather than training that was meant "to fill the time and to

[be able to] say that women have a place among us." Braverman praised the fact that, for the first time, it was men rather than women who were raising "the question of women members in the unit." Based on what she had seen during the time she spent with the partisans in Yugoslavia, she believed that just as girls were fighting there along with boys, so Jewish girls in Palestine should be trained to fill all combat roles—but that they should be trained separately, and at a level suited to their physical abilities. "After some time," she estimated, "we will be able to evaluate the women's achievements and we will see that they do not fall far short of those of the men." In any case, in an actual battle no one would check whether the number of women met this or that standard, and the more women served, the greater the degree to which they would fill more demanding roles. Yechiam Weitz, a senior Palmach instructor who was later killed in the attack on the A-Zib (Achziv) bridge in June 1946, disagreed vehemently. He believed that when the Palmach unit left its base and had to spend a lengthy period in hostile Arab territory, "it's almost out of the question for a girl." He blithely waved off the percentage of women partisans taking part in battle—and certainly in face-to-face combat with the enemy, declaring decisively, "I don't think that in our situation the concept of a girl fighter is realistic," and argued that the women should fulfill auxiliary roles in kitchens, warehouses, and the like. By contrast, Pinchas Weinstein, deputy commander of the Second Battalion, believed that there was no need to decide right then whether women would take part in face-to-face combat; the main aim for now was to train them for participation in battle because, owing to the Yishuv's numerical weakness, it made no sense to forgo in advance the involvement of 50 percent of the population in a future war. He supported Braverman's view that the accumulated experience in women's training indicated that they could attain the same level of professionalism that men could. Dubnow, summing up the discussion, stated that even if it was not clear what the exact role of women would be in the "Haga-nah war," it was clear that they would participate in it and preparations had to be made and training carried out with this reality in mind. "In any army that includes women fighters, heaven help them if they fall into enemy hands," and Jewish women from this perspective were no different from Russian or Yugoslavian women. His professional directive, at the conclusion of the discussion, was as follows: "We must continue with our evaluation, our learning, and our experience, and this can be achieved only through the inclusion of women in all of our activities, in

the manner best suited to them."[52] Strong support for this policy came in the form of data showing that the national sharpshooting average was higher among women soldiers than among men. Nevertheless, the idea of training women to serve in auxiliary roles in battle, as signalers and paramedics, turned out to be mistaken, because these roles involve even great physical effort than that required of regular soldiers.[53]

In February 1945, Hava Admon, one of the molders of the training models for women in the Palmach, outlined the changes that had taken place over the course of time in the process of training women, gradually becoming an original creation of the Yishuv in Palestine. At first, when the Nazis reached Al-Alamein, "we were guided by a single magical and great goal: to be partisans! We joined the brigade with an unbridled readiness 'to kill and to be killed.'" Later on, it was military enlistment that was enticing; the romance of partisan fighting was replaced by uniforms, and the popular Soviet films glorified women soldiers who filled a wide range of combat roles. In response, the Palmach was depicted as "the nucleus of the independent Jewish army," and therefore "every one of us had to be a squad commander," and "almost every girl thought she could be a commander." The realization had now dawned that each girl should be trained in accordance with her physical capability and the special conditions she needed, while making the most of her talents and unique abilities.[54] About eight months later it became clear that Admon's idealization of the updated forms of training, suggesting that it was these that would ensure the readiness of the women and their involvement in actual military operations, was not entirely apt. The first Haganah operation in the struggle against the British—the liberation of illegal immigrants from the detention camp in Atlit on the night of October 9–10, 1945—involved more than a hundred Palmach fighters, among them only three women: platoon commander Devora Flum (Spektor), paramedic Michal Shefer (Wager), and private Hannah Helman (Oryon).[55]

Between 1945 and 1948, during the years of struggle and the War of Independence, women would aid operations that attacked and destroyed British installations; they would fill a range of roles in illegal immigration operations, and they would be involved—on the battlefield, on the roads, and on the home front—in the fighting during the War of Independence. The women who won fame for themselves during this period include Brakha Fuld, Esther Raziel-Naor, Geulah Cohen, Mira Ben-Ari, Zohara Levitov, Netiva Ben-Yehuda, and others. The commemoration of these figures and the legends surrounding their activities lent multifaceted

expression to women's participation in the military confrontations and civic efforts involved in the process of establishing the State of Israel.[56]

During the struggle and the War of Independence, there was a dramatic drop in the level of public discourse on the matter of women's involvement in defense matters. The most prominent piece centered on a female figure to be written during this time was authored by Yitzhak Sadeh—"My Sister on the Coast." It was first published in October 1945, and for the youth in Palestine it symbolized the imperative nature of the illegal immigration enterprise that was developing at the time. The article offered a shocking and heartbreaking description of Sadeh's encounter with an illegal immigrant woman, a Holocaust refugee, whose body and psyche had suffered the horrors of the Nazi hell: "Bastards abused her and left her barren. She sobbed: My friend, what do I have here? Why have they brought me here? Am I worthy of having healthy young people endanger their lives for my sake?"[57] Sadeh's article has served as the basis for some controversial ideas in historical research relating to the view of the Diaspora prevalent among the Yishuv and the adoption of an aggressive policy for the sake of realizing Zionism and its gender aspects (the strong, healthy Palmach soldiers in contrast to the lone, weak, despised woman).[58] It would seem that these ideas do not necessarily arise from the historical context of that time, because from the perspective of the generation that grew up on the article "My Sister on the Coast," its most immediate and, at the same time, most long-term impression lay entirely in the sense of "love of fellow Jews" and the faith in "the rightness of the cause"—ideas that admittedly are rather foggy, but were instinctively remarkably clear at the time. The real, tangible nature of that impression, as it spoke to that generation, is attested to by a few words penned by Miriam Shachor, the first Palmach casualty of the War of Independence, who fell in defense of the Negev water pipeline on December, 9, 1947: "I read over and over the pages of Hanna Szenes's book [diary]; I will leave her book by my head, under my pillow. Truly, this is the figure that I aspire to emulate."[59] A year earlier, at the 22nd Zionist Congress held in Basel, the Labor movement's top orator, Rubashov, had cemented the connection between "there" and "here": "The bravery of Hannah Szenes and Haviva Reik has forged a fraternal covenant with the bravery of Frumka and Tosia, who died in the Warsaw uprising. From one side of the ocean to the other there was silently signaled the message of pioneering selflessness, between one land

and another, rekindling the Maccabean Hanukah candle that speaks of the Jewish thirst for freedom."[60]

At the start of 1948, Hadassah Lampel, who had arrived in Palestine as one of the "Teheran children" in 1943, noted with frustration in her diary that she was "dying of jealousy" over the fact that, unlike her male friends and some of her female friends in the Palmach platoon (under the command of Rehavam Zeevi), she was not included in operational activities. She added, "Is this what I enlisted for? To sit at home?"[61] About two and a half weeks later she was sent to escort a convoy, but on January 19, 1948, the secretariat of the Women Workers' Council declared:

> The part played by women members in Haganah activities is a very minor one. They do a lot of hard work, especially at the settlement points, and they serve in auxiliary roles, but they play no part in the activities themselves. In the cities, veteran members [of the Haganah] have not been called. In the colonies etc., women members are sometimes left by themselves, without a single one of them being trained in and ready for defense. Even the Palmach has cancelled the participation of women members in patrols [following the death of Miriam Shachor)] There remains only participation in the escorting of convoys.[62]

Under these circumstances, just a few days after the fall of the "convoy of thirty-five" on the way to Gush Etzion, the prevalent feeling among the women was expressed by Rina Yaffeh-Nir, a Palmach fighter in the Harel Brigade, who told her platoon commander in Kibbutz Ein Shemer, "Either you're going to send me to do something, or I'm going home." She was sent, along with her colleague Naava Kalischer-Margalit, to accompany a convoy from the coastal plain to Jerusalem, and she fought as Kastel and elsewhere.[63] Six months later Mina Rogozhik (Ben-Zvi), commander of the Women's Force in the IDF, reported to the same forum of the Women Workers' Council: "Since the beginning of May, some 3,000 women soldiers have enlisted, in addition to those who were already serving (1,000) and those in the Palmach (1,000). The army wants 1,000 soldiers right away, and another 20,000 in the future."[64] This sharp turnaround in the enlistment of women, with no

public controversy or ideological power struggles, had come about only by virtue of the struggle of the women who pioneered this realm. One of these was Lampel, who was killed in the battle for Latrun on May 31, 1948. For her role as signaler in the half-track that burst into the courtyard of the Latrun police building, Haim Laskov (who commanded the attack and was appointed chief of staff a decade later) declared that she should have been awarded the Medal of Valor.[65]

Another potential candidate for the Medal of Valor was Palmach fighter Aviva Vin (Rabinowitz) of Kfar Warburg, who served in the Fourth Battalion. She rejected out of hand the proposal of the commander of Harel Brigade, Tabenkin, that she be considered for the award for her role in the failed battle on Radar Hill in the Jerusalem hills on June 1, 1948. Later, Vin refused the offer of her company commander, David Elazar (later, IDF chief of staff), to release her from service at the end of the war with an officer's rank in view of the role she had played in the patrol battalion. She preferred to be released as a private. Despite her humility, which was entirely out of character with her fighting spirit throughout the War of Independence, in an article that she wrote just prior to her release she expressed some heretical thoughts: "There were thousands of well-trained women in Palestine. How many of them took an active part in the fighting? One out of a company; two out of a platoon—and not necessarily the best trained among them. [. . .] For what purpose did hundreds of girls undertake commanders' courses? It was almost for nothing." Vin argued that the atmosphere that had prevented girls from active fighting "created girls—and I note specifically commanders—who were opposed to having girls fighting." At a conference of Haganah women commanders held on March 13, 1949, and summing up the years of women's participation in the organization's campaigns, she raised precisely the same questions that had troubled the activist women throughout the years of their struggle for women's involvement in guard duty and defense from the time of Hashomer onward: "Does a girl have the right, by virtue of being a girl, to live at the expense of the blood of her friends, or not? Is a woman in Palestine a passive creature that must be defended, or does she have the right to fight for her life?"[66] On the literal level, these were the same questions, but in view of the circumstances of the War of Independence, they were now imbued with new substance. The dilemma as to whether women should fight on the frontlines would be placed on the back burner for the years to come, effectively off the agenda until the twenty-first century. In her

commitment, self-sacrifice, and devotion to the military struggle, Vin was one of the finest products of the women's revolution in this realm. However, her uncompromising position was not a faithful reflection of the power of the revolution that had taken place over the course of the period that stretched from the beginning of the twentieth century until that congress of women commanders, which reviewed the activity of two generations of Haganah operations. In her concluding words to the conference, Rachel Katznelson condensed the image and path of the women's revolution from the Second Aliya up to that time:

> In the presence of an ideal, weapons give a woman nobility. If the fighting is to realize an ideal—perhaps the most lofty in human history: to save and rebuild the Jewish People—then weapons do not detract from feminine softness and tenderness, but rather add to it, imbuing it with a different light—the light that shone on figures who are no longer with us, and that now shines on the figures who are here.[67]

The booklet of *Dvar ha-Po'elet* in which the information about the Haganah women commanders' congress was published was devoted to the first International Women Workers' Day to be marked in Israel. The cover featured a photograph of Chana Orloff's sculpture, "Woman Survivor of the Buchenwald Camp." The merging of "there" and "here" was now complete. Three years later, another of Orloff's sculptures, showing "a woman, farmer and Jewish mother, growing out of the ground and wielding a weapon to defend her children from every enemy and danger," was unveiled at Kibbutz Ein Gev. It was dedicated to the heroic stand of women during the War of Independence.[68] Despite the revolution, despite the bravery, and despite the memorial, I am inclined to agree with the view of Ein Gev member Muki Tzur, who wrote, in his biographical sketch of Rachel the poetess, that from the perspective of the women contemporaries of these early women fighters, "feminism was still a journey to the unknown; not a triumphant reality, but rather a far-off challenge."[69]

The fact that the participation of women in the military struggle to realize the political aims of Zionism ceased to be a controversial phenomenon and became the accepted, conventional path arose from four parallel processes that occurred during the years of the Second World War: the growing numbers of women who joined the ranks of

the Haganah, as well as the Irgun and Lehi; the personal example and model for emulation represented by the women members and graduates of the Zionist youth movements that fought in Eastern Europe and the sense of identification in Palestine with their sacrifice; the enlistment of thousands of Jewish women in the British army; and the introduction of a Palmach track training women for combat roles. None of this could have happened without the unique civilian contribution—in organization, in setting the direction, and in raising awareness—of four frameworks: the Council of Women's Organizations, led by WIZO; the Women Work- ers' Council, which was a partner in leading the Council of Women's Organizations and operated in parallel to it in independent ways; the ideological education inculcated in the Zionist youth movements (in Palestine as well as in Eastern Europe); and the unflagging commitment of women in the Hakibbutz Hameuhad movement to nurture the vision of women's participation in guard duty and defense as part of the scope of their activity and their faith in the realization of socialist Zionism.

A view of the dramatic defense-related events that occurred in Palestine in 1945–48 shows that during this period the arguments and public controversies concerning women's participation in various defense roles ceased almost completely. The subject disappeared from the agenda of the kibbutz, the movement, and the Yishuv in general. On the one hand, the matter of the woman's right to contribute to the national struggle in the realm of defense as in other realms was now considered an unquestioned given. On the other hand, the suppression of the echoes of earlier controversy was not necessarily evidence of a conscious will- ingness to include women in combat. In June 1945, Shulamit Klivanov, who held the most senior defense position of any woman in the Yishuv, charged the veteran woman members of Hakibbutz Hameuhad with the challenge of continuing the integration of women in the defense realm and called upon them to question themselves: "What is the degree of ability, willingness, and eagerness among our women members to enlist in public endeavors, in important local public roles, to be the security person for an area, to live defense matters in the same way that they live the local labor matters and social roles?" Her penetrating insight that there is a close connection between involvement in public activity and women's participation in defense needs no further clarification in view of all that has been described above. Nevertheless, her assertion that the demands for inclusion of women in defense "should be directed towards ourselves," which had been sounded as far back as the "rebellion" in Ein

Harod in 1936, now in fact reflected a reality that no longer existed.[70] From guard duty during the Arab Revolt there remained mainly the "night watch" by women over the children's houses in the kibbutzim.[71] This would be fixed in the kibbutz folklore for many years as a remnant that was "sanctified" while at the same time restoring the woman to her traditional role of childminding.

As always, Eva Tabenkin was aware, sensitive, and attentive to the changing circumstances. In the wake of a talk by "a girl in the image of Palestine" (it might have been Surika Braverman) to women Haganah members in the Jezreel Valley at the beginning of 1945, Tabenkin wrote in *Alon ha-Palmach* that from the point of view of the veterans who had raised the banner of the "rebellion" in 1936, her words held no new message. However, she acknowledged, more than she had listened to them, "I drank with my eyes this image of the girl who has arisen in our society, who will continue and succeed us, carrying within her—even if she is unaware of it—our command: the revival of the Jewish woman who fights and defends herself, her home, and her children, with all her strength." In contrast to the convention that had become the Palmach rule, in this final public speech before her death in 1947, Eva declared: "The yardstick of our lives should not be competition with the male members, to 'be like them,' but rather to dare to achieve an easing of our lot and an adaptation to our abilities at home and on the frontlines." In summing up Zionist history up to that point, and in anticipation of times to come, Eva concluded: "It is a profound truth when we say that our entire life in Palestine is a frontline: the frontline of man in his struggle with himself and the frontline of the nation in the world at large."[72]

Conclusion

Herzl's basic assumption, as presented at the beginning of the book, that mere representation for women at the Zionist Congress would suffice to resolve the question of women in Zionism, was neatly matched by the prevailing assumption among the early kibbutz pioneers that the building of a socialist, egalitarian society would automatically resolve the question of "women's liberation." This goal was adopted, in kibbutz life, in accordance with a masculine yardstick, and it was with this orientation that "they tried to liberate women from their femininity, during the Yishuv period, and to turn them into men driving tractors," as Benko (Binyamin) Adar of Kibbutz Ein Shemer declared decades later.[1] Thus, for example, in the early 1970s, then–Prime Minister Golda Meir stated that one of Israel's unique features was the partnership and equality between men and women, finding expression in roadworks, labor in the field, and war.[2] The philosopher Martin Buber maintained a different approach. To attain a proper understanding of his worldview, let us return to Bassewitz.

At the 12th session of Hakibbutz Hameuhad Council, which opened in July 14, 1939, marking the 150th anniversary of the French Revolution, a number of speakers questioned whether their kibbutz movement could continue to exist in its same form; specifically, there was a questioning of Tabenkin's leadership and the ideology of a "great kibbutz growing without restraint and without controls" (in the spirit of Reuven Cohen's oft-stated maxim), and there was sharp criticism of the everyday reality in Ein Harod. Bassewitz was impassioned in her response to those denigrating Hakibbutz Hameuhad leadership, its ideology, and its flagship kibbutz.

Don't believe those descriptions; Ein Harod isn't like that! There's another Ein Harod, too—the Ein Harod of the vision;

223

the ideal Ein Harod—and that's no less "realistic" than the one you've been told about here. There is the Ein Harod that reveals itself to all of us at certain moments in all its greatness; the one by whose light many have been educated. [. . .] Ein Harod commits its members to a high personal level, because it needs to pave the way and to be first in many areas.[3]

Six years later, a month before the First World War ended in Europe, Martin Buber gave the introductory address at a conference held at the Hebrew University of Jerusalem. The title of the conference, held in April 1945, was "The Social Character of the Hebrew Village." Buber defined the aim of the discussion as "bridging" between the "teaching of the 'mountain' and the teaching of the 'valley,' since each needs the other; only through joining them will awareness be complete."[4] To his view, to properly understand and evaluate what was going on in the communal settlements, it was not enough to study and analyze them; one had to view them along with the inestimably positive—veritably religious—attitude of these people towards the innermost essence, the actual essence, of their village; toward that which one member once referred to as the 'supernal Ein Harod.'" Actual kibbutz life, and the absolute faith in the kibbutz as a way of life, were two sides of the same inner world, and they could not be severed from one another.[5]

This would seem to be one of the most purely distilled expressions of the way of thinking and mode of conduct that guided the women of Ein Harod, including Bassewitz—the member whom Buber had referred to—in their struggle for proper representation and great involvement of women in kibbutz institutions and for participation in guard duty and other aspects of communal security.

Buber invited Bassewitz to deliver an address at the conference held at the university, because after reading speeches she had delivered at various conferences of Hakibbutz Hameuhad, he had concluded that she was a first-rate representative of his theoretical approach to the proper nature of kibbutz life. In her activity and her words from count-less podiums over a public career that spanned two decades, reaching its pinnacle with the publication of her speech at this symposium in the journal Mibifnim,[6] as a sign and testimony of being the authorized spokesman of Hakibbutz Hameuhad on the subject of female members, Bassewitz presented again and again the compass for her public activity in the public realm: the combination of a willingness to take a critical

view of the situation of women on the kibbutz, along with an organic and uncompromising commitment to this way of life—all with a view to increasing the participation of women who were aware of themselves and of their value in building the pioneering society in a socialist-Zionist spirit and in ensuring its long-term survival. Bassewitz's demand at the Hakibbutz Hameuhad congress held in Ashdot Yaakov in 1941 that the kibbutz demonstrate "renewed pioneering spirit" and start addressing social questions was trumpeted by Buber at the close of the Second World War, bearing out his famous prophecy that the kibbutz was an experiment that would not fail.[7] The hope that Buber expressed also rested upon his estimation that the consolidation of kibbutz society had matured beyond its temporary, experimental stages. Likewise, on the smaller scale of the specific individual and place, Bassewitz, in her own somewhat limited view, showed great honor to the poet Rachel by adopting the last line of her poem "Echo" (*hed*), composed in Ein Harod in 1925, as the title of a collection of her articles—*Ve-lu rak hed* ("Even if just an echo"). From a broader historical perspective, however, she identified completely with the approach of Rachel Zisaleh (Lavi), as reflected in the summing-up by Rachel Katznelson: "When one lives an Ein Harod life, one approaches things differently."

At this conference Bassewitz stated that despite the associations aroused by the comparison between the activity of the kibbutz women and that of the suffragette movement overseas, "There is great difference between us, for there they were fighting for political rights, while here we are fighting for obligations in realization, in building."[8] Even if her definition did not reflect fully the prevalent trends among other women's movements around the world, and even if she was not entirely accurate in emphasizing the "profound, innermost aspirations" animating the organized activities of the Jewish women in Palestine in their "liberation movement," as Katznelson succeeded in pointing out on several occasions,[9] Bassewitz did manage to capture what the women of Ein Harod viewed as being of the essence: the ability to identify problems and shortcomings along with an abiding commitment to the kibbutz framework in order to participate in it as women aware of themselves and of their value in building the pioneering agricultural society and ensuring its survival. This overall orientation had guided the women in their actions pertaining to participation in guard duty. In one of the better-known poems from that period, Levi Ben-Amitai succeeds in reflecting the change that occurred in women's status in view of the

security reality and the success of the women of Ein Harod in bringing about a shift in the consciousness of the generations: "By day—at work and by night—on the shift [. . .] / women at the lookout and men in the trenches / for the enemy is spread on the roads."[10]

In the local context of Ein Harod, it seemed for one historical moment that a fundamental change had taken place in the public status of kibbutz women. Academic research on gender often skips over this turning point. Sometimes it is even knowingly excluded in the interests of anchoring in ever-multiplying patterns of life the phenomenon of women's exclusion from active participation in realizing the pioneering Zionist ideology.[11] Ein Harod gave expression to different voices in the complex mosaic of the struggle of Jewish women in Palestine against gender obstacles. To my view, proper attention should be given to this range of voices in an attempt to understand the magic of the Ein Harod approach. For the purposes of our discussion, kibbutz member Rachel Savorai was one of the extreme manifestations of this magic. During the War of Independence in 1948, she joined the former Palmach forces at her own initiative, contrary to the decision of the Ein Harod institutions, after her request to enlist in a unit guarding fields in the Jezreel Valley was turned down. In a letter of apology that she submitted to the kibbutz newsletter, Savorai tried to justify her actions:

> I am asked: Why does it have to be you? Who will work? I am the only female kibbutz member who is willing and able to fight. Because I am a woman, they do not wish to include me in the fighting on the home front. Every young boy at home knows that when war comes, he will be permitted to fight. But me? [. . .] Can I stay at home milking cows, while all my contemporaries, all those who trained together, are spread along the front lines?[12]

When the real test came in 1948, Savorai was (according to her testimony) the only woman who was willing and able to serve on the battlefield, like the men. "Women who are strong and trained—to war," she proclaimed from the pages of the Palmach newsletter, during the second lull in the War of Independence. A fellow kibbutz member, Zerubavel Gilad, noted that the daily experience of women in the Palmach was "bitter and harsh, and scathingly insulting." He quoted Rachel's account of the battles in which she had participated, during the War of Independence,

as "a sort of repayment for the additional suffering of the girls, over and above the many hardships that we all encountered."[13] Rachel's desire as a woman in 1948 to realize what she viewed as her equal right was formally blocked by the institutions of her kibbutz. Although there were doubtless a host of individual circumstances involved, none of which are documented, Savorai's fundamental position echoed the earlier demand of the women of Ein Harod in 1936. Among the 126 members of Ein Harod who enlisted for military service in 1948, 33 were women.[14] This numerical fact, which probably does not reflect the division of the security burden in other communities—and, of course, says nothing about what these recruits actually did in the army—was not necessarily the result of the struggle waged by the women of Ein Harod during the Arab Revolt. The circumstances of the war were very different from those of the Revolt, and we cannot draw automatic conclusions regarding one period on the basis of the other. Whether this was a matter of a seed that had previously been planted, and which now bore fruit, is a question for a separate discussion.

The same applies to the validity of the assessment by Idelberg, whose position as countrywide recruiter for the ATS was terminated in 1944, that service in the British army was valuable not only in its own right, but also as a "significant boost to the woman's role in building up Yishuv life for the day after."[15] A more realistic evaluation would seem to be offered by Leyla Yosef, daughter of Zahava and Dov Yosef, who served in the Palmach and wrote, a few months before she was killed in October 1948 near Kibbutz Dorot in the Negev (near Sderot): "They used to say, with derision, that the girl's role was to amuse the army; it's a vulgar expression, but essentially correct." Leyla refused to accept officers' stripes, even though she had filled officers' roles in the war and even though when she was still very young, a family friend—Ben-Gurion—had expressed his certainty that she would "become one of the country's most prominent women leaders." Speaking of life in the Palmach, she said, "In reality, our lives sometimes looked quite gray, but our value wasn't determined by acclaim and Tarzan-style pictures"; rather, it was everyday life "in which the girls willingly bore any difficult yoke, that gave them a place in history."[16] The desire to have "a place in history" was a significant breakthrough in the women's perception of themselves and of their activity, for it expressed their aspiration to extricate themselves from self-abnegation as a motif defining their identity, activity, and presence in the public sphere. This self-abnegation was not a reflection of the

"modesty" demanded of Jewish women from ancient times. It was not an oppressive command imposed on them from without, but rather arose from self-awareness and a deliberate and conscious identification with the demands of history and Jewish destiny within the context of the realization of the Zionist vision. The commitment to the general goal, and the understanding that humility was needed to advance this public, national vision, entailed a relinquishing of individualism and a separate sense of self. The women of the period we have examined were directed almost in advance to service and support roles, and their humble willingness to devote themselves to the public good appeared at times to conceal their own will and free choice. However, this was largely a façade, the product of circumstances at the time, rather than a true expression of the way in which they—individually and collectively—perceived themselves and their activity within the framework of realizing the Zionist enterprise. Even if, in the realm of defense, they appeared to fail time after time in achieving their aims, in retrospect we can assert that their efforts in this area contributed decisively to the growing recognition of their relative contribution and of their importance in realizing the national project, along with consolidating their self-perception as embodying the aim of equal participation in building up the homeland.

Our research shows that three political figures helped to lay the foundation for women's "place in history" in the defense realm and for the viewing their inclusion within this realm as a legitimate and integral part of the Zionist revolution: Tabenkin, Golomb, and Shertok. These men were among the Yishuv's most senior figures in defense during the British Mandate, but it actually Ben-Gurion who molded defense policy from the second half of 1945 onward. On May 19, 1948, the following appeared in *Davar*: "The Jewish army is an existing fact. [. . .] As though with a magic wand, the various brigades have arisen, one after the other—and they are becoming increasingly consolidated, increasingly sophisticated. Finally, there is the 'women's auxiliary force' brigade." Some have emphasized the fact that with the establishment of the State of Israel (in fact, on May 4), the necessity of integrating women in the army was recognized, while others place the emphasis on the expression "finally." What is clear is that three weeks after the establishment of the new women's force, the letter '*ayin*' was dropped from its name—whether because of the "ignorance" of some of the men, who had trouble reading and pronouncing the word "h-e-n" (the Hebrew acronym of "*Heil Ezer*

Nashim"—"women's auxiliary force"), or whether by order of Ben-Gurion, who refused to view women as an auxiliary accompaniment.[17]

At the end of the War of Independence, the prime minister and minister of defense set down the following rule for the IDF: "We shall not send women into combat units, nor shall there be an infantry that includes women, nor will there be an artillery platoon that includes women. We shall not send women to war; there is no necessity for it, no need for it, no reason for it."[18] The Defense Service Law, passed on September 9, 1949, set down a twelve-month mandatory military service for women (except for married women, women with children, pregnant women, and "religiously observant" women). During the discussions in the Knesset preceding the passing of the law, Ben-Gurion maintained that with regard to women's military service, two elements had to be kept together in mind: the woman's special mission—motherhood, and that "the woman is not only a woman, but also a person, just like the man. This person deserves all the same rights and obligations that a man deserves." The concrete conclusion, as Ben-Gurion saw it, was that there should not arise a situation in which, "in the name of so-called progress, the role and importance of motherhood would be ignored,"[19] and hence, women should not be integrated in combat positions. Twenty years later, in 1969, Ben-Gurion would declare that "if a woman wishes to perform a man's roles in the army, she may do so, and if a woman wants, for example, to be a pilot, she can be a pilot."[20] Another thirty-two years would pass until the air force's first woman fighter pilot, Roni Zuckerman—granddaughter of Zivia Lubetkin—received her wings. Ben-Gurion, however, as noted, did not want women in combat, even if at the beginning of 1951 he had heckled in the Knesset: "In our army, a woman can even become the Chief of Staff. Let's hope that will happen someday."[21] Just before his first retirement to Sde Boker, in 1953, he reviewed the various IDF norms, including military service for women. He reported to the government: "It has become clear to me without any doubt that a woman who has served in the army, will, when she leaves the army, be a better civilian and, most importantly—for me, at least—is that she will be a more disciplined, more mature mother, a better housewife—and since I think that the foundation of our nation is the mother, I consider this important."[22] At that time some 6,000 women were serving in the IDF. Ben-Gurion's words, and—contrasting with them—the number of women serving in the army, symbolized the

two sometimes contradictory faces of the women's defense revolution, whose development over the years of Israel's existence still awaits thorough academic examination and redemption.

In his words of greeting at the opening of the Sixth Conference of the Women Workers' Council on July 31, 1949, Prime Minister and Minister of Defense David Ben-Gurion had the following suggestion for the women audience:

> As a veteran member of the Workers' Movement I say to you: Don't rely on us. Not because we aren't faithful to the principle of equality. We are. But there are things that happen not out of deliberate choice; things that arise from a long tradition. We suffer from this tradition, and you, too, suffer from it. You have a tradition of making yourselves invisible at a joint meeting of men and women workers. And sometimes at such a meeting, women members who actually have more to say than some of the well-known leaders do, fall suddenly silent.[23]

Although Ben-Gurion's relationship with the Shochat couple included some sharp disagreements, and although they were largely responsible for his exclusion from the Hashomer organization, in his early days in the country, he repeatedly described Manya, in a series of lectures that he gave throughout the 1950s and 1960s, as the Zionist pioneering link that revived the tangible connection with the chain of biblical heroines—Sarah, Rebecca, and Deborah, the prophet. With a view to encouraging the enlistment of women to the IDF, Ben-Gurion presented Manya Shochat as the ideal model of the woman soldier, devoting herself entirely to the service of the Jewish people and its homeland, and took pains to note that the first female military general in history had not been Joan of Arc, but rather Deborah.[24]

The 10th anniversary of the establishment of the State of Israel was marked in 1958 with an array of events, ceremonies, and celebrations. One notable example was the Hebrew date of the 11th of Adar, the 10th anniversary of the battle at Tel Hai. Of all the possible venues for the public commemoration of this major symbolic event in Zionist history, Ben-Gurion chose to address it in a speech that he delivered at a conference of the Working Mothers Organization, devoted to the woman's place in the defense establishment from the days of Hashomer up until

the IDF of that time. At a rally that took place at the Concert Hall in Tel Aviv, Ben-Gurion mentioned the chain of great feminine Jewish figures, from the biblical Miriam and Deborah via Queen Shlomtzion (commenting that the Jews of the Second Temple Period were fortunate to be living prior to the Medieval authority Maimonides, who would ban women from the monarchy), leading up to Manya Shochat in the days of Hashomer and the contribution of women to the Haganah and to the IDF. As to the principle of mandatory military enlistment for women, Ben-Gurion emphasized: "There can be no equality in Israel without equality of obligation. Equality of rights is not yet real equality; without equality of obligations one person is not equal to another."[25]

Over the course of the Mandate period, there was a gradual erosion of the demand for equality in rights and obligations as a central tool for molding the attitude of women's participation in guard duty. Then, as the security situation grew to occupy a more significant place in kibbutz life, from the outbreak of the Arab Revolt until the War of Independence in 1948, there developed among the women a recognition that the "no choice" reality demanded on the most prosaic, existential, physical level of survival that they take an increasingly significant role in the security realm. This dimension was emphasized by Eva Tabenkin, who had raised the banner of a "women's rebellion" for participation in guard duty in Ein Harod, when women from her kibbutz signed up for service in the British army during the Second World War. She, too, like Ben-Gurion during the period following the establishment of the State, drew encouragement from the model embodied in the heroic women of the Bible, and she called upon her colleagues "to fight like Jael, Deborah, and Judith."[26] Despite her separation from her husband, Hakibbutz Hameuhad leader Yitzhak Tabenkin, when it came to the value of holding onto the land as "the sole truth of life" for the realization of Zionism, they shared the same approach: "All of our generation is fertilizer for the fields of the Land of Yisrael," Eva had quoted Yitzhak on the eve of the final battle at Tel Hai.[27] This shared inner awareness guided the joint attitude of the Tabenkins—sometimes contrary to a great many of their friends and colleagues in the kibbutz movements—as to the necessity of integrating women in security matters. As Rachel Katznelson, the most moderate of the leaders of the Women Workers' Movement in Palestine, mused in the midst of the Second World War: "It is no coincidence that the early pioneers of the First and Second Aliya were mesmerized" by Josephus's

book *The Wars of the Jews*—which they read as "lyrical poems, as music," not as the fruit of the poet's imagination but rather the fruit of the labors of a historian documenting the chronicles of the Jewish People.[28]

The model of the historical continuity of national sovereignty, leading from the biblical narratives and the First and Second Temple periods to the Yishuv period, was one of the foremost elements of the national ethos woven by Zionism, serving to mold identity even in the expressly secular pioneering movement and embedding itself in the world of mythical symbols and images that this society nurtured.[29] To this day, the goal of integrating women as full partners in army and security matters has not yet been achieved. However, the success of the "women's revolt" of July 4, 1936, in Ein Harod, the "Jerusalem" of the kibbutz movement, was followed a few weeks later by the auspicious and inspired moment that testified that the issue of women and security was now an item on the Zionist agenda. In a poem published in the newspaper *Davar*, writer and poet Menahem Zalman Wolfovsky expressed his yearning for the days of the return from Babylonian exile and the rebuilding of the wall of Jerusalem under the leadership of Nehemiah (Neh. 2:12), his description in fact conveying what the women of Ein Harod had achieved in his own time:

<div align="center">

Daughters of Shallum son of Hallohesh
(From the Time of the Return from Babylon to Zion)

</div>

"Shallum son of Hallohesh, ruler of a half-district of Jerusalem, repaired the next section with the help of his daughters" (Nehemia 3:12).

> The sound of millstones and the light of a candle . . .
> Who is awake in the dead of night?
> Shallum's daughters are they, in the courtyard
> Drawing water from a well.
>
> Shallum's lovely daughters are they,
> Arising to bake bread
> Drawing water and setting the pot
> And bringing straw to stoke the fire.
>
> The sound of millstones, the sound of wood
> A great day awaits them:

Morning: daughters with their father
To build the rampart do they head out.

Yesterday their father did they entreaty:
It's time to strive, time to redeem!
If you were denied a son,
Take us for the labor.

Do not say, we will be mocked
Do not ask us to stand afar!
That it be told by the elders:
Shallum's daughters are among the builders!

The moon turns slowly on its course
And the street is bathed in dew.
Light in their eyes glow:
Israel is a widower no more!

It is time, [a time] as has never been . . .
And may no enemy dare scorn!—
For ready for battle, for fire
Are the daughters of Shallum son of Hallohesh![30]

Notes

Introduction

1. Rachel Katznelson, "Tafkidei ha-Seminar," introductory comments at the seminar of the Workers Council, June 6, 1937, LA, IV-230-6-85.

2. See also Shapira, *Land and Power*, 141.

3. Tzur, "Ke-Hakot Rahel: Kavim Biografi'im," *Rachel*, 78.

4. The decision of the Ministerial Committee for Ceremonies and Symbols was approved at a government meeting on January 28, 2010. Idan Helman, "Heikhan ha-Tnuah ha-Kibbutzit," *Ha-Daf ha-Yarok*, January 21, 2010; Aviv Leshem, "Ha-Tnuah Pa'alah," ibid., January 28, 2010.

5. Herzl, "Mi-Divrei Herzl ba-Kongress ha-Tzioni ha-Rishon," August 29–31, 1897, *Ne'umim*, vol. 1, 122; Meir Avner, "Nashim ba-Kongress ha-Tzioni ha-Rishon," in Yaffe, ed., *Sefer ha-Kongress*, 212–13; Buzitz-Hertzig, *Ha-Pulmus*, 11–12; Herzog, "Redefining Political Spaces," 1–2.

6. Herzl, "Tafkidan shel ha-Nashim ba-Tziyonut," May 19, 1899, *Neumim*, vol. 1, 364.

7. Herzl, "Me-Divrei ha-Neila ba-Kongress ha-Tzioni ha-Shishi," August 28, 1903, *Neumim*, vol. 2, 262.

8. Elbaum-Dror, "Ha-Ishah ha-Tzionit," 99–100.

9. M. K., "Agav (Reshamim Kalim)," *Ha-Olam*, August 28, 1925.

10. Hayuta Bussel, "The Woman's Role," Bussel file, Kibbutz Degania Alef Archive, Date unknown, apparently 1920s.

11. Melman, "Min ha-Shulayim," 244.

12. Ben-Artzi, "Have Gender," 25.

13. See, for example, Barak Erez, "Al Tayasot," 65–98.

14. Naveh, "Nashim ve-Tzava," in *Migdar ve-Tzava*, 18.

15. See, for example, Goldstein, *War*; Noakes, *Women*.

16. Izraeli, "Migdur," 85–109; Berkowitz, "Eshet Hayil," 277–318; Sasson-Levi, *Zehuyot*.

17. See, for example, Almog, "Ha-Nashim"; Yanait Ben-Zvi et al., eds., *Ha-Haganah*; Eshel, *Ha-Bahurot*; *Ha-Haganah be-Tel Aviv*, 323–40; Ironi-Avrahami, *Almoniot*; Rosenberg-Friedman, *Mahapkhaniot*, 241–316. It is interesting to note that in a document recording the discussions held in 1936, to summarize Haganah activities in Tel Aviv, not a single woman is mentioned. Slutsky, *Sefer*, vol. 2, part 3, 1317–23.

18. For the beginnings of a historical discussion of this sort during the Yishuv era, see Elad, "Kol Bahur," 211–51; Efron, "Ahayot," 353–80. For the beginnings of this discussion with respect to the period of the War of Independence, see Rosenberg-Friedman, "Religious Women," 119–47; Kabalo, "Leadership," 14–40.

19. See Near, "Ha-Hityashvut ha-Ovedet," 529–35. For discussion of the diverse issues pertaining to women in kibbutz life, see, for example, Fogiel-Bijaoui, "From Revolution," 211–31; Kafkafi, "The Psycho-Intellectual," 188–211.

20. For theoretical contexts of this discussion, see Bernstein, *Ishah*, 69; Near, "What Troubled Them," 124–25; Melman, "Shulayim," 253–54.

21. Shapira, *Land and Power*, 219, 251–57; Ben-Eliezer, *Derekh ha-Kavenet*, 35–46.

22. Kaminsky, *Bedarkan*; Shaham Koren, *Hesed Neurim*.

23. Near, *Rak Shvil*, 34–35.

24. See Herzog, "Nashim be-Politika," 337–38. For a different explanation regarding this historical episode, see Shilo, *Girls of Liberty*.

25. See Margalit Stern, "'Hu Halakh ba-Sadot,'" 195–225.

26. See, for example, Shilo, *Etgar ha-Migdar*, 181–92, 258–75; Elad, *Kol Bahur*; Granit-Hacohen, *Ishah Ivriya*.

27. Blum, *Ha-Ishah*; Brenner, *Hakibbutz*; Reinharz, "Manya," 95–118; Goldstein, *Ba-Derekh*.

28. See Melman, "Shulayim," 245–66.

29. Protocol of Women Workers Council Executive with several invited participants, June 26, 1939, LA, IV-230-6-183.

30. Hayuta Bussel, "Ha-Po'el ba-Hityashvut," *Davar*, January 27, 1932.

31. Efron, *Ahayot*.

32. Sasson-Levi, *Zehuyot*.

33. See, for example, DeGroot and Peniston-Bird, eds., *A Soldier*; Goldstein, *War*; Noakes, *Women*.

34. For theoretical contexts pertaining to these issues, see, for example, Enloe, *Does Khaki*; Robbins and Ben-Eliezer, "'New Roles,'" 309–42.

35. "Hadad Halevy, Rachel," Yizkor website, Israeli Ministry of Defense, www.izkor.gov.il; "Yerushalem T"V Rosh Hodesh Nissan 1886," *Hatzevi*, April 9, 1886; Letter of Shmuel Hirsch to Leon Pinsker, April 4, 1886, in Laskov, ed., *Ktavim*, vol. 4, 117–24; Ya'ari (Polaskin) and Harisman, eds., *Sefer ha-Yovel*, 361–62.

36. Zeltovsky-HaKohen, Nechama (Natka), Yizkor website, Israeli Ministry of Defense, www.izkor.gov.il (accessed November 29, 2021); Tom Segev, "He-Halal ha-Rishon," *Haaretz*, December 7, 2007; Elyada Bar-Shaul, "Ha-Bahurot ha-Hen: Nashim She-Asu Historia," December 12, 2011, Arutz 7 website.

Chapter 1

1. Blum, *Ha Ishah*, 5–6; Shilo, *Etgar ha-Migdar*, 140, n. 8.

2. According to Manya Shochat, the women who were full members of Hashomer were Keila Giladi, Esther Beker, Rachel Yanait, and herself. They were joined by Rivka Nisanov after her husband Yehezkel was killed in February 1911. Letter of Manya Shochat to Ruth Krol, July 3, 1954, in Reinharz, Reinharz, and Golani, eds., *Im ha-Zerem*, 521–23. Yanait Ben-Zvi lists, in addition to the above, Sarah Sturman (Kriegser) and Haya-Sara Hankin. (On the other hand, Haya-Sara Hankin appears along with Keila Giladi, Manya Shochat, and Esther Beker in a photograph with the inscription—"First women members of Hashomer"—in the first Hashomer publication, from 1930). Ever-Hadani, ed., *Hashomer, La-No'ar*, after 16. Rachel Yanait, "Bi-Yemei Milhemet ha-Olam ha-Rishona," in Ben-Zvi et al., eds., *Sefer Hashomer*, 168.

3. On women in Hashomer, see, for example, *Kovetz Hashomer*, 75–84, 135–62, 254–67; Ben-Zvi et al., eds., *Sefer Hashomer*, 38–144, 351–66; Brenner, "Makom ha-Ishah," 181–86; Blum, *Ha-Ishah*, 70–82; Goldstein, *Ba-Derekh*, 57–71, 217–23; Shilo, *Etgar ha-Migdar*, 181–92; Sinai, *Ha-Shomrot*, esp. 31–44, 67–96.

4. Letter of David Ben-Gurion to Yisrael Shochat, January 15, 1956, BGA; Allon, "'Hashomer' u-Morashto," *Kelim Shluvim*, 63. The definition coined by Ben-Gurion has been mentioned repeatedly since then by veterans of Hashomer and the admirers of its legacy. To this day it adorns the fliers of the Hashomer Museum in Kfar Giladi.

5. Manya Shochat-Wilbushewitch, "Ha-Shmira ba-Aretz," in *Kovetz Hashomer*, 75. Her memoirs, which represent the basis for the present work, were written in August 1930, LA, IV-104-1.

6. See Shilo, *Etgar ha-Migdar*, 181–92; Golani, "Manya," 1–20, esp. 6–8.

7. Atara Sturman, "Shanim ba-Aretz," in Bassewitz and Bat-Rachel, eds., *Haverot ba-Kibbutz*, 6.

8. Ibid., 5.

9. See, for example, Yanait, *Manya Shochat*; Reinharz et al., eds., *Im ha-Zerem*.

10. Hayuta Bussel, "Bi-Tnuatenu," in Katznelson-Rubashov, ed., *Divrei Po'alot*, 95; Izraeli, "Tnuat ha-Po'alot," 112, 119–20; Blum, *Ha-Ishah*, 19–25;

Bernstein, *Ishah*, 16–22; "Kolot Min ha-Gar'in ha-Kasheh: Mi-Sippurehen shel Tze'irot ha-Aliya ha-Shniya," in Azmon, ed., *Ha-Tishma Koli*, 126–28.

11. Ben-Artzi, "Bein ha-Ikarim," 309–24; Gofer, "Ha-Element," 123–50.

12. Address by Manya Shochat at the Seminar of the Workers Council, June 20, 1937, Goldstein, *Ba-Derekh*, 264–67.

13. Keila Giladi, "Ba-Galil," in Bassewitz and Bat-Rachel, eds., *Haverot ba-Kibbutz*, 29.

14. See Blum, *Ha-Ishah*, 58–69; Izraeli, *Tnuat ha-Poalot*, 112–20; Paz-Yisha-yahu, *Tnaim*, 37–47.

15. See Ever-Hadani, ed., *Hashomer*, page following 16; the three editions of *Kovetz Hashomer*, published in 1937, 1938, and 1947, respectively; *Sefer Hashomer*, 474–75.

16. Ever Hadani (ed.), *Hashomer*, pp. 44–45.

17. Yehezkelia [Nisanov], "Zikhronot mi-Tekufat 'Hashomer,'" in Margalit, ed., *Bayit*, 211.

18. See, for example, Rivka Nisanov, "Im Avot 'Hashomer,'" *Dvar ha-Po'elet*, March 11, 1937; Sturman, *Shanim ba-Aretz*, 5–16; Giladi, *Ba-Galil*, 25–35; Esther Becker, "Me-Hayei Mishpahat Hashomer," in Habas, ed., *Sefer*, 509–20; Tzippora Zaid, "Im 'Hashomer,'" ibid.,. 530–35.

19. Goldstein, *Ba-Derekh*, 66.

20. Tabenkin, "Al ha-Shmira," 23.

21. Yisrael Shochat, "Shlihut va-Derekh," in Ben-Zvi et al., eds., *Sefer Hashomer*, 32.

22. Malkin, *Im*, 21–22; Yosef Baratz, "Sara Malkin," *Ha-Po'el ha-Tza'ir*, March 1, 1949; Shmuel Dayan, "Tzvi Yehuda: Hamishim Shnot Po'el ba-Aretz," *Davar*, May 24, 1956.

23. R. B. [Binyamin], "Ba-Meh Haya Koha Gadol?," *Ha-Po'el ha-Tza'ir*, March 8, 1949; Sprinzak, "Al Sara Malkin," *Bi-Khtav*, 424.

24. Eva Tabenkin, "Hamesh Esreh Shana la-Emek: Mi-Kinneret le-Ein Harod," *Dvar ha-Po'elet*, October 25, 1936. Eva Stashbaska (Tabenkin) suffered from a heart defect, and the doctors forbade her from engaging in prolonged physical activity. Following the establishment of Ein Harod, Eva joined Yitzhak, although she had wanted to continue living in Kinneret, and focused her activity on the realm of collective education. The couple, who had been together since 1903, parted in the early 1930s.

25. Tzur, *Lo ba-Avim*, 38.

26. Hayuta Bussel, "Problemot Tnuat ha-Po'alot," May 7, 1929, Bussel file, Kibbutz Degania Alef Archive.

27. Tanhum [Tanpilov], "Yamim Rishonim," *Niv ha-Kvutza*, November–December 1954, 8.

28. Gofer, "Ha-Ishah ha-Tzionit," 207–17.

29. A. [Aharon] Hermoni, "Mah Atem Rotzim?," Ha-Olam, January 22, 1908.

30. Shapira, Avoda ve-Adama, 226–28, 316–19; Izraeli, Tenu'at ha-Po'alot, 118–24; Margalit Stern, Geula, 51–58.

31. Yanait, Anu Olim, 144.

32. Teveth, Kina'at David, vol. 1, 165. For various aspects of Rachel Yanait's life, see Hacohen, "Rachel," 92–109; Kark, "Not," 128–50. Yanait Hebraized her name in the same spirit as did others, before and after her, in the Po'alei Tzion party. Yitzhak Ben Zvi, Yaakov Zerubavel, and David Ben-Gurion.

33. Rachel Yanait, "Michael Halperin," ISA, P-2062/2. In her autobiography, Yanait makes no mention of Halperin in the context of her decision to emigrate. See Yanait Ben-Zvi, Anu Olim, 303–5. In his youth, during the First Aliya period, Halperin was one of the most interesting and colorful personalities in the Yishuv, and he extolled the value of developing the Yishuv's military power. See Halperin, Avi.

34. Tzvi Sohovolsky, "Al Sara Malkin," Ha-Po'el ha-Tza'ir, March 22, 1949.

35. The pamphlet was written against the background of the transition from the Bar-Giora organization to Hashomer, the incident with the Arabs that took place at that time at Sejera, in which three Jews were killed (April 12, 1909), and the call that was subsequently publicized, in the name of the Po'alei Tzion party, asking its members to move to the Galilee: "Where are you, where are you, sons of the Maccabees! Descendants of Bar Giora and Bar Kokhba." Yanait Ben-Zvi, Anu Olim, 146–47.

36. Ibid., 147–49; [Rachel Yanait], Bar Kokhba, 1.

37. Bar Kokhba, ibid., 12.

38. Shapira, Land and Power, 242–43. See also Zerubavel, Recovered Roots, 48–56.

39. Shochat, "The Collective," in Raider and Raider-Roth, eds., The Plough Woman, 3–12; Golani, Manya, 3–4.

40. Katznelson-Shazar, Adam, 323–24. Concerning Nili and Sarah Ahronson, see Livneh, Nedava, and Efradi, eds., Nili; Melman, "The Legend," 55–92; Gofer, Ha-Ishah ha-Tzionit, 262–68.

41. Manya Shochat, "Darki be-'Hashomer,'" in Ben-Zvi et al., eds., Sefer Hashomer, 389–91; Reminiscences of Se'adia Paz u-Pinhas Shneorson about Manya Shochat, Hashomer Archive, Kfar Giladi, box 18, file d/32.

42. Rachel Katznelson-Shazar, "Manya Wilbushewitch-Shochat (a year after her passing)," Dvar ha-Po'elet, March 1962. Shochat passed away in February 1961, at the age of eighty-two—but ceased to fill any real position in the Yishuv public life from 1942.

43. Nahum Sokolov, "Jewish Heroine," Ha-Olam, December 4, 1907. See also Shapira, Land and Power, 12–15, and elsewhere.

44. Yanait, *Be-Yemei*, 182; Yehuda Harshlag and Yehuda Slutsky, "Ba-Matzor," in Dinur, chief ed., *Sefer*, vol. 1, part 1, 389, 397–98, part 2, 740.

45. Rachel Yanait, "Mi-Yemot Hashomer," *Kovetz Hashomer*, 544–45; Yanait, *Be-Yemei*, 152–166.

46. Brenner, *Makom*, 183–84; Yanait, *Be-Yemei*, 155–201; Yanait, *Anu Olim*, 358–59. On Yanait and Nili, see ibid., 480–90; Reinharz et al., eds., *Im ha-Zerem*, 87–89, 95–96.

47. R. Yanait, "Ha-Internatzional be-Erev ha-Milhama," *Ha-Ahdut*, September 4, 1914. Concerning the ideological climate prevailing at the time among the workers' camp in Palestine, see Shapira, *Berl*, 70–97.

48. R. Yanait, "Min ha-Amal el ha-Avoda," *Al ha-Saf*, 6; Shapira, *Land and Power*, 89–90.

49. Carmi, *Daliot*, 15. Yosef Haim Brenner, one of the opponents of the volunteering campaign, wrote in an article that was left in his estate, concerning Yanait's assertion in *Al ha-Saf*, that "the right to the land is acquired, first and foremost, with blood," that she had "adopted new and strange words for the mouth of a Social Democrat." Brenner, "Nosafot," *Ktavim*, vol. 4, 1490. Brenner adopted a fair degree of venom toward Yanait's style of writing. See Brenner, ibid., 1489; ibid., "Me-ha-Sifrut ve-ha-Itonut she-ba-Aretz," ibid., vol. 3, 333.

Chapter 2

1. Abbreviated protocol of the first conference of volunteers in Palestine, Jaffa, February 15–16, 1918, *Al ha-Saf*, 96; T. [Rachel Yanait], "Gilgulei Shihrur," ibid., 104.

2. Abbreviated protocol of the Conference of Volunteers, *Al ha-Saf*, 90–91.

3. Grayzel, *Women's Identities*, 190–225; Noakes, *Women*, 39–81.

4. Ouditt, *Fighting Forces*, 16–30; Schönberger, "Motherly Heroines," 87–113; Gavin, *American Women*.

5. So states Ada Fishman, *Tnuat ha-Po'alot*, 62.

6. Protocol of the General Meeting of Women Volunteers, August 31, 1918, LA, IV-130–12.

7. Yanait Ben-Zvi, *Anu Olim*, 512–13.

8. Ben-Hillel Hacohen, *Milhemet ha-Amim*, vol. 2, 846, 856.

9. Moshe Smilansky, "Histadrut Haklait," *Ha-Po'el ha-Tza'ir*, December 27, 1909.

10. Jesse, *The Sword*. The quote from *Henry VI* appears as the epigraph.

11. About Ada Fishman, see Margalit Stern, *Ma'apkhanit*.

12. A memorandum submitted by the Committee of Volunteers to the British Military Command spoke of "an initial group of 500 people, 2/3 of them

men, 1/3 women." Abridged protocol of the Committee of Volunteers, *Al ha-Saf*, 100. Moshe Smilansky wrote on the 20th anniversary of the establishment of the Jewish Legion: "About five hundred people signed up with us as volunteers for the Jewish Legion; of them, a hundred and fifty were women." M. S-ky [Moshe Smilansky], "'Ha-Gdud,'" *Bustenai*, June 23, 1937.

13. Yaffe, "Kit'ei Prakim mi-Yomani," *Ktavim*, vol. 2, 148.

14. Hayim Hillel Ben-Sasson, "Ha-Gdudim," in Dinur, chief ed., *Sefer*, 506; Eilam, *Ha-Gdudim*, 218.

15. Smilansky, "Ha-Gdud," *Bustenai*, July 14, 1937.

16. Letter of the War Office to the Under Secretary of State, Foreign Office, June 25, 1918, NA, FO 371/3409, ISA, M-3409/4545.

17. Telegram of Lord Reading to the War Office, April 19, 1918, Letter of the War Office to the Under Secretary of State, Foreign Office, April 24, 1918, and telegram of the War Office to Lord Reading, April 27, 1918, NA, FO 371/3407, ISA, M-3407/4545.

18. B. H. [Bracha Habas], "Mi-Yomanah shel Na'ara," *Kuntres*, July 20, 1928. Habas, born to a religious family, went on to become a member of the *Davar* editorial board, a journalist, and prolific writer on the history of the Labor Movement.

19. Letter of Jabotinsky to Nina Berlin, May 28, 1918, in Jabotinsky, *Igrot*, vol. 2, 207.

20. Habas, *Mi-Yomana shel Na'ara*. Habas's name does not appear on the lists of women volunteers from that period—perhaps because of her age, or perhaps she changed her mind.

21. Letter of Dov Hoz and Shifra Yehielit to members of the Jewish Legion in Jerusalem, June 1918, ISA, P-26/2061.

22. Letter of Rachel Gutman to the Committee of Volunteers, June 25, 1918, ISA, P-35/2061.

23. Jacobson, *From Empire*, 69–73; Noakes, *Women*, 76–80; Shilo, *Etgar ha-Migdar*, 219–40; Gofer, *Ha-Ishah ha-Tzionit*, 277.

24. Protocol of Po'alei Zion Central Committee, June 26, 1918, LA, IV-403-39; Shilo, *Girls*, 32–35.

25. Ada Fishman, "Mi-Ve'idat ha-Po'alot bi-Yehuda," *Ha'aretz Veha'avoda*, no. 4, July 1918, 64–66; R. K. [Rachel Katznelson], "A Word to the Legionnaires," in Raider and Raider-Roth, eds., *The Plough Woman*, 85–88; Rachel Katznelson-Shazar, *Adam*, 150, 189.

26. Fishman, *Mi-Ve'idat ha-Po'alot bi-Yehuda*, 64.

27. Katznelson, *Adam*, 153. On Women pacifism during WWI, see Grayzel, *Women*, 79–97.

28. Bracha [Habas], "Ha-Yamim ha-Ahronim," *Kuntres*, July 20, 1928.

29. Protocol of the Departure Meeting of Po'alei Zion Party, July 1, 1918, LA, IV-130-11.

30. Smilansky, "Ha-Gdud," *Bustenai*, July 14, 1937; "Be-Olamenu," *Ha'aretz Veha'avoda*, no. 4, July 1918, 79; Mishori, *Shuru*, 202–3, 210–13; Melman, "Min ha-Shulayim," 271; Guilat, "Imahut," 246–47.

31. Smilansky, "Ha-Gdud," *Bustenai*, July 14, 1937.

32. Letter of the Committee of Women Volunteers to Allenby, July 9, 1918, ISA, P-35/2061.

33. Katznelson, *Adam*, 189; Fishman, *Tnuat ha-Po'alot*, 62.

34. Letter of the Committee of Women Volunteers to Allenby, July 9, 1918, ISA, P-35/2061.

35. Grayzel, *Women*, 37–41; Leah Leneman, "Medical Women," 171–72.

36. Letter of the Committee of Women Volunteers to Allenby, July 9, 1918, ISA, P-35/2061.

37. Tzahor, *Ba-Derekh*, 16; Blum, *Ha-Ishah*, 5–6; Melman, "Min ha-Shulayim," 270.

38. Dolev, *Allenby's Military*, 52–55, 144–51.

39. Letter of the Committee of Women Volunteers to Allenby, July 23, 1918, ISA, P-35/2061.

40. See Yanait, *Be-Yemei*, 204; *Anu Olim*, 511; "Le-Toldot ha-Gdudim ha-Ivri'im," in Ben-Zvi, ed., *Ha-Gdudim*, XXXIX.

41. Jabotinsky, *The Story*, 111–12; Protocol of the Women Volunteers General Assembly, August 31, 1918, LA, IV-130-12; Grayzel, *Women*, 54; Grayzel, *Women's Identities*, 204.

42. Letter of the Committee of Women Volunteers to Allenby, July 30, 1918, ISA, P-35/2061.

43. Hacohen, *Rachel Yanait*, 95–108.

44. Letter of Clayton to Weizmann, August 2, 1918, CZA, L4/799.

45. Letter of Weizmann to Vera Weizmann, August 19, 1918, in Weizmann, *The Letters*, vol. 8, 59–62.

46. Protocol of the Women Volunteers General Assembly, August 31, 1918, LA, IV-130-12.

47. Katznelson, *Igrot*, vol. 2, 480; Gofer, *Ha-Ishah ha-Tzionit*, 269, 274.

48. Protocol of the Women Volunteers General Assembly, August 31, 1918, LA, IV-130–12.

49. "Scheme of Formation of Jewish Women's Military Unit," September 1, 1918, ISA, P-35/2061.

50. Letter of Miryam Lubman to Rachel Yanait, September 9, 1918, ISA, P-38/2060.

51. See Yanait's Travel visa with Weizmann to Cairo, September 10, 1918, ISA, P-44/2060.

52. Teveth, *Kina'at David*, 417–19; "Mi-Pi Rachel," in Ben-Zvi, ed., *Ha-Gdudim*, 21–22.

53. "Odds and sods, like Jewish battalions and regiments of Hottentots, are useful in a way; but they won't win wars." Letter Allenby to Wilson, June 5, 1918, in Hughes, ed., *Allenby*, 161.

54. Ben-Sasson, *Ha-Gdudim*, 501.

55. Jabotinsky, *The Story*, 118.

56. E. Golomb, "Ha-Gdud ha-Ivri," *Kuntres*, July 25, 1928.

57. A. B. Golomb, "Meatot Kamoha," *Dvar ha-Po'elet*, December 12, 1937.

58. M. D. [Ma'arelkhet Davar], "Dvar Hayom," *Davar*, December 24, 1941. See also Granit-Hacohen, *Ishah Ivriha*.

59. David Ben-Gurion, "Tzava le-Haganah ve-le-Binyan," *Davar*, November 13, 1948.

60. Shekhter, *Likhbosh*, 222.

61. Habas, Ha-Yamim ha-Ahronim.

Chapter 3

1. Rachel Bluwstein is Rachel the Poet. Rachel Zisaleh Lavi is Shlomo Levkovich's (Lavi) wife, who was one of Ein Harod principal founders and the "Kibbutz Big Group" ideologist. Katznelson-Shazar, *Adam*, 322–23.

2. On Ein Harod, see, for example, Gilad and Tzizling, eds., *Ein Harod*; Zeira, *Kru'im Anu*, 75–106; Kanari, *Tabenkin*.

3. Shapira, "Ha-Halom," 39–51; Near, *Ha-Kibbutz*, 44–128; Kafkafi, *Emet*, 4–12.

4. Tzizling, "Le-Darka shel Ein Harod," *Ein Harod*, 57; Kanari, *Laset*, 289–392.

5. Sturman's eulogy for Sergeant Moshe Rozenfeld, British Jewish policeman who was murdered by Sheich Az El-Din Al-Kasam's group at Mount Gilboa on November 1935.

6. Gilad and Tzizling, eds., *Ein Harod*, 500–4; Baki, "Ha-Sturmanim," 136–46. In relation to the security aspect, it is worthwhile to mention also Yosef Tabenkin, Itzhak Tabenkin's son, Palmach member who replaced Itzhak Rabin as "Har'el" Brigade commander during the 1948 War.

7. Fogiel-Bijaoui, *From Revolution*, 144.

8. "Ha-Kibbutz be-Tavla'ot: Mispar ha-Haverim ba-Kibbutz ve-Halukatam le-Plugoteihem," *Mibifnim*, June 1933, 54; *Ha-Kibbutz be-Misparim*, vol. 12, June 1936, 7; ibid., vol. 21, November 1939, 22.

9. Shapira, "Le-Shivro," 157–207; Tzachor, *Ba-Derekh*, 65–69.

10. Ben-Yocheved (Pinchas Shneorson), "Dvora Drekhler," *Kovetz Hashomer*, 389–93; Rogel, *Tel Hai*, 172–77, 184–85; Trumpeldor Diary, January 6, 1920, in

Rogel, ed., *Parashat Tel Hai*, 137; Rogel, *Ha-Yotz'im*, 143; Sinai, "Ha-Noflot," 294–317.

11. Manya Shohat, "Yom Tel Hai," March 3, 1947, Kibbutz Kfar Giladi Archive, Manya Shohat file.

12. On Tel Hai's myth, see Shapira, *Land and Power*, 98–109; Zerubavel, *Recovered Roots*, 41–45, 84–89, 148.

13. M. H. Ne'eman, "Shomrot ha-Galil," *Haaretz*, March 20, 1925. The statue was made out of clay. The sculptor wanted to have it copper cast, but no donor was found. During the 50th the statue disappeared and wasn't found until today. See also Sinai, *Ha-Shomrot*, 249–51.

14. Letter of Ze'ev Jabotinski to the Women's Federation in Eretz Yisrael, July 13, 1920, CZA, J75/2; Shohat, *Darki be-Hashomer*, 388–91; Slutsky, *Sefer*, vol. 2, part 1, 271, 282–85; Rab, "Aviv 1921 be-Petah Tikva," *Gan she-Harav*, 178–81.

15. "Hahlatot ha-Veida ha-Klalit shel Hapoel Hatzair," November 29—December 4, 1918, *Ha'aretz Veha'avoda*, vol. 5, January 1919; Izraeli, *Tnuat ha-Po'alot*, 125–29; Tzahor, *Ba-Derekh*, 103, 121; Bernstein, *Ishah*, 57–61; Margalit Stern, *Geula be-Kvalim*, 66–73; Gofer, *Ha-Ishah ha-Tzionit*, 389.

16. Golda Meir, "Be-Lev Shalem ve-be-Simcha," December 25, 1960, in Erez, ed., *Sefer ha-Aliya ha-Shlishit*, vol. 2, 910. About Meir's early days in Palestine, see also Medzini, *Golda*, 51–68.

17. Shapira, "Golda," 303–12.

18. Sharet, *Yemei London*, vol. 3, 289.

19. Izraeli, *Tnuat ha-Po'alot*, 109–40.

20. *Protocol ha-Ve'ida ha-Shniya shel ha-Histadrut ha-Klalit shel ha-Ovdim ha-Ivri'im be-Eretz Yisrael*, February 7–20, 1923, 99.

21. Ofaz, "She'elat ha-Ishah," 101–18.

22. Reinharz et al., eds., *Im ha-Zerem*, 169–84; Paz-Yeshayahu, *Tnaim*, 165–77; Goldstein, *Ba-Derekh*, 93–131.

23. Fania [Artzi], "Ha-Havera be-Bdiduta," *Mibifnim*, May 5, 1930. See Near, *What*, 122–30.

24. Alexander Zaid, "Avodat ha-Ishah be-Mishkenu," *Kuntres*, February 19, 1921.

25. Clements, *Bolshevik Women*, 171–89. My thanks to Prof. Sylvie Fogiel-Bijaoui for referring me to that book.

26. Lilia Bassewitz, "Be-Siman ha-Elem," *Tzror Mikhtavim*, July 12, 1940.

27. See, for example, Shechter, *Likhbosh*; Karmel-Chakim, *Shalhevet Yeruka*; Sinai, *Miriam*.

28. "Reshimot Artzi'yot le-Ve'idat ha-Po'alot ha-Revi'it," *Davar*, November 27, 1931; "Reshimat Muamadim la-Ve'ida ha-Shvi'it shel ha-Histadrut," ibid., February 10, 1949. On the Women Workers Conferences, see Margalit Stern, *Geula*, 120–28.

29. Bassewitz, "Asher Siparti le-Nechdi," *Ve-Lu*, 9–18; idem., *Be-Merotz*, 9 32.

30. Ibid., 35; Lilia [Bassewitz], "Im Hits'tarfut ha-Banim le-Hevratenu," *Tzror Mikhtavim*, August 12, 1945.

31. Yehuda Gothelf, "Mashot ba-Kibbutzim: Hach ba-Sela va-Yetz'hu Mayim," *Hashomer Hatzair*, December 1, 1935.

32. See also Govrin, "Nashim," 16–17; Herzog, "Itonut," 43–45; Stern, *Geula*, 156–60; Shechter, *Likhbosh*, 338–44.

33. Bassewitz, *Be-Merotz*, 24, 37.

34. Lilia Bassewitz, "In the Kvuzah," in Raider and Raider-Roth, eds., *The Plough Woman*, 116–19.

35. Bassewitz, *Be-Merotz*, 38–40.

36. Ibid., 21–23.

37. Bassewitz, "Kan ve-Sham," *Ve-Lu*, 30.

38. Kanari, *Tabenkin*, 176, 470–73 and more.

39. Bassewitz, *Be-Merotz*, 37–41.

40. See, for example, "Me-Divrei ha-Haverot be-Pgishat ha-Po'alot shel Mishkey ha-Emek be-Ein Tiv'on [Moshav Kfar Yechzkel]," April 14–15, 1928, *Davar*, June 3, 1928; Meeting of Ein Harod women members' about job issues, November 13, 1932, YTA, 15-28/23/2.

41. Izraeli, *Tnuat ha-Po'alot*, 113–18; Bernstein, *Ishah*, 24, 68–69.

42. Moshe, "Avoda la-Haverot," *Mibifnim*, September 1, 1925, 319–20.

43. See also Izraeli, *Tnuat ha-Po'alot*, 132, 139.

44. "Tel Aviv: Hozrot Aharey Avoda," *Davar*, November 25, 1925.

45. Lilia [Bassewitz], "Asefa Achat," *Davar*, April 9, 1926; Bassewitz, *Be-Merotz*, 137.

46. Protocol ha-Ve'ida ha-Shlishit shel Mo'ezet ha-Po'alot, April 18–24, 1926, LA, IV-230-2-2, 154; "Veidat ha-Po'alot," *Davar*, April 29, 1926.

47. Margalit Stern, *Geula*, 267.

48. Bassewitz, *Be-Merotz*, 50.

49. Margalit Stern, *Geula*, 152.

50. Bassewitz, *Be-Merotz*, 93.

51. Letter of Bassewitz to Tabenkin, early 1926 (no exact date), YTA, 15-28/7/1.

52. Lilia Bassewitz, "Zkhut Rishonim," in Gilad and Tzizling, eds., *Ein Harod*, 331.

53. L. [Lilia Bassewitz], "Madua Shotkim," [no date], YTA, 15-28/12/1.

54. Fogiel-Bijaoui, "Ha-Omnam," 262–84 (esp. 277); Herzog, "Irgunei Nashim," 111–33 (esp. 115–16); Margalit Stern, *Geula*, 17–31; Shilo, *Girls*, 62–63.

55. See, for example, Fishman and Yanait's remarks at the Jewish Agency Executive, June 2, 1926, CZA; Gerda Arlozorof-Goldberg, "Le-Ve'idat ha-Po'alot," *Ha-Ishah*, vol. 2, May 1926, 16–20.

56. R., "Al Thiyat ha-Ishah," *Doar ha-Yom*, June 9, 1926.

57. Atiyash, *Sefer ha-Teudot*, 430–39. The total number of representatives to the conference was not constant.

58. *Protocol of the 21st Zionist Congress*, August 16–25, 1939, 15–16.

59. Puah Rakovsky, "Eifo Hen ha-Nashim?," *Ha-Yom*, March 11, 1925. See also, for example, Yehoshua Yehuda Gordon, "Ha-Ishah ha-Ivriya ve-ha-Tzioniut," *Doar ha-Yom*, September 13, 1927.

60. Bussel, "Tafkid ha-Ishah," Kibbutz Deganya Alef Archive.

61. Brenner, *Hakibbutz*, 9, 15, n. 5–6.

62. Ibid., 9–12.

63. Slutsky, *Sefer*, vol. 2, part 1, 384–87. The western side of the Jezreel valley was abandoned due to Arab attack on Mishmar ha-Emek (which was in his early days).

64. Lavi, *Megilati*, 275–78; Kanari, *Tabenkin*, 288.

65. Yehudit Eidelman, "Be-Yemei Av Tarpat," in Gilad and Tzizling, eds., *Ein Harod*, 110–11.

66. Lavi, *Megilati*, 277.

67. Gozal Yitzhak [Yitzhak Tabenkin], "Ba-Tnua: le-She'elot Haganatenu," *Mibifnim*, December 10, 1929; Brenner, *Hakibbutz*, 28; Kanari, *Tabenkin*, 289–90; Shapira, *Land and Power*, 126.

68. Bernstein, *Ishah*, 12.

69. Halamish, *Meir Ya'ari*, 114.

70. Sarah Blumenkrantz immigrated from the Soviet Union in 1923 and was a member of Kibbutz Tel Yosef until the split in the kibbutz movement in the early 1950s, when she moved to Kibbutz Beit ha-Shita. Many years later, her daughter, Orna Shimoni, would be one of the founders of the Four Mothers organization, whose public pressure contributed to the decision to withdraw from Lebanon in 2000.

71. Protocol of the Women Members Conference, August 21, 1930, EHMA, file 4.7.3; Protocol of Members General Assembly at Kibbutz Ein Harod, August 26, 1930, ibid., General Assemblies file.

72. Herzog, *Nashim Re'aliot*, 134–36; Fogiel-Bijaoui, *Demokratia*, 114–16.

73. Protocol Hakibbutz Hameuhad Council at Givat ha-Shlosha, September 22–25, 1930, YTA, Hakibbutz Hameuhad Archive (hereafter AKM), 2-1/1/8.

74. *Kinus Haverot shel Kibbutzey ha-Po'alim ba-Moshavot*, mitokh ha-Protocol shel Moshav Mo'etzet ha-Po'alot be-Hishtatfut Haverot ha-Kibbutzim ba-Moshavot, Tel Aviv, December 18, 1930.

75. Ibid.

76. Mintz, *Chevley Neurim*.

77. *Hashomer Hatzair*, no. 23–24, December 15, 1930.

78. Nimilov, *The Biological*; Kafkafi, "Mi-Sublimatsia," 328. On Hashomer Hatzair and the gender issue in its early days, see also Gofer, *Ha-Ishah ha-Tzionit*, 355–72.

79. Gola Mire, "Misaviv le-She'elat Hinukh ha-Bahura," *Hashomer Hatzair*, vols. 23–24, December 15, 1930, 6–9.

80. "Le-She'elat ha-Havera ba-Kevutsah," *Niv ha-Kevutsah*, July 1930, 18; Miryam B. [Baratz], "Od le-She'elat ha-Havera," ibid., 20–21.

81. Lilia [Bassewitz], "Ha-Havera ba-Meshek ha-Kibbutzi," *Mibifnim*, November 23, 1931.

82. "Al She'elot ha-Hevrutiot ba-Kevutzah," *Mibifnim*, July 1, 929. In the protocol given at *Mibifnim*, Bassewitz is identified as L-H and Sareni as S.

83. Lilia [Bassewitz], "Ha-Havera ba-Meshek ha-Kibbutzi," *Mibifnim*, November 23, 1931.

84. Lilia [Bassewitz], "Ha-Havera ba-Meshek ha-Kibbutzi," *Davar*, December 30, 1931.

85. Lilia Bassewitz [chach], "Ha-Havera ba-Meshek ha-Kvuztati," *Davar*, January 27, 1932.

86. Lilia [Bassewitz], "Hishtatfut ha-Havera ba-Ha'im ha-Tziburi'im ba-Kibbutz," *Mibifnim*, November 23, 1931. See also, for example, Rosenberg-Friedman, *Mahapkhaniot*, 226–31.

87. "Tafkidei Tnuat ha-Po'alot (mi-Divrei Haverot be-Pgishat ha-Po'alot be-Nahalal)," *Davar*, June 2, 1931.

88. Protocol of Women Members meeting at Ein Harod, November 13, 1932, YTA, 15-28/23/2.

89. During the women workers meeting in 1932, a member of Merhavia, Tzivia Nagler, criticized the "third" principal and said: "Kibbutz which defined such regulation—seems as everything wrong with it." Lilia Bassewitz, "She'elat ha-Havera be-Mo'etzet Hakibbutz Ha'artzi Hashomer Hatzair," *Tzror Michtavim*, November 25, 1945.

90. Protocol of Hakibbutz Hameuhad Council at Yagur, June 30–July 5, 1933, YTA, AKM, 2-1/1/10.

91. Yehuda Roznichenko, "Sikumei ha-Hakira ba-Kibbutzim," *Tzror Mikhtavim*, June 10, 1936, 12–14.

92. Near, *Ha-Kibbutz ve-ha-Hevra*, 220–22.

93. Lilia [Bassewitz], "Al Pe'ula Tarbutit ve-Al Havay Tarbuti," *Mibifnim*, June 1933.

94. Kanari, *Tabenkin*, 374.

95. Lilia [Bassewitz], "Be-Masekhet ha-Hagshama," *Dvar ha-Po'elet*, December 3, 1936.

96. *Protocol of Hakibbutz Hameuhad 11th Council at Yagur, October 2–7, 1936*, 69.

97. Katznelson, "LiKrat ha-Yamim ha-Ba'im," *Ktavim*, vol. 1, 76–77.

98. Lilia Bassewitz, "Al Reshimati 'Shlishi,'" YTA, 15-28/25/3.

99. Keshet, *Ha-Mahteret*, 63–64.

100. Rachel [Lilia Bassewitz], "Shlishi," *Mibifnim*, October 1934.

101. See, for example, M. Beilinson, "Nikmat ha-Shlishi," *Davar*, November 15, 1934; Dr. P. Lander, "Ha-Matzav ha-Sanitari ba-Kibbutzim," ibid., February 25, 1935. Lander mentioned, in regard to the article "Shlishi," that "for the 5,469 young and developed physically good people in 65 kibbutzim—only 667 children for 902 families! In the 42 kibbutzim in Jehuda, Shomron and ha-Sharon there are 3,947 adults—young and developed—only 292 children to 608 families!"

102. Reuven Cohen, "Dira la-Haver," *Mibifnim*, November 1934.

103. *Protocol of Hakibbutz Hameuhad 13th Conference in Ashdot Ya'akov*, October 3–8, 1941, 83.

104. Ibid.

105. Lilia [Bassewitz], "Al Pe'ula Tarbutit ve-Al Havay Tarbuti," *Mibifnim*, June 1933; idem., "Hinukh le-Re'iyat ha-Adam," ibid., December 1933.

106. *Protocol of Hakibbutz Hameuhad 12th Council at Na'an*, July 14–21, 1939, 159.

107. Bassewitz, *Ve-Lu*, 32.

108. Lilia Bassewitz, "Al Reshimati 'Shlishi,'" YTA, 15-28/25/3.

109. Lilia Bassewitz, "Ha-Po'elet ve-Bituya," *Dvar ha-Po'elet*, March 1935. Bassewitz was for many years a member of *Dvar ha-Po'elet* editorial staff.

110. Bassewitz's words in "Pgishat Haverim be-Inyanei *Mibifnim*," June 8–9, 1934, YTA, 2-2/10/1.

111. Lilia Bassewitz, "Be-Eineha shel Havrat Ma'arekhet," *Dvar ha-Po'elet*, March–April 1974.

112. Rachel Katznelson, "Be-Tnuat ha-Po'alot ba-Aretz," *Dvar ha-Po'elet*, June 26, 1934.

113. "Le-Yom ha-Po'elet ha-Bein Leumi," *Dvar ha-Po'elet*, March 31, 1935.

114. Ha-Va'ada ha-Mesaderet, "Kinus be-Yom ha-Po'elet ha-Bein Leumi," April 6, 1935, YTA, 15-28/14/1.

115. Rachel Katznelson, "Be-Yom ha-Po'elet ha-Bein Leumi," *Dvar ha-Po'elet*, April 30, 1935.

116. "Le-Zekher Yemei Av Tarpat: ha-Havera," *Dvar ha-Po'elet*, August 25, 1935.

117. *Alon Kevutzat Hugim*, April 12, 1936, Kibbutz Beit ha-Shita Archive.

118. "Ha-Kinus be-Tel Yosef be-Yom ha-Po'elet," Yoman Meshek Ein Harod, Alon Kibbutz Ein Harod, April 12, 1936, EHMA.

119. Hela Mozes, "Be-Mi ha-Asham?," *Hedim*, March 1936, vol. 3, 11–13.

120. Meir Ya'ari, "Ba-Derekh le-Shivyon," *Hedim*, April 1936, vol. 4, 2.

121. Amma [Levine-Talmi], "Tahanot," *Hedim*, March 1936, vol. 3, 4.

122. Ibid.

123. Ya'ari, "Ba-Derekh le-Shivyon," *Hedim*, April 1936, vol. 4, 4–6.

124. Meir Ya'ari, "Likrat Motsa," *Hashomer Hatzair*, December 15, 1930, vols. 23–24, p. 5; Kafkafi, *Sublimatsia*, 329.

125. Halamish, *Meir Ya'ari*, 120–21.

126. Gothelf, "Mashot ba-Kibbutzim," *Hashomer Hatzair*, April 15, 1936, 7–8.

127. Katznelson-Shazar, *Adam*, 332–33, diary entry on December 1931; Protocol of Mapay Secretariat, December 6, 1931, LPA.

128. Lilia [Bassewitz], "Mishe'elot Tnuat ha-Po'alot," Tosefet le-Yoman Meshek Ein Harod, February 14, 1936, EHMA.

129. Bat-Rachel, *Banativ*, 136. Diary entry on March 15, 1935.

130. Letter of Lilia Bassewitz to Batya Brenner, December 7, 1935, YTA, 15-28/7/3.

Chapter 4

1. *Yoman Ein Harod*, July 5, 1936, EHMA.

2. Near, *Rak Shvil*, 250, 262; *Ha-kibbutz be-Misparim*, no. 12, June 1936, 7; ibid., no. 21, November 1939, 22.

3. For the workers' settlement movement during the first wave of the Arab Revolt, see Slutsky, *Sefer*, vol. 2, part 2, 676–88; Brenner, *Ha-Kibbutz*, 118–31. For the Yishuv during the Arab Revolt, see Shapira, *Land and Power*, 219–76.

4. See, for example, P., "Ha-ishah ba-Haganah," *Yoman ha-Meshek*, July 25, 1936, Kibbutz Gvat Archive; "Shomeret, mah Mi-leil?," *Alon Kibbutz Merhavia*, July 31, 1936, HHA, 103-51.1(1); Woman Member, "Ve-od le-Inyan Hishtatfut ha-Haverah ba-Shmirah," *Yoman Na'an*, August 19, 1936, Kibbutz Na'an Archive.

5. "Ha-Zkhut le-Haganah," *Alon Mishmar ha-Emek*, May 10, 1936, Kibbutz Mishmar ha-Emek Archive.

6. "She'elot ha-Sha'ah," *Dvar ha-Po'elet*, May 10, 1936.

7. Lilia Bassewitz, "Ma'avak ha-Haverot al Shituf ba-Shmirah," *Dvar ha-Po'elet*, May 1956.

8. "Shiluvei Dvarim: Me-divrei haverot be-shurah shel asefot be-Ein Harod she-hayu mukdashot le-berur she'elat shitufah shel ha-haverah ba-haganah," *Mibfnim*, June 1936, 83.

9. Letter of Mordechai Hadash to Aharon Tzizling, June 14, 1936, EHMA, 1/7/4. Over the following few weeks, various versions of the letter were published in the Ein Harod bulletin and journals of Hakibbutz Hame'uhad, *Tzror Mikhuuvim* and *Mibfnim*. See also Brenner, *Ha-Kibbutz*, 160–61.

10. Klonimus, "Im hagigat gmar be-meshek ha-Po'alot," *Davar*, October 16, 1933.

11. Beba Idelson, "Mikhtav Hozer," June 22, 1936, EHMA, 4/7/1.

12. Protocol of Hakibbutz Ha'artzi Executive Committee in Sarid, May 12, 1936, HHA, 5-10.1 (12).

13. Protocol of the General Assembly of Ein Harod, June 27, 1936, EHMA; *Yedi'ot ha-Mazkirut*, no. 11, June 29, 1936, YTA, AKM, 2-5/1/1.

14. Protocol of General Assembly of Ein Harod, July 1, 1936, EHMA; "Hahlatot ha-Asefah ha-Klalit," *Yoman Meshek Ein Harod*, July 3, 1936, ibid.

15. "Ha-bakhurot Mitgaysot," *Alon Mishmar ha-Emek*, July 4, 1936, Kibbutz Mishmar ha-Emek Archive.

16. "Bahurot Merhaviyah ba-Shmirah," *Alon Mishmar ha-Emek*, August 22, 1936, Kibbutz Mishmar ha-Emek Archive.

17. Emma [Talmi], "Zkhut Haganah la-Haverah," *Hedim*, July 1936, 4–6.

18. See, for example, Tzila [Reich], "Al Asefat ha-Haverot," *Alon Givat Brenner*, July 15 and 23, 1936, Kibbutz Givat Brenner Archive; A Woman Member, "Al Shivui ha-Zkhuyot," *Alon Kevutzat Na'an*, August 17, 1936, Kibbutz Na'an Archive.

19. Geula Shertok, "Le-Shituf ha-Haverah ba-Haganah," *Alon Givat Brenner*, August 14, 1936, Kibbutz Givat Brenner Archive.

20. Protocol of General Assembly Members at Givat Brenner, August 8, 1936, Kibbutz Givat Brenner Archive.

21. Woman Member, "Al Shivui ha-Zkhuyot," *Alon Kevutzat Na'anah*, August 17, 1936, Kibbutz Na'an Archive.

22. "Levayat Hayah Freund be-Ramat ha-Kovesh," *Davar*, August 19, 1936; *Ramat ha-Kovesh*, 66, 120; Rivlin, ed., *Yemei Ramah*, 89. Haya Freund was born in Poland in 1913 and immigrated to Palestine in 1934 after agricultural training in Hehalutz.

23. *Ramat ha-Kovesh*, 126.

24. Ibid., 119–21.

25. Rachel Katznelson, "Le-She'elot ha-Sha'ah," *Dvar ha-Po'elet*, October 25, 1936.

26. Protocol of General Assembly Members at Givat Brenner, August 8, 1936, Kibbutz Givat Brenner Archive.

27. Zehava Bergman, "Ha-Ishah ha-Araviyah ve-ha-Me'ora'ot," *Dvar ha-Po'elet*, June 10, 1936. See also Ellen L. Fleischmann, *The Nation and Its "New" Women: The Palestinian Women's Movement, 1920–1948*, 123–35.

28. Protocol of Mapai Political Committee, July 22, 1936, LPA, 2-23-1936-14.

29. Sara L., "Mi-tokh Igrot ve-Pinkasim," *Dvar ha-Po'elet*, July 12, 1936.

30. See, for example, "Hafganat Nashim be-Yerushalaim," *Davar*, May 7, 1936; "Telegramat Nashim le-Melekh Anglia," ibid., May 8, 1936; MD [Ma'arekhet Davar], "Dvar ha-Yom," ibid., June 12, 1936; "Leket me-ha-Itonut ha-Aravit," *Dvar ha-Po'elet*, July 12, 1936.

31. M. D. [Ma'arekhet Davar—the article was written by Moshe Beilinson], "Dvar ha-Yom: Yeladeinu Mit'orerim be-Bekhi be-Emtza ha-Laila," *Davar*, June 29, 1936.

32. "Hutzat Beit ha-Tinokot," *Davar*, June 21, 1936; Ha-Nashim ha-Yehudiot be-Eretz Yisrael, "Dvar Imahot el Imahot," ibid., July 5, 1936.

33. Letter of F. Hayot to the Wizo International Executive, August 7, 1936, CZA, F49/2104; "Netzigut Meuhedet shel Neshei ha-Yishuv," ibid.; "Takanot ha-Mo'atza shel Irgunei Nashim Ivriyot be-Eretz Yisrael," LA, IV-230-6-64.

34. "Tshuvat ha-Nashim ha-Araviyot," *Davar*, July 12, 1936.

35. Anda Pinkerfeld, [no title], *Davar*, Evening Supplement, June 25, 1936.

36. M. Kushnir, "He'ara," *Davar*, July 7, 1936; Bracha Habas, ed., *Sefer Me'ora'ot Tartzav*, 544.

37. "Leahar To'evat ha-Ptzatza be-Tel Aviv," *Davar*, July 24, 1936; "Ha-Yishuv ha-Mezo'aza Mohe Neged To'evat ha-Ptzatza," ibid., July 26, 1936; "Ha-Natziv Mebia Tiuvo la-Ptzatza ba-Yeladim," ibid., July 28, 1936.

38. "Sh. Tshernihovsky Nitzal be-Nes mi-Kadur Meratzhim," *Davar*, May 7, 1936; M. D. [Ma'arekhet Davar], "Dvar ha-Yom: Sakanat Nefesh la-Gdolim ve-la-Ktanim," ibid.; Sh. Tshernihovsky, "Ba-Mishmar," May 13, 1936, *Davar*, Evening Supplement, May 18, 1936; Tshernihovsky, "Shir Eres," *Davar*, May 26, 1936. On this issue and herewith about Fanya Bergstein, see also Shapira, *Land and Power*, 224–25, 237–38.

39. Fanya [Bergstein], "Ani ha-Bat," in Habas, ed., *Sefer Me'ora'ot Tartzav*, 522–23; Tirtza, "Mi-Shirei ha-Me'ora'ot," *Dvar ha-Po'elet*, February 21, 1937.

40. Jessie Sampter, "Watchwomen," August 17, 1936, *Jewish Frontier*, November 1936, 45–54; Sampter, "Something Happened," *Palestine Post*, May 31, 1938. This article was chosen by Berl Katznelson to conclude the controversial book he edited on the unification of the kibbutz movements, *Ha-kibbutz veha-kevutzah: Yalkut le-verur she'elat ha-ihud* (1940). See Shapira, *Berl*, 250–52; Haim Ben-Asher, "Ha-hakhamah mi-Givat Brenner," *Davar*, December 27, 1938.

41. Protocol of Conference at Givat Ha-Shlosha, July 13, 1936, YTA, AKM, 15-28/23/7.

42. Ibid.

43. "Sikumei ha-Kinus le-She'elot ha-Avoda shel ha-Haverah," *Tzror Mikhtavim*, August 20, 1936, 7–8.

44. Shifra Haikin, "Darki le-Eretz Yisrael," in Gilad and Tzizling, eds., *Ein Harod*, 154.

45. Protocol of General Assembly Members at Kibbutz Tel Yosef, August 19, 1936, Kibbutz Tel Yosef Archive.

46. Protocol of General Assembly Members at Kibbutz Tel Yosef, August 29, 1936, September 3, 1936, Kibbutz Tel Yosef Archive; "Mesiba Meinyanei Deyoma," August 31, 1936, *Mehayeynu*, Tel Yosef bulletin, ibid.; Interview with Rachel Shelon-Fridland, AHH, 134.31; Aktin, *Ba-Derekh*, 42.

47. Sarah Amster, "Al Shmirat ha-Haverah," Kibbutz Merhavia bulletin, September 4, 1936, HHA, 103-51.1(1).

48. Protocol of Women Members Conference in Sarid, August 29–30, 1936, HHA, 20.1(2); "Decisions of a Conference of Women Members of Jezreel Valley and Haifa Bay Kibbutzim," Hashomer Hatzair, September 15, 1936, 16.

49. Protocol of Women Members Conference in Gan Shmuel, October 30–31, 1936, HHA, 1.20(2); Rivka Gurfine, "Le'ahar Kinus ha-Khverot be-Gush ha-Shomron," Hedim, November 1936, 17–18; "Kinus ha-Haverot be-Gan Shmuel," Hashomer Hatzair, December 1, 1936, 16.

50. Protocol of the Executive Committee of Hakibbutz Ha'artzi in Rishon LeZion, January 25, 1937, HHA, 5-10.1(13).

51. Tzesia Ushenkar, "Al Admat Avot," Dvar ha-Po'elet, February 21, 1944.

Chapter 5

1. Protocol of Activist Members in Defense Issues in Hakibbutz Hameu-had, at Kibbutz Gesher, February 14, 1937, YTA, AKM, 2-4/5/1.

2. Haya [Tanpilov], "She'elot mi-She'elot Shonot," Ba-Avodah uva-Hayim, Alon Kibbutz Deganyah Alef, March 12, 1937, Kibbutz Degania Alef Archive.

3. Fanya [Artzi], "Ha'im ha-Haverah Nadonah le-Akrut," Ba-Avodah uva-Hayim, February 16, 1937, Kibbutz Degania Alef Archive.

4. Brenner, Ha-Kibbutz, 180.

5. Protocol of the 11th Council of ha-Kibbutz ha-Me'uhad, Yagur, October 2–7, 1936, Ein Harod 1937, 140.

6. Ibid., 144, 199–200.

7. Brenner, Ha-Kibbutz, 165, 202; Protocol of the Women Workers' Council, December 22–24, 1936, LA, IV-230-5-24A.

8. Lilia Bassewitz, ed., "Ha-Haverah ba-Shmirah," supplement to Ein Harod and Tel Yosef newsletter on International Working Women's Day, March 20, 1937, EHMA; "Shaharit ha-Yeladim: Mukdeshet le-Yom ha-Po'elet ha-Bein-leumi," Yoman Meshek Ein Harod, March 19, 1937, ibid.

9. Mo'etzet ha-Po'alot, "Le-Yom ha-Po'elet ha-Beinleumi," Dvar ha-Po'elet, March 11, 1937.

10. Shapira, Land and Power, 238.

11. Emma Levin and the Secretariat of Hakibbutz Ha'artzi, circular letter no. 13, February 16, 1937, HHA, 5-3.97 (4); Secretariat of Hakibbutz Ha'artzi, Bulletin, no. 157, May 30, 1937.

12. "Ba-Kibbutz Ha'artzi," Hashomer Hatzair, March 1, 1937, 15; ibid., July 15, 1937, 16.

13. Letter of Ya'ari to members of the seminar, April 1937, HHA, 95-7.26(2). For Ya'ari's illness, see Halamish, Meir Ya'ari, 137–41.

14. Protocol of the Members General Assembly at kibbutz Givat Brenner, May 22, 1937, May 29, 1937, Givat Brenner Archive.

15. Rachel Katznelson, "Tafkidei ha-Seminar," June 6, 1937, LA, IV-230-6-85.

16. Iysrael Galili, "Mi-She'elot ha-Bitahon ba-Aretz," June 20, 1937, LA, IV-230-6-85; "Tokhnit ha-Seminar le-Po'alot," June 6–27, 1937, YTA, 11-2/5/3.

17. "Tokhnit ha-Seminaryon ka'asher Nitgashma," LA, IV-230-6-85; "Ha-Nos'im ba-Seminar," Dvar ha-Po'elet, July 28, 1937.

18. Rachel Katznelson, "Ahat ha-Rishonot," in Puah Rakovsky, Lo Nikhnati, 7; Katznelson, "Dmut Historit," Dvar ha-Po'elet, August 11, 1940; "Puah Rakovsky bat Shmonim," Davar, July 1, 1945. About Rakovsky, see Rakovsky, My Life.

19. Puah Rakovsky at the Po'alot Seminar, June 21, 1937, LA, IV-230-6-85.

20. R. Moshe, "Be-Keren Zavit," Ha-Tzfira, May 8, 1931; Katznelson, Ahat ha-Rishonot, 8–9.

21. R. K. H. [Rachel Katznelson], "Seminar ha-Po'alot," Dvar ha-Po'elet, August 2, 1937; R. K. H., "Dmut Historit," ibid., August 11, 1940.

22. "Ha-Shavua ha-Shlishi," YTA, 15-28/12/3; "Hartza'ata shel Manya Shohat al ha-Ishah be-Hashomer," June 20, 1937, in Goldstein, Ba-Derekh, 264–67.

23. "Ptihat ha-Seminar shel Mo'etzet ha-Po'alot," Davar, June 6, 1937; "Nin'al Seminar ha-Po'alot," ibid., June 27, 1937.

24. R. K. H. [Rachel Katznelson], "Seminar ha-Po'alot," Dvar ha-Po'elet, August 2, 1937.

25. Protocol of Acting Secretariat of Hakibbutz Hame'uhad, November 2, 1936, YTA, AKM, 2-4/5/3; Letter of Hakibbutz Hame'uhad Secretariat to its Kibbutzim, February 10, 1937, ibid., 2-culture/2/1; questionnaires filled out by participants in the seminar, ibid.; "Im Siyum Mif'al," Tzror Mikhtavim, October 30, 1937, 1–6.

26. H. Fish, "Le-Zekher Hayale Freund," Tzror Mikhtavim, August 26, 1937, 22–23.

27. Rahel, "Ha-Haverah ba-Hityashvut ha-Kibushit," Hedim, September 1938, 20.

28. "Ba-Shmirah uba-Gvul," Alon Kibbutz Ein ha-Shofet, February 11, 1938, Kibbutz Ein Hashofet Archive, box 4, file 128.

29. Shapira, Land and Power, 249–57; Slutsky, Sefer, vol. 2, part 2, 911–67.

30. N. [Rahel Katznelson], "Ha-Ishah ba-Hitgonenut (me-Sihat Haverot)," Dvar ha-Po'elet, August 15, 1939.

31. Protocol of an Activists' Day on Questions of Security, July 29, 1938, YTA, AKM, 2-4/5/1.

32. See, for example, Y. H.-G., "Mi-Hutz la-Bayit," Yedi'ot Kinneret, Alon Kevutzat Kinneret, August 19, 1938, YTA, 16-4-84/1/6.

33. Protocol of 37th Histadrut Council, July 25–26, 1938, LA.

34. See Chazan, "Ha-Nisyonot," 172–84.

35. Tabenkin, *Al ha-Shmira*, 20.

36. Yanait Ben-Zvi, *Manya Shohat*, 129.

37. Letter of Manya Shohat to Yisrael Shohat and Yosef Harit, February 27, 1938, YTA, 15/4/3. Tova Portugaly and Moshe Elyovitz were brothers and members of kibbutz Kfar Giladi. They spoke Arabic fluently and were involved in the attempts to improve the relations between Jews and Arabs in the Upper Galil region.

38. Shohat-Wilbushewitch, *Ha-Shmira ba-Aretz*, 75–76; Letter of Manya Shohat to Ruth Krol, July 3, 1954, in Reinharz et al., eds., *Im ha-Zerem*, 521–23.

39. "Yom shel Te'unot Kashot," *Davar*, March 30, 1938; Le'a Likhtental, "Mitokh Igrot ve-Pinkasim: Yedei Em," *Dvar ha-Po'elet*, May 29, 1938. Ramataim is today one of the neighborhoods of the city Hod ha-Sharon.

40. Letter of Itzhak Ben-Zvi to Mo'etzet ha-Po'alot, January 26, 1938, LA, IV-230-1-136; Letter of Beba Idelson to the Va'ad Leumi, February 17, 1938, ibid.

41. Fanya Tomashov, "Le-Hagah shel ha-Po'elet," March 25, 1938, *Ba-Avodah uva-Hayim*, March 25, 1938, Kibbutz Degania Alef Archive.

42. Hayuta [Bussel], "Le-yom ha-Po'elet ha-Beinle'umi," *Ba-Avodah uva-Hayim*, March 25, 1938, Kibbutz Degania Aleph Archive.

43. Moetzet ha-Po'alot, "Haverot!," *Davar*, April 1, 1938.

44. "Hedei ha-Zman," *Dvar ha-Po'elet*, March 28, 1939.

45. See "Pasiyonariyah Hayeah u-Po'alah," *Davar*, January 5, 1937; "Neshei ha-Gvurah be-Sfarad," *Dvar ha-Po'elet*, March 11, 1937.

46. On the struggle for "National Consumerism," see Margalit Stern, "Imahot," 91–120.

47. Miriam Baratz, "La-Haverot ba-Ir," *Dvar ha-Po'elet*, July 12, 1936.

48. Mo'etzet ha-Po'alot, "El Ha-Po'elet ve-ha-Em ha-Ovedet," [no date], LA, IV-239-6-15.

49. "Kofer ha-Yishuv: Matat Takhshitim," *Davar*, September 14, 1938, "Matat Takhshitim," ibid., October 16, 1938; "She'elot ha-Sha'ha: Hitparku," ibid., October 25, 1938; "Hefetz Ehad lekhol Arba Nefashot," ibid., December 14, 1938.

50. Gute [Luria], "Emdat ha-Haverah ba-Kibbutz ke-Gorem Hinukhi," *Hedim*, September 1938, 18–19.

51. Feige Hindes, "Mah Darkhenu Lehaba?," *Hedim*, September 1938, 25–26.

52. D', [no title], *Hedim*, September 1938, 23–24.

53. Protocol of a meeting of women delegates at the Agricultural Council, January 10, 1939, YTA, 15-28/23/6.

54. "Hahlatot ha-Moshav," *Dvar ha-Po'elet*, December 30, 1938.

55. Dvora Dayan, "Sikumo shel Moshav Mo'etzet ha-Po'alot," *Dvar ha-Po'elet*, December 30, 1938.

56. Protocol of the 18th Session of the Women Workers' Council, March 26–27, 1939, YTA, 15-28/12/1.

57. Women Workers' Council, "Le-yom ha-Po'elet ha-Beinleumit," *Davar*, April 3, 1939.

58. See, for example, Letter of Beba Idelson to the Executive of Moetzet ha-Po'alot, July 4, 1938, LA, IV-230-6-64; Protocol of Women Organizations Council, November 22, 1938, CZA, F49/2104; IV-230-6-15; Protocol of Women Organizations Council, May 4, 1939, LA, IV-230-6-15.

59. Katzburg, "Ha-Asor ha-Sheni," 426–28; Slutsky, *Sefer*, vol. 3, part 1, 25–30.

60. "Ha-Hafgana ha-Adira shel Bnot Yerushalaim," *Davar*, May 23, 1939; "Bnot Yerushalaim Niz'aku Lehafgin Oz Nekhonutan lo Lehikana la-Gzerot," ibid.

61. Protocol of the Women Organizations Council, May 26, 1939, LA, IV-230-6-15.

62. On Yanait's activity in the Haganah, see, for example, Slutsky, *Sefer*, vol. 2, part 1, 134–36, 349–51, 423–25, 563–64.

63. Protocol of a Meeting of Jerusalem Women at Mrs. Yosef House, May 24, 1939, ISA, P-15/2071.

64. "Neshei Yerushalaim be-Shaha Zo," *Dvar ha-Po'elet*, July 5, 1939 (Yanait's name isn't signed on the article, but from the substance it's clear that she wrote it).

65. Slutsky, *Sefer*, vol. 3, part 1, 30.

66. Ben-Gurion Diary, May 24, 1939, July 4, 1939, BGA. On Ben-Gurion's decision to be aided by the Youth Organizations, see many entries in his diary during May–July 1939.

67. Protocol of the Women Organizations Council, June 12, 1939, LA, IV-230-6-15; letter of the Women Organizations Council to Jewish Agency and Va'ad Leumi Executives, June 13, 1939, ibid., IV-230-6-14B.

68. Katznelson, *Ha-Ishah ba-Hitgonenut*, *Dvar ha-Po'elet*, August 15, 1939.

69. Niv, *Ma'arakhot*, vol. 2, 74–83, 228, 238–50; Shapira, *Land and Power*, 240–57.

70. Puah Rakovsky, "Kol Ishah Ivriya," in R' Binyamin and Peterzil, eds., *Neged*, 84–85.

71. Ibid.

Chapter 6

1. "Nashim be-Tel Aviv al ha-Mishmar," *Davar*, September 4, 1939; "Neshei Tel Aviv!," ibid., September 6, 1939; "Ha-Ishah Mitgayeset," ibid., September 11, 1939.

2. Slutsky, *Sefer*, vol. 3, part 1, 295–98; Moshe Smilanski, "Hitgaysut— Hitnadvut," *Haaretz*, September 11, 1939; "Mispar ha-Okhlusim ba-Aretz" *Davar*,

October 6, 1939; M. D. [Ma'arekhet Davar], "Dvar ha-Yom," ibid., September 26, 1939; Gelber, *Toldot*, vol. 1, 158–59.

3. C. H., "Barukh she-Heganu le-Gdud Haverot," *Bamahane*, October 14, 1939.

4. David Ben-Gurion, "Be-Mesibat Haverim," September 8, 1939, BGU.

5. Ben-Gurion's diary, entry on September 28, 1939, BGU.

6. On the topic of women volunteers, see especially Habas, *Bnot Hail*; Gelber, *Toldot*; Granit-Hacohen, *Ishah Ivriya*.

7. "Talukhat Oz ve-Kavod," *Davar*, October 1, 1939; "Talukhat Meguyasim be-Rehovot Tel Aviv," *Haaretz*, October 1, 1939; "Thalukhat ha-Mishmar ha-Ez-rahi be-Tel Aviv," ibid., October 6, 1939.

8. "Hoda be-Retzah ha-Ahayot Fink ve-Tzedek?," *Davar*, October 4, 1939.

9. "Tel Aviv: Mahleket ha-Po'alot ve-Irgun Imahot Ovdot," *Davar*, September 6, 1939; "Tel Aviv: Haverot Wizo," ibid.; Protocol of Women Workers at the Colonies Committee and the Country Board of Working Mothers Organizations meeting, Tel Aviv, October 8, 1939, YTA, 15-18/12/1.

10. Women Workers' Council Executive, "Le-Haverot Histadrut ha-Ovdim," *Dvar ha-Po'elet*, September 12, 1939.

11. Sarah Gafni, "Kronot Yeladim," *Dvar ha-Po'elet*, March 31, 1940. For news about children freezing to death in trailers, see, for example, "Me-Hamtza'ot ha-Satan shel ha-Natzim be-Polin," *Davar*, January 18, 1940.

12. Letter of Beba Idelson to the Jewish Agency Executive, The Va'ad ha-Leumi Executive and to the Histadrut Executive Committee, September 21, 1939, YTA, 15-28/12/1; Beba Idelson, "Mishmartenu bi-Sh'at Herum," *Dvar ha-Po'elet*, October 16, 1939.

13. See also Habas, *Bnot Hail*, 46–47; Gelber, *Toldot*, vol. 1, 479; Granit-Hacohen, *Ishah Ivriya*, 40–45, 49, 74–75.

14. Protocol of Women's Organizations Council meeting with the Va'ad Leumi Executive Representatives, July 12, 1940, LA, IV-230-6-16; Letter of Women's Organizations Council Secretary to the Va'ad Leumi, July 12, 1940, ibid.; Protocol of Country Council of Women's Organizations Council, July 17, 1940, ibid.; Letter of Women's Organizations Council Secretary to the Va'ad Leumi, July 19, 1940, CZA, J1/4570; Letter of the Va'ad Leumi Executive to Women's Organizations Council, August 11, 1940, ibid.

15. "Mi-Yomana shel Mo'etzet ha-Po'alot," *Dvar ha-Po'elet*, August 11, 1940; "Me-ha-Va'ad Hapo'el: Ba'ayot ha-Herum la-Po'elet," *Davar*, September 26, 1940; Letter of Moshe Shertok and Itzhak Ben-Zvi to Women's Organizations Council, September 24, 1940, LA, IV-230-6-16.

16. Rachel Katznelson, "Beikvot ha-Milhama," *Dvar ha-Po'elet*, November 26, 1940.

17. Hacohen, *Manhiga*.

18. Jessie Sampter, "Ha-Em," *Dvar ha-Po'elet*, December 22, 1940.

19. Barslavsky, ed., *Hannah Szenes*, 99. Szenes immigrated to Palestine in 1939 and was then at the end of her studies in the Nahalal Young Women Agriculture school.

20. Protocol of *Women Lecturers Meeting in Preparation for the Elections to Working Women Conference*, Haifa, May 22, 1941, 31.

21. Ibid., 14–15; Protocol of Women's Organizations Conference, May 25, 1941, CZA, F49/2104; Ada Fishman, "Giyus la-Avodah," *Dvar ha-Po'elet*, July 4, 1941.

22. "Conclusions of Consultation about Including women Organization at the Medical Service Activities," February 16, 1941, CZA, S25/6002; Letter of Chaim Yassky to Shertok, March 4, 1941, ibid.; D. Gorevitz, "Memo: Commander to the National Service of Nurses," March 27, 1941, ibid.; "Enlisting Nurses to Medical Service during April 1941," ibid.

23. Granit-Hacohen, *Hebrew Women*, 41–50; Gelber, *Toldot*, vol. 1, 479.

24. S. [Sonya] Idelberg, Report about her work at the recruitment division when retiring from her position as national requiting, 1944 [no specific date], CZA, S25/5099; "Ha-Giyus Hofekh Tnuat Hitnadvut," *Davar*, October 8, 1941.

25. "Imahot Kor'ot la-No'ar Lehitnadev la-Tzava," *Davar*, October 14, 1941; Y. K., "Inyanim: Nashim Megaysot," *Haaretz*, October 16, 1941.

26. Protocol of the 53rd Histadrut Council, October 19, 1941, LA; Protocol of the Jewish Agency Executive, October 26, 1941, CZA.

27. "Dmei Sarah Aharonson Tov'im: Hitgaysu," *Haaretz*, October 15, 1941; Melman, "The Legend," 63–64, 67–75.

28. Campbell, "Women in Combat," 301–23; Yellin, *Our Mothers' War*; Pennington, "Offensive Women," 775–820; Noacs, *Women*, 103–32.

29. Letter of Bedington to Samuel, April 26, 1941, CZA, S25/6001; Letter of Samuel to Bedington, May 8, 1941, ibid.; Letter of Samuel to Colonel Sail, September 5, 1941, ibid.

30. Protocol of Women's Organizations Council Executive meeting with representatives of Jewish Agency Recruitment Department, October 12, 1941, CZA, F49/2104.

31. Granit-Hacohen, *Ishah Ivriya*, 49–50; Protocol of Shertok's Speech at the Working Women's 5th Conference, February 23, 1942, CZA, S23/91.

32. Protocol of Working Women Organization 22nd Council, November 3, 1941, CZA, IV-230-6-183; "Mo'etzet ha-Po'alot Tova'at: Teshutaf ha-Ishah ba-Ma'amatz ha-Milhamti ha-Yashir!," *Davar*, November 5, 1941; "Moshav Mo'etzet ha-Po'alot al Giyus ha-Ishah," *Dvar ha-Po'elet*, January 30, 1941; Letter of Shertok to the Youth *Aliya* Bureau, November 18, 1941, CZA, S25/5099.

33. Jewish Agency Recruitment Department, "Horaot be-Dvar Giyus Nashim," December 31, 1941, YTA, 12-3/107/1; Letter of Shertok to Chiti, February 2, 1941, CZA, S25/6001.

34. "Bnot Yisrael le-Haganat ha-Moledet," *Davar*, December 28, 1941; "Giyus ha-Nashim Idud le-Hitnadvut ha-Gvarim," ibid., January 1, 1942.

35. M. D. [Ma'arekhet Davar], "Dvar ha-Yom," *Davar*, December 24, 1941.

36. Protocol of the Jewish Agency Executive, December 21, 1941, CZA; Message from the Va'ad ha-Leumi Board's Press Department to Members of the Va'ad ha-Leumi Executive, December 24, 1941, ibid., J1/3057.

37. Telegram of Vera Weizmann to Hadasa Samuel, January 18, 1942, CZA, S25/5099; Telegram of Chaim Weizmann to Samuel, January 17, 1942, ibid., S25/6001.

38. Protocol of Mapai Central Committee, January 8, 1942, LPA.

39. Letter of Shertok to Hever Hakevutzot Council, April 10, 1942, CZA, S25/5099.

40. Protocol of Mapai Central Committee, January 8, 1942, LPA.

41. Protocol of Hakibbutz Hameuhad Council in Givat Haim, December 26–28, 1941, YTA, 2-2/3/10; Protocol of Hakibbutz Hameuhad Secretariat, January 15, 1942, ibid. 2-4/6/9; Protocol of Hakibbutz Hameuhad Council in Yagur, February 6–7, 1942, ibid. 2-2/3/11; "Sikum ve-Hahlatot she-Nitkablu be-Mo'etzet ha-Kibbutz," Giv'at Haim, December 26–28, 1941, *Tzror Mikhtavim*, January 9, 1942.

42. Yocheved Bar-Rachel, "Ein Harod," *Dvar ha-Po'elet*, January 30, 1942.

43. Protocol of Hakibbutz Hameuhad Council in Yagur, February 6–7, 1942, YTA, 2-2/3/11.

44. Ibid.

45. In regard to Tebenkin's contribution to the Palmach, see Kanary, *Tabenkin*, 495–504.

46. Shapira, *Yigal Allon*, 211–20.

47. Protocol of Hakibbutz Hameuhad Council in Yagur, February 6–7, 1942, YTA, 2-2/3/11.

48. "Ha-Hitgaysut," *Tzror Mikhtavim*, September 29, 1941.

49. Protocol of Hakibbutz Hameuhad Council in Givat Brenner, April 15–16, 1942, YTA, 2-2/3/12; Gelber, *Toldot*, vol. 1, 531–34.

50. Protocol of Hakibbutz Hameuhad Council in Yagur, February 6–7, 1942, YTA, 2-2/3/11.

51. Gelber, *Toldot*, vol. 1, 534.

52. Yitzhak Tabenkin, "Be-Mri ha-Bdidut," Hakibbutz Hameuhad Council in Ramat ha-Kovesh, January 2, 1943, *Tzror Mikhtavim*, January 22, 1943.

53. M. D. [Ma'arekhet Davar], "Dvar ha-Yom," *Davar*, February 22, 1942.

54. Bat-Sheva Haikin, "Hartzaha be-Veidat ha-Po'alot," February 1942, *Bat-Sheva*, 74–75.

55. Protocol of the 5th Working Women Conference, February 23, 1942, CZA, S23/91.

56. "Kshe-Kor'im She-E'ezor," *Davar*, March 10, 1942; Ksania, "Mi-Veidat ha-Po'alot," *Tzror Mikhtavim*, March 29, 1942; Gelber, *Toldot*, vol. 1, 489–90; Granit-Hacohen, *Ishah Ivriya*, 160–65.

57. "The Women Workers 5th Conference Decisions in Regard to Women Recruitment," LA, IV-230-6-16.

58. "Hahlatot Mo'etzet ha-Moshavim le-Inyanei Giyus," April 29–30, 1942, *Tlamim*, May 1942.

59. Protocol of Women's Organizations Council, November 17, 1941, CZA, F49/2104; Protocol of Women's Organizations Council Executive, December 3, 1941, ibid., S25/5099.

60. "Meeting among the Organization Female Members: Joining the Army," February 4, 1942, AHH, 117/16.

61. Protocol of Women's Organizations Council Executive, December 30, 1941, CZA, S25/5099; Protocol of Women's Organizations Council, January 19, 1942, LA, IV-230-6-15.

62. Ibid.

63. Sonia Eidelberg, "Ha-Ishah ha-Ivrit be-Milhemet ha-Olam ha-Shniya," AHH, 3.19. Based on other data from Gelber, which might be more accurate, 3,155 Hebrew women served along the period at ATS, 789 women served at the WAFF, and in total 3,944 Hebrew women served the British army in WWII. Gelber, *Toldot*, vol. 4, 300–1.

64. Gelber, "Hitgabshut," 401, 425; Granit-Hacohen, *Hebrew Women*, 105–7.

65. Ibid., 178–83.

66. The ATS anthem (unknown writer and composer), in Almagor, ed., *Be-Fi*, 8.

67. Rivka Alterman, "Be-Yom Tzetenu la-Mahane," *Davar*, March 12, 1942; "Ha-Yishuv Melave et Bnotav le-Mahane ha-Tzava," ibid., March 16, 1942.

68. Leah [Goldberg], "Be-Tzet Bnot Yisrael le-Mitzraim," *Bamachaneh*, May 1, 1942.

69. *Davar*, April 17, 1942.

70. "Le-Yom ha-Po'elet ha-Bein Leumi," *Dvar ha-Po'elet*, April 23, 1942; "Hitgaysut ha-Havera be-Moshav Mo'etzet ha-Po'alot," *Davar*, May 17, 1942.

71. S. [Sonya Eidelberg], "Be-Tnuat ha-Hitnadvut la-ATS," *Bamachane*, June 5, 1942. See also Gelber, *Toldot*, vol. 1, 650–51.

72. Letter of Shertok to Hakibbutz Hameuhad Council Meeting at Givat Brenner, April 15, 1942, YTA, 2-2/3/12; Granit-Hacohen, *Ishah Ivriya*, 88–100.

73. See, for example, Shapira, *Land and Power*, 68–79; Kamir, *She'ela*, 43–70.

74. B. H. [Bracha Habas], "Haverim, Hizaharu be-Divreikhem," *Davar*, August 2, 1942; Protocol of the Women's Organizations Council, August 4, 1942, LA, IV-230-6-43; Letter of Bracha Habas to Shertok, June 15, 1941, CZA, S25/6002.

75. Ruth Berman's speech in a meeting of the Histadrut Executive and the Women Workers' Council, August 23, 1942, LA, IV-230-6-43, "Yedi'ot," Women Workers' Council Bulletin, September 1942, no. 2, ibid.

76. Protocol of the Executive Secretariat of the Women Workers' Council, September 17, 1942, LA, IV-230-5-98; Letter of the editors of *Dvar ha-Po'elet* to the Women's Organizations Council, September 23, 1942, ibid., IV-230-6-16.

77. "HA-Hayalot ha-Ivriyot Amdu ba-Mivhan," *Davar*, October 16, 1942; Rosenberg-Friedman, *Mahapkhaniyot*, 286–87; Granit-Hacohen, *Ishah Ivriya*, 98–99, 282–97.

78. "Mikhtav," *Igeret la-Hayalim ve-la-Hayalot*, August 14, 1942; Habas, *Bnot Hail*, 150–59.

79. "Theilat Hayloteinu be-Fi Mefakdetan ha-Britit," *Davar*, September 16, 1942; Protocol of the Jewish Agency Executive, August 30, 1942, CZA; Protocol of Women's Organizations Council, September 6, 1942, ibid., F49/2105; Protocol of the Histadrut Council, September 7, 1942, LA.

80. "Giyus kol ha-Ravakim be-Gila'ei 20–30," *Davar*, May 2, 1941; "Har-havat Tzav ha-Giyus," ibid., March 27, 1942; Protocol of the Limited Zionist Executive Council, April 28, 1942, CZA; Gelber, *Toldot*, vol. 1, 353–60, 476–78, 491, 539.

81. Protocol of the Recruiting Executive, March 25, 1942, CZA, S25/5099; Protocol of the Women Recruiting Team, March 8, 1942, ibid.; Letter of Shertok to Dov Yosef, June 17, 1942, ibid.

82. Yitzhak Tabenkin, "Le-Tzava Ivri Atzma'i," Speech during a meeting with "Haganah" commanders, June 7, 1942, in Zrubavel Gilad and Mati Meged, eds., *Sefer ha-Palmach*, vol. 1, 129.

83. Szenes, entry on July 6, 1942, *Diaries*, 122.

84. "Ha-Tzav le-Hitgaysut Klalit shel ha-Yishuv," *Davar*, June 21, 1942; Letter of Women's Organizations Council to Shertok, May 20, 1942, CZA, S25/5099; Letter of Eidelberg to the Requirement's Department, November 3, 1942, LA, IV-230-I-419; Gelber, *Toldot*, vol. 1, 544–55.

85. See, for example, Letter of Women's Organizations Council to the Jewish Agency Political Department and to the Va'ad Leumi Executive, June 24, 1942, CZA, J1/3057; Protocol of the Jewish Agency Executive, July 12, 1942, July 14, 1942, ibid.; Letter of Shertok to Women's Organizations Council, August 9, 1942, ibid., S25/5099.

86. Letter of Eidelson to the Women Workers' Departments in Cities and Settlements, to the Working Mother Organizations, to Women in the Settlements, July 16, 1942, YTA, 2-5/12/8, "Yedi'ot," The Women Workers' Council Bulletin, August 1942, no. 1, LA.

87. "Tzav ha-Giyus ha-Murhav," *Davar*, December 6, 1942.

88. M. D. [Ma'arekhet Davar], "Dvar ha-Yom: Tzav le-Tzav," *Davar*, December 7, 1942.

89. "Tzav ha-Giyus ha-Murhav," *Davar*, December 6, 1942.

90. "Im Tzav ha-Giyus," *Dvar ha-Po'elet*, December 10, 1942; Protocol of the Histadrut Council, September 7–8, 1942, LA; Sonia Eidelberg, "Skira al Giyus ha-Nashim," August 1942 (approximate date), ibid., IV-230-6-16; Protocol of the Jewish Agency Executive, November 1, 1942, November 8, 1942, ibid.; Protocol of Mapai Secretariat, November 9, 1942, LPA.

91. Letter of Eidelberg to Shertok, October 29, 1942, LA, IV-230-6-16; Sonya Eidelberg, "Tazkir," November 3, 1942, ibid.; Letter of Eidelberg to the Recruitment Department Executive, November 3, 1942, ibid., IV-230-1-419.

92. Protocol of Women's Organizations Council, February 3, 1943, CZA, F49/2105; "Ahotenu At He'i le-Alfei Revava," *Davar*, February 11, 1943. On the 93's affair, see Baumel, "The 93," 117–38.

93. "Yedi'ot," Women Workers' Council Bulletin, no. 6–7, January–February 1943, LA, IV-230-6-44.

94. A. V., "Me-Et ha-Ma'arekhet," *Ha-Hayelet*, Journal 505Coy (515 ATS troop in Sarafend), May 1943.

95. Gelber, *Toldot*, vol. 2, 59–60; Granit-Hacohen, *Ishah Ivriya*, 174–78.

96. Ibid., 289–97; "Nashim ba-Sherut," *Ma'arakhot*, May–July 1943.

97. Protocol of the Women Workers' Council Secretariat, May 30, 1943, LA, IV-230-6-183. See also Gelber, *Toldot*, vol. 2, 64.

98. Ha-Merkaz le-Hitgaysut ha-Yishuv, "Giyus le-Heil Ezer le-Nashim," *Davar*, April 23, 1943; Women's Organizations Council, "El Bnot ha-Yishuv," ibid., April 25, 1943; Protocol of Women's Organizations Council, June 15, 1943, CZA, F49/2105; "News of the Recruitment Department," December 1943, LA, IV-230-6-17; Gelber, *Toldot*, vol. 2, 66, 87–89; Granit-Hacohen, *Ishah Ivriya*, 185–87.

99. Protocol of Women's Organizations Council, October 12, 1943, May 18, 1944, CZA, F49/2105; Letter of Beba Idelson to the Women Soldiers, October 22, 1943, LA, IV-230-6-17.

100. Granit-Hacohen, *Ishah Ivriya*, 353.

101. Simhonit, *Tnuat ha-Po'alot*, 67–68.

102. Rachel Katznelson, "Peulot Tnuat ha-Po'alot," *Protocol of 6th Conference of the Histadrut, Second Session*, January 28–February 2, 1945, Tel Aviv, July 1945, 51.

103. Protocol of Histadrut Executive, October 12–13, 1942, LA.

104. Katznelson, "Peulot," 50.

Chapter 7

1. *Davar*, January 4, 1943; Szenes, *Diaries*, 125.

2. *Ha-No'ar Nokhah Sho'at ha-Golah*, January 15–16, 1943, 41.

3. "Yehudim be-Polin Mitkomemim!," *Davar*, January 15, 1943.

4. Shapira, *Land and Power*, 98–105, 330–31.

5. M. D. [Maarekhet Davar], "Dvar ha-Yom: Kidush ha-Shem," *Davar*, March 21, 1943.

6. Karay, "Ha-Nashim," 109–29 (the poem at 122).

7. Dan Pines, "Yehidiyot Lohamot," *Dvar ha-Po'elet*, May 17, 1943.

8. M. N. [Melech Nayshtat (Noy)], "Zivia Lubetkin and Tosia (Tova) Altman," *Davar*, June 1, 1943; "Shtei Joan of Arc," ibid., June 7, 1943; Shalev, *Tosia*, 54–58, 208, and more; Guterman, *Zivia*, 153–56 and more.

9. M. Ya'ari, "Im Yedi'a Aharona," *Hashomer Hatzair*, June 2, 1943; Ya'ari, "Be-Taba'at shel Ah'va Lohemet," ibid., June 16, 1943; Halamish, *Meir Ya'ari*, 225; Shpigel, *Hitgaysut*, 91.

10. Natan A. [Alterman], "Na'ara Ivriya," *Davar*, June 4, 1943; "Likhvod Gvurat Yisrael be-Geta'ot Polin," ibid., June 6, 1943; L. Levite, "Memorial Prayer" at a memorial conference in Yagur, June 4, 1943, *Mibifnim*, June 1943.

11. Protocol of the Women Workers Council, June 14, 1943, LA, IV-230-6-183.

12. Slutsky, *Sefer*, vol. 3, part 1, 628–645; Baumel Schwartz, *Perfect Heroes*, 5–44. The exact number of the Jewish Yishuv's paratroopers is debatable in the historical research.

13. Szenes, entries on April 22, 1942, May 16, 1942, February 22, 1943, June 12, 1943, *Diaries*, 120–21, 126, 129. Szenes moved to kibbutz Sdot Yam at the end of 1942, a year before she joined a working youth group "Sdot Yam" at Kiryat Haim near Haifa.

14. Aharon Meged, "Kavim le-Dmutah," in Meged., ed., *Hannah Szenes*, 71.

15. Ofer and Ofer, *Haviva*, 120–68, 236–43, 308–33, and more; Sadeh, "Haviva," January 10, 1946, *Ktavim*, vol. 2, 67.

16. Gozes-Svorai, *Sapri Li*, 55–57, 122–26.

17. Testimony of Giora She'nan, AHH, 55.44; Yigal Allon, "Megamot ve-Ma'as," in Gilad and Meged, eds., *Sefer ha-Palmach*, vol. 1, 30; Shapira, *Yigal Allon*, 219–20, 239, 522, n. 70; Slutsky, *Sefer*, vol. 3, part 1, 459–62; Efron, *Ahayot*, 361–63.

18. Slutsky, *Sefer*, vol. 3, part 1, 377, vol. 3, part 3, 1664.

19. "Oshiyot," May 15, 1941, in Slutsky, *Sefer*, vol. 3, part 3, 1839. See also ibid., vol. 2, part 3, 1315.

20. Letter of Yisrael Galili to Tzipora Galili, March 24, 1942, Galili, *El ve-Al*, 34.

21. Shulamit Klivanov, "Banot ba-'Shura,'" *Dvar ha-Po'elet*, April 1961; Protocol of the Women Workers Secretariat, July 19, 1942, LA, IV-230-5-98; *Mi-Veida le-Veida*, 14.

22. "Sikumim ve-Hahlatot shel Mo'etzet Hakibbutz Hameuhad be-Na'an," August 21–23, 1942, *Tzror Mikhtavim*, August 28, 1942.

23. Protocol of the Youth Board and the Security Board Secretariat of Hakibbutz Hameuhad, August 31, 1942, YTA, 2-4/7/1; Protocol of Active Members of Hakibbutz Hameuhad on the Palmach Issues, September 14, 1942, YTA, 2-4/7/1; Shoshana (Shosh) Spector, "Irgun ha-Haverot," in Gilad and Meged, eds., *Sefer ha-Palmach*, vol. 2, 775; Shapira, *Yigal Allon*, 522, n. 70; Kadish, *La-Meshek*, 119–20.

24. Protocol of the Palmach's Second Company Meeting with Yisrael Galili, October 19, 1942, YTA, 15-34/11/10.

25. Brenner, *Le-Tzava Yehudi*, 177; Protocol of a Meeting of Palmach's members within Hakibbutz Hameuhad, Kibbutz Alonim, November 10, 1942, YTA, 2-6/8/1.

26. Slutski, *Sefer*, vol. 3, part 1, 459, vol. 3, part 3, 1678.

27. "Yedi'ot," Women Workers Council Bulletin, September 1942, no. 2, LA.

28. Protocol of the Hakibbutz Hameuhad Secretariat, December 20, 1942, YTA, 2-4/7/1; Z. H., "Ha-Havera ba-Palmach," *Alon ha-Palmach*, no. 6–7, March 1943; H. [Zivia Katznelson], "Be-He'avkut," in Bassewitz and Bat-Rachel, eds., *Haverot ba-Kibbutz*, 404; Elad, *Kol Bahur*, 222–23.

29. Protocol of Hakibbutz Hameuhad Secretariat, December 14, 1942, YTA, 2-4/7/1.

30. Protocol of a Meeting of Palmach's members within Hakibbutz Hameuhad, Kibbutz Alonim, November 10, 1942, YTA, 2-6/8/1.

31. Klivanov, "Banot ba-'Shura,'" *Dvar ha-Po'elet*, April 1961.

32. B.-S. [Sarah Braverman], "Mi-Pgishat ha-Haverot," *Alon ha-Palmach*, no. 10, September 1943; Sarah (Surika) Braverman, "Darkan shel ha-Palme'achiyot," *Sefer Hashomer Hatzair*, vol. 2, 98; Katznelson, *Be-He'avkut*, 407; Protocol of Women Workers Seminar Meeting with Active Members, [December 1942], YTA, 2-6/1/7.

33. Report of Shulamit Klivanov, February 1943, YTA, 15-36/162/1; Slutski, *Sefer*, vol. 3, part 2, 1225.

34. Elad, *Kol Bahur*, 227–31; Kadish, *La-Meshek*, 284.

35. *Protocol of Hakibbutz Hameuhad 14th Conference in Givat Brenner*, January 14–21, 1944, 182, 192; Ben-Yehuda, *Kshe-Partza*, 184–88, 208–9. The numerical data of women recruitment, as of October 1, 1945, *The Kibbutz in Numbers*, vol. 32, Ein Harod January 1946, 5.

36. Gali [Zrubavel Gilad], "Shalosh Shanim," *Alon ha-Palmach*, no. 18–19, May–June 1944.

37. *Alon ha-Palmach*, no. 24–25, November-December 1944; Elad, *Kol Bahur*, 235–38; info.palmach.org.il.

38. H. A. [Hava Admon], "Tziyunei Derekh," *Alon ha-Palmach*, no. 15, February 1944; "Mi-Yeme'i Ramat ha-Kovesh," ibid.

39. I. [Itzhak Sadeh], "Ha-Havera be-Yehidoteynu," *Alon ha-Palmach*, no. 15, February 1944; Shapira, *Land and Power*, 337–38, 412, n. 161.

40. Geva, *El ha-Ahot*, 43.

41. Kazanelson, *Be-He'avkut*, 407–8; Porat, "Mekoma," 227–47.

42. Kazanelson, *Be-He'avkut*, 408–9.

43. "Be-Hitgonenut ha-Geta'ot," *Alon ha-Palmach*, no. 15, February 1944.

44. See Shapira, "Lean," 69–70.

45. Zrubavel [Gilad], "Na'arot be-'Hahalutz,'" *Davar*, December 19, 1939; Zrubavel, ed., *Hanche ve-Frumka*, 172–73. Frumka's picture was published in *Alon ha-Palmach*, no. 26, January 1945, and Tosia's picture in the following booklet, which was published on February 1945.

46. Sadeh, "Ruzhka" (originally published on January 19, 1945), *Ktavim*, vol. 2, 113–15; Porat, "'Be-Sliha," 81–116.

47. "Me-Divrei Ruzhka (at a meeting with members of the Women Workers Council)," *Dvar ha-Po'elet*, February 27, 1945.

48. *Protocol of the 6th Histadrut Conference, second session*, January 28, 1945–February 2, 1945, 270–71, 367.

49. Y. Ro'e, "Misaviv la-Veida," *Davar*, February 6, 1945; Porat, *Be-Sliha*, 92–94; "Ha-Havera be-Milhemet ha-Getaot (Midvare'a shel Ruzhka)," *Alon ha-Palmach*, no. 31, June 1945.

50. Surika Braverman, "Ksharim Mufla'im," in Tuvin, Dror, and Rav, eds., *Ruzka*, 245–46.

51. Yoav [Yitzhak Dubno], "Le-Megamot Imunenu," *La-Madrikh*, 21–26; "Siha Beikvot ha-Hartzaha," ibid., 27–35.

52. *La-Madrikh*, 27–35.

53. Protocol of Yigal Paikovich [Allon] Speech during *Shlihim* Seminar of Hakibbutz Hameuhad Members in Givat ha-Shlosha, May 29, 1945, YTA, 6/5/Series4/9-15.

54. Hava [Admon], *Alon ha-Palmach*, no. 27, February 1945.

55. Gozes-Svorai, *Sapri Li*, 132.

56. See, for example, Cohen, *Woman of Violance*; Ben Yehuda, *1948*; Gal, *Brakha Fuld*; Rosenberg-Friedman, "Captivity," 64–89.

57. Y. Noded [Yitzhak Sadeh], "Misaviv la-Medurah," *Le'ahdut Ha'avoda*, October 4, 1945.

58. See, for example, Halamish, "Ha-Ha'apala," 87; Shapira, *Land and Power*, 334; Zertal, *From*, 263–69.

59. "Miram Shachor," *Dvar ha-Po'elet*, February 5, 1948.

60. *Protocol of the 22nd Zionist Congress*, December 9–24, 1946, 437.

61. Hadasa Lampel, "Mi-Yomana shel Helinka (Hadasa Lampel)," in Tomer, ed., *Adom*, 226; Gal, "Parashat Gvurata," 130–58.

62. Protocol of Women Workers Secretariat, January 19, 1948, LA, IV-230-5-97.

63. Gozes-Svora'i, *Palmachiyot*, 44.

64. Protocol of Women Workers Secretariat, July 9, 1948, LA, IV-230-5-97.

65. Shapira, "Historiography," 20–61, 70; Gal, *Parashat Gvurata*, 152–54. See also Mir-Tibon, *Hadas*.

66. Aviva [Vin, Rabinovitz], "Leahar Kenes ha-Mefakdot," *Dvar ha-Po'elet*, May 24, 1949; Iza Dafni interview with Aviva Rabinovitz, July 2002, YTA, 16-12/52/65.

67. Rachel Katznelson, "Me-Divrei Siyum ba-Kenes," *Dvar ha-Po'elet*, March 22, 1949.

68. "Matzeva Lezekher Meginei Ein Gev," *Davar*, June 4, 1952.

69. Tzur, *Kehakot Rachel*, 13.

70. Protocol of Hakibbutz Hameuhad Council in Yagur, June 22–24, 1945, YTA, 2-2/2/5.

71. See Moshe Basuk, "Shomeret Laila," *Mibifnim*, November 1946; Haya Vered, "Shomeret ha-Laila," ibid., February 1947.

72. Eva [Tabenkin], "'Gilgulo shel Nigun' . . . ," *Alon ha-Palmach*, no. 28, March 1945.

Conclusion

1. Banko Hadar, "Ha-Havera ba-Kibbutz Ke-Ishah," *Hedim*, September 1966, 49–53.

2. Golda Meir, "Hakdama," in *Bat Hen*.

3. *Protocol of Hakibbutz Hameuhad 12th Council*, 158.

4. Martin Buber, "Divrei Ptiha," *Simpozion*, 11.

5. Martin Buber, "Darko shel ha-Kfar ha-Shitufi," ibid., 54.

6. Lilia Bassewitz, "Ha-Havera ba-Kibbutz," *Mibifnim*, January 1946.

7. Buber, *Darko*, 53–54.

8. Bassewitz, *Ha-Havera*, 175.

9. See, for example, Rachel Katznelson, "Hishtatfuta shel ha-Po'elet," *Kuntres*, December 24, 1926.

10. Levi Ben-Amitai, "Ba-Matzor," September 1, 1936, *Davar*, September 21, 1936.

11. See, for example, Naveh, "Reading Berl," 142–43; Gilad and Krook, *Ma'yan Gidon*, 60–63.

12. Yanai, *Ein Harod*, 326–27.

13. Rachel S. [Svorai], "Le-Shituf ha-Banot ba-Lehima," *Alon ha-Palmach*, no. 70, August 22, 1948; "Na'ara Ba-Krav," in Gilad and Meged, eds., *Sefer ha-Palmach*, vol. 2, 780–84.

14. Gilad and Tzizling, eds., *Ein Harod*, 270.

15. S. [Sonya] Eidelberg, Memorandum about her work in the Recruitment Department, 1944 [n.d.], CZA, S25/5099.

16. Leyla Yosef [no title], in Even-Nur, ed., *Yiftach*, 74; Yosef, *Ir va-Em*, 89–90.

17. "Yugbar Giyus Ahayot ve-Ha'an," *Davar*, May 19, 1948; "Ha-Ain Nashra ve-ha-Hen Nish'ar," ibid., May 25, 1948.

18. Protocol of Foreign Affairs and Defense Committee of the Knesset, June 6, 1949, ISA, A-3/7561.

19. Protocol of the Knesset Plenum, September 5, 1949, *Divrei Ha-Knesset*, vol. 2, 1568–69.

20. Interview with Ben-Gurion to Hadassah–WIZO Journal in Canada, July 1969, BGU.

21. Protocol of the Knesset Plenum, January 2, 1951, *Divrei Ha-Knesset*, vol. 7, 666.

22. Protocol of Government, October 20, 1953, November 15, 1953, ISA.

23. David Ben-Gurion, "Ta'akru et Sridei ha-Kipuh ve-Ta'aniku la-Tnua mi-Yesodot Nafshekhen," *Davar*, August 1, 1949.

24. Ben-Gurion, "Be'ikvot Dvora," March 1, 1951, *Hazon ve-Derekh*, 75–81.

25. David Ben-Gurion, "Be-Kinus Irgun Imahot Ovdot," March 3, 1958, BGU.

26. Eva Tabenkin, "Be-Tzet ha-Mitgaysim," *Tzror Mikhtavim*, May 29, 1942.

27. A. [Eva Tabenkin], "Mi-Yomana shel Em," in Katznelson-Rubashov, ed., *Divrei Po'alot*, 188–89.

28. Rachel Katznelson, "Mul Goralenu," *Dvar ha-Po'elet*, January 31, 1943.

29. Shapira, "The Bible," 11–42.

30. M. Z. [Menahem Zalman] Wolfovsky, "Bnot Shalum Ben ha-Lohesh," "Daughters of Shallum son of Hallohesh," *Davar*, July 31, 1936.

Bibliography

Archives

AHH = Haganah Archive, Tel Aviv.
BGA = David Ben-Gurion Archive, Sde Boker.
CZA = Central Zionist Archives, Jerusalem.
EHMA = Kibbutz Ein Harod Meuhad Archive.
HHA = Hashomer Hatzair Archive, Givat Haviva.
Hashomer Archive, Kfar Giladi.
ISA = Israel State Archives, Jerusalem.
Kibbutz Beit ha-Shita Archive.
Kibbutz Degania Alef Archive.
Kibbutz Ein Hashofet Archive.
Kibbutz Givat Brenner Archive.
Kibbutz Gvat Archive.
Kibbutz Kfar Giladi Archive.
Kibbutz Mishmar Haemek Archive.
Kibbutz Na'an Archive.
Kibbutz Tel Yosef Archive.
LA = Labor Archive, Tel Aviv.
LPA = Labor Party Archive, Beit Berl.
NA = National Archives, London.
YTA = Yad Tabenkin Archive, Ramat Gan.

Journals

Alon ha-Palmach, Bamachaneh, Bustenai, Davar, Doar ha-Yom, Dvar ha-Po'elet, Haaretz, Ha'aretz Veha'avoda, Ha-Ahdut, Ha-Daf ha-Yarok, Ha-Hayelet, Ha-Ishah, Ha-Kibbutz be-Misparim, Ha-Olam, Ha-Po'el ha-Tza'ir, Ha-Tzfira,

Ha-Tzvi, Ha-Yom, Hashomer Hatzair, Hedim, Jewish Frontier, Kuntres, Le'ah-dut Ha'avoda, Mibifnim, Niv ha-Kevutsah, Palestine Post, Tzror Mikhtavim.

Published Minutes

Divrei Ha-Knesset.
Minutes of 2nd Conference of the Histadrut, February 7–20, 1923.
Minutes of 6th Conference of the Histadrut, Second Session, January 28–February 2, 1945.
Minutes of the 11th Council of Hakibbutz Hameuhad, Yagur, October 2–7, 1936.
Minutes of the 12th Council of Hakibbutz Hameuhad, Na'an, July 14–21, 1939.
Minutes of the 13th Conference of Hakibbutz Hameuhad, Ashdot Ya'akov, October 3–8, 1941.
Minutes of the 14th Conference of Hakibbutz Hameuhad, Givat Brenner, January 14–21, 1944.
Minutes of the 21st Zionist Congress, August 16–25, 1939.
Minutes of the 22nd Zionist Congress, December 9–24, 1946.
Minutes of Women Lecturers Meeting in Preparation for the Elections to Working Women Conference, Haifa, May 22, 1941.

Books

Al ha-Saf: Kovetz le-Inyanei ha-Hayim ve-ha-Sifrut. Jerusalem, 1918.
Almagor, Dan, ed. Be-Fi Hayalaikh Mizmor: Shirat ha-Mitnadvim. Tel Aviv: Tivonai, 1993.
Allon, Yigal. Kelim Shluvim. Tel Aviv: Hakibbutz Hameuhad, 1980.
Atiyash, Moshe. Sefer ha-Teudot shel ha-Va'ad ha-Leumi le-Kneset Israel be-Eretz Yisrael, 1918–1948. Jerusalem: Refael Haim Cohen, 1963.
Aktin, Ruth. Ba-Derekh she-ba Halakhti. Tel Aviv: Hakibbutz Hameuhad, 1990.
Bat-Rachel, Yokheved. Banativ Shehalkhti: Pirkey Haim ve-Mokdei Pe'ilut. Tel Aviv: Hakibbutz Hameuhad, 1981.
Bassewitz, Lilia. Be-Merotz Im ha-Zman. Tel Aviv: Hakibbutz Hameuhad, 1987.
———. Ve-Lu Rak Hed . . . Tel Aviv: Hakibbutz Hameuhad, 1981.
———, and Yokheved Bat-Rachel, eds. Haverot ba-Kibbutz. Ein Harod: Hakibbutz Hameuhad, 1943.
Bat Hen: Sipuran shel ha-Hayalot ha-Me'malot Tafkidim Hiyuni'im u-Meguvanim u-Mosifot Hen le-Tzahal. Haifa: Shikmona, 1972.
Bat-Sheva Haikin: Mishela ve-Aleiha. Tel Aviv: Hakibbutz Hameuhad, 1965.
Baumel Schwartz, Judy. Perfect Heroes: The World War II Parachutists from Palestine and the Israeli Heroic Ethic. Madison, WI: University of Wisconsin Press, 2010.

Ben-Gurion, David. *Hazon ve-Derekh*. Tel Aviv: Mapai, 1952.

Ben-Yehuda, Netiva. *1948: Bein ha-Sfirot*. Jerusalem: Keter, 1981.

———. *Kshe-Partza ha-Medinah*. Jerusalem: Keter, 1991.

Ben-Zvi, Itzhak, ed. *Ha-Gdudim ha-Ivri'im: Igrot*. Jerusalem: Yad Itzhak Ben-Zvi, 1969.

———, et al., eds. *Sefer "Hashomer": Divrei Haverim*. Tel Aviv: Dvir, 1957.

Ben-Zvi, Rachel Yanait. *Anu Olim: Pirkei Ha'im*. Tel Aviv: Am Oved, 1959.

———. *Bar Kokhba*. Jerusalem: Ahdut, 1909.

———, et al., eds. *Ha-Haganah bi-Yerushalayim*. Jerusalem: Kiryat Sefer, 1973.

Bernstein, Deborah. *Ishah be-Eretz Yisrael: ha-She'ifa le-Shivyon be-'Tkufat ha-Yishuv*. Tel Aviv: Hakibbutz Hameuhad, 1987.

Brenner, Uri. *Hakibbutz Hameuhad ba-Haganah, 1923–1939*. Tel Aviv: Hakibbutz Hameuhad, 1980.

Brenner, Yosef Haim. *Ktavim*. Vols. 3–4. Tel Aviv: Hakibbutz Hameuhad, 1985.

Carmel-Hakim, Esther. *Shalhevet Yeruka: Chana Meizel—Mif'al Ha'im*. Ramat Ef'al: Yad Tabenkin, 2008.

Carmi, Moshe. *Daliot ha-Gefen*. Ein Harod: Hakibbutz Hameuhad, 1954.

Clements, Barbara Evans. *Bolshevik Women*. Cambridge: Cambridge University Press, 1997.

Cohen, Geulah. *Woman of Violence: Memoirs of a Young Terrorist, 1943–1948*. New York: Holt, Rinehart and Winston, 1966.

DeGroot Gerard J., and Corinna Peniston-Bird, eds. *A Soldier and a Woman: Sexual Integration in the Military*. Harlow, UK: Longman, 2000.

Dinur, Ben-Zion, chief ed. *Sefer Toldot ha-Haganah*. Tel Aviv: Ma'arakhot, 1954.

Dolev, Eran. *Allenby's Military Medicine: Life and Death in World War I Palestine*. London: I. B. Tauris, 2007.

Eilam, Yigal. *Ha-Gdudim ha-Ivri'im be-Milhemet ha-Olam ha-Rishona*. Tel Aviv: Ma'arakhot, 1973.

Enloe, Cynthia. *Does Khaki Become You? The Militarization of Women's Lives*. London: Pandora, 1988.

Erez, Yehuda, ed. *Sefer ha-Aliya ha-Shlishit*. Vol. 2. Tel Aviv: Am Oved, 1964.

Eshel, Tzadok. *Ha-Bahurot ha-Hen . . . : Sefer Haverot ha-Haganah be-Haifa*. Tel Aviv: Ministry of Defense Press, 1997.

Even-Nur, Yisrael, ed. *Yiftach Ahuzat ha-Sufa: Sipura shel Hativat Yiftach-Palmach*. Bat Yam: Dfus A. Levin Epshtein, 1970.

Ever-Hadani, Aharon, ed. *Hashomer, La-No'ar: Sifriyat Eretz Yisrael shel ha-Keren ha-Kayemet le-Yisrael*. Tel Aviv: Ha-Keren ha-Kayemet le-Yisrael, 1931.

Fishman, Ada. *Tnuat ha-Po'alot be-Eretz Yisrael, 1904–1929*. Tel Aviv: Ha-Poel ha-Tzair, 1929.

Fleischmann, Ellen L. *The Nation and Its "New" Women: The Palestinian Women's Movement, 1920–1948*. Berkeley: University of California Press, 2003.

Fogiel-Bijaoui, Sylvie. *Demokratia ve-Feminism: Migdar, Ezrahut ve-Zkhuyot Adam*. Ra'anana: The Open University, 2011.

Gal, Sari. *Brakha Fuld*. Tel Aviv: Sifriyat Poalim, 1999.

Galili, Yisrael. *El ve-Al: Igrot ve-Dmuyot*. Edited by Arnan Azaryahu and David Eshkol. Ramat Ef'al: Yad Tabenkin, 1990.

Gavin, Lettie. *American Women in World War 1: They Also Served*. Colorado: University Press of Colorado, 1997.

Gelber, Yoav. *Toldot ha-Hitnadvut*. Vols. 1–2, 4. Jerusalem: Yad Itzhak Ben-Zvi, 1979–84.

Geva, Sharon. *El ha-Ahot ha-Lo Yedu'ah: Giborot ha-Shoa ba-Hevra ha-Israelit*. Tel Aviv: Hakibbutz Hameuhad, 2010.

Gilad, Zrubavel, ed. *Hanche ve-Frumka: Mikhtavim ve-Divrei Zikaron*. Ein Harod: Hakibbutz Hameuhad, 1945.

———, and Dorothea Krook. *Ma'yan Gidon*. Tel Aviv: Hakibbutz Hameuhad, 1990.

———, and Mati Meged, eds. *Sefer ha-Palmach*. Vols. 1–2. Tel Aviv: Hakibbutz Hameuhad, 1957.

———, and Neriya Tzizling, eds. *Ein Harod: Pirkey Yovel*. Tel Aviv: Hakibbutz Hameuhad, 1973.

Goldstein, Joshua S. *War and Gender: How Gender Shapes the War System and Vice Versa*. 2nd ed. Cambridge: Cambridge University Press, 2004.

Goldstein, Yaakov. *Ba-Derekh el ha-Ya'ad: Bar Giora ve-Hashomer, 1907–1935*. Tel Aviv: Ministry of Defense Press, 1994.

Gozes-Svora'i, Aya. *Palmachiyot be-Milhemet Tashah*. Dalya: Maarekhet, 1997.

———. *Sapri Li Sapri Li: Havrot ha-Palmach Mesaprot*. Tel Aviv: Yad Tabenkin, 1993.

Granit-Hacohen, Anat. *Ishah Ivriya el ha-Degel: Neshot ha-Yishuv be-Sherut ha-Kokhot ha-Briti'im be-Milhemet ha-Olam ha-Shniya*. Jerusalem: Yad Itzhak Ben-Zvi, 2011.

Grayzel, Susan R. *Women and the First World War*. London: Longman, 2002.

———. *Women's Identities at War: Gender, Motherhood and Politics in Britain and France during the First World War*. Chapel Hill, NC: University of North Carolina Press, 1999.

Guterman, Bela. *Zivia ha-Ahat: Sipur Hayea shel Zivia Lubetkin*. Tel Aviv: Hakibbutz Hameuhad, 2011.

Habas, Bracha. *Bnot Hail*. Tel Aviv: Am Oved, 1964.

———. *Sefer ha-Aliya ha-Shniya*. Tel Aviv: Am Oved, 1947.

———. *Sefer Me'ora'ot Tartzav*. Tel Aviv: Davar, 1937.

Hacohen, Dvora. *Manhiga Lelo Gvulot: Henrietta Szold, Biyografiyah*. Tel Aviv: Am Oved, 2019.

Hacohen, Mordechai Ben-Hillel. *Milhemet ha-Amim (Diary)*. Vol. 2. Jerusalem: Yad Itzhak Ben-Zvi, 1985.

Ha-Haganah be-Tel Aviv. Tel Aviv: Keren ha-Haganah al shem Y. Shori ve-Haverav, 1956.

Ha-kibbutz veha-kevutzah: Yalkut le-berur she'elat ha-ihud. Tel Aviv: Ha-Vaad ha-Poel, 1940.

Halamish, Aviva. *Meir Ya'ari: Biyografiyah Kibbutzit, Hamishim ha-Shanim ha-Rishonot, 1897–1947.* Tel Aviv: Am Oved, 2009.

Halperin, Yirmiyahu. *Avi, Michael Halperin.* Tel Aviv: Hadar, 1964.

Herzl, Theodor. *Ne'umim u-Ma'amarim Tzioni'im.* Vols. 1–2. Jerusalem: Hasifriya ha-Tziyonit, 1976.

Herzog, Hanna. *Nashim Re'aliot: Nashim ba-Politica ha-Mekomit be-Israel.* Jerusalem: Makhon Yerushalaim le-Heker Israel, 1994.

Hughes, Matthew, ed. *Allenby in Palestine: The Middle East Correspondence of Field Marshal Viscount Allenby,* June 1917–October 1919. Stroud, UK: Sutton, 2004.

Ironi-Avrahami, Chaya. *Almoniyot be-Haki: Sipuran shel Haverot ha-Haganah be-Tel Aviv.* Tel Aviv: Milo, 1989.

Jabotinsky, Vladimir. *The Story of the Jewish Legion.* New York: Bernard Ackerman, 1945.

Jabotinsky, Zeev. *Igrot.* Vol. 2, edited by Daniel Carpi. Jerusalem: Makhon Jabotinsky, 1995.

Jacobson, Abigail. *From Empire to Empire: Jerusalem between Ottoman and British Rule.* Syracuse: Syracuse University Press, 2011.

Jesse, F. Tennyson. *The Sword of Deborah: First-hand Impressions of the British Women's Army in France.* New York: Doran, 1919.

Kadish, Alon. *La-Meshek ve-la-Neshek: ha-Hakhsharot ha-Meguyasot ba-Palmach.* Ramat Ef'al: Yad Tabenkin, 1995.

Kafkafi, Eyal. *Emet o Emuna: Tabenkin Mehanekh Halutzim.* Jerusalem: Yad Itzhak Ben-Zvi, 1992.

Kaminsky, Tami. *Bedarkan: Neshot Ein Harod, 1921–1948.* Sede Boker: Ben-Gurion University Press and Yad Tabenkin, 2019.

Kamir, Orit. *She'ela shel Kavod: Israeliyut ve-Kvod ha-Adam.* Jerusalem: Carmel, 2004.

Kanari, Barukh. *Laset et Amam: Ha-Hagshama, ha-Shlihut ve-ha-Dimui ha-Atzmi shel Hakibbutz Hameuhad.* Tel Aviv: Hakibbutz Hameuhad, 1989.

———. *Tabenkin be-Eretz Yisrael.* Ramat Ef'al: Yad Tabenkin, 2003.

Katznelson, Berl. *Igrot.* Vol. 2, edited by Yehuda Sharet. Tel Aviv: Am Oved, 1974.

———. *Ktavim.* Vol. 1. Tel Aviv: Mapai, 1945.

Katznelson-Rubashov, Rachel, ed. *Divrei Po'alot: Me'asef.* Tel Aviv: Mo'etzet ha-Po'alot, 1929.

Katznelson-Shazar, Rachel. *Adam Kmo Shehu: Pirkei Yomanim u-Reshimot.* Edited by Michal Hagati. Tel Aviv: Am Oved, 1989.

Keohet, Shula. *Ha Mahteret ha-Nafshit. Al Reshit ha-Roman ha-Kibbutzi.* Tel Aviv: Hakibbutz Hameuhad, 1995.

Kovetz Hashomer. Tel Aviv: Ha-Arkhiyon ve-ha-Muzeon shel Tnuat ha-Avoda, 1947.

La-Madrikh: Kovetz le-Divrei Iyun ve-le-Birurim. August 1945.

Laskov, Shulamit, ed. Ktavim le-Toldot Hibat-Tzion vi-Yishuv Eretz Yisrael. Vol. 4. Tel Aviv: Hakibbutz Hameuhad, 1987.

Lavi, Shlomo. Megilati be-Ein Harod: Ra'ayonot, Zikhronot ve-Ma'asim. Tel Aviv: Am Oved, 1947.

Livneh, Eliezer, Yosef Nedava, and Yoram Efrati, eds. Nili: Toldoteiha shel He'aza Medinit. Jerusalem: Shoken, 1980.

Malkin, Sara. Im ha-Aliya ha-Shniya: Zikhronot. Tel Aviv: Ha-Poel ha-Tzair, 1929.

Margalit Stern, Bat-Sheva. Ma'apkhanit: Ada Fishman Maimon, Biographya. Jerusalem: Yad Itzhak Ben-Zvi and Ben-Gurion University Press, 2018.

———. Geula be-Kvalim: Tnuat ha-Po'alot ha-Eretz Yisraelit, 1920–1939. Jerusalem: Yad Itzhak Ben-Zvi, 2006.

Margalit, Yosef, ed. Bayit ba-Moshav: Haverot Mesaprot. Tel Aviv: Tarbut ve-Hinukh, 1962.

Medzini, Meiron. Golda: Biographia Politit. Tel Aviv: Miskal, 2008.

Mintz, Matitiyahu. Hevley Neurim: ha-Tnua ha-Shomerit, 1911–1921. Jerusalem: Hasifriya ha-Tziyonit, 1995.

Mir-Tibon, Gali. Hadas Biktze Halailah. Tel Aviv: Am Oved, 2021.

Mishori, Alik. Shuru Habitu u-Reu: Ikonot ve-Smalim Hazuti'im Zioni'im ba-Tarbut ha-Israelit. Tel Aviv: Am Oved, 2000.

Mi-Veida le-Veida: Pirkei Din ve-Heshbon, 1942–1949. Tel Aviv, July 1949.

Near, Henry. Ha-Kibbutz ve-ha-Hevra, 1923–1933. Jerusalem: Yad Itzhak Ben-Zvi, 1984.

———. Rak Shvil Kavshu Raglai: Toldot ha-Tnu'a ha-Kibbutzit. Jerusalem: Mosad Bialik and Hakibbutz Hameuhad, 2008.

Nimilov, Anton V. The Biological Tragedy of Woman. New York: Covici, 1932.

Niv, David. Ma'arakhot ha-Irgun ha-Tzvai ha-Leumi. Vol. 2. Tel Aviv: Mosad Klozner, 1965.

Noakes, Lucy. Women in the British Army: War and the Gentle Sex, 1907–1948. London: Routledge, 2006.

Ouditt, Sharon. Fighting Forces, Writing Women: Identity and Ideology in the First World War. London: Routledge, 1994.

Paz-Yishayahu, Avigail. Tnaim shel Shutfut: Kevutzah, Komuna Artzit ve-Kibbutz, 1910–1926. Sede Boqer Campus: Makhon Ben-Gurion le-Heker ha-Tziyonut, 2012.

Binyamin, R., and Ya'akov Peterzil, eds. Neged ha-Teror: Ma'amarim, Reshimot, Neumim, Giluyei Da'at. Jerusalem: Dfus Liga, 1939.

Rab, Ester. Gan she-Harav. Tel Aviv: Sifriyat Tarmil, 1983.

Raider, Mark A., and Miriam B. Raider-Roth, eds. The Plough Woman: Records of the Pioneer Woman of Palestine, A Critical Edition. Hanover and London: Brandeis University Press, 2002.

Rakovsky, Puah. Lo Nikhnati: Sefer Zikhronot. Tel Aviv: N. Tverski, 1952.

————. My Life as a Radical Jewish Woman: Memories of a Zionist Feminist in Poland. Edited by Paula E. Hyman. Bloomington, IN: Indiana University Press, 2001.

Ramat ha-Kovesh: Te'udot ve-Reshimot. Tel Aviv: Labor Federation, 1937.

Reinharz, Jehuda, Shulamit Reinharz, and Motti Golani, eds. Im ha-Zerem ve-Negdo: Manya Shochat—Igrot ve-Te'udot, 1906–1960. Jerusalem: Yad Itzhak Ben-Zvi, 2005.

Rivlin, Gershon, ed. Yemei Ramah: Pirkei Ramat ha-Kovesh, Tel Aviv: Ma'arakhot, 1964.

Rogel, Nakdimon. Ha-Yotz'im el Eretz Tzafon: Reshitan shel Kevutsot ha-Po'alim be-Etzba ha-Galil, 1916–1920. Jerusalem: Yad Itzhak Ben-Zvi, 1987.

————. Parashat Tel Hai: Teudot le-Haganat ha-Galil ha-Elyon be-Taraf (1919–1920). Jerusalem: Yad Itzhak Ben-Zvi, 1994.

————. Tel Hai: Hazit Bli Oref. Tel Aviv: Yariv, 1979.

Rosenberg-Friedman, Lilach. Mahapkhaniot Be-al Korhan: Nashim u-Migdar ba-Tzionut ha-Datit be-Tkufat ha-Yishuv. Jerusalem: Yad Itzhak Ben-Zvi, 2005.

Ofer, Tehila, and Ze'ev Ofer. Haviva: Sipur Hayea, Shlihuta ve-Nefilata shel ha-Tzanhanit Haviva Reik. Bnei Brak: Sifriyat Poalim, 2004.

Sasson-Levy, Orna. Zehuyot be-Madim: Gavriyut ve-Nashiyut ba-Tzava ha-Isre'eli. Jerusalem: Hebrew University Magnes Press, 2006.

Sefer Hashomer Hatzair. Merhavia: Sifriyat Poalim, 1961.

Shaham Koren, Tsafrira. Hesed Neurim. Jerusalem: Yad Tanenkin and Yad Itzhak Ben-Zvi, 2018.

Shalev, Ziva. Tosia: Tosia Altman—Me-ha-Hanhaga ha-Rashit shel Hashomer Hatzair le-Mifkedetha-Irgun ha-Yehudi ha-Lohem. Tel Aviv: Moreshet, 1992.

Shapira, Anita. Berl: The Biography of a Socialist Zionist. Cambridge: Cambridge University Press, 1984.

————. Land and Power: The Zionist Resort to Force, 1881–1948. New York and Oxford: Oxford University Press, 1992.

————. Yigal Allon: Native Son—A Biography. Tel Aviv: Hakibbutz Hameuhad, 2004.

Shapira, Yosef. Avoda ve-Adama. Tel Aviv: Am Oved, 1964.

Sharet, Moshe. Yemei London: Mikhtavei Moshe Sharet mi-Yemei ha-Limudim, London 1923–1925. Vol. 3. Tel Aviv: Ha-Amuta le-Moreshet Moshe Sharet, 2008.

Shekhter, Tamar. Likhbosh et ha-Lev: Sipura shel Rachel Katznelson-Shazar. Jerusalem: Yad Itzhak Ben-Zvi, 2011.

Shilo, Margalit. Etgar ha-Migdar: Nashim ba-Aliyot ha-Rishonot. Tel Aviv: Hakibbutz Hameuhad, 2007.

————. Girls of Liberty: The Struggle for Suffrage in Mandatory Palestine. Waltham, MA: Brandeis University Press, 2016.

Simhonit, Yehudit. Tnuat ha-Po'alot le-Yovulu. 25 Shana la-Veida ha-Klalit ha-Rishona shel Po'alot Ivriyot be-Eretz Yisrael, May 1, 1946. Pinkas Katan, Tel Aviv, 1946.

Simpozion shel ha-Universita ha-Ivrit be-Shituf im Histadrut ha-Po'alim ha-Hakli'im: le-Dmuto ha-Hevratit shel ha-Kfar ha-Ivri be-Eretz Yisrael, April 8–11, 1945. Jerusalem 1946.

Sinai, Smadar. *Ha-Shomrot Shelo Shamru: Nashim u-Migdar be-"Hashomer" u-be-Kibbutzo—Kfar Giladi, 1907–1939.* Tel Aviv: Hakibbutz Hameuhad, 2013.

———. *Miriam Baratz: Dyokana shel Halutza.* Ramat Ef'al: Yad Tabenkin, 2002.

Sprinzak, Yosef. *Bi-Khtav u-ve-Al Peh.* Tel Aviv: Mapai, 1952.

Szenes, Hannah. *Hannah Szenes: Diaries, Songs, Evidence.* Edited by Moshe Barslavsky. Tel Aviv: Hakibbutz Hameuhad, 1994.

Teveth, Shabtai. *Kina'at David.* Vol. 1. Jerusalem and Tel Aviv: Shoken, 1976.

Tiger, Lionel, and Joseph Shepher. *Women in the Kibbutz.* New York: Harcourt Brace Jovanovich, 1975.

Tomer, Ben-Zion, ed. *Adom ve-Lavan ve-Re'ah Tapuhei Zahav: "Yaldei Teheran."* Jerusalem: Hasifriya ha-Tziyonit, 1971.

Tuvin, Yehuda, Levi Dror, and Yosef Rav, eds. *Ruzka: Lehimata, Haguta, Dmuta.* Tel Aviv: Moreshet, 1988.

Tzahor, Zeev. *Ba-Derekh le-Hanhagat ha-Yishuv: ha-Histadrut be-Reshita.* Jerusalem: Yad Itzhak Ben-Zvi, 1992.

Tzizling, Aharon. *Ein Harod ve-Yerushala'im: Dvarim, Ma'amarim, Reshimot.* Ramat Ef'al: Yad Tabenkin, 1988.

Tzur, Muki. *Lo ba-Avim Me'al: Mea Rishona le-Degania.* Jerusalem: Yad Itzhak Ben-Zvi, 2010.

Weizmann, Chaim. *The Letters and Papers of Chaim Weizmann.* Vol. 8, edited by Dvorah Barzilay and Barnet Litvinoff. Jerusalem, 1977.

Ya'ari (Polaskin), Y., and M. Harisman, eds. *Sefer ha-Yovel le-Mlot Hamishim Shana le-Yisud Petach Tikva, 1878–1928.* Tel Aviv: Va'adat Sefer ha-Yovel, 1929.

Yaffe, Eliezer. *Ktavim.* Vol. 2. Tel Aviv: Am Oved, 1947.

Yaffe, L., ed. *Sefer ha-Kongress: Li-Mlot Hamishim Shana la-Kongress ha-Tzioni ha-Rishon.* Jerusalem: Hanhalat ha-Histadrut ha-Tziyonit, 1950.

Yanai, Aharon. *Ein Harod: Parashat Drakhim.* Tel Aviv: Davar, 1983.

Yellin, Emily. *Our Mothers' War: American Women at Home and at the Front During World War II.* New York and London: Free Press, 2004.

Yosef, Goldie. *Ir va-Em: Zikhronot, Yomanim, Igrot ve-Sipurim.* Jerusalem: R. Mass, 1979.

Zeira, Moti. *Kru'im Anu: Zikata shel ha-Hityashvut ha-Ovedet be-Shnot ha-Esrim el ha-Tarbut ha-Yehudit.* Jerusalem: Yad Itzhak Ben-Zvi, 2002.

Zertal, Idith. *From Catastrophe to Power: Holocaust Survivors and the Emergence of Israel.* Berkeley: University of California Press, 1998.

Zerubavel, Yael. *Recovered Roots: Collective Memory and the Making of Israeli National Tradition.* Chicago and London: University of Chicago Press, 1995.

Articles and Book Chapters

Baki, Ruth. "Ha-Sturmanim." In *Emek Yezreel, 1900–1967*, Idan, vol. 17, ed. Mordechai Naor, 136–46. Jerusalem: Yad Itzhak Ben-Zvi, 1983.

Barak-Erez, Daphne. "Al Tayasot ve-Sarvaniyot Matzpun: Ma'avak Ehad o Shnei Ma'avakom Shonim?" In *Iyunim be-Mishpat, Migdar ve-Feminizm*, edited by Daphne Barak-Erez, 65–98. Kiryat Ono: Nevo, 2007.

Baumel, Judith Tydor. "The 93 Beth Jacob Girls of Cracow: History or Typology?" In *Double Jeopardy: Gender and the Holocaust*, 117–38. London: Vallentine Mitchell, 1998.

Ben-Artzi, Yossi. "Bein ha-Ikarim la-Po'alim: Ha-Ishah be-Reshit ha-Hityashvut be-Eretz Yisrael (1882–1914)." In *Eshnav le-Hayehen shel Nashim Yehudiot: Kovetz Mehkarim Bein-Thumi*, edited by Yael Azmon, 309–24. Jerusalem: Merkaz Zalman Shazar, 1995.

———. "Have Gender Studies Changed Our Attitude toward the Historiography of the *Aliyah* and Settlement Process?" In *Jewish Women in Pre-State Israel: Life History, Politics, and Culture*, edited by Ruth Kark, Margalit Shilo, and Galit Hasan-Rokem, 18–32. Waltham, MA: University Press of New England, 2008.

Berkovitch, Nitza. "'Eshet Hayil Mi Yimtza?' Nashim ve-Ezrahut be-Israel." *Sotziologiyah Yisre'elit* 2, no. 1 (1999–2000): 277–317.

Brenner, Uri. "Makom ha-Ishah be-'Hashomer.'" *Shorashim*, no. 2 (1980): 181–86.

Campbell, D'Ann. "Women in Combat: The World War Two Experience in the United States, Great Britain, Germany, and the Soviet Union." *Journal of Military History* 57 (April 1993): 301–23.

Chazan, Meir. "Ha-Nisyonot le-Haya'at Hashomer." *Alei Zait va-Herev* 7 (2007): 149–88.

Efron, Yonit. "Ahayot, Lohamot ve-Imahot: Etos ve-Metzi'ut be-Mivhan Bnot Dor 1948." *Iyunim Bitkumat Israel* 10 (2000): 353–80.

Elad, Ofra. "'Kol Bahur va-Tov la-Neshek—Bahurah, Al ha-Mishmar!'" In *Palmah: Shtei Shibolim va-Herev*, edited by Yechiam Weitz, 211–51. Tel Aviv: Ministry of Defense Press, 2000.

Elbaum-Dror, Rachel. "Ha-Ishah ha-Tzionit ha-Idialit." In *Ha-Tishma Koli? Yitzugim shel Nashim ba-Tarbut ha-Israelit*, edited by Yael Atzmon, 95–115. Jerusalem: Makhon Van Leer, 2001.

Fogiel-Bijaoui, Sylvie. "From Revolution to Motherhood: The Case of Women in the Kibbutz, 1910–1948." In *Pioneers and Homemakers: Jewish Women in Pre-State Israel*, edited by Deborah S. Bernstein, 211–31. Albany: State University of New York Press, 1992.

———. "Ha-Omnam ba-Derekh le-Shivyon? Ma'avakan shel ha-Nashim le-Zkhut Behira ba-Yishuv ha-Yehudi be-Eretz Yisrael, 1917–1926." *Megamot* 34, no. 2 (1991): 262–84.

Gal, Sari. "Parashat Gvurata shel Hadasa Lampel: Mabat Nosaf al Hantzahat ha-Noflot be-Tashah." *Alei Zait va-Herev* 10 (2010): 130–58.

Gelber, Yoav. "Hitgabshut ha-Yishuv ha-Yehudi be-Eretz Yisrael, 1936–1947." In *Toldot ha-Yishuv: Tkufat ha-Mandat ha-Briti*. Part 2, edited by Moshe Lissak, 303–463. Jerusalem: Mosad Bialik, 1994.

Gofer, Gilat. "'Ha-Element ha-Yoter Mat'im le-Tafkid shel Ikarot u-Po'alot Haklaiyot': Nashiyut Tzionit ba-Moshavot be-Tkufat ha-Aliya ha-Shniya." *Israel*, no. 5 (2004): 123–50.

Golani, Motti. "Manya: Aliyata ha-Ktzara ve-Nefilata ha-Aruka." *Israel*, no. 3 (2003): 1–20.

Govrin, Nurit. "Nashim ba-Itonut ha-Ivrit: Hathalot." *Kesher* 28 (November 2000): 8–20.

Guilat, Yael. "Imahut ve-Leumiyut: Kolan shel Nashim Omaniyot be-shiakh ha-Shkhol ve-ha-Hantzaha." *Israel*, no. 18–19 (2011): 237–67.

Hacohen, Dvora. "Rachel Yanait Ben-Zvi ve-Havat ha-Limud le-Banot be-Yerushalayim." In *Ishah be-Yerushalayim: Migdar, Hevra ve-Dat*, edited by Tova Cohen and Yehoshua Schwartz, 92–109. Ramat Gan: Bar-Ilan University Press, 2002.

Halamish, Aviva. "Ha-Ha'apala: Arakhim, Mitos ve-Metziut." In *Nekudot Tatzpit: Tarbut ve-Hevra be-Eretz Yisrael*, edited by Nurit Gretz, 86–98. Tel Aviv: The Open University Press, 1988.

Herzog, Hanna. "Irgunei Nashim ba-Hugim ha-Ezrahi'im: Perek Nishkhah ba-Historyografia shel ha-Yishuv." *Cathedra*, no. 70 (1994): 111–33.

———. "Itonut Nashim: Merchav Mesha'atek o Merchav le-Kri'at Tagar?" *Kesher* 28 (November 2000): 111–33.

———. "Nashim be-Politika u-Politika shel Nashim." In *Min Migdar Politika*, edited by Dafna Izraeli et al., 307–55. Tel Aviv: Hakibbutz Hameuhad, 1999.

———. "Redefining Political Spaces: A Gender Perspective on the Yishuv Historiography." *Journal of Israeli History* 21, no. 1–2 (2002): 1–25.

Izraeli, Dafna. "Migdur ba-sherut ha-tzva'i be-Tzahal." *Teoriyah ve-Bikoret* 14 (1999): 85–109.

———. "Tnuat ha-Po'alot be-Eretz Yisrael me-Reshita ad 1927." *Cathedra*, no. 32 (1984): 110–40.

Kabalo, Paula. "Leadership behind the Curtains: The Case of Israeli Women in 1948." *Modern Judaism* 28, no. 1 (2008): 14–40.

Kafkafi, Eyal. "The Psycho-Intellectual Aspect of Gender Inequality in Israel's Labor Movement." *Israel Studies* 4, no. 1 (1999): 188–211.

———. "Mi-Sublimatziyah shel ha-Nashiyut le-Sublimatziyah shel ha-Imahut: Shlavim be-Yahaso shel ha-Shomer ha-Tza'ir le-Nashim." *Iyunim Bitkumat Israel* 11 (2001): 306–49.

Kaplan, Temma. "On the Socialist Origins of International Women's Day." *Feminist Studies* 11, no. 1 (1985): 163–71.

Karay, Felicia. "Ha-Nashim be-Gehto Krakov." *Yalkut Moreshet* 71 (2001): 109–29.

Kark, Ruth. " 'Not a Suffragist.' Rachel Yanait Ben-Zvi on Women and Gender." *Nashim*, no. 7 (2004): 128–50.

Katzburg, Netan'el. "Ha-Asor ha-Sheni le-Mishtar ha-Mandat ha-Briti be-Eretz Yisrael, 1931–1939." In *Ha-Yishuv ha-Yehudi be-Eretz Yisrael meaz ha-Aliya ha-Rishona: Tkufat ha-Mandat ha-Briti*. Part 1, edited by Moshe Lissak, 329–432. Jerusalem: Mosad Bialik, 1994.

Leneman, Leah. "Medical Women at War, 1914–1918." *Medical History* 38, no. 2 (1994): 160–77.

Margalit Stern, Bat-Sheva. " 'He Walked through the Fields,' but What Did She Do? The 'Hebrew Woman' in Her Own Eyes and in the Eyes of Her Contemporaries." *Journal of Israeli History* 30, no. 2 (September 2011): 161–87.

———. "Imahot ba-Hazit: ha-Ma'avak lema'an Totzeret ha-Aretz ve-ha-Imut bein Interesim Migdari'im le-Interesim Leumi'im." *Israel*, no. 11 (2007): 91–120.

Melman, Billie. "Min ha-Shulayim el ha-Historia Shel ha-Yishuv: Migdar ve-Eretz Yisraeliut (1890–1920)." *Zion* 62 (1997): 243–78.

———. "Shula'im ve-Merkaz: Historiyah shel Nashim ve-Historiyah shel Migdar be-Israel." *Zion*, special issue: *Lizkor ve-gam Lishkoah: Mabat Isre'eli el ha-Avar ha-Yehudi* 54 (2009): 245–66.

———. "The Legend of Sarah: Gender, Memory and National Identities (Eretz Yisrael/Israel, 1917–90)." *Journal of Israeli History* 21, no. 1–2 (2002): 55–92.

Naveh, Hannah. "Nashim ve-Tzava." In *Migdar ve-Tzava*, 15–25. Tel Aviv: The Broadcast University, 2010.

———. "Reading Berl: The Hidden Seams of Biography." *Journal of Israeli History* 22, no. 2 (2003): 130–49.

Near, Henry. "Ha-hityashvut ha-Ovedet, 1919–1948." In *Toldot ha-Yishuv ha-Yehudi be-Eretz-Yisrael me'az ha-Aliyah ha-Rishonah: Tkufat ha-Mandat ha-Briti*. Part 3, edited by Moshe Lissak, 409–544. Jerusalem: Mosad Bialik, 2007.

———. "What Troubled Them? Women in Kibbutz and Moshav in the Mandatory Period." In *Jewish Women in Pre-State Israel: Life History, Politics, and Culture*, edited by Ruth Kark, Margalit Shilo, and Galit Hasan-Rokem, 122–30. Waltham, MA: University Press of New England, 2008.

Ofaz, Aviva. "She'elat ha-Ishah ve-Kolan shel Nashim ba-Hevra ha-Halutzit leor ha-Kovetz 'Kehiliyatenu.' " *Cathedra* 95 (April 2000): 101–18.

Pennington, Reina. "Offensive Women: Women in Combat in the Red Army in the Second World War." *Journal of Military History* 74 (July 2010): 775–820.

Porat, Dina. " 'Be-Sliha u-ve-Hesed': Ha-Mifgash bein Ruzka Korchak le-vein ha-Yishuv u-Manhigav, 1944–1946." In *Kafe ha-Boker be-Re'ah ha-Ashan: Mifgasham shel ha-Yishuv ve-ha-Hevra ha-Israelit im ha-Shoa ve-Nitzoleiah*, 81–116. Tel Aviv: Am Oved, 2011.

———. "Mekoma shel Eretz Yisrael be-Tnuot ha-No'ar be-Polin be-Tkufat ha-Sho'a." In Porat, *Kafe ha-Boker*, 227–47.

Reinharz, Shulamit. "Manya Wilbushewitz-Shochat and the Winding Road to Sejera." In Bernstein, *Pioneers and Homemakers*, 95–118.

Robbins, Joyce, and Uri Ben-Eliezer. " 'New Roles' or 'New Times?' Gender Inequality and Militarism in Israel's 'Nation in Arms.' " *Social Politics* 7, no. 3 (2000): 309–42.

Rosenberg-Friedman, Lilach. "Captivity and Gender: The Experience of Female Prisoners of War During Israel's War of Independence." *Nashim*, no. 33 (2018): 64–89.

———. "Religious Women Fighters in Israel's War of Independence: A New Gender Perception or a Passing Episode." *Nashim*, no. 6 (Fall 2003): 119–47.

Schönberger, Bianca. "Motherly Heroines and Adventurous Girls: Red Cross Nurses and Women Army Auxiliaries in the First World War." In *Home/Front: The Military, War, and Gender in Twentieth-Century Germany*, edited by Karen Hagemann and Stefanie Schüler-Springorum, 87–113. Oxford: Berg, 2002.

Shapira, Anita. "Golda: Femininity and Feminism." In *American Jewish Women and the Zionist Enterprise*, edited by Shulamit Reinharz and Mark Raider, 303–12. Waltham, MA: University Press of New England, 2005.

———. "Ha-Halom ve-Shivro: Hitpathuto ha-Politit shel Gdud Ha'avoda al-shem Trumpeldor, 1920–1927." *Ba-Derekh* 3 (December 1968): 39–51.

———. "Historiography and Memory: Latrun, 1948." *Jewish Social Studies* 3, no. 1 (1996): 20–61.

———. "Lean Halkha 'Shlilat ha-Galut.' " In *Yehudim, Tziyonim uma sh-Beineihem*, 63–110. Tel Aviv: Am Oved, 2007.

———. "Le-Shivro shel Halom Ehad: Gdud Ha'avoda al-shem Yosef Trumpeldor." In *Ha-Alikha al Kav ha-Ofek*, 157–207. Tel Aviv: Am Oved, 1988.

———. "The Bible and Israeli Identity." *AJS Review* 28, no. 1 (April 2004): 11–42.

Sinai, Smadar. "Ha-Noflot ha-Rishonot, Dvora Drachler ve-Sarah Chizik, u-Mekoman be-Sipur Tel Hai." In *Tel Hai 1920–2020: Bein Historya le-Zikaron*, edited by Yael Zerubavel and Amir Goldstein, 294–317. Jerusalem: Yad Itzhak Ben-Zvi, 2020.

Tabenkin, Yitzhak. "Al ha-Shmira ve-'Hashomer' ba-Aliya ha-Shniya." *Shorashim*, no. 1 (1979): 9–24.

Tzur, Muki. "Ke-Hakot Rahel: Kavim Biografi'im." In *Rachel: Ha-Haim, ha-Shirim*, 11–86. Tel Aviv: Hakibbutz Hameuhad, 2011.

Unpublished Academic Works

Almog, Orna. *Ha-Nashim be-Koah ha-Magen: Me-ha-"Haganah" la-Hen, 1920–1948*. Master's thesis, Hebrew University of Jerusalem, 1987.

Blum, Shlomit. *Ha-ishah bi-Tnu'at ha-Avodah bi-Tkufat ha-Aliyah ha-Shniyah.* Master's thesis, Tel Aviv University, 1980.

Buzitz-Herzog, Zohara. *Ha-Pulmus al Zekhut Behira le-Nashim le-Mosdot ha-Yishuv be-Reshit Tkufat ha-Mandat.* Master's thesis, Bar Ilan University, 1990.

Gofer, Gilat. *"Ha-ishah ha-Tziyonit": Havnayat ha-Nashiyut bi-Tkufat ha-Reshit shel Tnu'at ha-Avodah, 1903–1923.* PhD diss., Tel Aviv University, 2009.

Index

CPSIA information can be obtained
at www.ICGtesting.com
Printed in the USA
BVHW081857090223
658229BV00003B/52

9 781438 490144